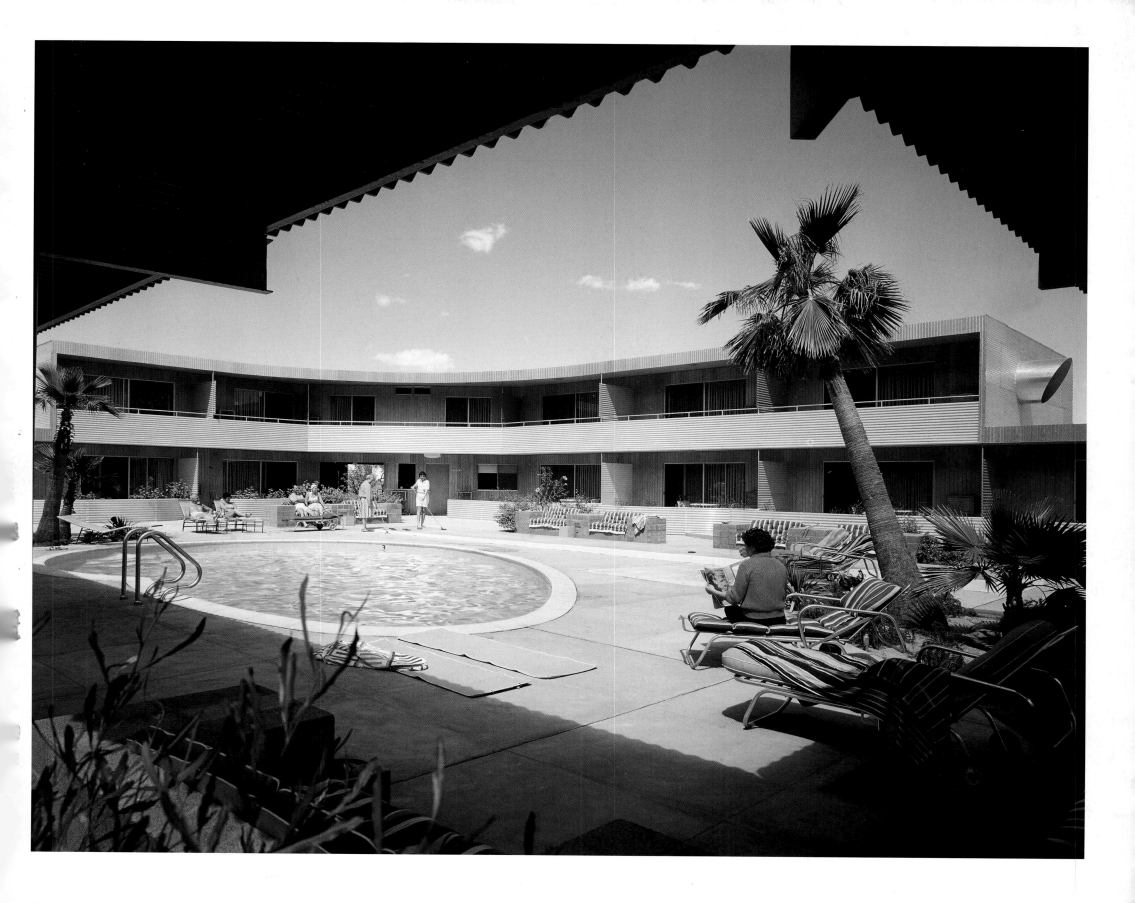

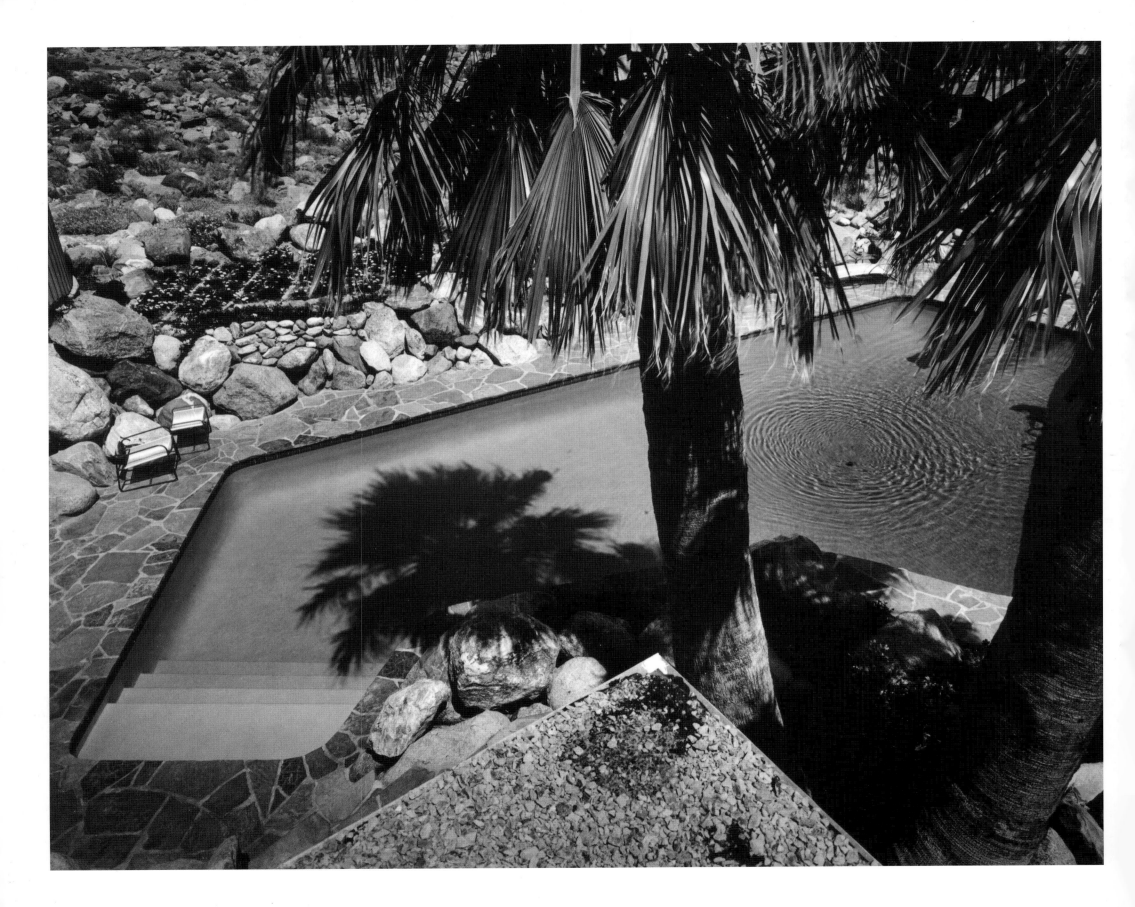

Julius Shulman: Palm Springs

Michael Stern and Alan Hess

RIZZOLI NEW YORK | Palm Springs Art Museum

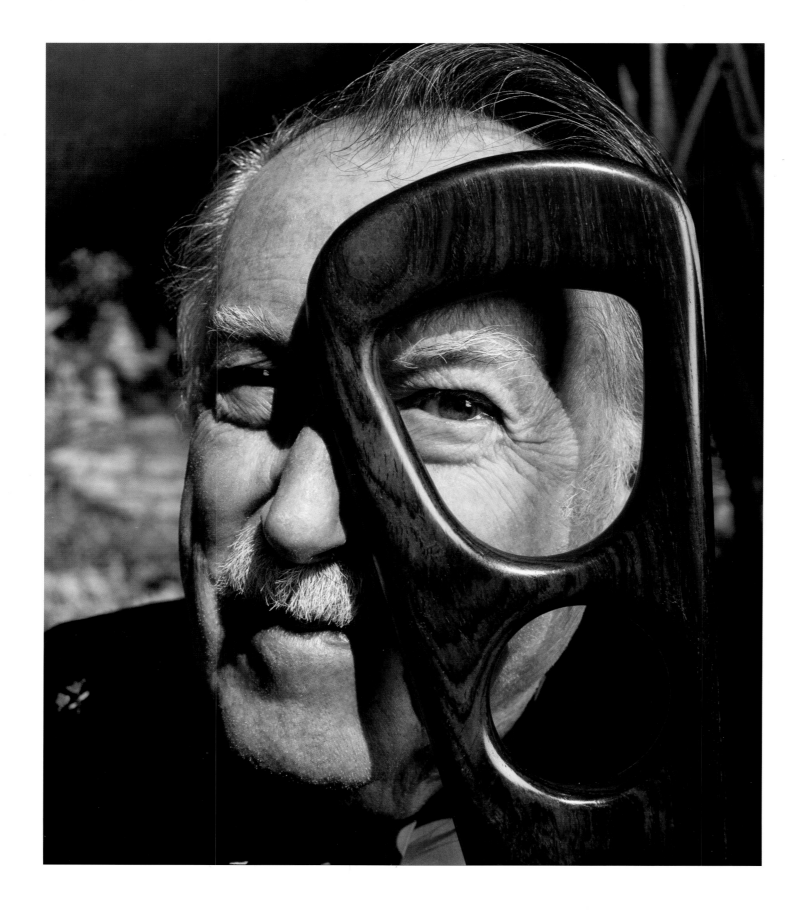

Left: **Julius Shulman, 2006.**
Photograph by Michael Childers.

Opposite, top: **Shulman**
in Palm Springs, 1926.
Bottom: **Shulman in Palm**
Canyon, 1926.

Foreword

In my observation, Palm Springs is one of the great spaces in this country. Its environment, from the floor of vast desert areas to snow-clad mountain peaks, displays a uniqueness of "close-at-hand" natural phenomena. Amidst those canyons, mountains, sand dunes, and countless golf courses, architects have created a volume of homes oriented toward a relationship with nature not found in many areas of the world.

My first introduction to the rare isolated Palm Canyon occurred in 1926, when with a group of friends seeking a camping spot, we encountered the stream coursing through a dense grove of palm trees. Even at the "tender" age of sixteen, we became enamored of the magnificence of the miracle, palm trees thriving amidst huge boulders that trapped the stream, plunging down the canyon from snowy peaks of the San Jacinto Mountains. Thus were created numerous pools that provided a means of escaping the head of the midday desert sun.

In such an environment, how could we not become captivated by this discovery! During successive years, we continued to camp, sleeping with the musical performance of the water traversing the rocks.

Into this treasured land scores of visitors, encountering the intimate, welcoming of Nature, began in the early periods of Palm Springs to establish an experience of learning how to live in this environment. **— Julius Shulman**

Acknowledgments

To David,
for more than everything...
— *Michael Stern*

For Linda Brown,
My friend from the plains
to the desert to the sea
— *Alan Hess*

Michael Stern would like to greatly thank:

Julius Shulman, for his extreme generosity, complexity, and brilliance;

The Palm Springs Art Museum, for making the idea a reality: Harold Meyerman, Board President, the Board of Trustees of the Palm Springs Art Museum, Dr. Steven Nash, Dr. Janice Lyle, Katherine Hough, Scott Schroeder, Kimberly Nichols, Lisa Vossler, Greg Murphy, and all of the members of the "Shulman Team";

The Getty Research Institute, for great support and expedience: Wim deWit, Julio Sims, and the staff at Visual Media Services;

Rizzoli International Publications, for making this book a pleasure to do: David Morton, Douglas Curran, and Meera Deean;

Juergen Nogai, for his wonderful photographic work and infinite patience;

Judy McKee and Rose Neilsen, for kind and gracious assistance;

The architects and their families, including: Donald Wexler, William Krisel, Catherine Cody, Erik and Sidney Williams, and Elaine Jones;

The homeowners for opening their homes to Mr. Shulman: Mrs. Leonore Annenberg; Mrs. Bob Hope and Linda Hope; Harold and Dorothy Meyerman; Jim Moore; David Lee, Michael Kilroy, Dana and Jaime Rummerfeld; for assistance in this regard: Linda Brooks, Jim Hardy, Donna Ellis, and Juanita Moore;

Gudrun Freuhling, Tony Merchell, Gordon Baldwin, Adele Cygelman, and Chris Nichols, for invaluable insight and information;

Michael Childers and Jay Jorgenson, for the portraits of Julius Shulman;

Richard Beckerman and Alan Hess, for editorial assistance;

The Palm Springs Modern Committee (www.psmodcom.org) and its founder, Peter Moruzzi, for pre-preliminary support;

Zand Gee, for making this book so beautiful;

Christy Eugenis and the Orbit In, for accommodations for Mr. Shulman.

For extraordinary curatorial research assistance:
Anne Blecksmith, Getty Research Institute.

A special note of gratitude:
Sidney Williams, Palm Springs Art Museum.

I add my thanks to everyone in Michael's acknowledgments for their help in making this book possible. Julius Shulman has contributed not only his photos but also his insights and knowledge to enrich the text. I would particularly like to note the help of the architects, including Hugh Kaptur, William Krisel, and Donald Wexler, who aided me in documenting their work. It was a pleasure to be able to talk with these creative architects about their careers. For their exceptionally generous help in my research, I also thank Catherine Cody, Andrew Danish, Christy Eugenis, Tony Merchell, and Christina Patoski. — *Alan Hess*

Julius Shulman: Palm Springs

Palm Springs Art Museum

February 15 through May 4, 2008

Contents

Architects

Preface

In 1938 the village of Palm Springs incorporated as a city and the Palm Springs Desert Museum opened its doors. It is therefore especially appropriate to celebrate the seventieth anniversary of these events with this book and exhibition showcasing the Palm Springs architectural photography of Julius Shulman.

In addition to Richard Neutra, architects John Porter Clark, William F. Cody, Albert Frey, A. Quincy Jones, John Lautner, Palmer and Krisel, E. Stewart Williams, Paul Williams, and others commissioned Julius Shulman to photograph their newly completed projects. After World War II the city attracted wealthy clients who sought modern houses that, in their open plan and interior-exterior flow, incorporated the sunshine and light of the desert. With his flawless eye for light and shadow, design, and form, Shulman recorded these outstanding examples of Mid-Century Modern architecture.

In order to make this exhibition and accompanying publication complete in its telling of the story of Modernism in Palm Springs, in October 2006, the museum commissioned ninety-six-year-old Shulman and his partner Juergen Nogai to photograph nine additional properties that had not previously been documented by him: the Palm Springs International Airport, the Alexander Steel Houses, and the Dinah Shore House, all designed by Donald Wexler; Victor Gruen's City National Bank; the William Burgess House; John Lautner's Arthur Elrod House and Bob Hope House; and Sunnylands, the estate designed by A. Quincy Jones and Frederick E. Emmons for Ambassador Walter and Leonore Annenberg.

This is, of course, not the first exhibition of Julius Shulman's photographs at the museum. Seven exhibitions have featured his photographs over the past fifteen years including shows dedicated to Albert Frey and museum architect E. Stewart Williams' work, as well as several surveys of Shulman's photography. However, this exhibition is the largest ever assembled of Shulman's work and thus affords us the opportunity to view in great detail and variety the extensive work of a master photographer. We are confident that it will confirm his place as one of America's greatest architectural photographers.

We are indebted to the Getty Research Institute, for their very generous cooperation; to the University of California Los Angeles, University of California Santa Barbara, and numerous private individuals for their generous loans of material for the exhibition; but most especially to exhibition curator Michael Stern for his tireless and exacting professionalism in initiating and completing this huge undertaking, both the exhibition and the book. We extend our appreciation to Alan Hess for his fine writing in this book and the exhibition text panels. (We are delighted that the City of Palm Springs is the exhibition's presenting sponsor and are grateful for the joint celebration of Palm Springs's architecture and history that this exhibition represents.)

For the City of Palm Springs and the Palm Springs Art Museum, this is truly a year of celebration. We applaud Julius Shulman and his extraordinary lifetime of superb photography. •

Steven Nash, Ph.D.
Executive Director,
Palm Springs Art Museum

Opposite: **Palm Springs Desert Museum,**
E. Stewart Williams, 1976.
Photo: 1976.
The silhouetted figure at center is museum architect E. Stewart Williams.

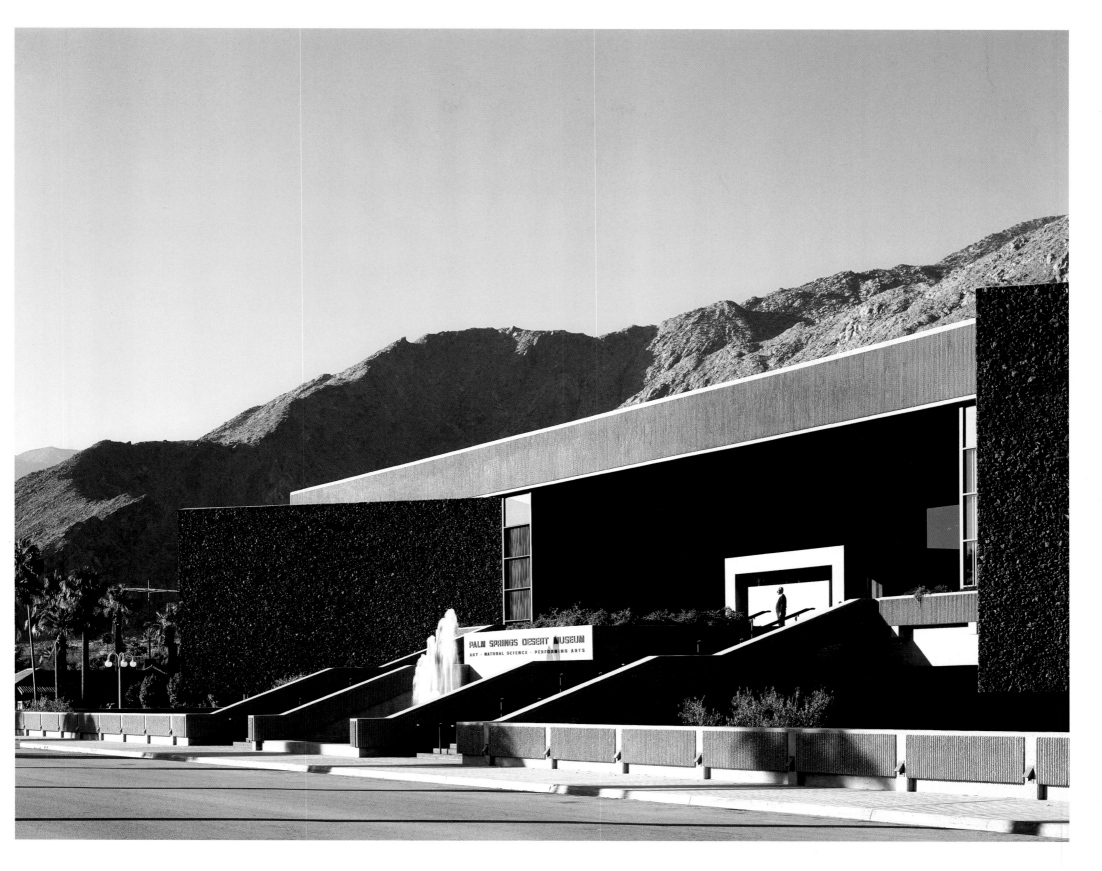

Palm Springs and Julius Shulman by Michael Stern

Palm Springs figures large in Julius Shulman's body of work, and a surprising percentage of his most famous photographs come from the desert region. The interplay of nature and architecture, coupled with Shulman's impeccably sharp eye, created images that are etched on the cultural consciousness; a complex choreography played out between modern architecture, landscape, mountains, and a luminosity that is rare in this world.

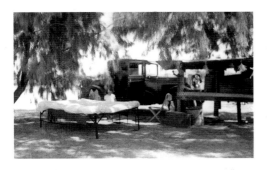

Top: **Shulman campsite at Spa Hotel site, 1938.**
Bottom: **Shulman working on roof of Spa Hotel, 1970.**
Opposite: **Wasserman House, Harold Levitt, 1962.**
Photo: 1962.

Palm Springs is a region that seemingly exists on its own plane.[1] The steep San Jacinto Mountains that form the western barrier keep the smog, urban noise, and coastal clouds at bay. This dramatically vertical rock wall creates a locale with the aura of a desert island: a world that exists unto itself, despite its landlocked location in Southern California. Injected into the stark desert is an artificial oasis of tropical lushness. It is this juxtaposition of nature and culture that gives Palm Springs its unique identity.

Shulman's first experience of Palm Springs came in 1926, when he was sixteen years old. Having developed a love of nature from a boyhood spent on a farm in Connecticut, Shulman and his teammates on the high school gymnastics team in Los Angeles would camp and hike in the canyons located near town. This was often done in the heat of summer, when Shulman and his friends basically had the place to themselves, save for several of the local members of the Agua Caliente tribe who were caretakers of the Canyons (most of the members of the tribe would move to cooler elevations during the heat of summer). Shulman befriended a few of them, who allowed him the opportunity to camp where naturally bubbling hot springs came to the surface. Known for their healing properties, the land around

the springs is now the site of the Palm Springs Spa and Hotel.

The cultivated landscape of Palm Springs is largely due to an enormous aquifer that lies underneath the desert floor. The water is pumped to the surface, nurturing the irrigated manmade landscape. In spite of this artificiality, the natural desert exerts its powerful influence, and Shulman's photographs depict this potent duality. Developed land is never more than minutes away from awe-inspiring, pristine desert terrain. The carpet of lawns, golf courses, and swimming pools leading to the desert wall is a distinct byproduct of its Southern California location. A major focus of Southern California life was, and is, the indulgence of pleasure by the masses. Stimulated by breathtaking scenery and beautiful weather, it is a common thread that has united visitors and residents for decades. Palm Springs is a mecca for that pleasure.

The milieu depicted in Shulman's photographs is a beautiful one, in which the people are attractive and buildings are exquisitely groomed and flawlessly framed. Yet the truth is not terribly distant from this somewhat fictionalized ideal. The reality is that California is a land of illusion, improbability, and hope. It is this aspiration toward a better life that has drawn immigrants from across America. The dream and reality of California commingle in the sensual abundance of the land and the lifestyle—the days are warm and balmy, palm trees sway, swimming pools glisten, and the sunlight on the mountains creates an ever-changing kaleidoscope of highlights and shadows. California is the land of promise, laden with abundant resources that have conspired to create this specific culture, and Shulman renders this culture in all of its sensuality. The beauty of the architecture harmonizes with the beauty of the landscape, and ultimately yields to it. The power of the desert reigns supreme.

The area first gained attention for its recuperative climate for respiratory ailments. Subsequently, the ultra-wealthy in the 1920s recognized its value as a place for rest, relaxation, and fun. Its worldwide renown, however, was established when the desert region became a vacation playground for the Hollywood set. The quiet hush that envelopes the desert provided a safe haven for actors seeking respite away from the eye of intrusive photographers. Stars could often be seen walking down Palm Canyon Drive, the major thoroughfare, enjoying themselves in a relatively unfettered context. Many built second homes in the area.

Southern California Modernism, the relaxed regional variation of the more austere International Style of architecture, flourished in the desert. Architects in the middle of the twentieth century were eager to work in this new language. The popularity of this residential architecture in the desert was a result of the fact that most of the homes were designed as second homes. As non-primary residences, homeowners felt more at liberty to take risks with the design than they did in their main residences, and practical considerations were not as critical in a vacation dwelling. Typically, the architecture is understated, sophisticated, and horizontal, contrasting and deferring to the spectacular vertical natural landscape.

Shulman's photographs maximize the attributes of this unique location. His dual sensitivities to both architecture and nature reach their apex in his Palm Springs work. There he returned to photograph again and again, from the 1930s to today. Shulman's work in the desert can be characterized by his use of clarity, context, and contrast. Clarity is a primary ingredient of a Shulman photograph. His work is not about soft-focus and diffusion; a direct, distinct presentation of reality was his objective, and the rich, clear light and clean, dry air of the desert provided him with the

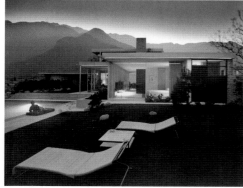

Top: **Shulman in Palm Springs, 1926.**
Bottom: **Kaufmann House, Richard Neutra, 1946.**
Photo: 1947.
Above right: **Maslon House, Richard Neutra, 1962.**
Photo: 1963.

precise requirements that give his photos their depth and detail.

The context for his photographs was the magnificent canvas of the San Jacinto and Santa Rosa mountain ranges that are ever-present and immediate in the Coachella Valley. Shulman rarely photographs architecture in Palm Springs as an isolated abstract entity, but he portrays it as a functioning and contextualized real-world place, albeit one with a cosmetic sheen. Context is further provided by the use of figures in his photographs. By bringing active people into the frame, Shulman provided a sense of scale, and showed the critical components of the cultural framework and its interaction with architecture.

Contrast describes the vivid tonalities contained in the printed photographs, and also expresses the interplay between the geometries of the built world and the natural environment. In Shulman's photograph of Richard Neutra's Maslon House *(shown right)*, the amorphous shape of the tree in the foreground contrasts with the crisp rectangularity of the house. Shulman sharpens that contrast to articulate Neutra's rational vision.

Shulman, ever sensitive to natural elements, often photographed during the magic hours of dusk. As the highest peaks in Palm Springs lie to the west, in the late afternoon hours the intense desert sun sets behind the mountains, creating a backlit silhouette of the dramatic ridgeline, and a rich source of indirect light. Shulman frequently waited for that time to take exterior photos, as the lighting was largely shadowless, and the interior illumination of the buildings equalized with the diminishing sunlight. This is seen in Shulman's iconic photograph of Richard Neutra's masterpiece, the Kaufmann House *(shown left)*. Using a lengthy exposure, and sequentially turning on a variety of lights inside the house and pool (employing the figure of Mrs.

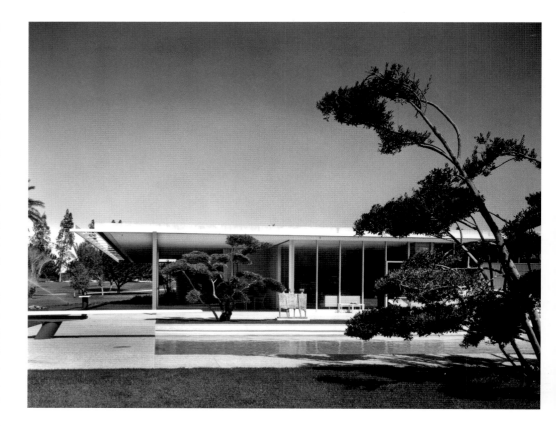

Kaufmann to block the harsh, direct light of the swimming pool), Shulman elegantly captured the drama of that particular time of day.

Shulman's photographs exhibit a remarkable sense of balance. Bringing comparable lighting to both indoor and outdoor elements enabled Shulman to depict realistically the indoor-outdoor lifestyle that epitomizes Palm Springs. Rather than closing curtains, or exposing for an interior while burning out the exterior, Shulman created a lighting equilibrium that correlates to the human eye's ability to correct for extreme shifts of light levels, conveying an experiential quality to his work. Shulman's compositional strategies also showcase a refined balance. Though often asymmetrical, there is a compositional counterpoint that creates a balanced

arrangement of form and energy. His use of raked diagonals leads the eye into the furthest reaches of his subjects. Frequently, there is a suggested divide drawn down the middle of the photographs and a tension between what lies on both sides of the division, be it the relationship between indoors and outdoors or natural and man-made.

Commercial photography is intended to flatter its subject. That was clearly Shulman's motivation, as he presents his buildings in their best light, highlighting distinctive architectural elements that could "sell" the buildings to magazine editors and architects' prospective clients. Shulman often utilized a variety of strategies, such as complex lighting and the rearrangement of objects to suit his desired composition (including the introduction of a tree

branch freely moved about to frame an image). These were devices that allowed him to bring some of the depth of three-dimensional architecture to a two-dimensional image. The human experience of architecture is sequential and enveloping. A photograph is immediate and flat. Shulman's heightened and articulate use of photographic techniques enabled him to simulate an experiential dimension of the buildings that he photographed. Much like the creations on a movie set, where a battalion of lighting and special effects creates the illusion of reality on the screen, Shulman's utilization of these dramatic devices caused his photographs to resemble the way humans perceive architecture.

Though their purpose was often promotional, the photographs have become cultural documents. Transcending their original purpose, they are now seen as stunning objects unto themselves; some emerging as true icons of the medium of photography. Shulman's photographs are historically significant in their expression of the optimism of the era, and the palpable hope that, through modern design, a better life could be attained. California has long represented the ideal of the "good life" in America, and Palm Springs represents the "good life" in California. These photographs are a sensual paean to how charmed this life can be. In spite of a forbidding context, the desire for pleasure has turned a windy, dusty desert into a playground that soothes, relaxes, and pampers. It is a somewhat peculiar triumph of man over nature, but one whose symbiosis has led to an environment that represents the best of both worlds.

Shulman is now recognized as a legend of the medium. His black-and-white photographs have become so widely known it is startling to see the color iterations of some of his famous photographs. Such is the "Shulman effect" that it is often difficult to imagine these buildings in anything other than their black-and-white world. Shulman produced hundreds of thousands of photographs throughout his career, which is by no means over, as Shulman, at the age of ninety-six, is a working photographer. Their widespread distribution has bestowed fame on buildings and architects that may never have experienced it were it not for his skillful illustrations. Shulman's clients ranged from name-brand architects to those who toiled in relative obscurity, until being discovered eventually through exposure in magazines and newspaper articles. An architect such as Albert Frey would not have been known beyond Palm Springs were it not for Shulman's documentation and desire to see Frey's work given the recognition that it deserved. Conversely, of course, it was the inspiration of this architecture that gave rise to Shulman's iconic photographs.

What ultimately unites Shulman's work and Palm Springs is that both are, on a primary level, an exercise in the relationship between truth and fiction. Who could guess that a lush tropical gardenland could exist in the middle of the desert, or that photographs so flawless could have a counterpart in reality? The desert town and Shulman's photographs both blur this line, thereby strengthening the very relationship between them. California, through its myriad pleasures and perils, is improbable; Palm Springs is beyond that, existing as a surreal green mirage floating above the desert floor. But it is real, and it is true. Shulman's precise compositions and splendid worlds seem somehow beyond truth, harkening to notions of glamour and the ideal. Yet at their essence they express a truth: the narrative of architecture told by a master storyteller in his highly informed discussion of buildings and their meaning. •

1 Palm Springs is used here in the vernacular sense, to include the entirety of the resort areas of the Coachella Valley, which encompasses Rancho Mirage, Palm Desert, Indian Wells, Desert Hot Springs, the Salton Sea, and neighboring cities.

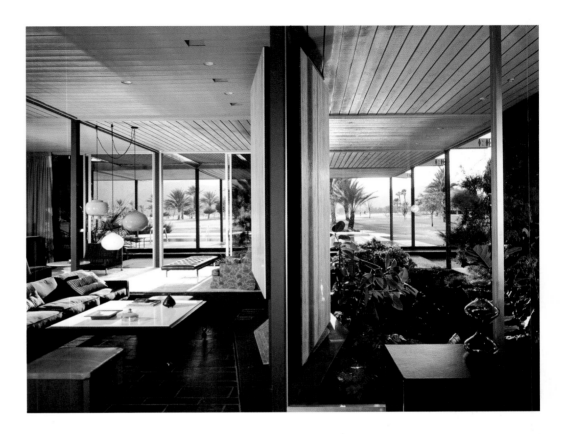

Above: **Shamel House, William Cody, 1962. Photo: 1964. The divided frame articulates the relationship between interior and exterior.**

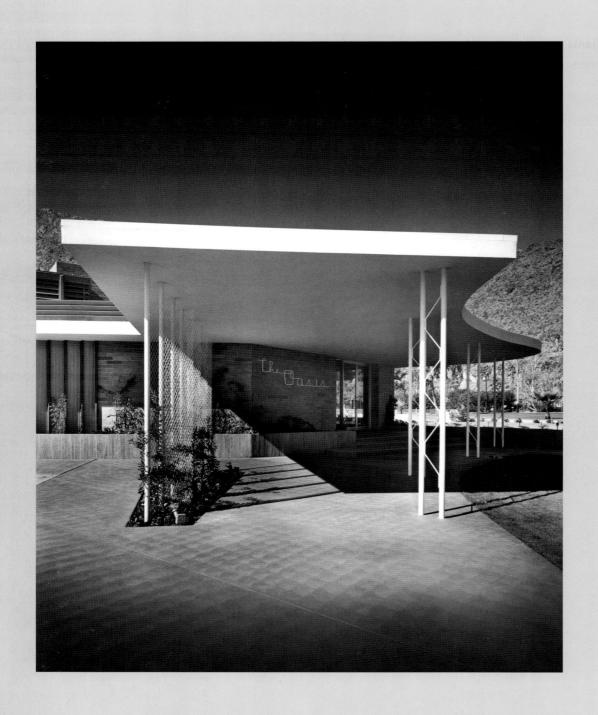

Architects

Architects and Projects List

Introduction

Much of the unknown story of Palm Springs architecture rests in Julius Shulman's photo files. Presented in his staccato, brilliantly lighted narrative style, the responses of varied architects to mountains, sunshine, and wealth in the modern age inspired some of the best-known images of Modernism anywhere; Shulman's depiction of the wild rubble that sets off Richard Neutra's airy Kaufmann House captures technology's triumph over the harsh elements.

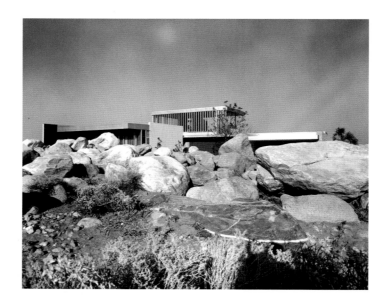

Yet despite such stupendously famous images, there is still much of Palm Springs that is not well known. It should be, though. Shulman has been regularly adding to his exploration of Palm Springs for seventy years. The story of Palm Springs architecture has been sitting there that entire time, and yet it has been only in the past decade or so that the architectural community (let alone the wider world) has begun to glimpse the fullness of that story. The small desert resort town, we now discover, is a textbook of California Modern architecture. Steel houses of the utmost delicacy, concrete architecture of the utmost daring, wood buildings of grace and warmth, roadside buildings of tremendous art and practicality, innovative commercial buildings of humanity and sociability, and of course residences great and small, custom and mass produced, which showed how the elements could be either conquered or coaxed into partnership with mankind: these are some of the basic themes of California architecture, and by a quirk of fate or economics, Palm Springs attracted architects who skillfully explored them. No other town of its size can boast such a range. It's as if Palm Springs was created as a summary, an exegesis of all that's important about California architecture in the twentieth century.

What role does Palm Springs architecture play in California architecture? While some of the very best examples are unquestionably there—including the Kaufmann and Elrod houses—Palm Springs's strength lies in reflecting the inventiveness and free experiment of the best of California design. It is not separate or unique, or even isolated; it is an extraordinary reflection of what California architects were capable of achieving.

Bringing Modern architecture to Palm Springs was not easy. "Palm Springs was a charming little town. It didn't want to change," remembered E. Stewart Williams. "The public was always against any kind of project. . . . There's no vision in Palm Springs. We fought every day against the lethargic government and public."[1] "We rarely had clients who were totally sympathetic" with Modernism, John Porter Clark agreed.[2]

Some of these architects came (and returned) to work in Palm Springs from metropolitan Los Angeles, a two-hour car drive away on the crude roads of the 1930s or the crowded highways of the 2000s. John Lautner, Richard Neutra, William Pereira, Victor Gruen, A. Quincy Jones, Val Powelson, Hal Levitt, Paul R. Williams, Welton Becket and Walter Wurdeman, and Dan Palmer and William Krisel were attracted to work there because of the luxe economic situation that demanded high-quality public and commercial buildings, or by wealthy clients who wanted excellent architecture in a superb natural setting.

But even more of these architects were local. William Cody, Donald Wexler, Albert Frey, John Porter Clark, E. Stewart Williams, Hugh Kaptur, and Herbert Burns all had practices in Palm Springs and environs, and seldom built elsewhere. This is astonishing: how could this small community sustain so many excellent designers? Why were they not lured to move to the big city beyond Beaumont Pass? Each had their own story for coming to and remaining in Palm Springs.

Fame did not tempt most of them. A steady stream of good clients for an interesting variety of buildings did, and Palm Springs supplied that.

What drew architects to this out of the way town? Clients brought the Los Angeles architects to Palm Springs. The local architects' motives for settling there are more diverse. Only Albert Frey chose Palm Springs quite intentionally, as he had chosen to work for Le Corbusier, and as he had chosen to move to America and New York. From his writings it is clear that the location inspired his artist's intuition. William Cody could have had a decent career in Los Angeles; even while in architecture school at the University of Southern California, he showed his entrepreneurial skill in getting jobs. Health reasons lead him to the desert. Donald Wexler, John Porter Clark, and Stewart Williams arrived in Palm Springs almost accidentally, in the random but pragmatic steps by which most young architects find jobs. Once there, however, all recognized that the desert struck a chord in them, and offered reasonably steady work. Nor did any of these local architects want to use Palm Springs as a springboard to a larger practice. "I never had a desire to get big. I saw what the Depression did to Shreve Lamb [in New York]. I never tried to send my buildings to magazines or have another office," said Stewart Williams.[3] Similarly with Bill Cody, "He was not a P.R. person. Never in a publication. Not his nature," remembered his friend George Hasslein.[4]

None of this explains why Palm Springs came to have such a high concentration of excellent design. In California, Santa Barbara, the Monterey Peninsula, Lake Tahoe, and La Jolla also had resort communities, wealthy clients, and excellent architects. Aspen, Sun Valley, and Scottsdale all attracted celebrities, the super-rich, and the upper middle class for recreation. Like Palm Springs, these towns benefited from the twentieth-century spread of resorts (enabled by the airplane and the automobile) to isolated, once-

inhospitable locations. In America (and particularly the American West) these conditions prompted the spread of Modern architecture as much as the development of steel girders, plate glass, and concrete. It was a particular kind of Modern architecture, unburdened by the socialist or intellectual theories of European Modernism. It was a Modernism for both the rich and the masses; it was a Modernism of luxury and pleasure, both for the well-off and the average middle-class family through the miracle of mass production.

Neither does this context explain the intriguing mix of backgrounds represented by this cohort of Palm Springs architects. There were Southern California natives (Paul Williams), Midwesterners (Wexler, Stewart Williams, Lautner, and Cody), and bona-fide Europeans (Frey, Neutra, and Gruen). There were sterling exponents of freeform Organic architecture (Lautner) and specialists in steel (Frey, Cody, and Neutra.) There were big commercial firms (Gruen, Becket, and Pereira and Luckman) and mainstream professionals and academics (Jones). There were architects involved in mass-produced housing (Palmer and Krisel, and Wexler) and architects with generalized practices (Cody, Stewart Williams, Wexler) who designed churches, homes, schools, restaurants, and motels.

Equally intriguing is the wide range of ideas that inspired these architects; looking through these photographs it is clear that there is no single answer to the question, "What is the proper way to design a desert building?" While Shulman's photos repeatedly show the same open landscape and backdrop of mountain, the objects these architects chose to place in the foreground are wildly dissimilar. Some dropped machined artifacts in the boulder fields, to which E. Stewart Williams objected: "I don't design something that looks as if some alien space ship set down onto the landscape."[5] Inspired by his own personal journey in Scandinavia as a young architect, he brought natural materials and natural forms from the cold north woods to the hot southern desert—and made it work. Some nestled houses in the bosom of the rocks and precipices. Albert Frey and John Porter Clark sought to disturb the native desert as little as possible, building artificial, lightweight, tentlike buildings of steel and glass that floated above the landscape. Some, such as Neutra, worked from their highly articulated theories of architecture; others simply worked. John Lautner also respected the existing desert in all its ancient hardness, but he burrowed the Elrod House into the earth so completely that it became like part of the rock. A. Quincy Jones at Sunnylands—no doubt at the insistence of the self-confident client—forcefully muscled the desert barrens into an oasis of greenery and high art, nestling his heavenly pavilions in a completely artificial setting.

The underlying concepts are startlingly different. Some respect the desert as is, others use the tools at hand to alter it to their vision. But the subtle and highly personal artistry of each architect comes through in Shulman's penetrating photos.

Cody, Neutra, and Frey, for example, all believed in lightness, and yet arrived at very different ways to express it. Cody makes the structure almost disappear, with planes of glass pressed one against the other without benefit of distracting frames; he often hoists the roof structure on columns separated from the enclosure of the house, where Neutra would make structure and walls part of an integrated system. Frey, on the other hand, uses materials that are self-evidently lightweight (corrugated metal, fiberglass, or thin metal trellises) and often he leaves his houses (like the Cree House) floating above the landscape through the use of cantilevers or thin metal legs. Each architect had his own interests; each had his own interpretation of the way to use modern materials to express the modern age.

This is why Palm Springs architecture has become such an excellent catalog of California design. It is time to look beyond the Kaufmann House. Those images are included in this book and are still indelible. But Palm Springs was never a one-trick pony. The depth and breadth of architecture and ideas here is astonishing. Julius Shulman has been present for seventy years to document much of it, and now we have a chance to explore this architecture in greater depth through his eye. •

1 E. Stewart Williams, interview by Alan Hess, Aug. 1, 1999.
2 John Porter Clark and Albert Frey, interview by Nan Tynberg, Nov. 8, 1986.
3 E. Stewart Williams, interview by Alan Hess, Aug. 1, 1999.
4 George Hasslein, interview by Alan Hess, Oct. 18, 1999.
5 E. Stewart Williams, *A Tribute to his Work and Life* (Palm Springs: Palm Springs Preservation Foundation, 2005), 9.

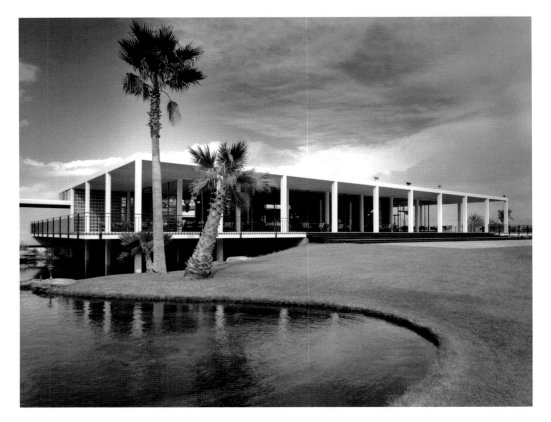

Left: **Eldorado Country Club, William Cody with Ernest Kump, 1958. Photo: 1960.**

Opposite page: **Kaufmann House, Richard Neutra, 1946. Photo: 1947.**

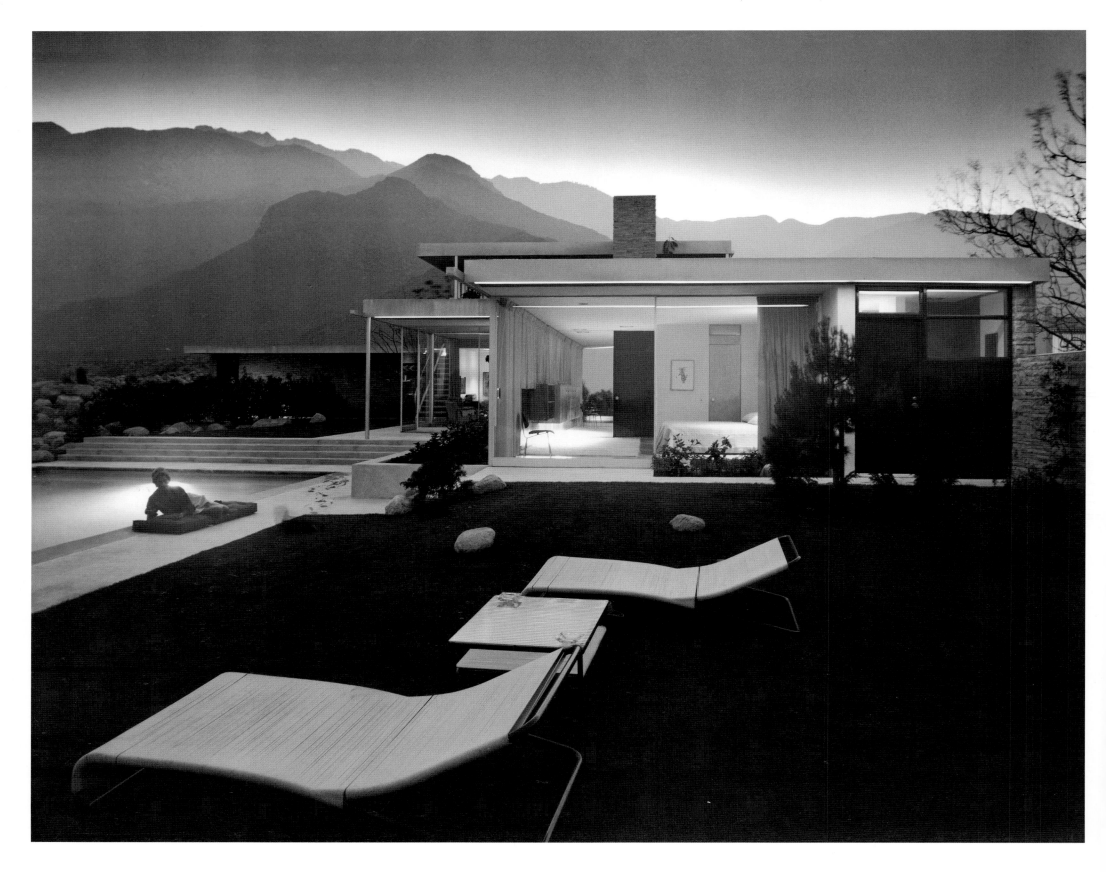

Richard Neutra

The three houses Richard Neutra (1892–1970) built in the Palm Springs area are only a tiny fraction of his work, an oeuvre that helped to define Modern architecture. Yet they span three major phases of his career and his ideas, and they include one undisputed masterpiece: the Kaufmann Desert House (1946).

Above: **Richard Neutra.**
Opposite: **Kaufmann House, Richard Neutra, 1946. Photo: 1947.**

Was there anything about Palm Springs that prompted this stunning design? Certainly the client was instrumental; Edgar Kaufmann—the Pittsburgh department store magnate who already assured his immortality as a patron of Modernism by choosing the has-been Frank Lloyd Wright to design a vacation home amid the woods and falling waters of east Pennsylvania—wanted a winter home, and Palm Springs was already well established as a retreat for his fellow industrialists and moguls. A wealthy client also made the architect's selection of luxury materials easier, freeing Neutra's palette. Neutra's preferred material, steel, made sense under the corrosive sun that warped and weakened wood, as Albert Frey had already determined, and as Donald Wexler would recognize in the future. He adjusted ventilation and mechanical systems for the climate (though Kaufmann intended to use it only in wintertime); the house could be thrown open to the fresh air, and radiant heat in the floors and walls tempered the cool nights. The glorious view also influenced the house; the "gloriette" (as Neutra identified it on the plans) is a distinguishing feature. That was the semi-enclosed roof terrace that created another outdoor space (complete with open fireplace and a dumb waiter to the pantry) and took in the breathtaking mountain

and valley panoramas. But his 1934 Beard House in Altadena had a roof terrace too. For two decades, in fact, Le Corbusier had been exhorting architects to make use of this previously wasted space.

There was little that was especially innovative about this Neutra design compared to others. It was simply an ideal opportunity to bring his passions about architecture together all at once.

So why is the Kaufmann House an icon? It may well be not the house but the *image* of the house in Julius Shulman's photographs that transformed an excellent but typical Neutra design into a famous building. As much as any architect of his era Neutra understood the indivisible link between design, publicity, clients, and fame, and he hovered over Shulman during the photo shoot to instruct him on the proper way to frame the house.

Thirty years before the Kaufmann House, when Neutra had been a young architect trapped in Vienna by the Great War, America beckoned to him with the enticements of better work and a seductive technological culture. In Europe the tantalizing possibilities of steel and glass architecture were still mostly in the future, in visionary examples like Walter Gropius's 1925 Bauhaus and Mies van der Rohe's 1928 Barcelona Pavilion. In Albert Kahn's America, steel and glass were already the reality of everyday life in factories, gas stations, and skyscrapers. Neutra yearned to work in this land of promise, and finally he did in 1923. Employed briefly in Spring Green, Wisconsin, by one of his heroes, Frank Lloyd Wright, he moved to Los Angeles. It was a risky choice at the time for an ambitious young architect; though the work of Lloyd Wright, Frank Lloyd Wright, Irving Gill, and R. M. Schindler in that remote western city had a small avant-garde following, New York or Chicago would have been better places to get noticed. Perhaps Neutra knew that he could manufacture his own fame. And besides that, his friend Schindler was

already established as an architect and had a house Neutra and his young family could share. Good enough reasons to move to the edge of the world. A dozen years later in 1936, Grace Miller, a recently widowed St. Louis society lady, gave him the opportunity to travel even farther, to Palm Springs.[1]

When Neutra first visited New York he had admired its "wild accidental beauty."[2] He might have said the same thing about Palm Springs. The site Miller purchased on the north side of the still-small village was surrounded by open land carpeted with sand, rock, and tumbleweed, though on the road to the fashionable Racquet Club.

Cut from the same socially progressive cloth as other Neutra clients like Phillip and Leah Lovell, Miller had adopted the Mensendieck System of Functional Exercise. While traveling in Europe she had become a teacher of this method of perfecting posture to improve life and health. Now Miller chose to move to Palm Springs to give classes in the method in a town where the wealthy and progressive citizens might be interested. A modern house and studio would serve her needs and be a good advertisement, too. In the early days of Modernism, the stark unconventional forms and open-floor plans of Modern architecture were often associated with new ways of living. They were new buildings for the modern age's new man and woman, interested in hygiene, exercise, health, culture, and self-improvement. Indeed, the Lovell House (1929) Neutra dubbed the "Health House."

For a small town, Palm Springs already had several modern buildings. R. M. Schindler had designed a cabin nearby in 1922; the 1925 Oasis Hotel by Lloyd Wright in the center of town was an astonishing statement of modern concrete construction and Organic form. William Gray Purcell, a Prairie School colleague of Frank Lloyd Wright, built the Purcell House in 1935. Albert Frey's office and

apartment for Dr. J. J. Kocher was built in 1934, and it introduced the International Style's boxy, flat-roofed geometry to the Coachella Valley—forms the Miller House would echo.

Though the Miller House (1937) was built of wood studs covered in stucco and trimmed with standardized metal windows, its basic concept is similar to the steel-frame Kaufmann House built ten years later. Small, filling several functions (home, studio, classroom, entertainment), the design had to be precise, efficient, and elegant—a one-story house on a concrete slab with a flat roof. The original landscaping created a grass carpet near the house. A small pool integrated into the corner of the house by the screened porch provided some coolness. Inside, the multifunctioning space is as close to abstract Modernist sculpture as in any Modern design: a combined storage partition and daybed thrusting into the room divide the L-shaped living space; the sparing placement of wood paneling, the fireplace, the well-proportioned windows, and Neutra's furniture may be functional, but it is also a stunning example of the minimalist aesthetic.

The vocabulary emphasizes thinness. A silver line of metal trim exaggerates the horizontal fascia line of the roof anchored on the taller, stucco-clad pylons. More than the cagelike steel frame of the Lovell House, this composition reflects a balanced asymmetry. Neutra had become freer with his proportions (a clear example of what he had learned from Frank Lloyd Wright). As with the large panels of plate glass in the Kaufmann House, these proportions would become even simpler and abstracted. With a larger house and larger budget, he would also use planes and pylons of stone and wood to add a dimension of texture and color absent in the gray, white, silver, and black-toned Miller House.[3]

Many of the Miller House features are seen in the larger, more expansive, more expensive Kaufmann

House. Kaufmann knew what he was getting; he had visited the Miller House in the late 1930s.[4] To his son's chagrin (Edgar Kaufmann Jr. was a Taliesin fellow) the father chose Neutra instead of Wright for his desert house after seeing Wright's Taliesin West, which he considered too heavy.[5]

The steel frame of the commodious U-shaped plan stretches to adapt to the needs of the house. One wing, parallel to the street, contains the living room and dining room; enormous sliding glass doors framed in steel pull the walls back to unite house, garden, and swimming pool. Sliding past the living room, the wing extends for the master bedroom, which looks out on another landscaped court facing the guest rooms. An outdoor corridor connects the two. Throughout the house inventive details (such as the moveable louvers lining this walkway) allow light and wind to be shut out, or welcomed in.

The Kaufmann's neighborhood had dramatic open views, but was destined for development. Raymond Loewy's house, designed by Albert Frey, was planned for next door when the Kaufmanns began construction. Until more houses came in, however, the boulder-strewn setting was the ideal Neutra canvas for his steel and glass design. The contrast of the artificial, ardently manmade artifact with rugged Mt. San Jacinto and its rocks was the perfect image of twentieth-century Modernism's dominion over primeval nature; even a desolate wasteland could be made safe for human habitation—and luxuriously so. Shulman's photos capture that juxtaposition, which no longer exists.

It would be another sixteen years before Neutra would complete another project in Palm Springs.[6] By then he was well established, had been on a 1949 *Time* magazine cover, and had attracted a stream of well-to-do house clients in cities around the world, as well as resort areas such as Santa Barbara and Rancho Santa Fe. Samuel and Luella Maslon were

such clients—well-informed art patrons with a growing collection to display.

Like the Kaufmann House, the Maslon House (1962) is a steel-frame house with a flat roof and large walls of glass. (It was demolished in 2002.) It looked out on the tamed landscape of a golf course, though, not the wild rubble field of the Kaufmann site. In the intervening years Neutra's office had grown. Larger civic and corporate buildings had come his way in partnership with Robert Alexander, and his design sensibility had evolved yet again.

The proportions of the house are larger, with higher ceilings to accommodate the Maslon's large art collection. The elegantly detailed roof planes, the slender steel columns, the broad glass walls evolving since the Miller and Kaufmann houses are present, but a crispness has been lost. The pieces are now articulated more explicitly; the living room's steel post-and-beam system is treated as a separate element, not engaged with the flat, plastered ceiling (extending outside) that it holds aloft. The window walls use a regular steel frame with the rhythms and proportions of a commercial or civic building. The design is still excellent, but rather than a modern residence, the house has the less personal sense of an office building.

The exotic desert served as the perfect foil for the Neutra houses. "This is what Modern Architecture stands for: the return to nature by modern means!" Neutra wrote as he began work on the Miller House in 1936.[7] Captured by Julius Shulman, the image of the Miller House helped spread Neutra's reputation. He belonged unabashedly to the architects who believed that Modernism's answer to nature was to conquer its vicissitudes with a bold, artificial, lightweight, steel tent. It was a long way from John Lautner's strategy of taking on the protective camouflage of the desert itself (hard, rocky, massive, solid, burrowed into the ground). But it is clear that

both approaches, though coming from diametrically opposed directions, could inspire great architecture.

One detail of the Kaufmann House sums up Neutra's command of materials, construction, site, and space. The fireplace block in the living room is clad in ashlar stone. The stones' surfaces are roughly hewn; the texture is visually rich, varied, and naturalistic. But overlaid on this texture is a precisely crafted ashlar pattern of thin gaps separating each stone. They are extraordinarily exact—almost machined. The image of this fireplace block is extraordinarily and intentionally ambiguous, at once natural and technological, primitive yet tamed. This is indicative of the equivocal nature of design in the desert. It is one reason why the architecture of Palm Springs has kindled so many divergent responses. •

1 Neutra later designed the tombstone for Miller's husband, Herman Benjamin Miller, in St. Louis Valhalla Cemetery; see Stephen Leet. *Richard Neutra's Miller House* (New York: Princeton Architectural Press, 2004), 183.

2 Thomas Hines. *Richard Neutra and the Search for Modern Architecture* (New York: Oxford University Press, 1982), 45.

3 Miller's career as a Mensendieck teacher did not develop as she wished, and she was forced to leave the house in 1943, returning to St. Louis. She sold it in 1950 to Charlie Farrell for $15,000; see Leet, p. 169. The house had originally cost $7000; see Hines, 121.

4 Leet, 186.

5 Hines, 200.

6 Neutra also built a store in 1945, later demolished; see Leet, 186.

7 Leet, 60.

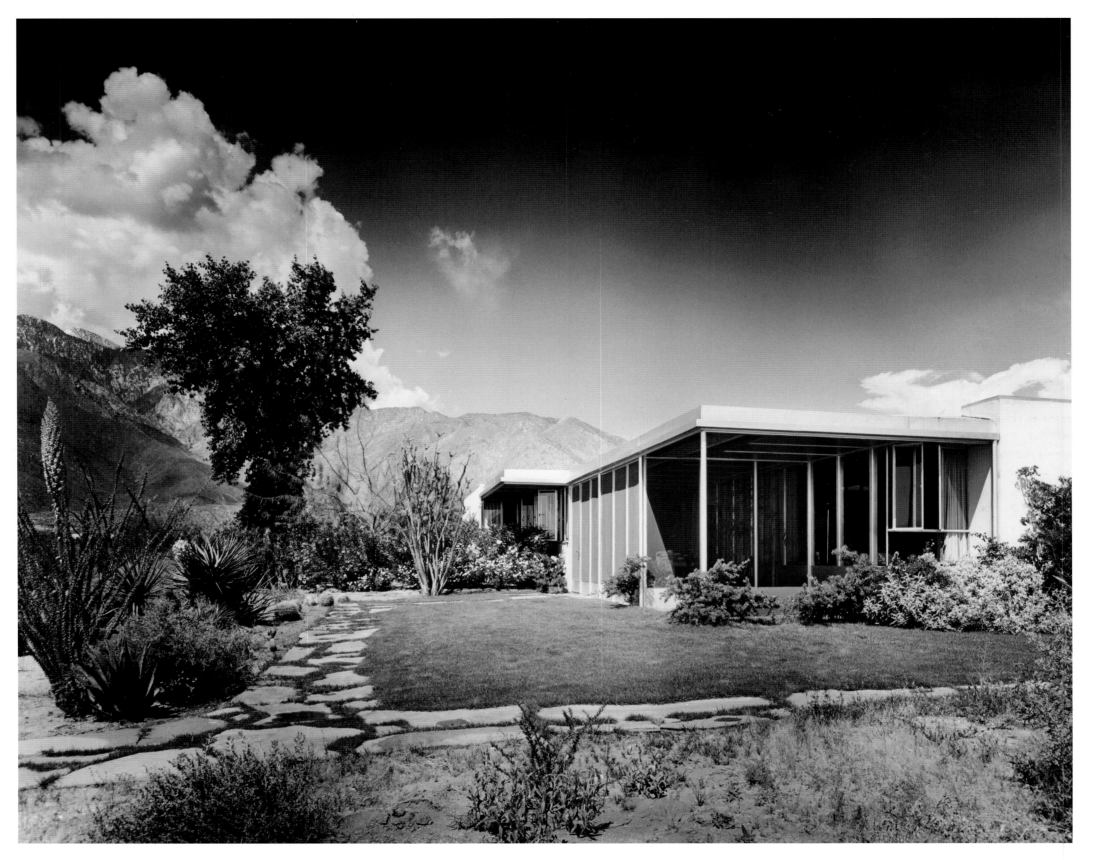

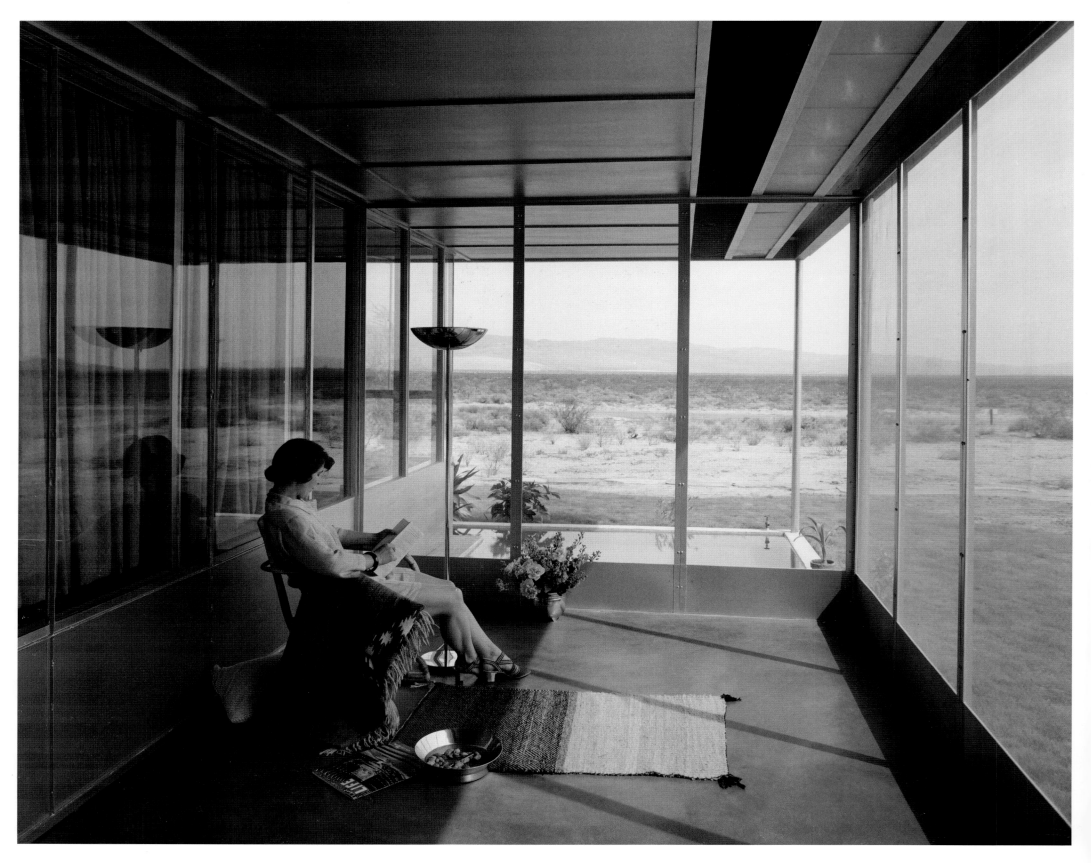

Grace Lewis Miller House,
Richard Neutra, 1937. Photos: 1937/1938.
Neutra, Shulman's first client, enjoyed a
mutually beneficial relationship with Shulman
that lasted thirty-five years. Neutra's rational
rectangularity provided the perfect
opportunity for Shulman's desire to juxtapose
organic and geometric elements.
Below: A small pool is integrated into the
corner of the house.
Right: Studio in which Miller taught the
Mensendieck System of posture.
Opposite: Client Grace Miller posing on the
screened porch.

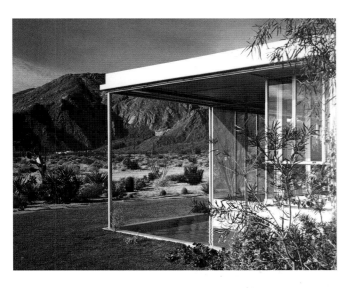

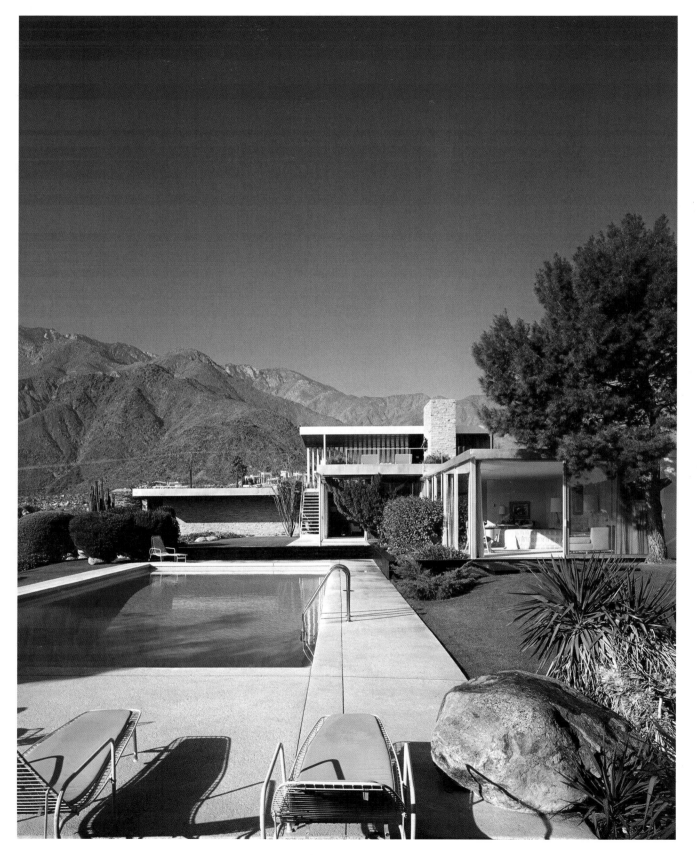

Edgar Kaufmann House,
Richard Neutra, 1946. Photos: 1947/49.
Left: **Pool terrace with master bedroom at right.**
Below: **Rooftop sun deck. House in background is Albert Frey's Raymond Loewy House.**
Bottom: **Stone pillar divides living room at right from passage to master bedroom at left.**
Opposite: **Master bedroom at left, guest rooms at right.**

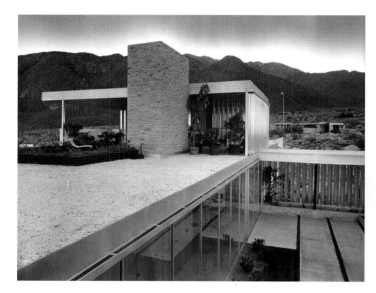

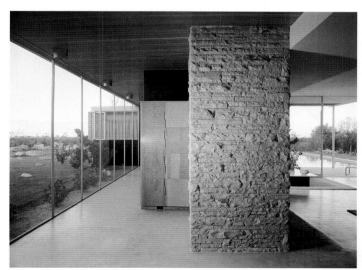

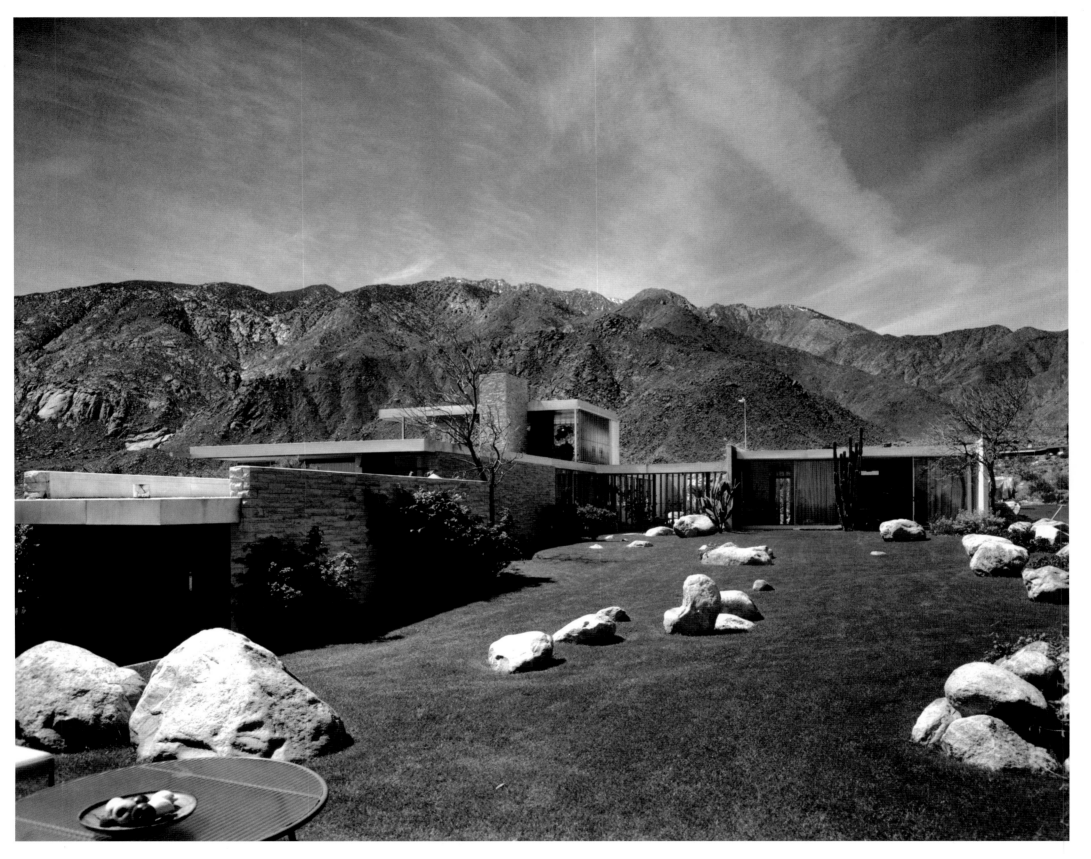

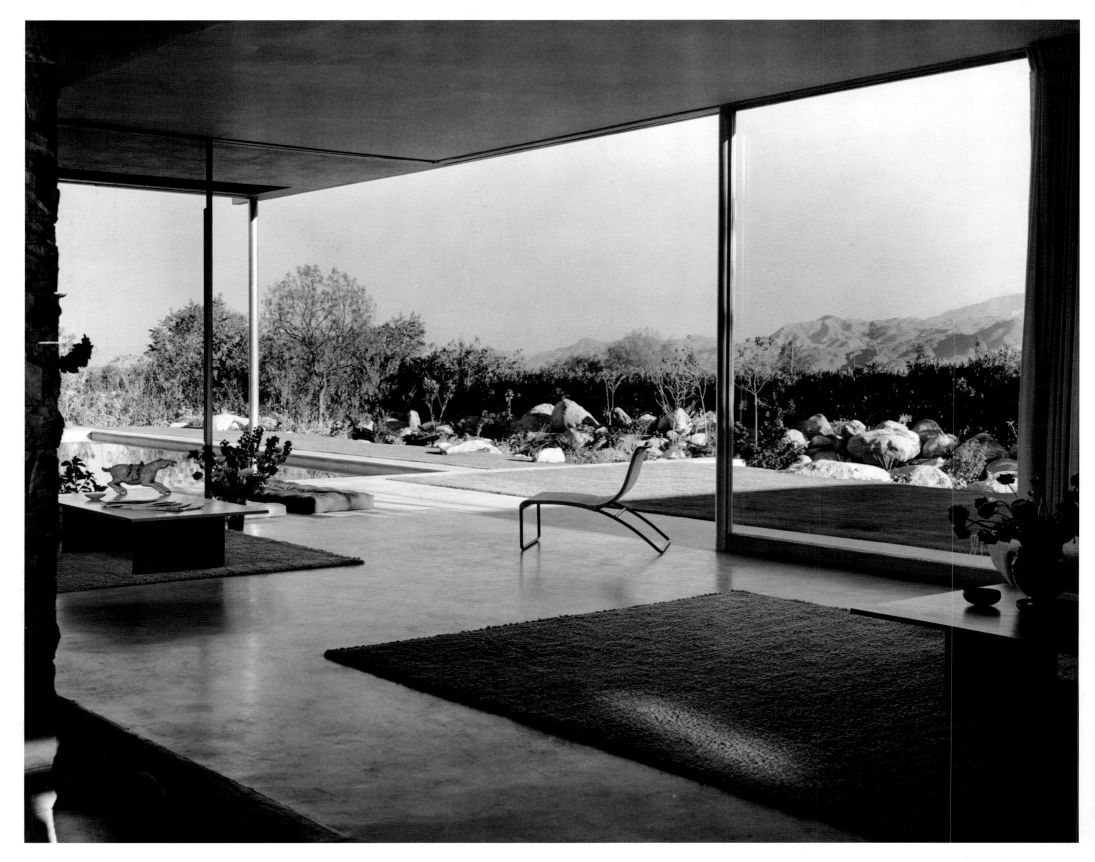

Edgar Kaufmann House,
Richard Neutra, 1946. Photos: 1947/49.
Below and opposite: **Living room.**
Right: **Roof deck viewed through
adjustable louvers.**

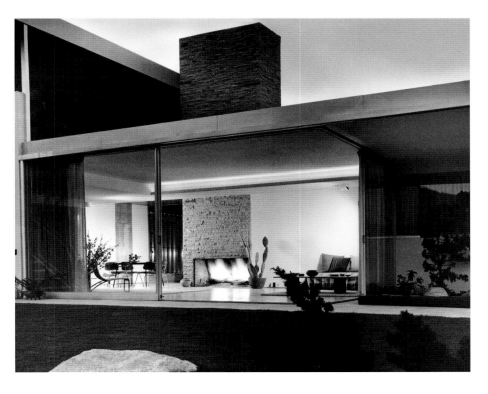

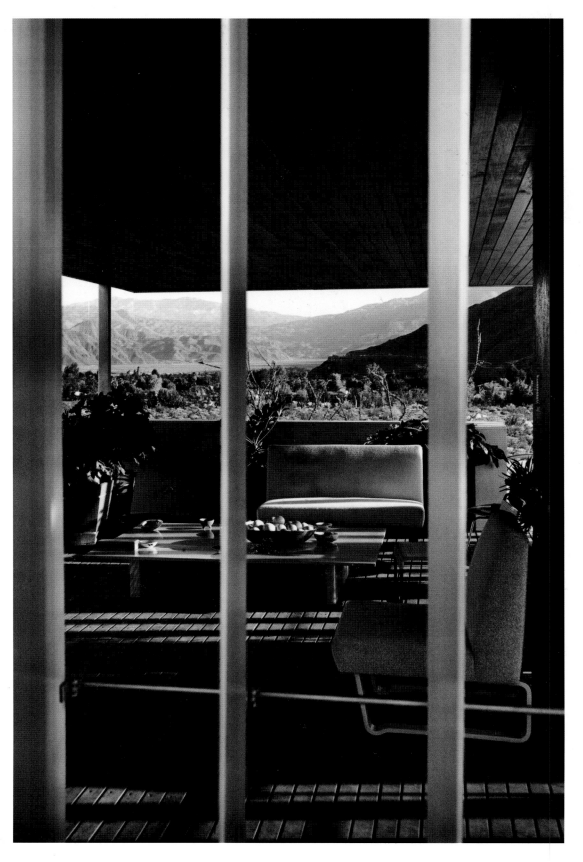

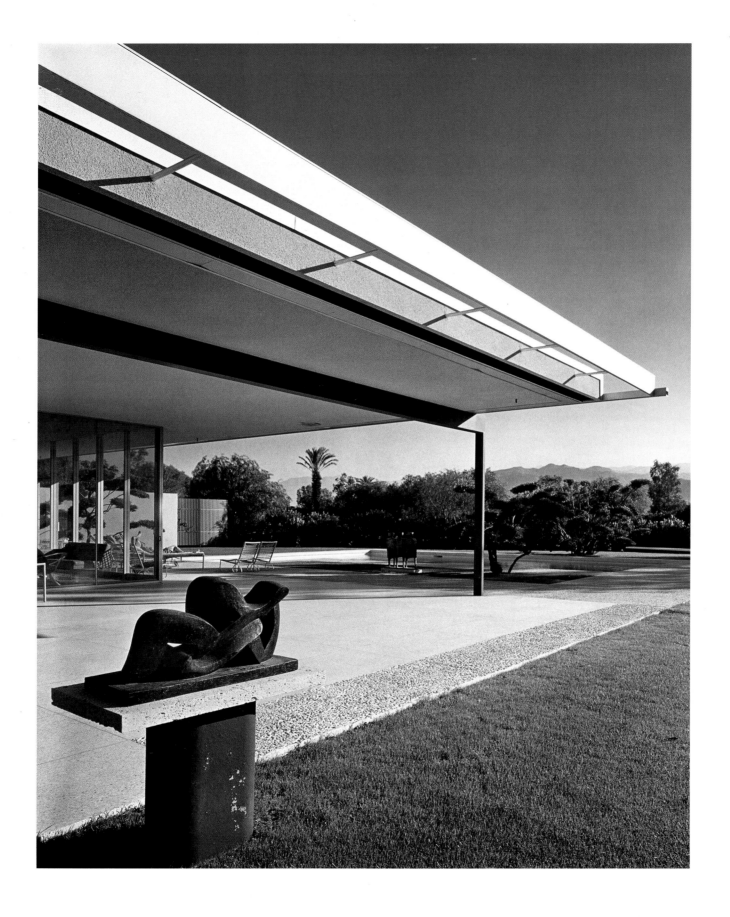

Samuel and Luella Maslon House,
Richard Neutra, 1962. Photos: 1963.
Left: **Terrace off living room. The
rounded form of the foreground
sculpture contrasts the crisp geometry
of the house.**
Opposite: **Three views of the living
room.**

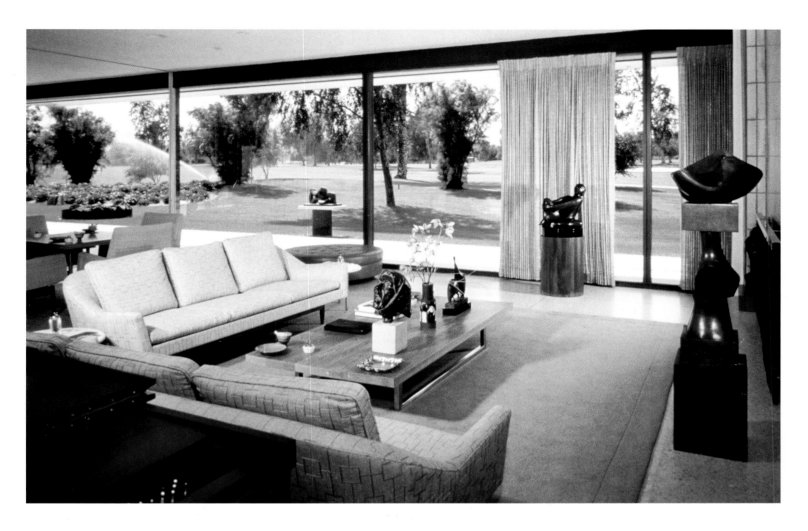

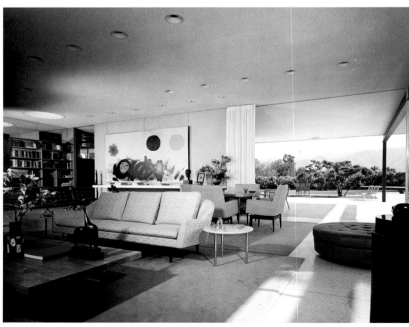

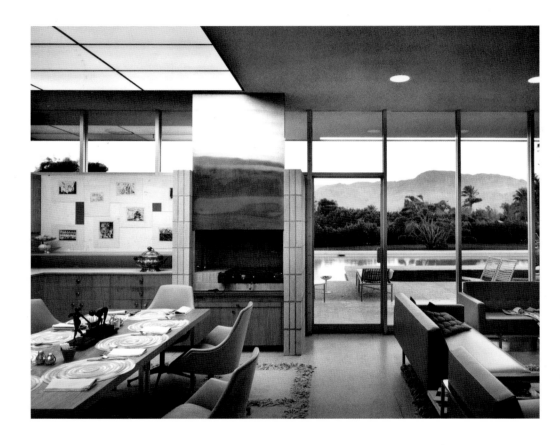

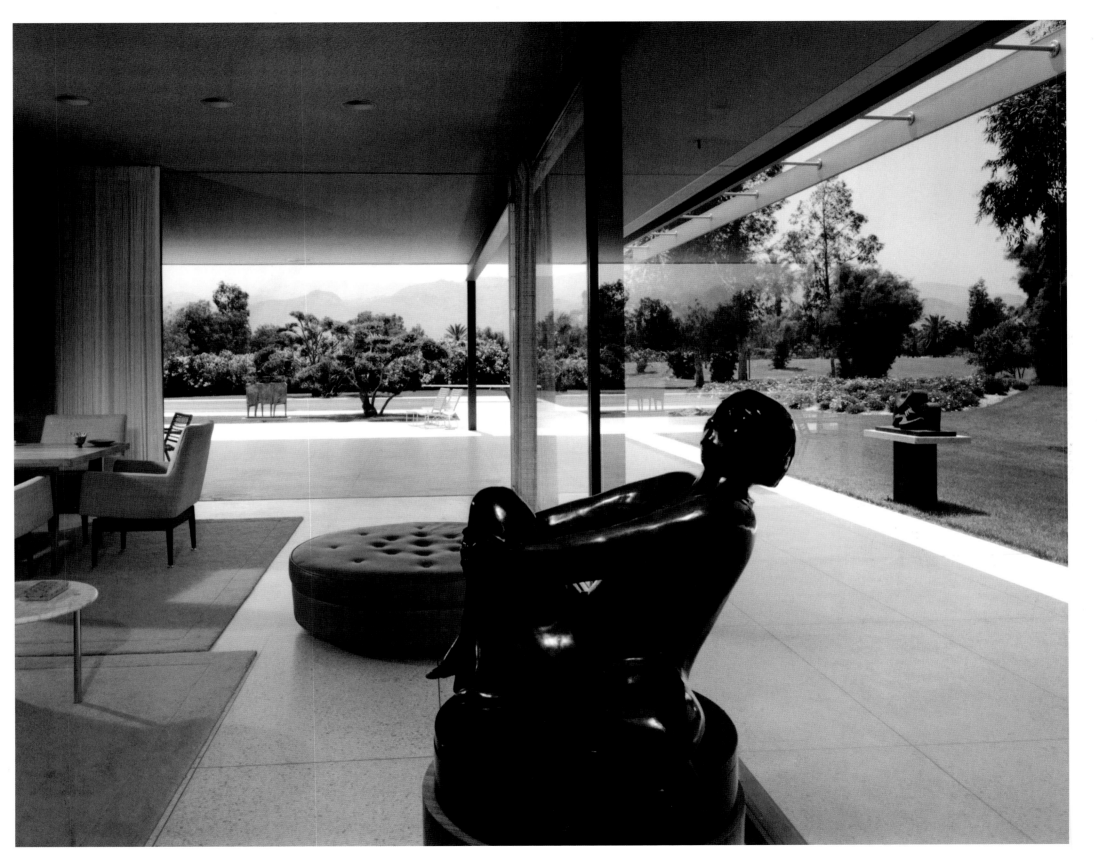

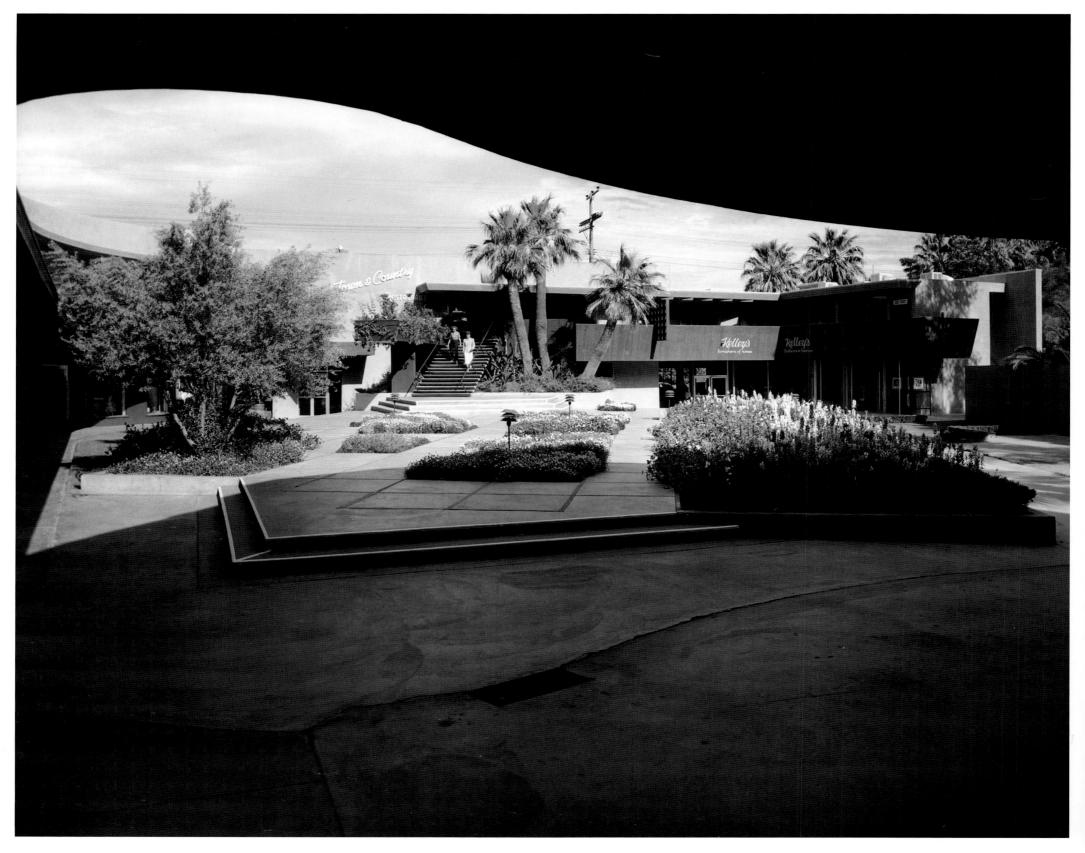

A. Quincy Jones and Paul R. Williams

The wide-open desert was an ideal setting for the type of California Modernism Paul Williams (1894–1981) and A. Quincy Jones (1913–1979) helped establish in Palm Springs in the late 1940s. Theirs was a distinct Modernism of abstract forms that refrained from imitating either historical styles or the Platonic white boxes of International Style Modernism.

Above: **A. Quincy Jones, left, and Paul R. Williams.**
Opposite: **Town and Country Center, Paul R. Williams and A. Quincy Jones, 1948. Photo: 1949.**

They used solid volumes of wedges, rectangles, or angles, clad in stone, brick, wood, or plaster, arranged on the ground or cantilevered into the air according to function as well as visual delight. Whether nestled against the mountainside boulder field at the Palm Springs Tennis Club (1947), or the Town and Country Center (1948) tucked into a lot in the center of the village's small but chic shopping district, the desert's spaciousness put their forms at best advantage, and the strong sunshine made the most of their shapes.

The two friends and sometime partners arrived at their common aesthetic by different routes. Williams, the elder by almost two decades, trained as an apprentice in the traditional styles and refinements of the Beaux-Arts era in the respected offices of Reginald Johnson and John C. Austin; after a few years at the University of Southern California's engineering school, the Los Angeles native launched his own office in 1922 and painstakingly developed his innate talent for proportion and detail in a series of large traditional homes in the 1930s for high-profile clients like E. L. Cord. But in the 1930s when new methods like steel construction and mass fabrication announced the start of the Modern era in architecture, Williams quickly turned his abilities to

the new style as his clients' tastes also changed. He paused for a moment to help develop the Hollywood Regency style which rendered classical ornament with a stripped-down sensibility, and then moved on to a full Modern expression.

His younger colleague Jones, trained in more modern approaches to architecture at the University of Washington (graduating in 1936) under Lionel Pries, worked well with Williams, first as an employee from 1939 to 1940, and later as an occasionally associated architect in a series of projects in the late 1940s and 1950s. For the first two decades of his career, Jones expertly conveyed the California Modernism of solid, abstract forms in his buildings— a style shared by other Jones employers George Vernon Russell, Douglas Honnold, Burton Schutt, as well as Paul Williams and Stewart Williams.

While Richard Neutra promoted a more purely European version of Modernism in his light steel-skeleton frame Lovell House in Los Angeles, most progressive West Coast architects looked elsewhere as they evolved Modern ideas. Like Streamline Moderne, they emphasized solid volumes, but usually with more sophistication than the idiomatic curved corners of that popular commercial style. Influenced by Frank Lloyd Wright and the vernacular buildings of rural California, they were drawn to natural wood and unpainted brick.

Few examples of this alternative West Coast Modernism are more skilled than Williams and Jones's Town and Country Center. Expanding on the innovative, multi-use planning concept of Harry Williams's Plaza Shopping Center (1936) with its arcades and courtyards, Town and Country was set around a courtyard in the center of the block between Palm Canyon and Indian Canyon Drives. The central space was devoted to landscaping and terraces, surrounded by two-story office and commercial space. Besides space for the local

newspaper, shops, and offices, the focal point was the Town and Country restaurant on the upper level.

The composition is emphatically Modern though markedly distinct from Neutra's then-brand-new Kaufmann House. A broad flight of floating steps set at a striking angle invites visitors from the lushly planted terrace to the balcony of the restaurant. Alongside, a large cantilevered planter clad in horizontal wood siding with greenery spilling over its sides (à la Wright) juts outward; the dynamic angles are set against a large billboardlike plastered wall. This energetic, asymmetric composition includes a flat overhead canopy punctured with holes (also like Wright), a strong horizontal balcony plane floating in front, and, tying it all together, a vertical egg-crate screen. Inside the fashionable restaurant, unpainted Roman-brick walls, vertical wood louvers, and hovering dropped soffits, clad in copper, set off the original wall murals and Eames plywood chairs.

The Palm Springs Tennis Club followed suit. Owned by Pearl McCallum McManus (who had first brought Modernism to Palm Springs proper in 1923 when she hired Lloyd Wright to design the daring Oasis Hotel), the popular resort had featured an oval pool marked by trademark twin palms, as well as tennis courts. Williams and Jones added a two-story building between the pool and the hillside for restaurant, bar, lounge, and meeting rooms. They used a similar abstract vocabulary of sharp-edged rooflines and wrap-around glass, but here the shapes are more freeform than at Town and Country, responding to the existing hillside topography. Long terrace parapets, tilted outward, are extended with angular metal railings that form a lively decorative motif. The building is split and angled to allow flights of steps inspired by natural washes coming off the mountainside; curving glass walls put the rock on display as the actual wall of the space; from the fireplace of natural boulders, visitors look

upward through strategically placed windows at the mountainside itself.

Later projects designed by the two architects independently are equally progressive, though by the mid-1950s Jones gave up the sculptural approach for the skeletal approach; like Neutra's Kaufmann House and Jones's own houses for developer Joseph Eichler (with Fred Emmons, his partner from 1950 to 1969), Palm Springs's Romanoff's on the Rocks restaurant (1957) used a steel frame lightly draped in sunscreens and wide eaves.

In his 1952 alterations for the Mediterranean-style El Mirador Hotel (one of the town's original fashionable hotels attracting Hollywood stars to the desert resort in the 1920s) Williams reprised his 1947 additions for the equally fashionable Beverly Hills Hotel. In both he contrasted the original historical-styled buildings with strong modern features: a porte-cochere of wide stone pylons, its roof hovering above on thin extended columns; a circular outdoor lounge patio walled with metal frames supporting a wall of vines, and a new pool with sleekly sculpted high dive (a focal point begging for stylishness) backed by a steel parabolic arch holding up a sunbathing balcony. Surrounded by cabanas, the pool terrace's symmetry and corner pavilions echoed his work at the Lake Arrowhead Resort (1940)—also a design slyly straddling contemporary simplicity and Hollywood Regency formalism for the well-to-do.

Two later houses by each architect, also designed independently, show the direction of each architect's career and their ability to capture two cultural ideals.

For Desi Arnaz and Lucille Ball, Williams designed a 1954 home at the Thunderbird Country Club. As a home for Hollywood stars, it was by definition the height of fashion: a low-slung contemporary Ranch house. The house sprawled casually over its site. The gabled roof (strewn with white rock to reflect the desert heat) and board-and-batten siding showed that it was a ranch; an ornamental concrete-block pylon, the patterned grills flanking the front door, and the open carport displaying a glamorous car marked it as contemporary. As a final, crowning Modernist capstone, a large television antenna rose from the roof to keep the television stars in touch with the latest on the airwaves. Inside the elegantly rustic board-and-batten walls bring the outdoors indoors, and the easy flow from patio to house through sliding glass doors is evident.

A country club home was perhaps the ultimate in suburban living at the time: your backyard was an emerald carpet for leisure; the house was designed for entertaining. Living room, dining room, and kitchen flowed together to support the casual life. Several hundred thousand Ranch homes in tracts across the country sought to emulate this ideal, which Paul Williams captured perfectly with his confident, easy hand.

For one of America's wealthiest couples, Walter and Leonore Annenberg, Quincy Jones began designing Sunnylands in 1963, completing it in 1966. An enormous estate even by Palm Springs standards, the house grounds and twelve lakes covered two-hundred-five acres, with an extra two-hundred acres as a buffer. Unlike Albert Frey's modest acceptance of the limits of the existing desert as the inspiration for his houses, Jones and the Annenbergs followed the alternate vision of life in the desert: the oasis. From this house, no patch of sand can be seen except for the sand traps on its private golf course. Trees and lawns create an utterly alien foreground for the view, framing the distant mountains. Jones, as a planner, was sensitive to many of the ecological questions even in the 1960s, and worked with hydrologists to mediate the impact of this vision. Nonetheless, the project's extraordinary effort to overcome the environment displays the Modernist faith that nature can be molded to man's vision with the help of extraordinary technology.

The 32,000 square foot house (Neutra's Kaufmann House was 3,200 square feet) is itself an integral part of this sprawling landscape. Low pyramid roofs rise gently above the surrounding trees and lawn. Enormous indoor-outdoor rooms merge onto terraces. The house is, of course, designed for entertaining on a large scale, but Jones's skill at subtly placing walls, creating focal points, and hanging low soffits at appropriate places is seen in the articulation of the great spaces. He worked closely with interior designer Billy Haines as well. After his early years designing well-shaped volumes as at Town and Country, after his mastery of the thin frames of Mid-Century Modern homes, Jones went back to creating strong formal shapes in his later career. Having become a major figure in the profession, partner in a large Los Angeles office, dean of the architecture school at the University of Southern California (1975–1978), Jones's office designed many large institutional buildings for companies, churches, and colleges. He gave them strong forms, but instead of the abstraction of the early years he now articulated them as an expression of their structural system— often concrete. In Sunnylands, the repeated waffle-slab ceiling serves both structurally, texturally, and spatially to define the design.

Paul Williams and Quincy Jones were Los Angeles architects, not local Palm Springs architects. Yet the small town afforded them opportunities to flex their abilities at crucial stages of their careers. The Town and Country Center remains a superb example of an important step in the evolution of California Modernism. Williams's house for Lucille Ball and Desi Arnaz is one of his most mature, fully realized contemporary house designs; it shows how well he translated his talent in designing traditional homes into the modern idiom. The Annenberg Estate gave Jones the kind of expansive project with discriminating clients that only rarely comes the way of any architect. Jones and Williams gave Palm Springs a great deal, and in return Palm Springs provided them with well-to-do clients and an inspiring desert landscape. •

Town and Country Center,
Paul R. Williams and A. Quincy Jones,
1948. Photos: 1949.
Below: **Restaurant interior.**
Right: Restaurant entry.

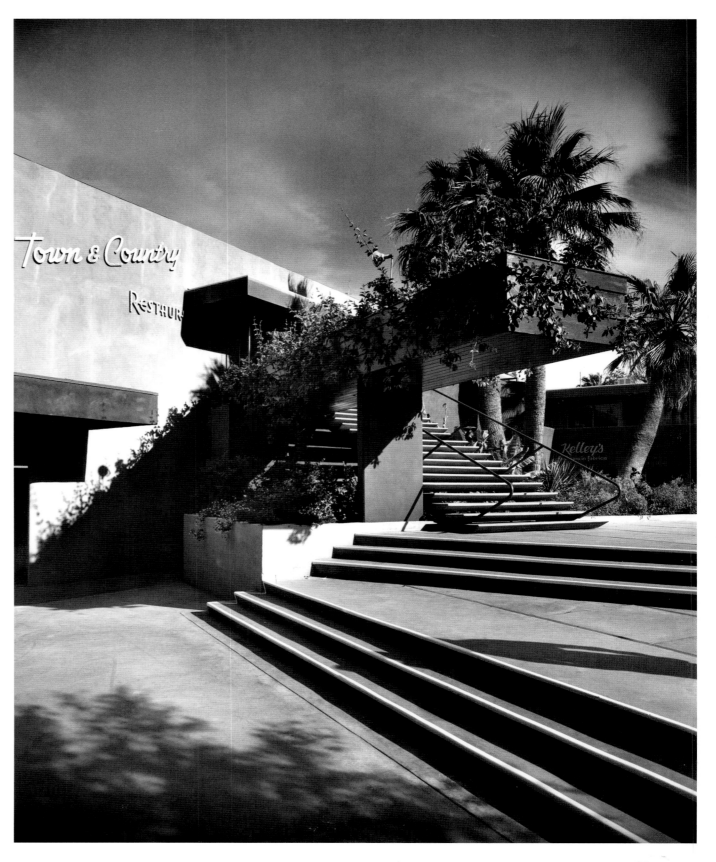

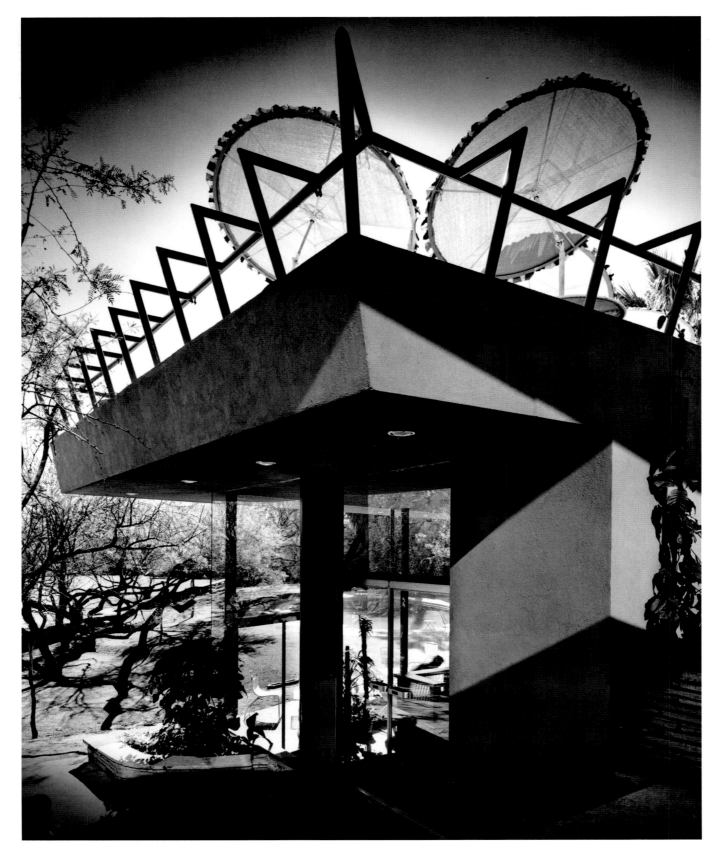

Palm Springs Tennis Club,
Paul R. Williams and A. Quincy Jones,
1947. Photos: 1947.
Right: **Pool as seen from sun deck.**
Opposite: **Sun deck above bar.**

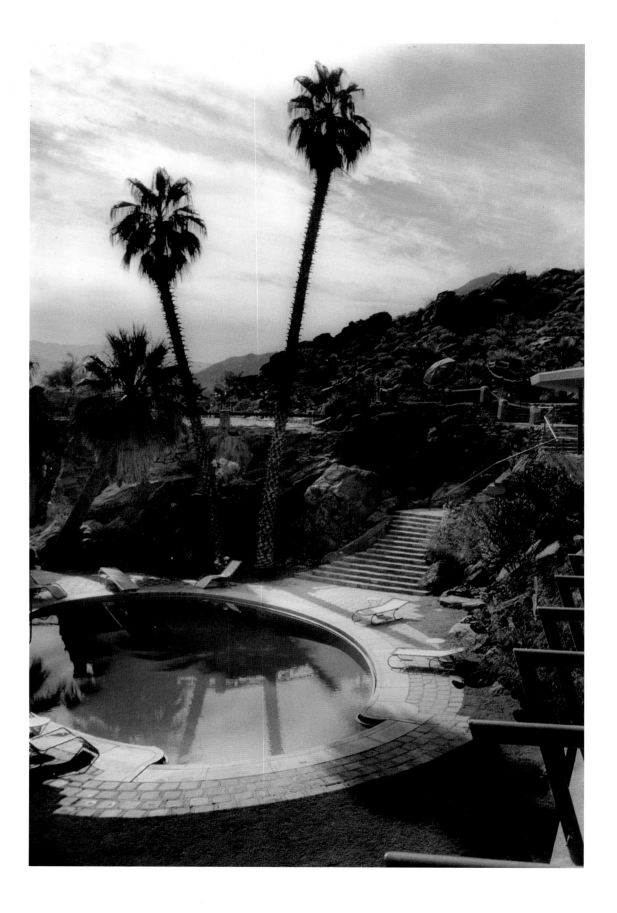

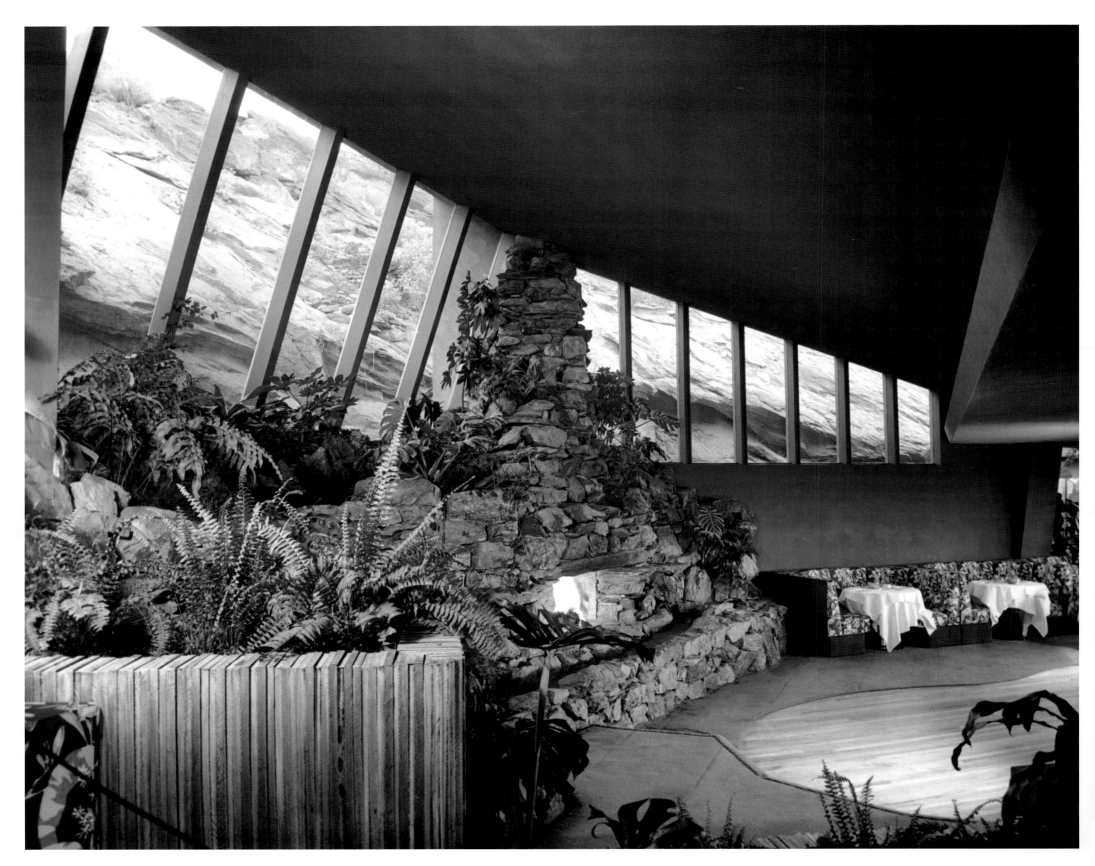

Palm Springs Tennis Club,
Paul R. Williams and A. Quincy Jones,
1947. Photos: 1947.
Right: Restaurant entry with glass
wall looking out on mountainside.
Opposite: Main restaurant.

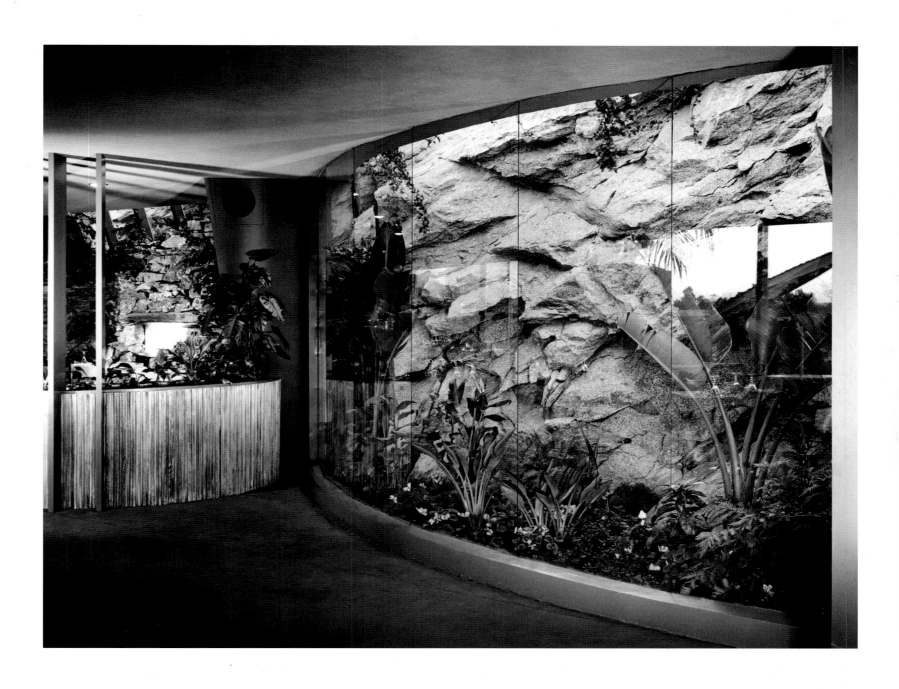

El Mirador Hotel additions,
Paul R. Williams, 1952. Photos: 1953.
Below left: Williams added the sleek new porte-cochere entry
to the original 1926 hotel with its Spanish-influenced tower.
Below right: Cabanas, sun decks, and a well-sculpted high dive
brought the resort up to date.
Opposite: An outdoor lounge included a modernistic trellis for
plants and a retractable canopy.

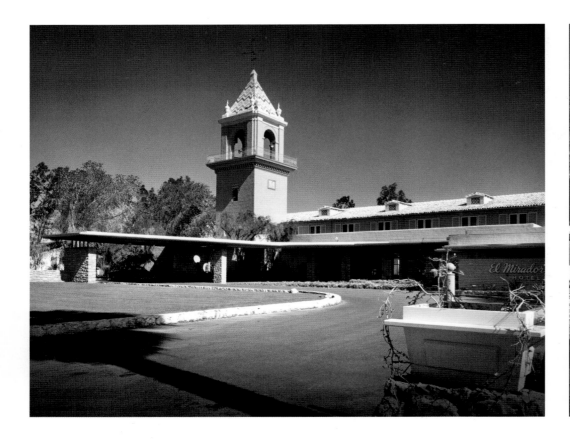

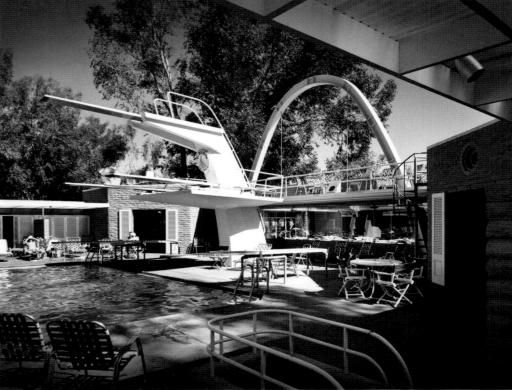

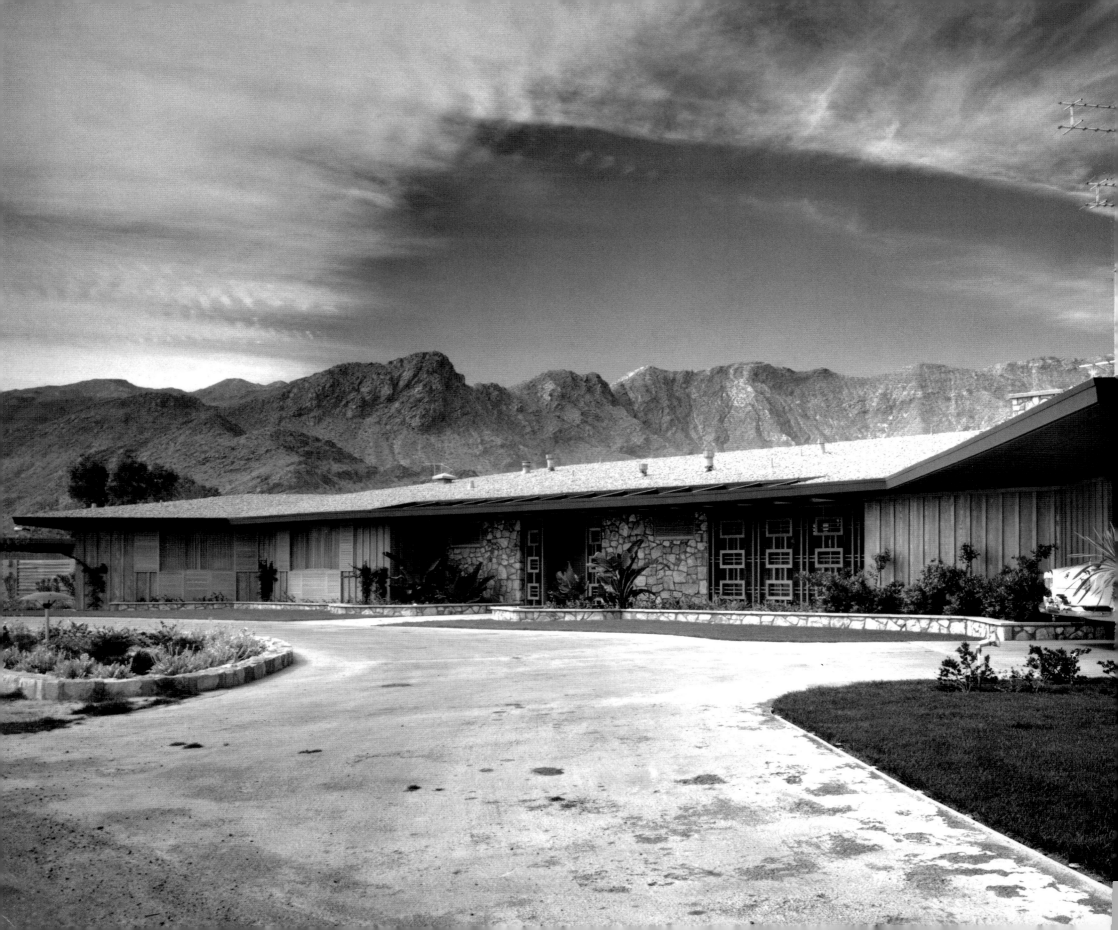

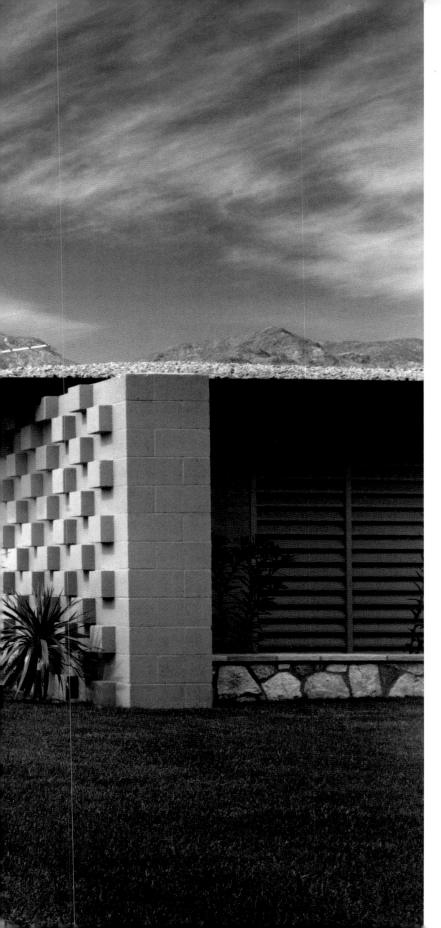

Lucille Ball and Desi Arnaz House,
Paul R. Williams, 1954. Photos: 1955.
Left: This ultramodern Ranch house stood on the Thunderbird Country
Club golf course. Note the prominent rooftop antenna, appropriate
for the home of two of America's biggest television stars.
Below: Living room flows easily onto the outdoor terrace.

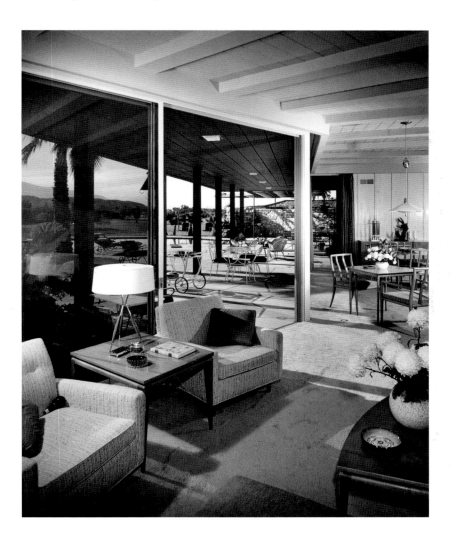

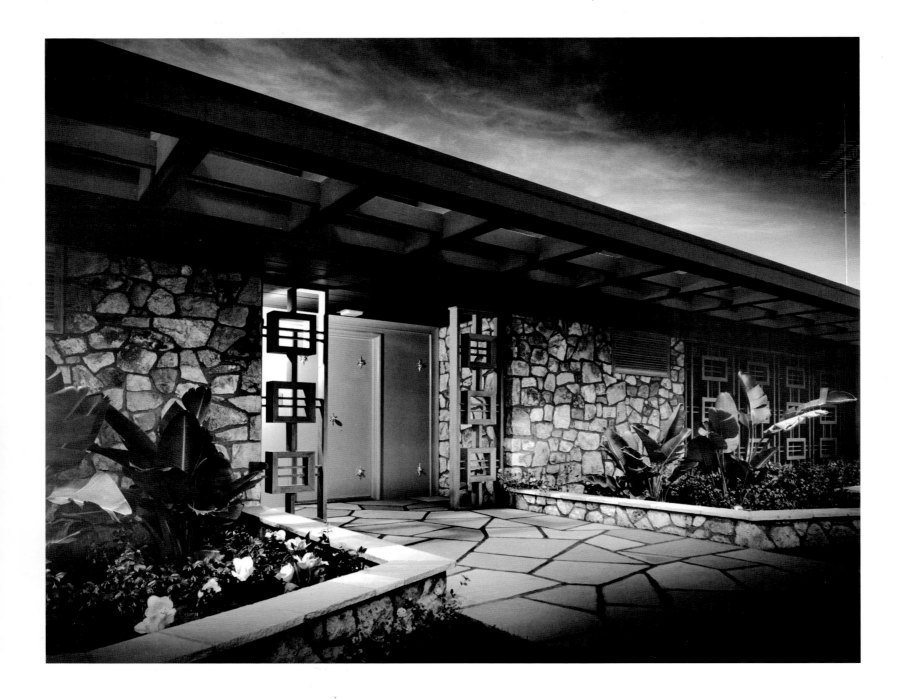

Lucille Ball and Desi Arnaz House,
Paul R. Williams, 1954. Photos: 1955.
Left: Entry combines natural stonework
with modern ornamental screens.
Opposite: This casual vacation home
rambles casually across the landscape.

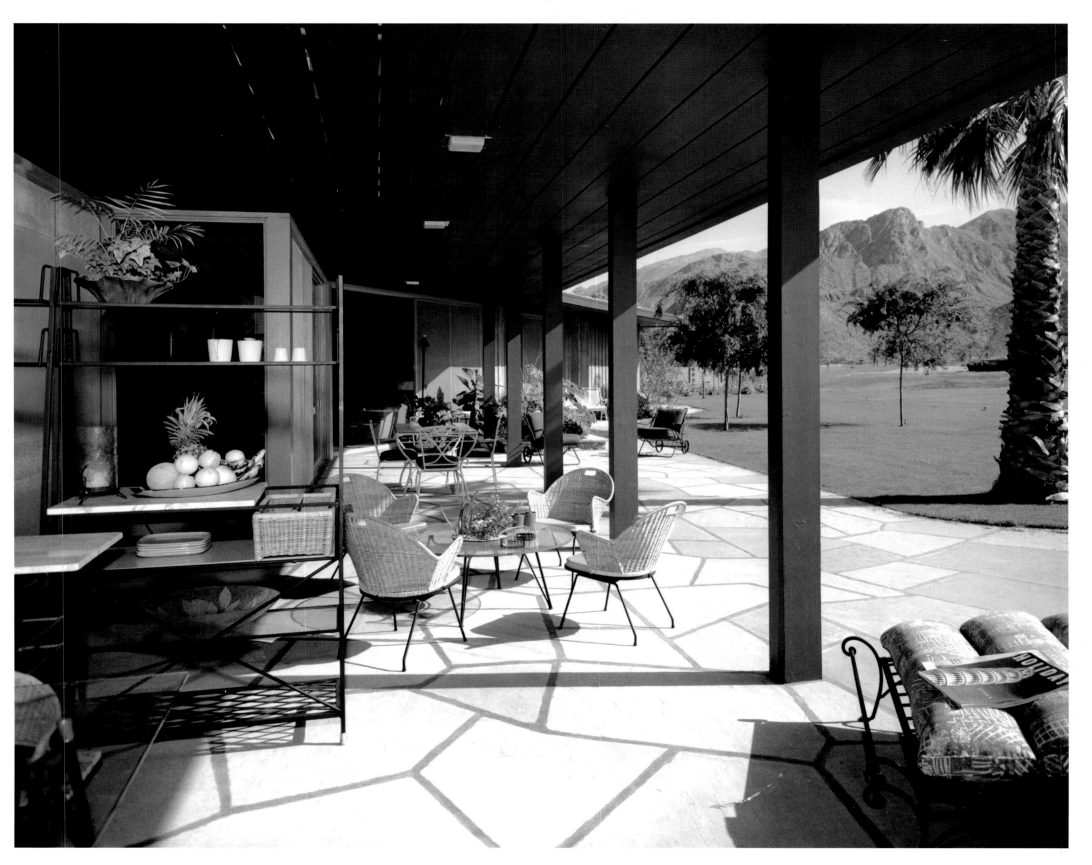

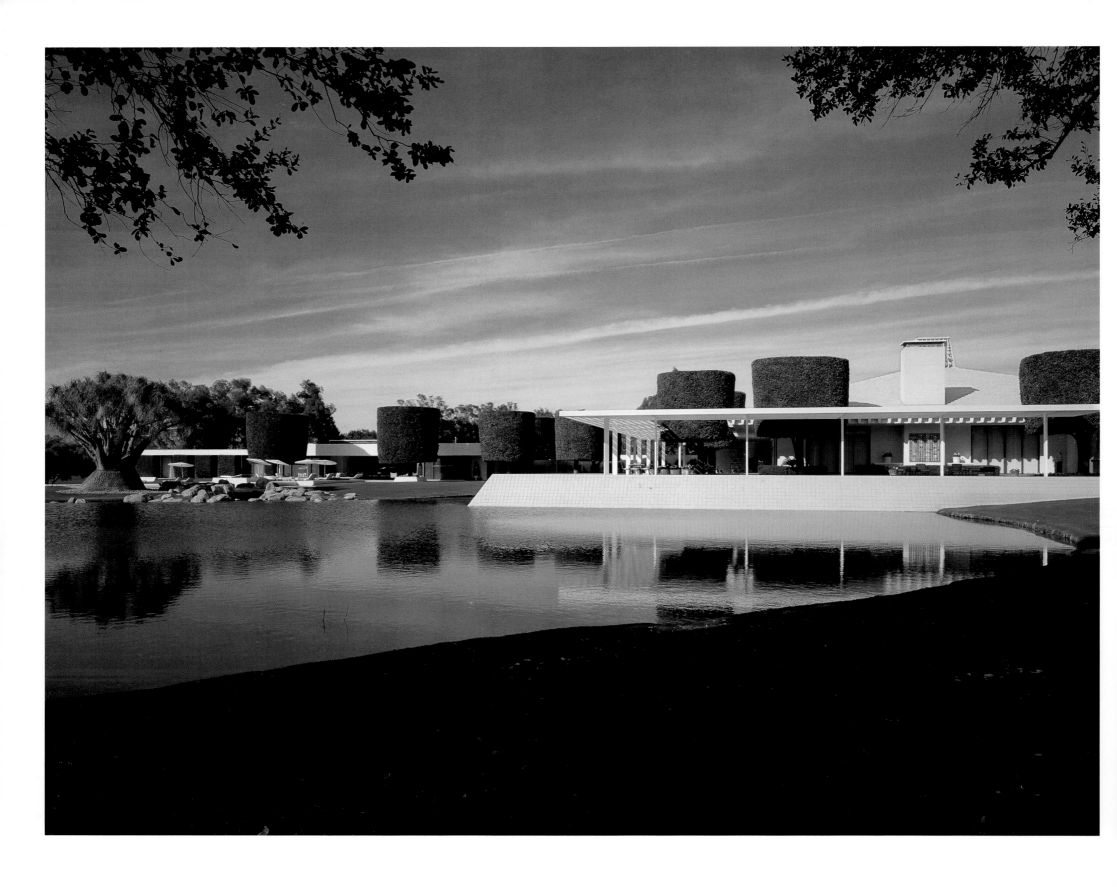

Sunnylands (Walter and Leonore Annenberg Estate),
A. Quincy Jones and Frederick E. Emmons, 1966. Photos: 2007.
Right: Main entry.
Opposite page: A collection of pavilions gathers around artificial lakes and a private golf course.

Next pages: A desert garden at right contrasts with the artificial landscape created on most of the estate's 205 acres. Water for the landscape is drawn from wells on the property.

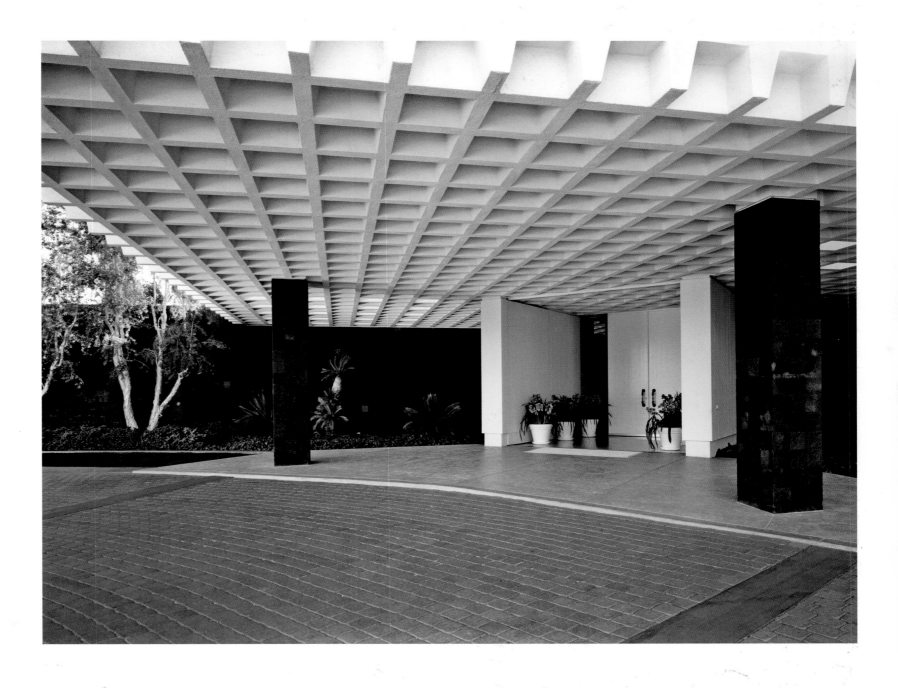

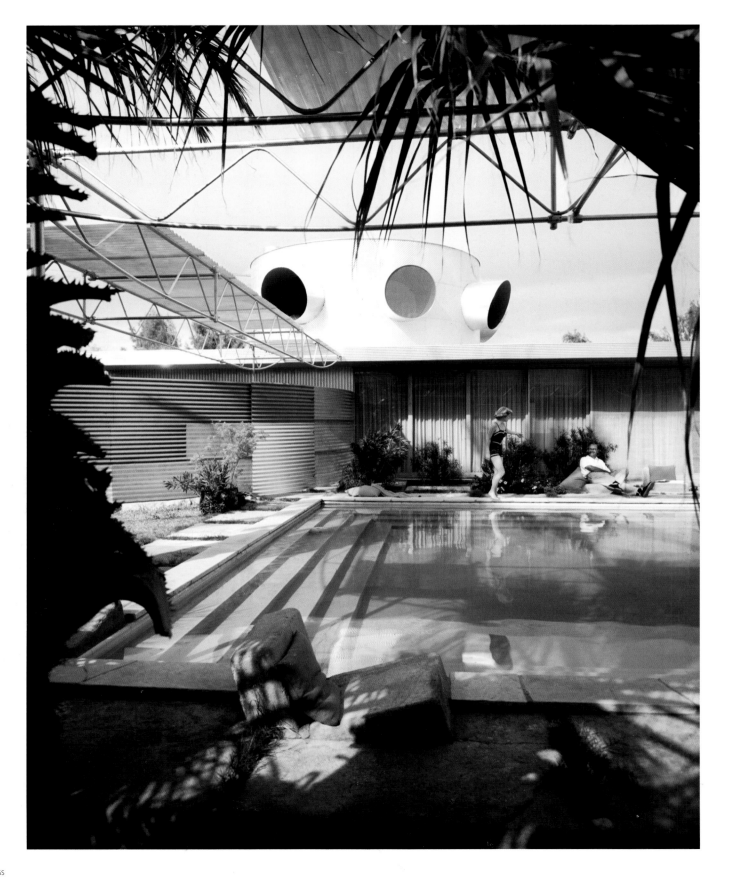

Albert Frey

A steady stream of immigrant architects has shaped California since the 1880s. The most interesting of these found something in the land of palm trees and redwoods, of oceans, deserts, mountains, and cars, that changed them. The rest simply repeated the ideas they carried in their baggage from Austria, Paris, New York, or London.

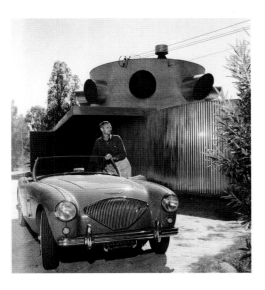

Above: **Albert Frey.**
Opposite: **Frey House #1, Albert Frey, remodeled 1953. Photo: 1954/56.**

Swiss-born Albert Frey (1903–1998) was one of these talented immigrant architects who discovered a fresh source of ideas in California. Like the other local Palm Spring architects, he had little compulsion to become famous. If he had, he certainly would have chosen a more central location than the Coachella Valley for his practice. He simply wanted to build in a place that provided inspiration, and he wanted to design adventurously—and he did. Palm Springs allowed him to do this.

The spectacular, expertly executed concepts that finally brought him deserved attention when he was in his nineties are fully displayed in the two houses he built for himself. They are adventurous and conceptually vivid, the kinds of houses an architect designs to express himself. The first house, built in 1941, is absolutely simple and absolutely clear: the home for a bachelor in the desert flats, it is a collection of walls that appear to slide past each other to subtly define the living areas, the kitchen, and the utility areas. But they are locked into the landscape. Glass walls evaporate the line between indoors and outdoors, even while the upright solid walls (clad in corrugated metal) keenly and effectively define the use of spaces. But unlike his former employer, Le Corbusier, Frey ties this light structure to the desert land around it. The colors are the sage, rose, and midnight blue of the surrounding desert. The deep, crystalline swimming pool is surrounded by sculpted concrete lounges—like rocks made useful, like the well-worn *metates* that Native Americans rubbed and ground for centuries as bowls, preparing meal, until the natural rock reflected their human use. Using poured concrete, Frey accomplishes the same effect. In later designs he would use concrete block to create a similar contrast of earthen, jagged forms against his clean steel walls.

Tiny, metal-clad, flat-roofed, Frey's first house reveals his European architectural roots, as did his Aluminaire House (1931) on Long Island, designed with partner Lawrence Kocher, and the Kocher Samson Building (1934), his first in Palm Springs. He had worked with Le Corbusier, the fount of European Modernism, for ten months in 1928 and 1929, and always held affection for Corbusier's ideas. He acknowledged the influence of Mies van der Rohe on the defining walls of his first house.[1] But he was also too good an architect not to be influenced by the unusual conditions he found around him when he moved to California. That included a cultural climate: "I think people in California are a bit more open minded than the people on the East Coast. There is more of a pioneering spirit," he wrote at the time.[2] His excitement about the built environment is clear from the beginning, as he drove across the United States in summer 1932 on his way to California. His snapshots of very non-European gas stations, drive-ins, and supermarkets are a record of his visual imagination at work. "The people who designed those are engineers. . . . They were thinking mostly of economy. No preconceived ideas of form," he said.[3] This was partly Frey's imagined America of Ford Motors and steel skyscrapers, a view nurtured and fed by reading Richard Neutra's book *Wie Baut Amerika?* and seeing pictures in magazines. But the impact of the real thing, of the wide open spaces and of entire cities shaped by the car, of attitudes of free experiment and pragmatic acceptance rather than intellectual theories that strangled free thought, made all the difference.

And so when Frey remodeled his own house in 1953, adding a second floor, the results are astonishing. In a liberating gesture worthy of the great architect Bruce Goff, Frey made the new level a circular turret punctuated with round windows with cylindrical sunscreens. A suspended staircase lifts you to this observatory, where yellow upholstered walls create a fantasia of color and form. Frey himself noted the impression that the circular Mayan observatory at Chichen Itza made on him, but it also conjures up military tanks and space ships. "You have to have your fantasy going, too," he said.[4] Not everyone was impressed; Stewart Williams praised Frey's original house as "a gem . . . but then he screwed it up. He added that damn round turret. It never fit on the box."[5]

The colors are echoed in the curving wall of corrugated plastic that shelters the pool in rose red, sage green, and sun yellow tones, reflecting and transmitting the light through the day. This is far from Le Corbusier. It is a lot nearer California. This house knows its natural neighbors, the boulders, flowers, lizards, and birds that surround it in the desert. The desert's life, its color and richness, its changeability are all reflected in the design. He would return to using desert color rendered in modern materials in the North Shore Yacht Club, the Premiere Apartments, and elsewhere.

Frey's second house returned to the minimal simplicity of his first design, but remains even more rooted in its site. Instead of the first house's location on the flats looking at the mountain, the new house is perched part way up the mountain, looking out at the expanse of the Coachella Valley. The view makes

the house: it is mostly glass with a simple shed roof. Quite intentionally, the design makes little effort to change the desert; the house is literally built around a great boulder existing on the site. But Frey does make one concession to altering the desert. He places the house on a plinth (with room for a swimming pool) formed of rose-colored concrete block.

By incorporating that boulder, the architecture modestly steps aside in acknowledgment of the presence and power of nature. With this attitude, Frey set himself apart from Palm Springs's prevailing will to turn the desert into a golf course. (This desire reached its zenith in A. Quincy Jones's design for Sunnylands, the estate for Walter Annenberg.)

Frey's other desert houses range greatly. He designed many Ranch houses, especially for Smoke Tree Ranch, a private community of vacation homes, which (like Frey himself) kept as close to the native desert as possible for seventy years. Though avoiding the picturesque elements of dovecotes and Dutch doors, they are definitely Ranch houses—and well-designed at that. "It is an architecture that is true to its use of materials," he later wrote.[6] But other houses like the Cree (1955) and Carey (1956) houses show the same experimental character as his own houses. The Cree House, for example, is lifted above the ground with a wide terrace to make its hillside site usable. It is a light structure that leaves the desert alone. "I like to do things with the least amount of material," he said.[7] He especially enjoyed that the sheet metal roof of his second house went on in a single day.

For the Raymond Loewy House (1947), next door to the Kaufmann House by Richard Neutra, Frey worked with the great industrial designer. Elements of the design show the dramatic flair of Loewy more than the romantic mechanical poetry of Frey. But the clean lines at the entry and the open plan—even the pool stretches from inside to outside—are all Frey.

Equally important to Frey's reputation are his public buildings. As a local architect, he designed nearly anything that came into his office: churches, banks, gas stations, schools, apartments, fire stations, stores. On his cross-country drives, he took photos, and in these it is clear that he appreciated the direct genius of roadside California architecture, with its pragmatism raised to transcendent art.

A typical Frey response to a commercial project is the Alpha-Beta Market on South Sunrise Way, now demolished. It is the sort of new, utilitarian program that excited many Modernists, before Modernism became detached from daily life. Like his houses it is lightweight and clad in corrugated steel. The building is a big square block reflecting the open interior space, but the wall parapet is angled to give the building formal distinction. Landscape elements complete the design: large zigzag-roofed colonnades nestle up to the building and stretch out into the parking lot to provide shade for the customers. Colorful tile walls greet visitors as they approach the front doors. It is a small shopping center with a collection of stores, and a small courtyard invites visitors to sit and enjoy the sun. This is a desert public building according to Frey's vision of light, tentlike, impermanent architecture.

The Alpha-Beta Market, the Tramway gas station with a parabolic roof, the Desert Hospital (with Williams, Williams & Williams), a yacht club for a pleasure boat marina—this is why Frey stayed in California to do architecture. These were not just elegant custom homes but real architecture, in sympathy with the Modernist desire to remake the world in their image. For Le Corbusier that assignment meant tearing out the heart of historic Paris for his 1925 Plan Voisin; for Frey it meant designing donut shops, gas stations, miniature golf courses, schools, banks, offices, and supermarkets. He tried to convey this discovery to his mentor in a

series of letters; the reality of modern cities Frey encountered in America lead him to a different perception than the theoretical conjectures about a New World that Corbusier developed in Europe. Frey wrote, "It is the new towns Out West, established during the evolution of the automobile, where modern American life is found. In Los Angeles commercial buildings are clustered at the intersection of main thoroughfares; the town is spread out, not concentrated, it's true, but one travels at forty kilometers [per hour] and traffic keeps moving."[8]

With John Porter Clark, Frey began a partnership in 1935 that would last until 1957 (when he continued with Robson Chambers), leading to many major projects. At Palm Springs City Hall (1957), built in association with Williams, Williams & Williams, Clark and Frey bring civic dignity to a progressive building. Walls of rose-tinted concrete block are simply angled to create shadows and texture. The entries are marked by two large aedicula, one a circular disk, one a square with a circle cut out of it—a fundamental geometric gesture that marks the specialness of the entry and the building itself. In Julius Shulman's photos, they mirror the essence of Greek temples set against elemental mountains.

At another public building for a resort area, Frey once again explores a sense of openness. The North Shore Yacht Club (1958) on the Salton Sea is one of the great Modernist declarations of freedom, a joyous yelp in modern materials that brings alive what was intended to be a great recreation area.

Marine imagery has always inspired Modernists, from Villa Savoie's promenade decks (a design on which Frey worked), to the CBS Building by William Lescaze in Los Angeles, to the Streamline Moderne steamship variations of Robert Derrah's Coca-Cola Bottling plant in Los Angeles (an example of the freedom and imagination that California allowed and of which Frey took full advantage.) Frey updated the

marine image for the popular pleasures of fiberglass speedboats, Evinrude outboard motors, water-skiing, and the rest of the exploding popular recreation culture growing up in the postwar America—and especially in the West. Frey warped both the concrete-block base and the fiberglass and metal bridge of the yacht club to give it the billowing dynamism of a speedboat plowing through the waves. The nautical derivation of the porthole windows and a central mast are obvious. But it is his wholly original translation of these images into a new form and vocabulary that marks his real skill.

Like the other Palm Springs architects, Frey benefited from the explosion of recreation. When he moved to Palm Springs, it was primarily the playground of the super rich, from the industrialists of Maytag and National Cash Register fortunes, to the modern industrialists of the movie industry—Warner, Garbo, Gable, and Disney. But after 1950 Frey and the other architects benefited from a widening of the community's demographic base. The middle class could also now vacation here, could even have second homes in the desert. The influx of clients for homes and for new recreational venues grew dramatically.

Palm Springs was always adept at turning a profit from the natural scenery. A long-planned project to build a cable tramway from the desert cacti to the San Jacinto mountain pines and winter snow finally became reality in the 1960s. Clark and Frey were selected from local architects to design the desert tram station; Williams, Williams & Williams won the mountaintop station and lodge. While Frey traveled to Switzerland to investigate the cable technology, Clark drew the preliminary sketches before World War II.

Their handsome structure mirrored the Modern architecture being built across the nation in national parks, as the parks system began to attract millions of

vacationers. The design used a triangulated truss to bridge the boulder-strewn wash that ran beneath the building. The elongated triangular forms—some glazed to offer dramatic views upward—also echoed the pinnacles of the rugged mountain. The building gave an excuse to put the machinery of the great winches and cables on display as the suspended cable cars paused to pick up a new load of tourists to lift up the mountain; this was architecture that was truly and appropriately kinetic.

Frey's architecture is an unusual blend of the visionary and the everyday. He created the thin steel and glass tents that were a statement of Modern theory and Modern living, but his houses also were ordinary homes for living, with sinks and fireplaces and sliding aluminum doors—not always that much different than any other. This modest Modernism may have been a product of his place and his clients; he made a living with bread-and-butter commissions, but he still maintained his creative edge, exploring new ideas and new materials, investing these buildings for everyday life with a vitality. Many architects played the role of the Great Man of architecture, creating an intimidating presence to bend a client to the will and logic of their architecture. But without the overwhelming desire for fame, Frey did not need that approach. He simply built one graceful house after another. •

Albert Frey House #1, Albert Frey, 1941. Photo: 1947/50. Again, Shulman strikingly counterpoints the organic with the geometric.

1 Jennifer Golub, *Albert Frey/Houses 1 + 2* (New York: Princeton Architectural Press, 1999), 80.

2 Ibid., 76.

3 Ibid., 79.

4 Ibid., 77.

5 E. Stewart Williams, interview by Alan Hess, Aug. 1, 1999.

6 Joseph Rosa, *Albert Frey, Architect* (New York: Princeton Architectural Press, 1999), 140.

7 Golub, 76.

8 Rosa, 15.

Albert Frey House #1,
Albert Frey, 1941. Photos: 1947/50.
Below left: The small original house emphasized the
connection between indoors and outside.
Below right: Open wall frame carries us out into the landscape.
Opposite: Simple built-in furniture (both indoors and out)
made the small space efficient and useful. The elements of
fire and water are counter-balanced by the interior wall.

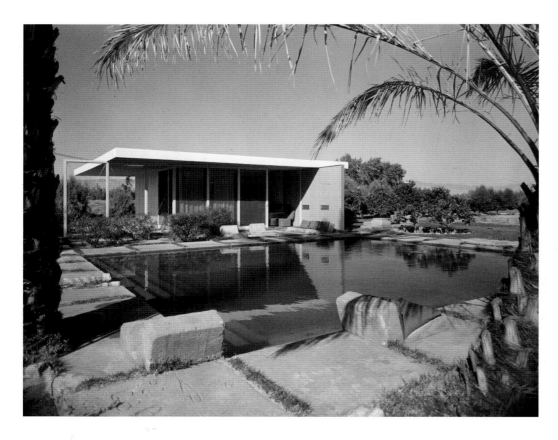

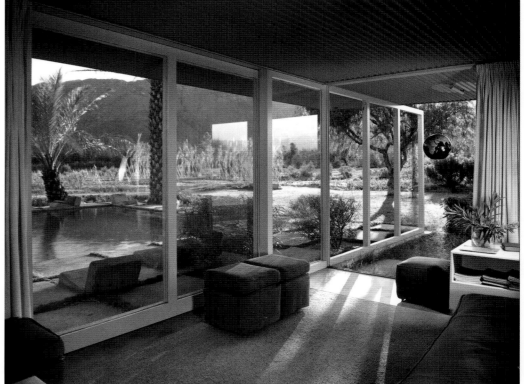

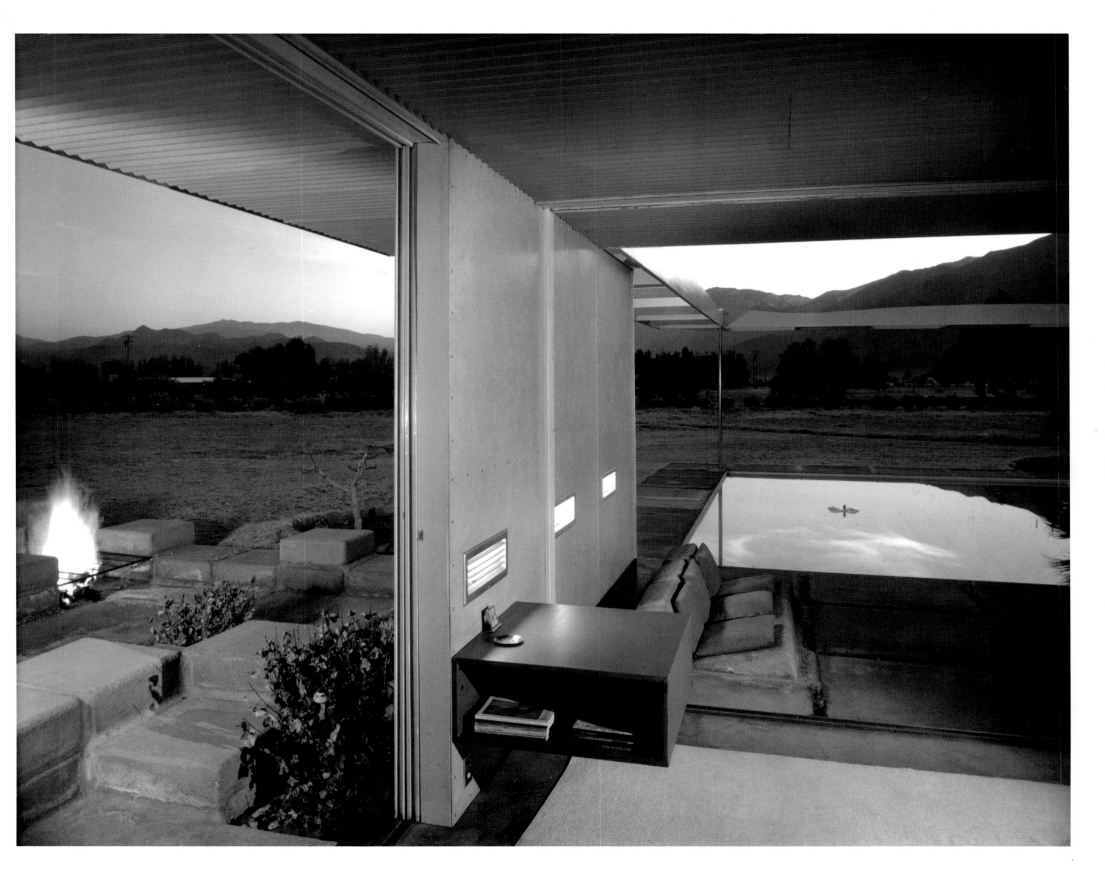

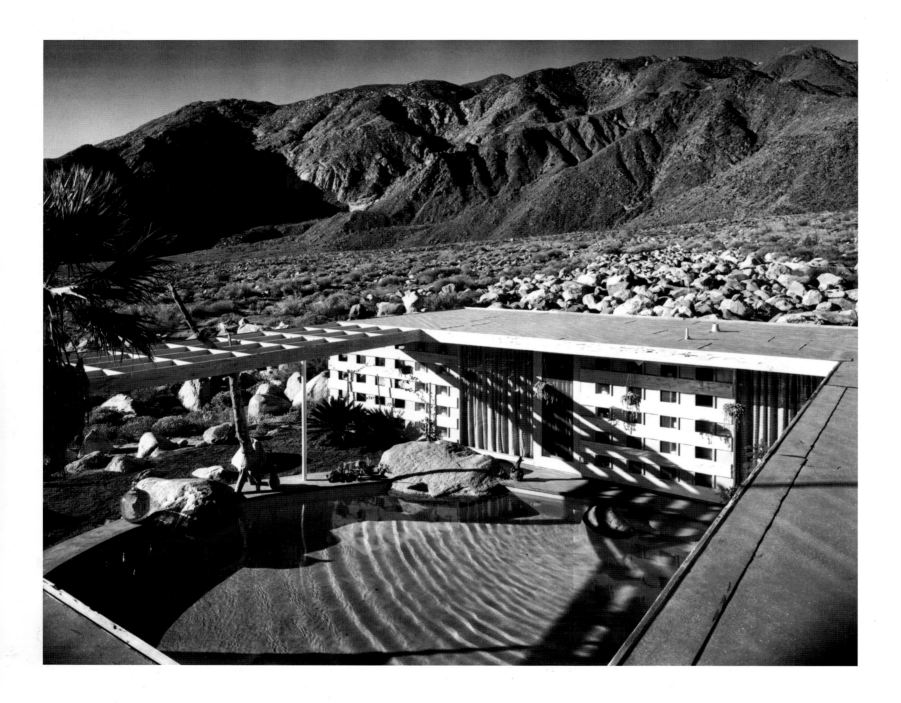

Raymond Loewy House,
Albert Frey and Raymond Loewy, 1947.
Photos: 1947.
Left: U-shaped house provided shelter for the oasis-like courtyard and pool.
Opposite: The pool flows into the living room, a popular and emphatic declaration of indoor-outdoor design used by several architects in this period. Note the interior carpet in the foreground.

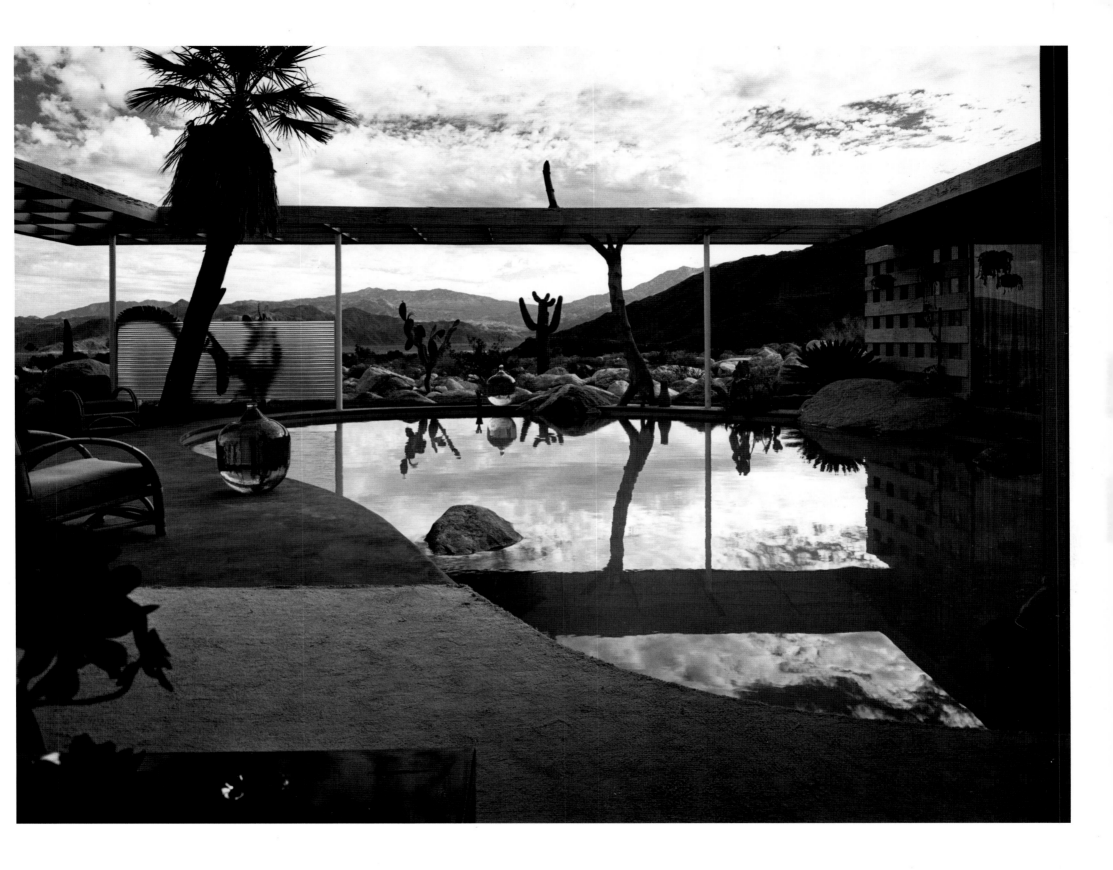

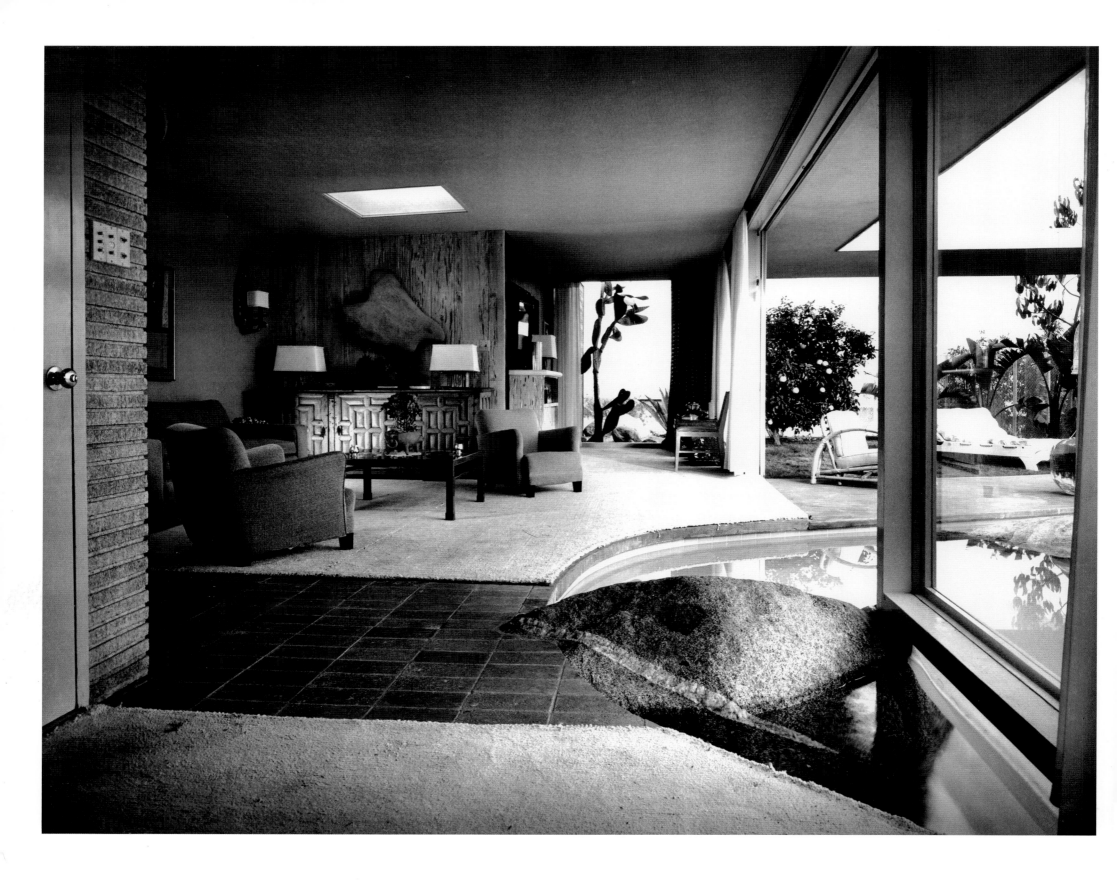

Below and right: **Clark and Frey Offices,**
Clark and Frey, 1947. Photo: 1950.

Opposite: **Loewy House,**
Albert Frey and Raymond Loewy, 1947.
Photo: 1947. Living room.

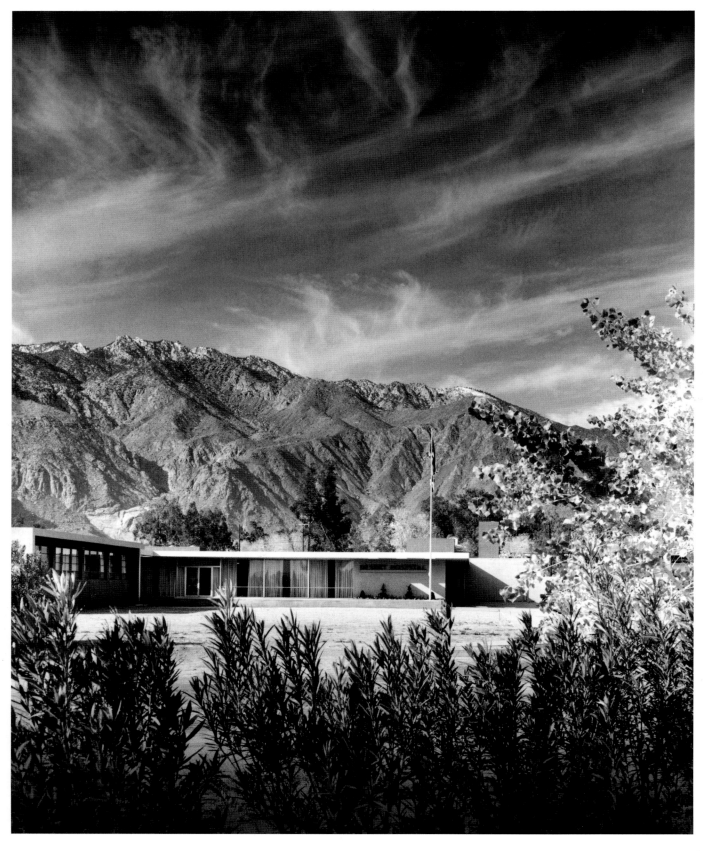

Left: **Desert Hospital,**
Clark and Frey, and Williams, Williams &
Williams, 1950. Photo: 1952.

Below: **San Gorgonio Pass Memorial Hospital,**
Clark and Frey, 1947. Photo: 1952.

Opposite: **Racquet Club Dining Room,**
Clark and Frey, 1950. Photo: 1951.

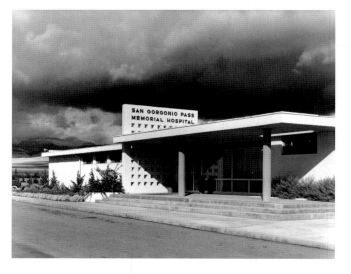

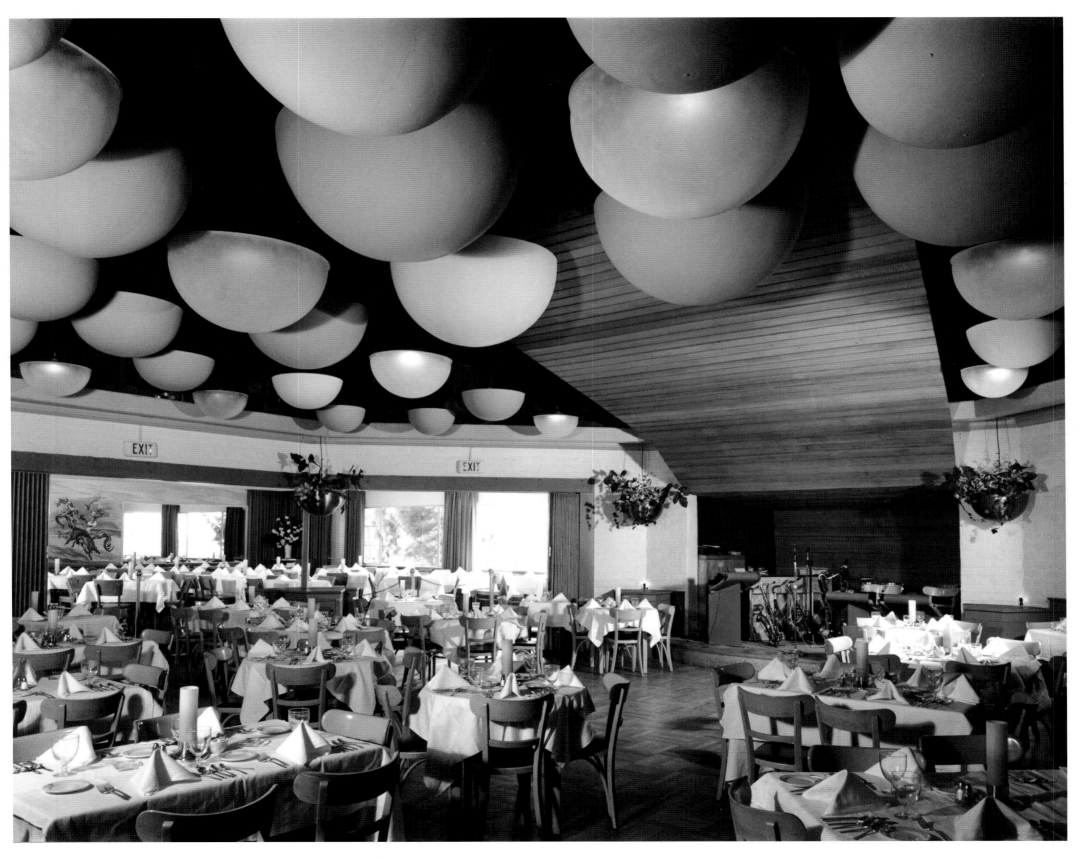

Albert Frey House #1,
Albert Frey, remodeled 1953. Photos: 1956.
Below: **A curving wall of corrugated fiberglass shelters the pool terrace in the 1953 remodeling of Frey's house.**
Right: **Frey added the second story circular bedroom.**

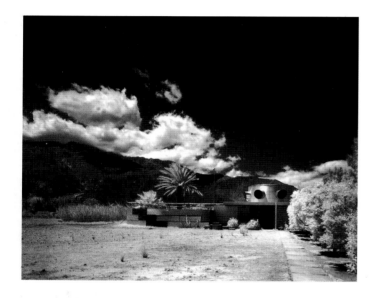

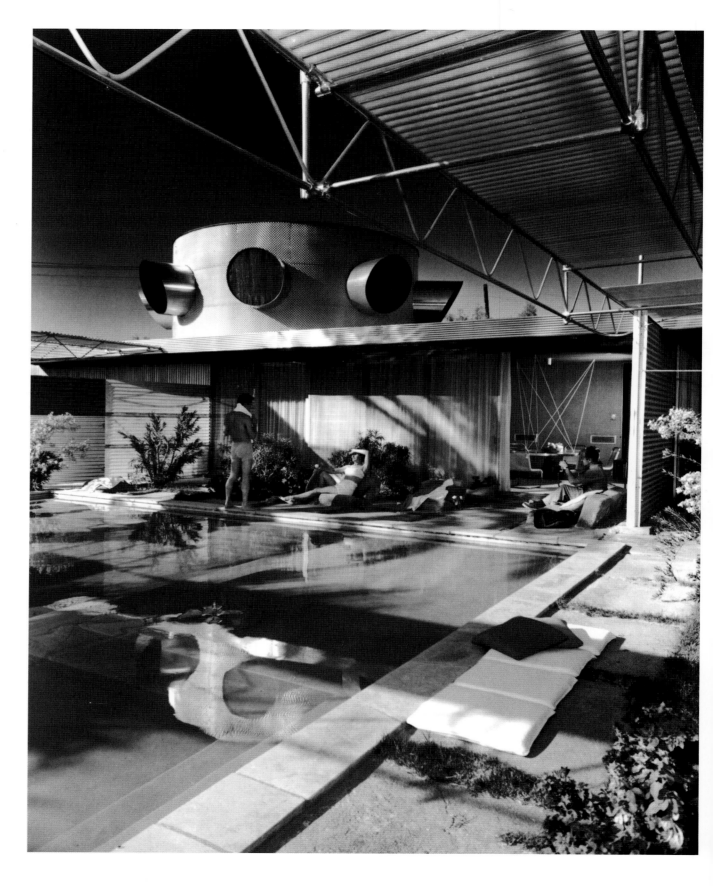

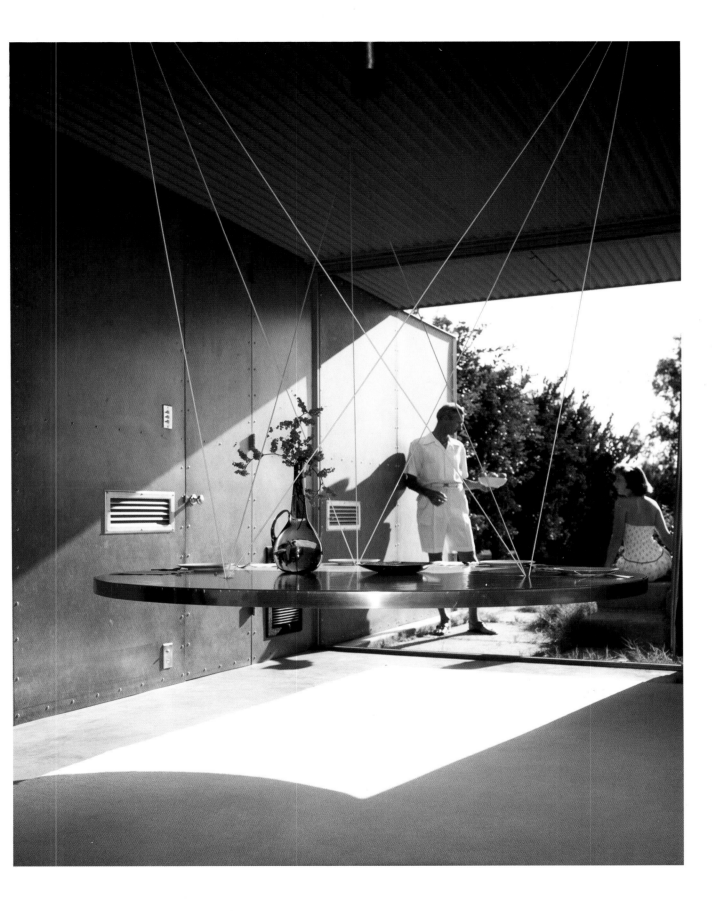

Left: **The suspended dining table's guy wires secured it so that it would not move.**
Below: **Living room with conical fireplace.**
Bottom: **Upholstered walls surrounded the bedroom's circular windows framed in sunshades. Color was always an important element of Frey's work. Stairs are at bottom right.**

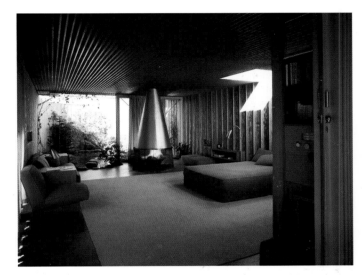

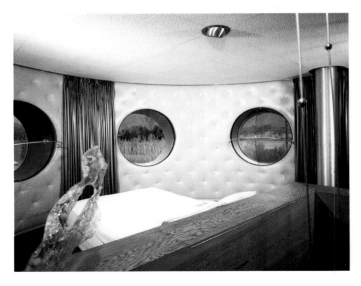

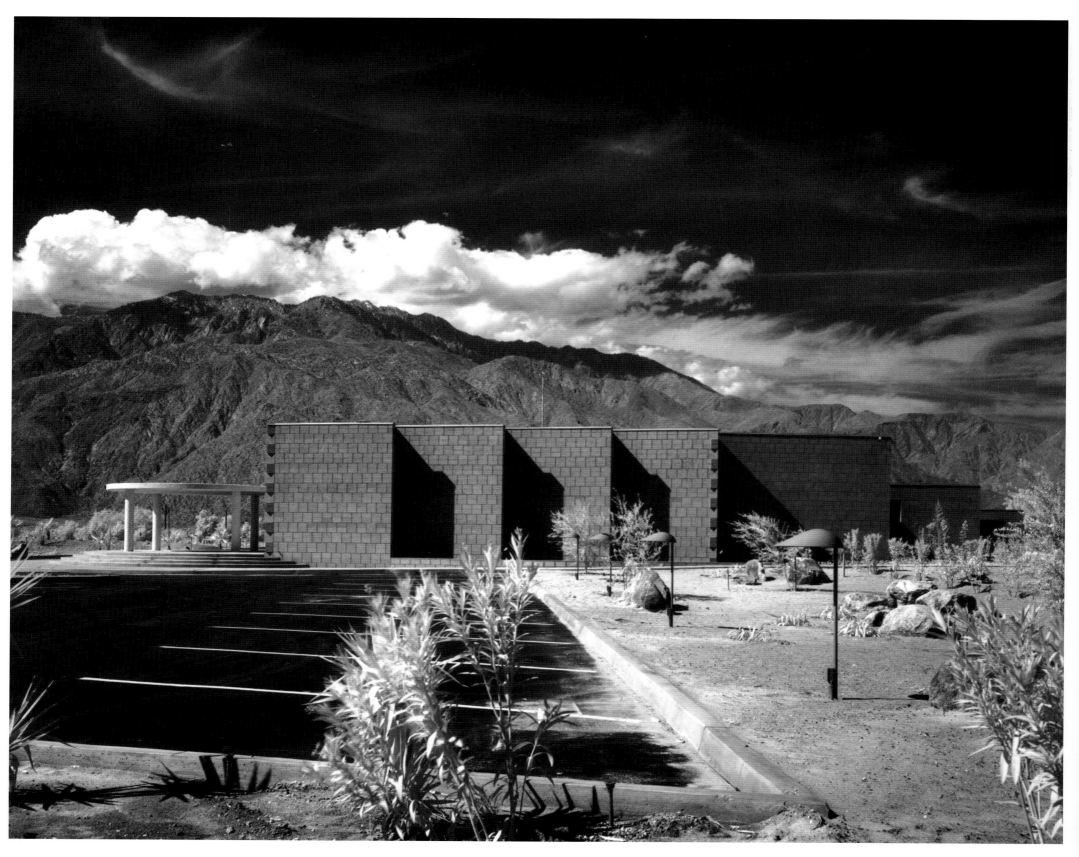

Palm Springs City Hall,
Clark, Frey and Chambers, and Williams,
Williams & Williams, 1957. Photos: 1958.
Below left: **Main entry.** Note the circular
sunscreens gathered on the wall at center.
Below right: **Main entry interior.**
Opposite: **Walls of council chamber step in.**

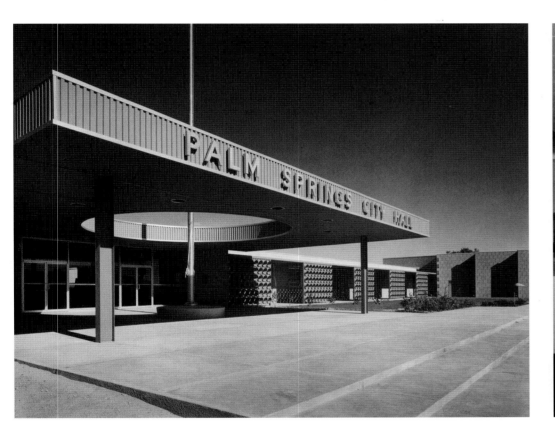

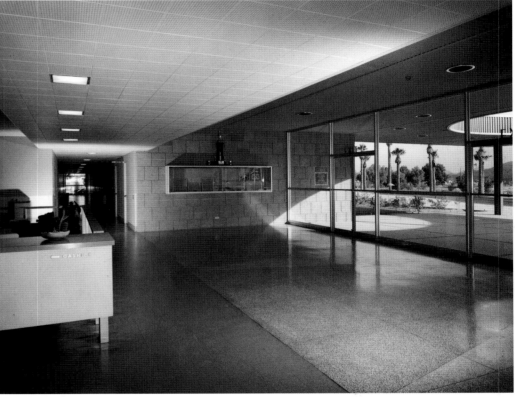

Palm Springs City Hall, Clark,
Frey and Chambers, and Williams, Williams &
Williams, 1957. Photos: 1958.
Below left: **Deep set windows are shaded by the
circular sunscreen wall at left.**
Below right: **The circular tholos marking the
council chamber entry contrasts with the
circular void cut in the canopy of the main entry,
seen on opposite page.**

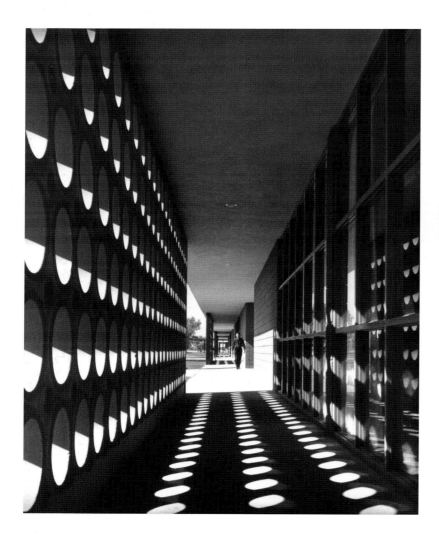

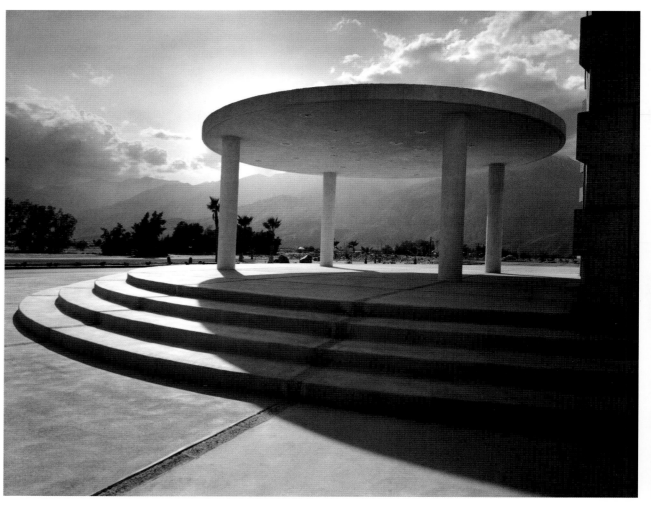

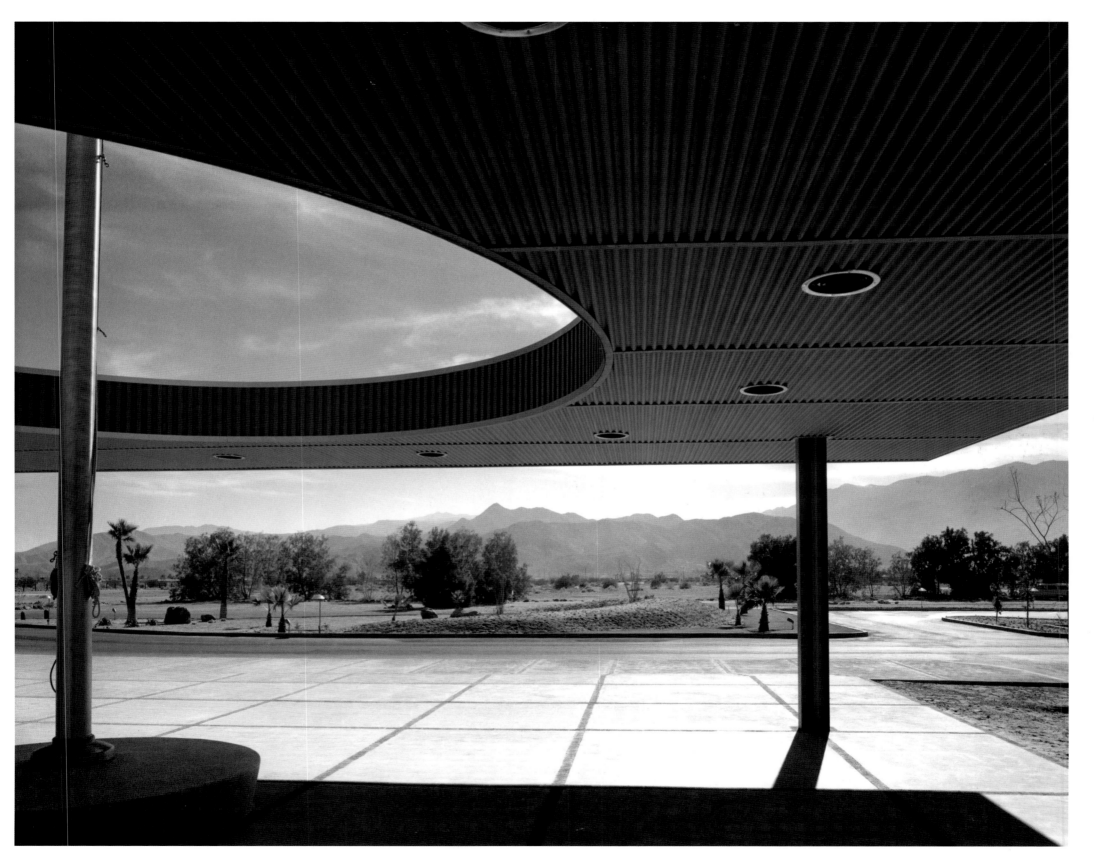

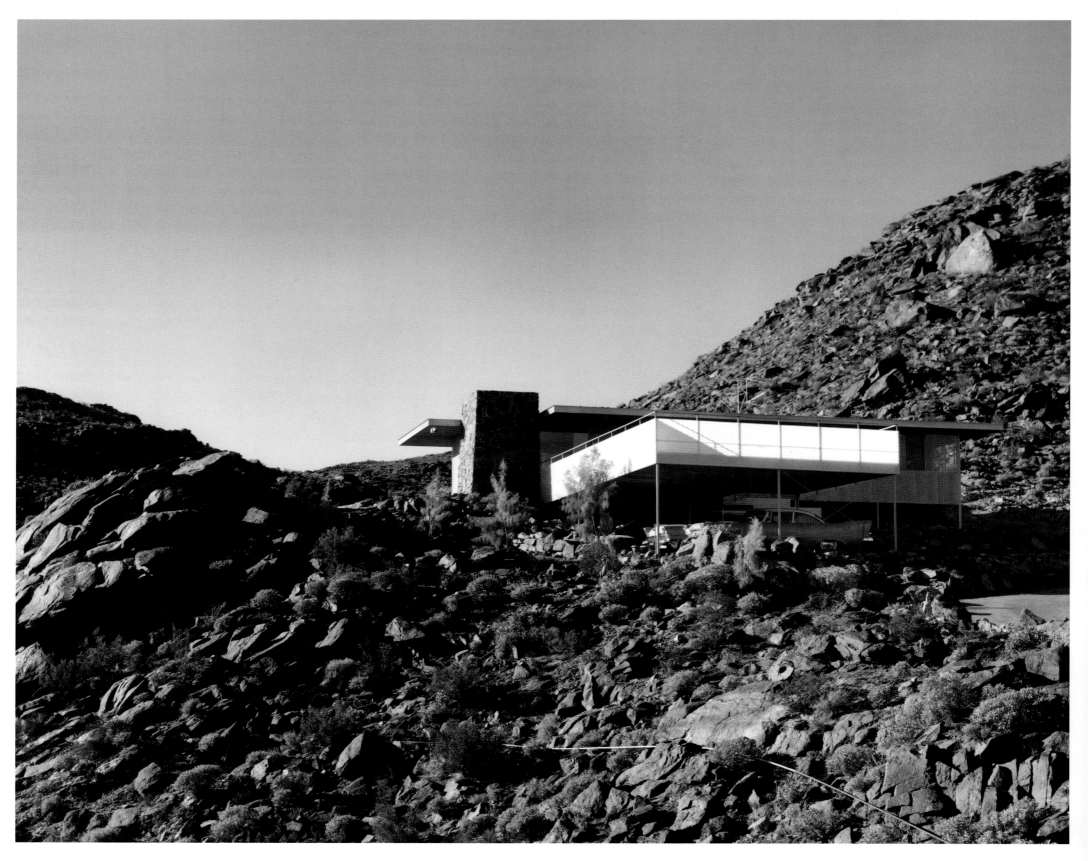

Right: **Premiere Apartments,**
Clark, Frey, and Chambers, 1957.
Photo: 1958.
Corrugated plastic and metal
panels clad the room balconies
overlooking pool.

Opposite: **Cree House,**
Albert Frey, 1955. Photo: 1957.
Natural materials tie the house to
the site, though it floats lightly
over the ground to leave the desert
largely undisturbed.

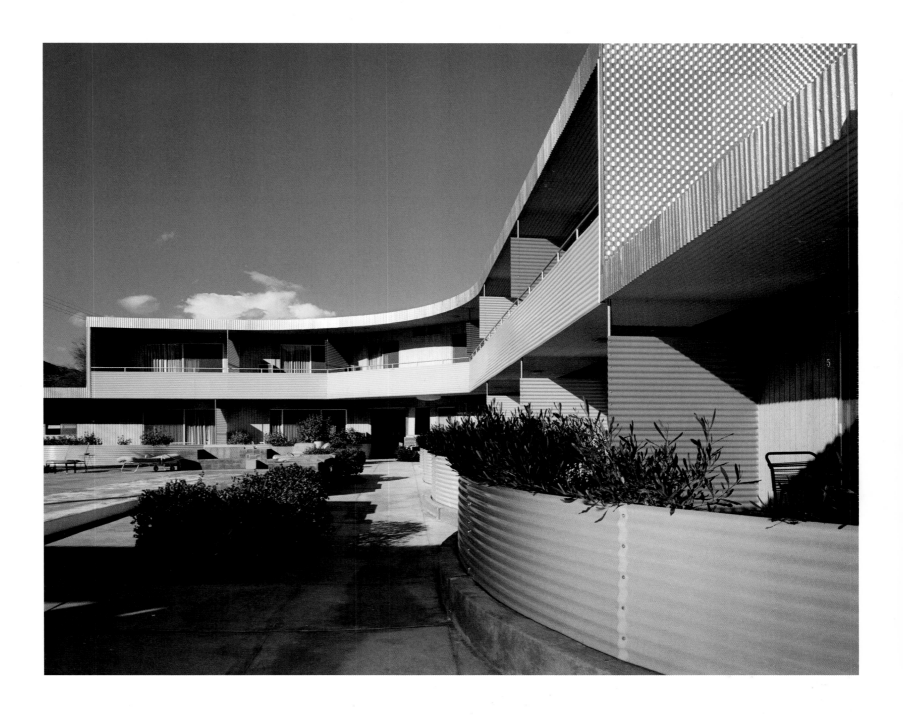

North Shore Yacht Club,
Frey and Chambers, 1958. Photos: 1960.
Below left: **Entry facing the land approach. The second floor is a lounge.**
Below right: **Porthole window from lounge looks out to the Salton Sea.**
Opposite: **For the ultramodern resort on the Salton Sea, Frey reinterpreted nautical imagery for the age of waterskiing and outboard motors.**

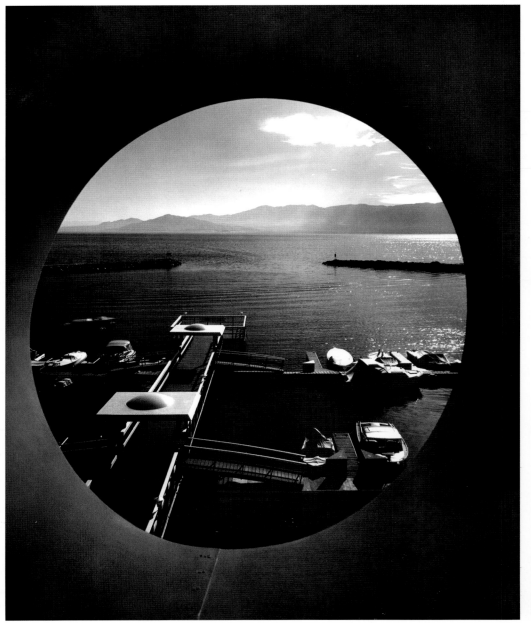

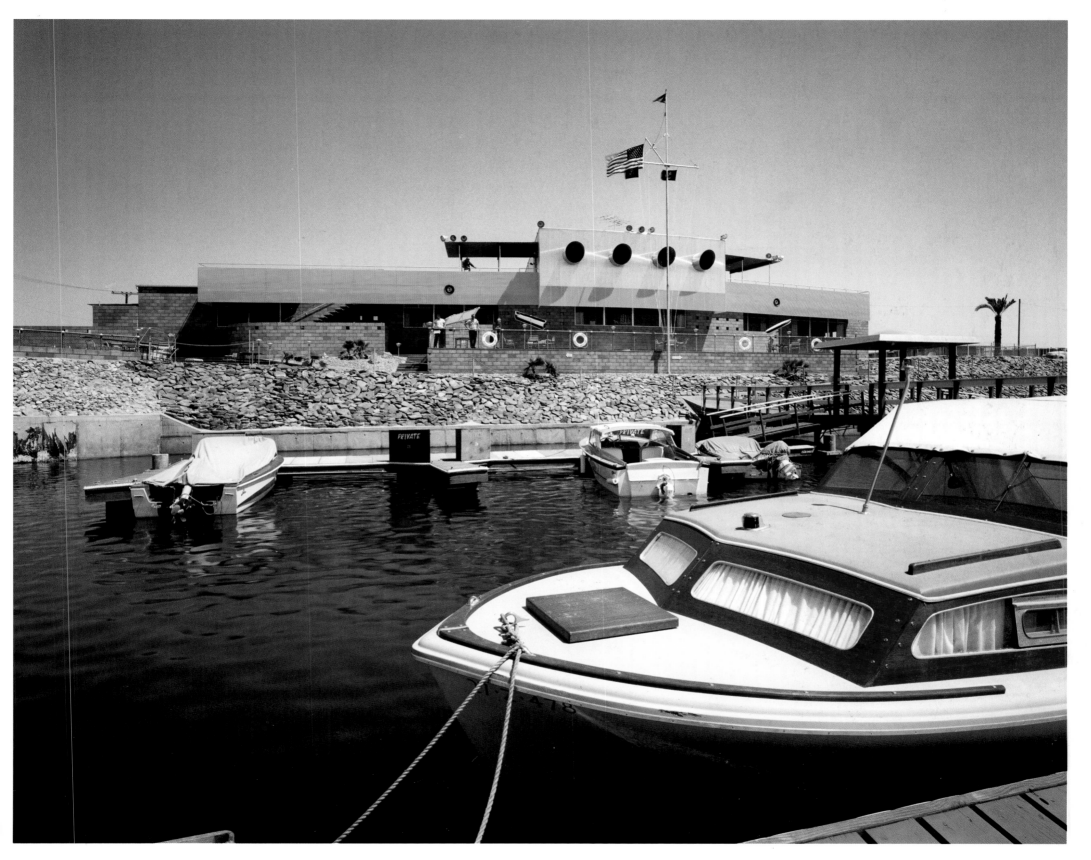

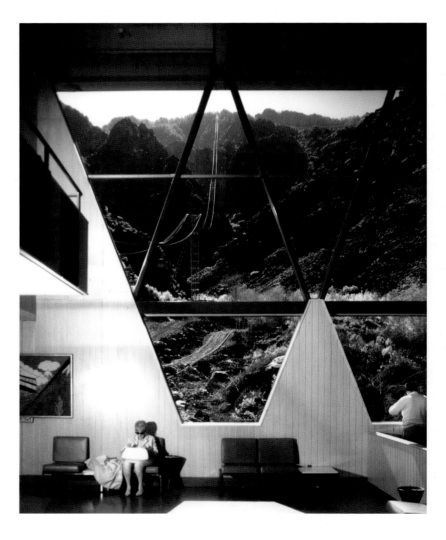

Alpha-Beta Shopping Center,
Frey and Chambers, 1960. Photos: 1963.
Left, top: Canopied walkways stretch
out into the parking lot as a response
to the desert climate.
Left, bottom: Simple wedge-shaped form
is accented by the zigzag canopy.

Palm Springs Tramway, Valley Station,
Clark and Frey, 1963. Photos: 1964.
Below: Waiting room provides a
dramatic view of the cables and towers
leading to the summit.
Opposite: The station forms a bridge
over the mountain wash. The vibrant
illumination of the tramway cables
highlights the building's function.

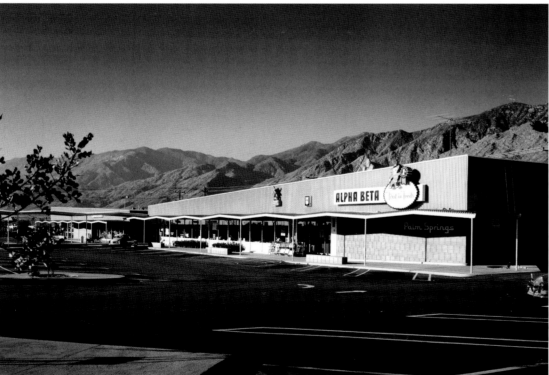

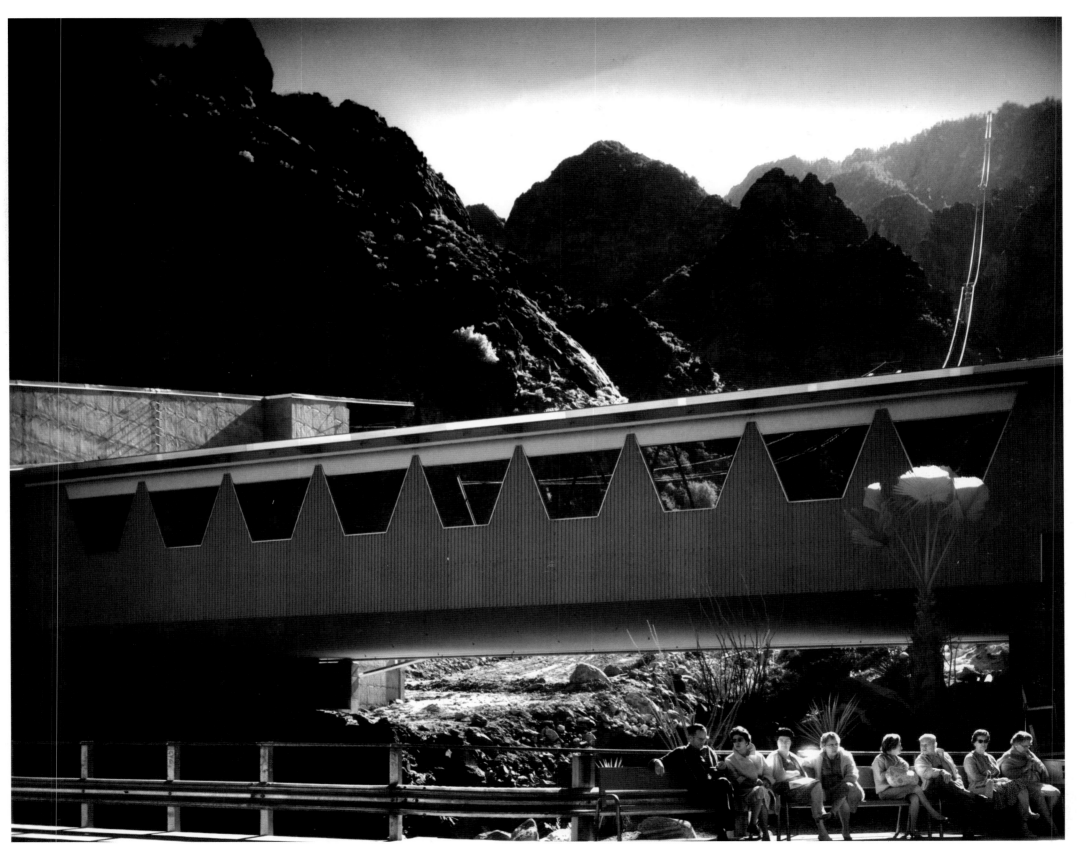

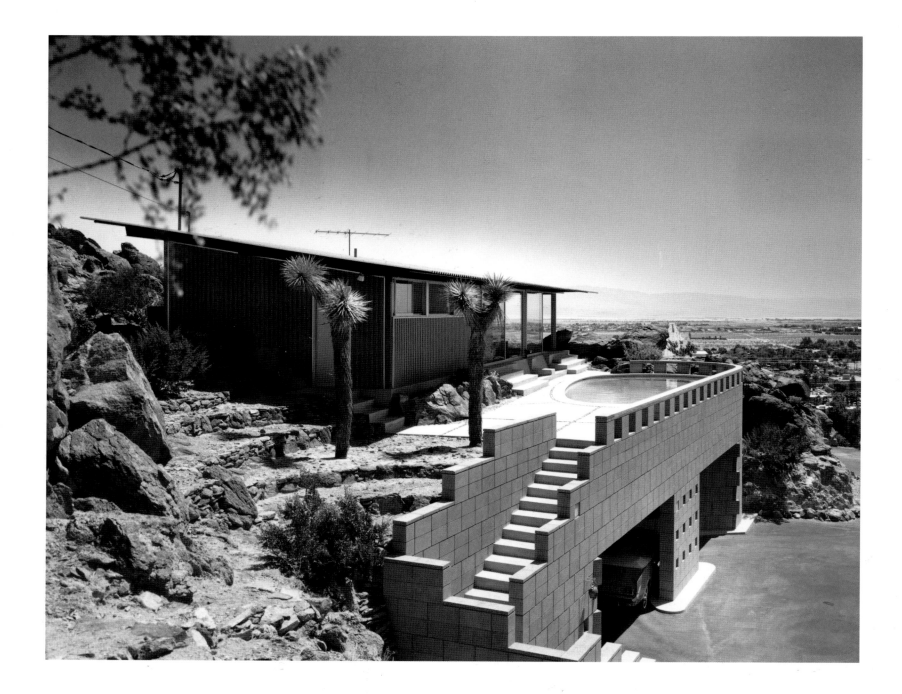

Albert Frey House #2,
Albert Frey, 1963. Photos: 1965.
Left: A concrete block podium forms
the base for the simple steel structure
house. The swimming pool and deck
function as the roof for the carport.
Opposite: The mountainside flows into
the house.

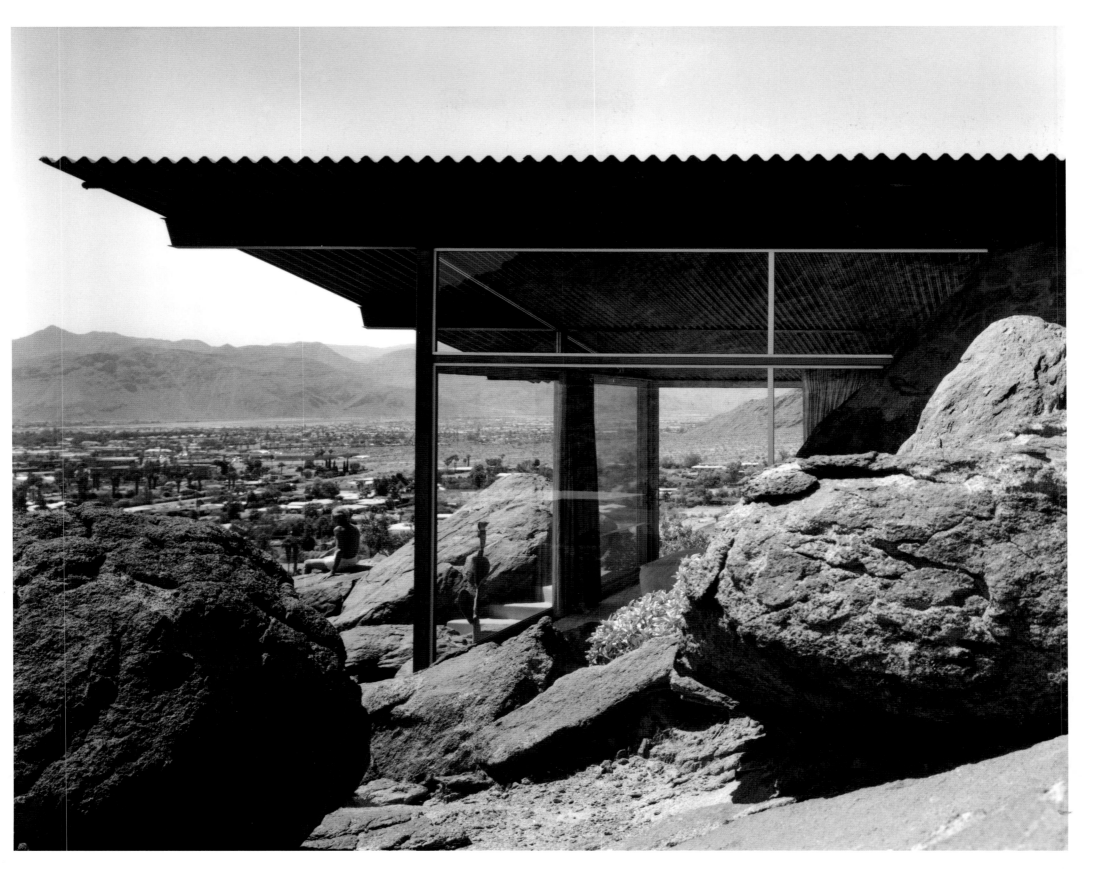

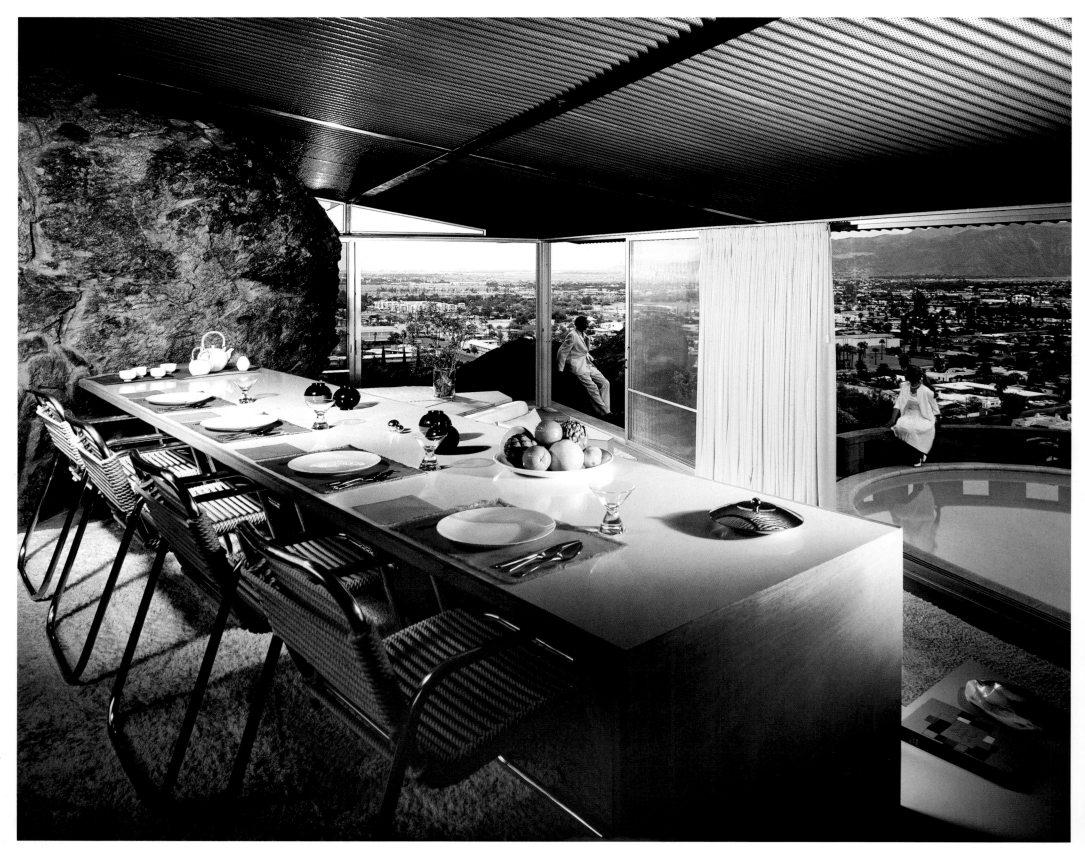

Albert Frey House #2,
Albert Frey, 1963. Photos: 1965.
Right: **Bedroom with native boulder acting as room partition.**
Opposite: **Economically designed, the house wraps an upper level with a dining/work table around a native boulder; the living room and original bedroom are on the lower level.**

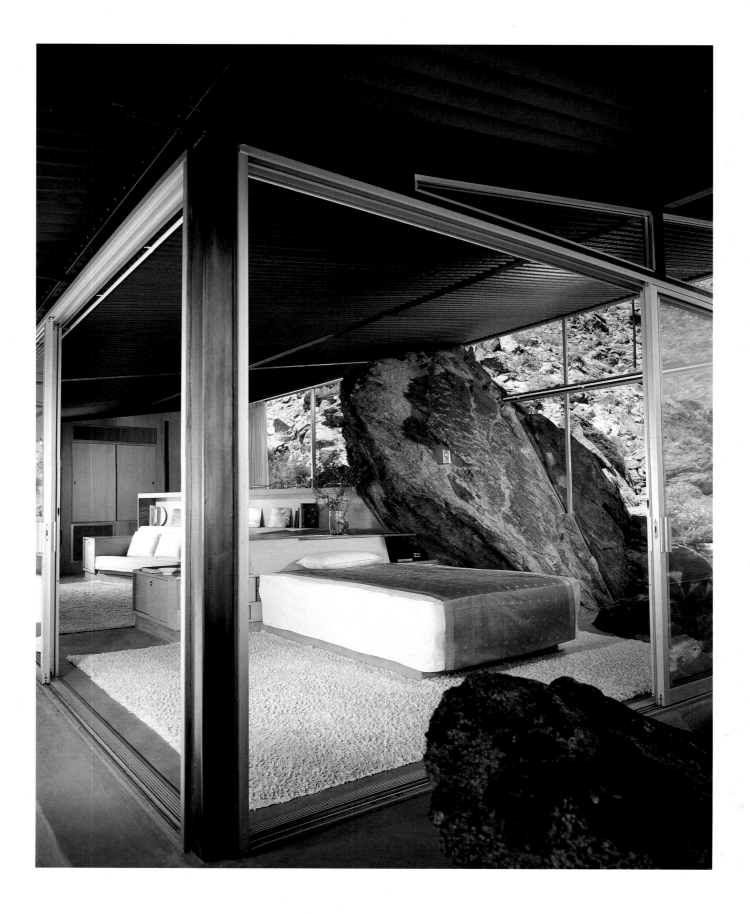

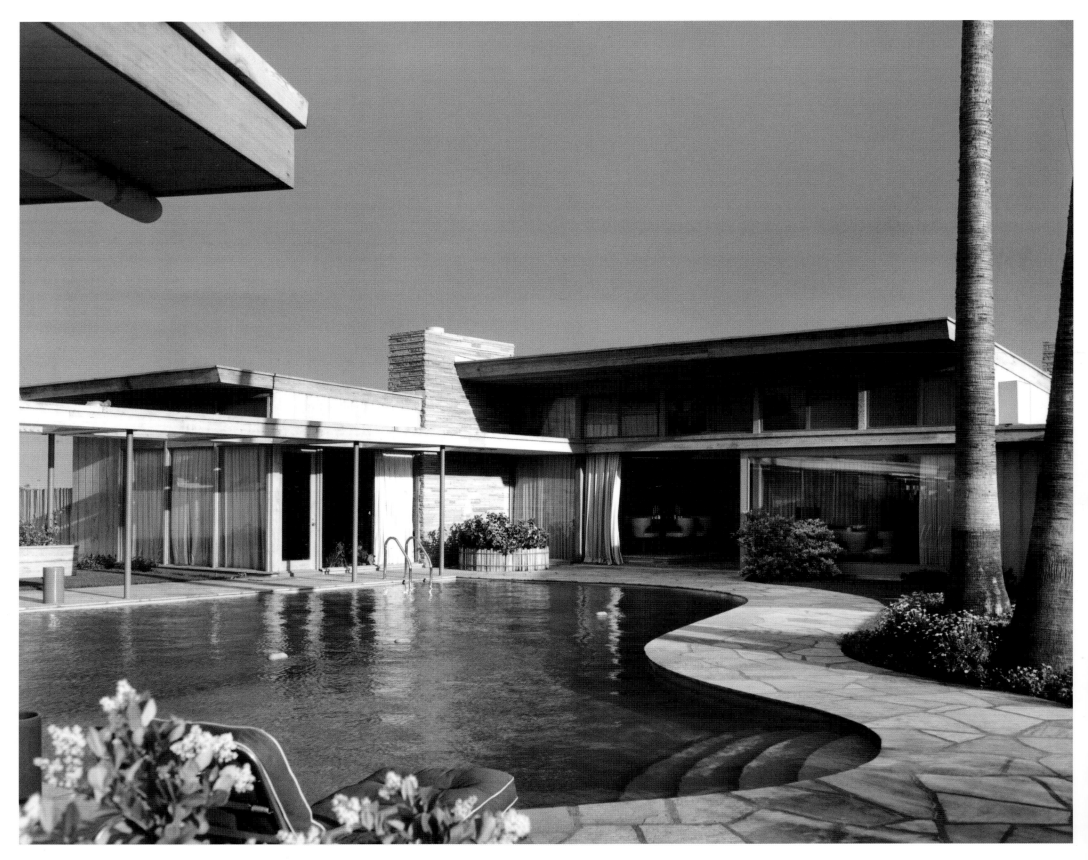

E. Stewart Williams

E. Stewart Williams took his time finding Modernism in the desert. Born in Dayton, Ohio, where his architect father, Harry Williams, was partner in Schenck and Williams, a large and prosperous firm serving industrial midwestern giants including Delco, General Motors, National Cash Register, and Frigidaire, E. Stewart Williams (1909–2005) leaned toward the East.

He studied architecture at his father's alma mater, Cornell University, graduated in 1932, and then earned a masters degree from the University of Pennsylvania in 1933, studying with Paul Cret. The Great Depression decimated his father's architecture practice, but young Stewart was fortunate to get a job teaching art and design at the experimental and progressive Bard College (associated with Columbia University) from 1934 to 1938. As he prepared his courses, he became interested in the Modern architecture of Walter Gropius, Mies van der Rohe, Eric Mendelsohn, Willem Dudok, Gunnar Asplund, Alvar Aalto, and Serge Chermayeff, but he recalled seeing only two books on Modernism in the entire Avery Library at Columbia. He left Bard in 1938 to travel in Europe with the intention of writing a book on this new architecture. Taking in the severe Modern icons of Gropius and others, he found himself drawn more to Scandinavian design, such as the 1911 Stockholm City Hall by Ragnar Östberg. Europeans like Frey and Neutra found the rigorous clarity of the Bauhaus and Le Corbusier appealing, but the young American found the greatest influence in his life in the softer, often organic forms and warm natural materials of Scandinavians like Aalto and Asplund. "They did things for human habitation, not like Le

Corbusier [who designed] according to his own mathematical formulas. . . . I wanted my buildings to have soul, a place where people were part of the human race, not an exercise in geometry."[1]

Williams's strong Eurocentric aesthetic could have kept him in the East forever. Before enlisting in the Navy in 1942, he worked briefly with his father on war-related projects in Dayton, and then took a job with one of the premier industrial designers, Raymond Loewy, working on the 1939 New York World's Fair and Lord & Taylor in Manhassett, Long Island, one of the first suburban department stores in the country. While a job with Loewy was prestigious, it meant a young architect never received any credit. Williams remembered that when Loewy was about to present a project Williams had worked on, he would look at the drawings before going into the meeting, whip out a gold pen, sign the drawings and head into the meeting—alone.[2] And when Loewy built his own house in Palm Springs in 1947, he chose Albert Frey as his architect, not his former employee.

But for the Great Depression, Williams and his family may well have stayed in the East. Then the economic blight that wiped out his father's prosperous firm turned everything upside down; when a long-time Dayton client, Julia Carnell, asked Harry Williams to design a multi-use, car-oriented shopping center in the remote resort town of Palm Springs in 1934, the elder Williams accepted and moved out West. Stewart, then in the military and stationed at Mare Island Naval Base in San Franciso Bay, visited Palm Springs in 1943. When the war ended, Dayton, Ohio, was no longer as appealing a location for a young architect. E. Stewart Williams settled in the desert in March 1946 where he and his brother (also an architect) went into business with their father for the next decade as the firm Williams, Williams & Williams.

Williams was still fairly inexperienced as an architect. "I didn't know anything about architecture

really when I came out here in 1946. . . . I didn't know about zoning, about building codes, didn't know anything about construction. . . . I detailed a lot of things in my dad's office but I didn't know how to build," he said later.[3]

Still Williams's first design by himself was a spectacular start for a young architect: a vacation house for Frank Sinatra, who (by Williams' account) simply wandered into the office one day. The design bears comparison with Frey's Loewy House and the Town and Country Center by Paul R. Williams (no relation) and A. Quincy Jones, both also from 1947. All were California Modern, a West Coast variation of shapely, untraditional, cleanly abstract forms punctuated with natural materials. All were Modern in their open plans and their openness to the outdoors; all were quite distinct from the hard-edged steel frames of Neutra's version of Modernism. Late Moderne motifs, such as egg-crate trellises catching the sunlight and dropped soffit ceilings, are found in all these designs.

The Sinatra House's wings were laid out not on a strict grid but at a casual angle. As a first design, the Sinatra House had some awkward moments; the front facade did not resolve the informal wings as elegantly as later Williams's designs would. But overall the careful proportions and subtle but rich mix of materials (stone, wood, glass, plaster) show a keen eye. It was an eye trained by Modern art and its deliberate arrangement of abstract form, color, and balance—not a fetish for astonishing structural gymnastics. Even Williams's larger public buildings in his early years, such as Temple Isaiah (1949), show the same sense of architecture as sculpture with strong focal points and contrasts of shapes and textures. With this sensibility, E. Stewart Williams showed himself to be closely in touch with California trends of the times, even if he lived and worked on the fringes of Los Angeles and the profession.

But Williams did not stay with the one style. Like other Palm Springs architects who had multi-faceted offices, he designed whatever the small community demanded. Cordrey's Colony (1947) was a small inn for Earl Cordrey (an artist and illustrator) for visitors on extended stays; though Palm Springs had short-term motels for travelers, many of the vacation venues were for those spending the season in the warm weather. Like the Bisonte Lodge (1951), also designed by Williams, Williams & Williams, the simple elements of Cordrey's Colony were arranged to take advantage of the weather, the sun, and the views, with a balance of privacy and sociability. In the second-story studio, the slanting ceiling of exposed wood leads the eye to the window wall and the view. Linoleum floors (laid in a striped pattern) were a contemporary, manufactured material that blended with the natural wood.

Even as his architecture moved toward a simpler, more structurally expressive form in the subsequent Williams, Kiner, Bligh, and Edris houses, Williams retained a sculptural character in the built-in furniture he invariably designed. In the Kiner and Bligh houses, consoles, wet bars, and television cabinets perform as space dividers and focal points; usually cantilevered off the floor and stopping short of the ceiling, they provided a well-composed accent to the broad wood ceilings and stone walls.

No example shows this sculptural quality more clearly than Williams's 1956 house for his own family. It may be more accurate to call this house a landscape design rather than architecture; a broad, gently sloping butterfly roof hovers lightly over the lot. Wide eaves made the house livable in the desert summer. One dominant wall marks the edge of the living space, but it seems completely untethered from the structure as it stretches out into the landscape. Fabricated of tilt-up concrete panels embedded with stones, the wall does not even bother to reach up to support the roof. The landscape then is free to invade the interior—"The garden ran through the living room," said Williams.[4] Completely undeterred by the invisible glass walls, rocks and plants spill inward, creating a setting for the suspended fireplace against the stone wall. The design is functional, pleasant, and informal.

The Spaniards who settled California in the eighteenth century lived easily amid the fresh air and sunshine, but their adobe haciendas did not allow them to break down the line between indoors and outside. Steel and plate glass enabled twentieth-century Modernists to evaporate those walls. Rarely did any California architect achieve the utter unity of indoors and outdoors that Williams achieved in his own house.

Williams's well-established penchant for blending landscape and architecture comes together in the Edris House (1953). There the stone walls seem a seamless continuation of the rubble-strewn hillsides of the nearby mountains (as can be seen in Shulman's original photos.) That landscape continues in the boulders surrounding the organically-shaped swimming pool. The sloping roof of the living room— the dominant form in the design—shows Williams's evolution away from abstract forms to structurally expressive forms; it takes the shallow triangular shape of a wood truss. While most desert architects avoided wood, which can dry and crack in the furnacelike heat, Williams embraced it. Functional elements like cabinets are treated as distinct fixtures, elegant and utilitarian, allowing the stone and wood structure to stay at the forefront.

E. Stewart Williams's public and commercial buildings show a parallel evolution as he worked and learned. The Oasis Hotel is a clear definition of freeform desert Modernism, in contrast to the rigorous, stripped-down structural expressionism that was raised to high art in the Kaufmann House. The hotel's curvilinear soffits in the dining room help to frame the windows and the view; the entry canopy is a freeform scribble held up on slender columns, an instant visual landmark and a statement of welcome. The form strikes many critics as a cliché of Mid-century Modernism, but in the hands of Williams it can be seen to be carefully intentional design. He did not need the logical lines of a grid to decide how to place walls and windows; his sense of the landscape and his sense of composition could lead him to a free placement of those elements, guided by a sense of movement through the space, of focal points and views, of the length of a space, of the wideness or narrowness of the space, and, especially, of the vertical height or enclosure of the space—an important dimension in Palm Springs where the mountains are so near that they draw your eye upward involuntarily. The popularity of this shapely and stylish architecture in Palm Springs and elsewhere in the 1950s is undeniable, and is the basis of its rediscovery today. This interpretation of Modernism is sometimes criticized as a less rigorous, more pleasurable, and sometimes self-indulgent form, but Williams's uncluttered, easy, yet controlled design shows it in its best light.

Yet Williams could work with a grid, too; the Oasis Office Building (1952), set on the main street of Palm Springs, is an oversized Bauhaus box lifted above the sidewalk on pilotis. Though a certain freeform whimsy is allowed (the ground-floor shop windows angle this way and that, opening up a central courtyard), it is a straightforward and direct commercial design. Similarly, the first Coachella Valley Savings and Loan bank (1956) uses the same motif of a lifted box, with a car entry tucked underneath. Williams's growth and adaptability as a designer is seen in a later bank building based on the grid, Santa Fe Federal Savings (1957). This is his version of the Miesian pavilion, adapted to Palm Springs with a series of moveable aluminum screens and wide eaves to cut the strong sun. Two thin plates, a roof and a floor, float above the ground; glass walls fill in between, with the structure held on detached steel columns, stiffened with slender fins. This elegant design forms an extraordinary Modernist district with Pereira and Luckman's Robinson's Department Store across the street. The concentration of good design, and of clients (residential and commercial), who insisted on high-quality and inventive Modern design—and who had customers who expected a level of architecture in their wintering spots—can be seen nowhere better than at the corner of Ramon Road and Palm Canyon Drive.

And yet it was a sense of dramatic forms to which Williams often returned. This is seen in the inverted arches, tapering upward to touch the wafer-thin roof, in the second Coachella Valley Savings and Loan (1961). Though the silhouette immediately brings to mind a variation on the well-publicized 1956 Alvorada Palace by Oscar Niemeyer in newly built Brasilia, Williams insisted that his design had no relation to the Brazilian Modernist's designs. His bank's arches are inverted structures, supporting the columns and widening at the bottom for seismic stability. Certainly Williams's detailing avoids Niemeyer's sinewy lines in a way that other overtly Brasilia-influenced architecture did not. The design also responds appropriately to its desert site. The two-story banking space is walled in with tall panels, but the panels are lifted up from the ground, and stop just short of the ceiling, in order to let light into the space. The strong sun is shielded, but the light is balanced and controlled to avoid the gloom.

His flexibility is seen yet again in his design for the mountain station for the Aerial Tramway (1964). The concept for this tramway was heroic: steel towers erected on the inaccessible, impossibly steep mountain side so that tourists could ride gondolas

from the desert floor to the alpine environment of Mt. San Jacinto. At the top, Williams designed a modern tram station with a restaurant, lounge, and hopping-off points for hiking in the pine forests. A modernized chalet, its angled wings with sloping roofs boasted large windows to the view. Instead of creating a flat site for the station, Williams fitted its wings and outdoor terraces to the topography, tying the building to the natural beauty that attracted tourists in the first place.

Williams took on yet another material and structure in the late 1960s: concrete—first at Crafton Hills College in Yucaipa and then notably at the Palm Springs Desert Museum. Both were "the very best I could turn out."[5] Unlike anything he had done before, Crafton Hills College (1968) is a megastructure, then popular in architecture. A series of ribbed concrete buildings ride a narrow ridge, connected by plazas and flights of steps responding to the difficult site. While many megastructure complexes (such as Paul Rudolph's Boston

Government Center) emphasized the massive, Brutalist character of poured concrete, Williams's version is surprisingly humane. He did not abandon his enduring sense of human scale.

The Palm Springs Desert Museum (1976) is Williams's major civic monument. As at Crafton Hills College he used large, blocky forms; while Lautner explored the organic shapes to which concrete could be molded, most architects accepted the rectilinear lines imposed by the strong forms into which the liquid concrete would be poured. But once again Williams' skill of proportion comes into play. The solid, mostly windowless wings of the museum are lifted above sunken sculpture gardens, imparting a sense of visual lightness. The sunken gardens provide a variety of smaller outdoor spaces that also break down the apparent massiveness of the structure. Secondary wings jutting at an angle from the main facade are impressed with a layer of reddish-brown volcanic cinder stone; as always, Williams ties his building to the site by recalling the rugged textures

and colors of the mountain rising immediately behind the museum. The Annenberg Theater on the below-grade level of the museum uses both curving concrete structural ribs and a thin skin of curving wood to reflect the organic shapes of Scandinavian design Williams had seen on his travels in the 1930s. Form, material, color, scale—the themes that he had been observing and mastering since his earliest studies in architecture unite in this building.

E. Stewart Williams was not a recluse. Over the years he won several awards from chapters of the American Institute of Architects (AIA), Julius Shulman photographed his work, and he was published occasionally in the national architecture journals. He did not seek publicity in the outside architecture world, however. The Palm Springs area brought him the opportunities to design different types of buildings, and to grow and change in his approach as he wished. Today, however, it is the larger architectural world that needs to know his work. •

1 E. Stewart Williams, interview by Alan Hess, Aug. 1, 1999.
2 E. Stewart Williams, interview by Alan Hess, July 15, 1999.
3 *E. Stewart Williams: A Tribute to his Work and Life* (Palm Springs: Palm Springs Preservation Foundation, 2005), 9.
4 E. Stewart Williams, interview by Alan Hess, Aug. 1, 1999.
5 Ibid.

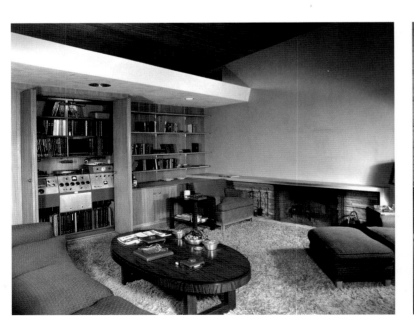

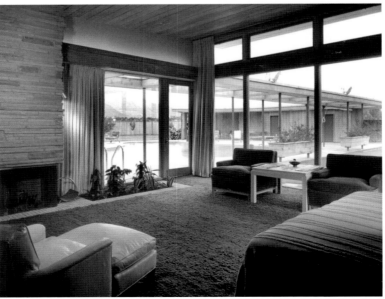

Frank Sinatra House,
E. Stewart Williams, 1947. Photos: 1949.
Far left: **Living room with state-of-the-art audio equipment built into closet.**
Left: **Bedroom looking out to pool.**

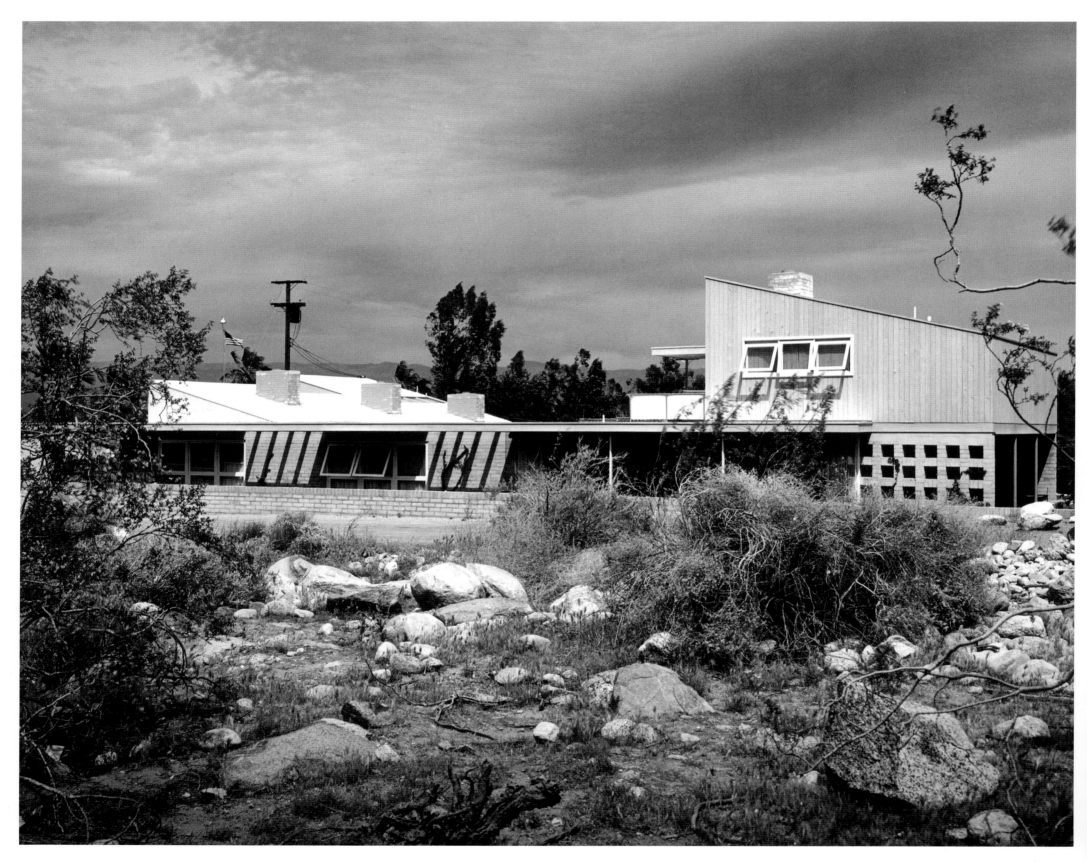

Cordrey's Colony,
E. Stewart Williams, 1947. Photos: 1949.
Right: **Second story studio for the owner, a noted illustrator.**
Opposite: **This small inn provided seasonal apartments for vacationers. Many of the owner's friends were artists; hence, the bungalows on the property contained artist's studios.**

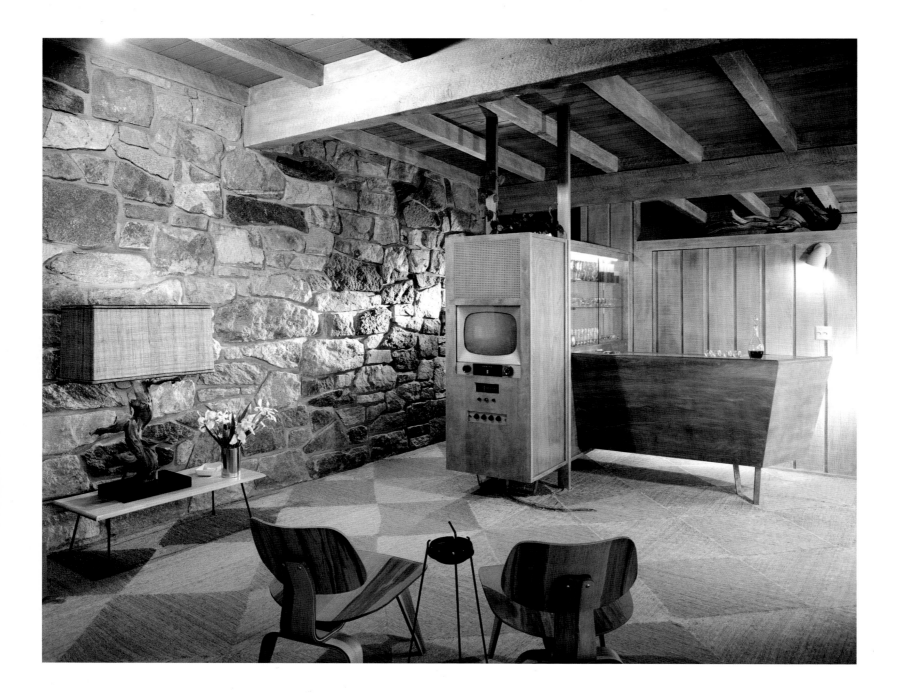

Left: **Ralph Kiner House,**
E. Stewart Williams, 1951. Photo: 1952.
Built-in furniture and partitions become
a part of the architecture.

Opposite: **H. J. Bligh House,**
E. Stewart Williams, 1952. Photo: 1953.
An alcove integrates the pool with the
interior of the house.

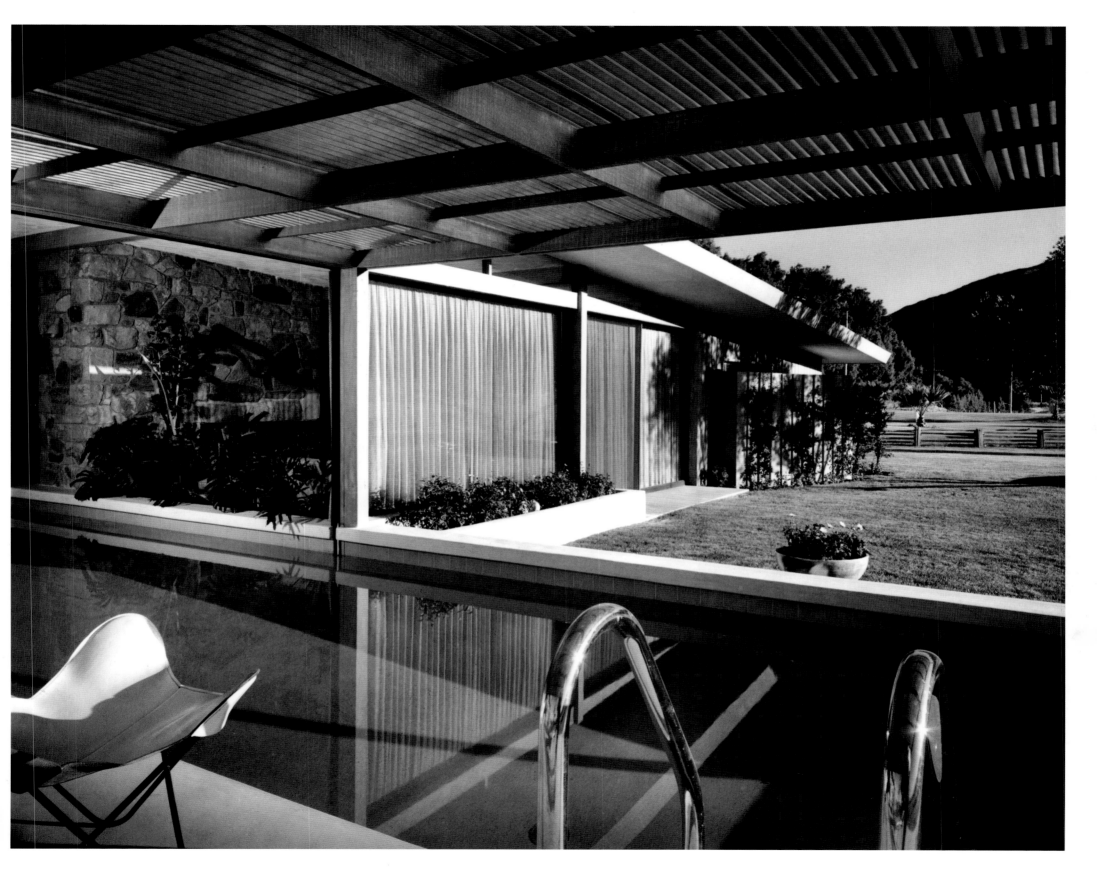

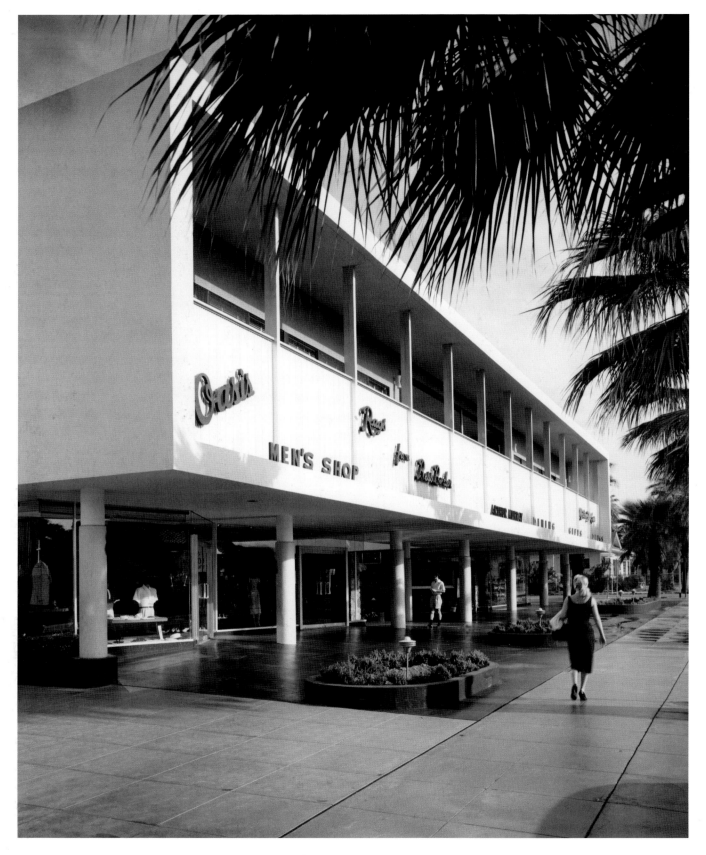

Oasis Office Building,
E Stewart Williams, 1952. Photos: 1953.
Left: Irregular storefronts on ground floor created courtyards and shaded walkways.
Below: The office building stood on part of the site of the 1925 Oasis Hotel designed by Lloyd Wright. Its slip-form concrete tower and commercial space can be seen at left.
Opposite: Offices of Williams, Williams & Williams in the Oasis Office Building.

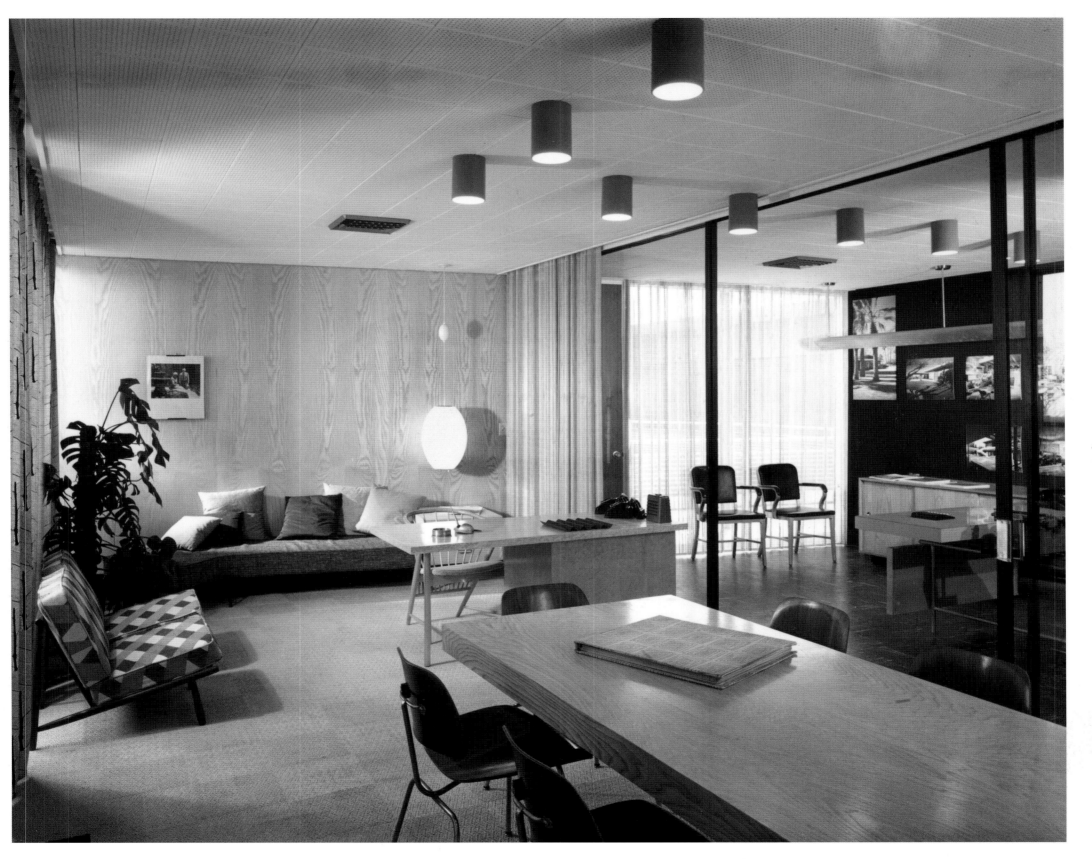

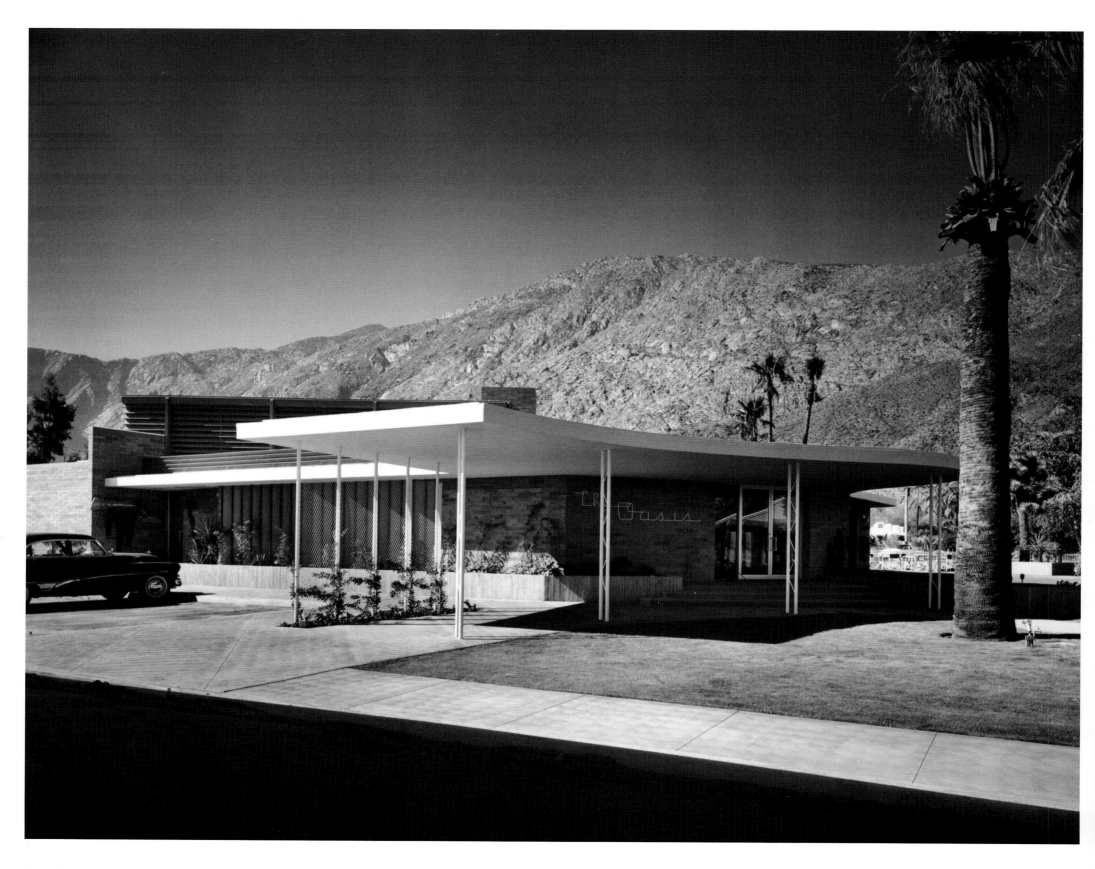

Oasis Hotel,
Williams, Williams & Williams, 1953.
Photos: 1953.
Right: **Dining room and lounge.**
Opposite: **Entry.**

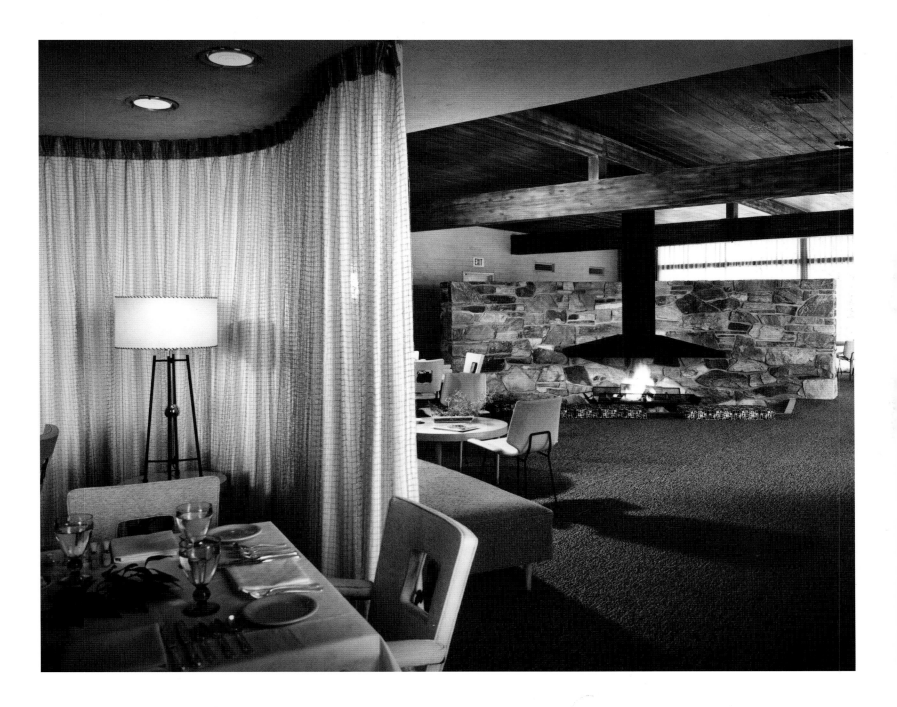

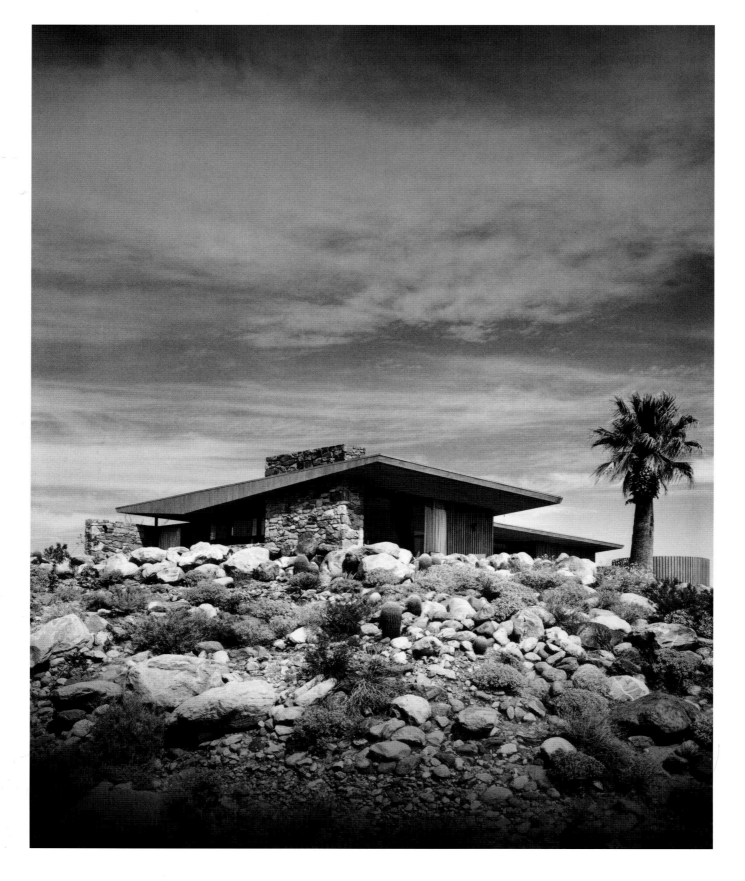

William and Marjorie Edris House,
E. Stewart Williams, 1953. Photos: 1954/55.
Left: **Living room wing.**
Opposite: **Master bedroom. The rock
wall merges seamlessly into the natural
desert terrain.**

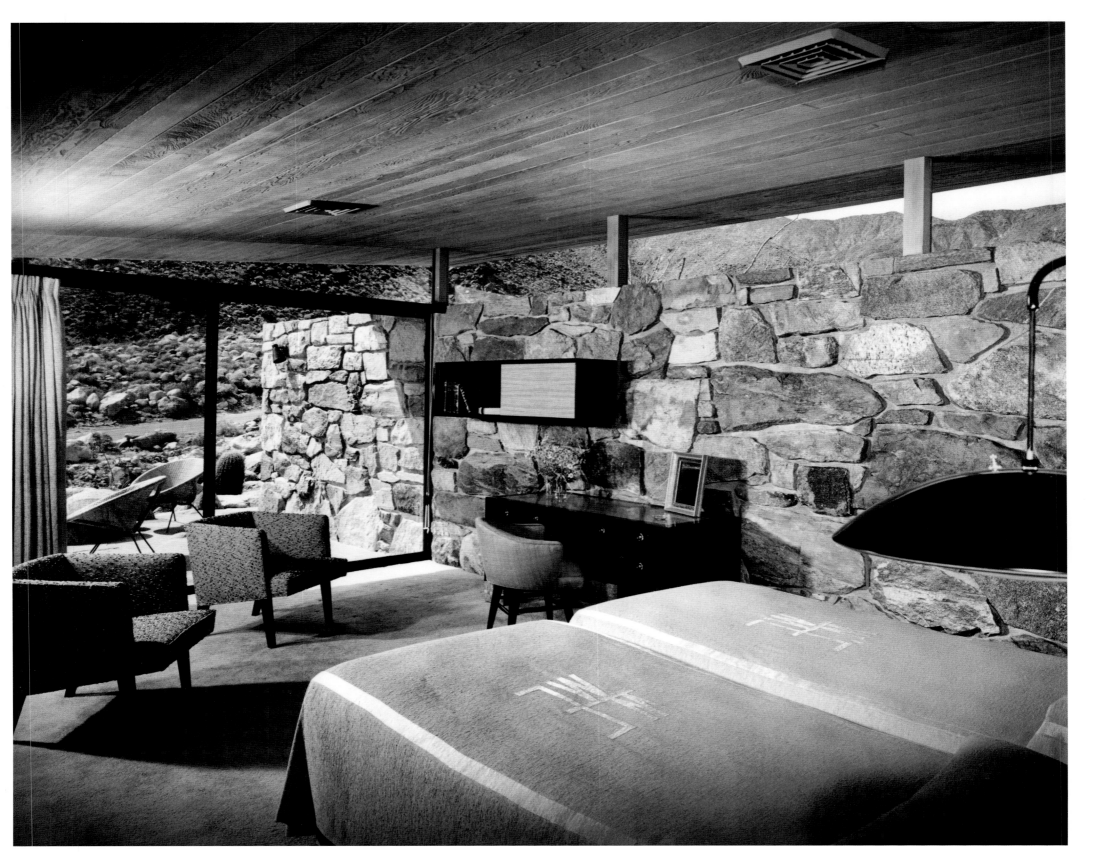

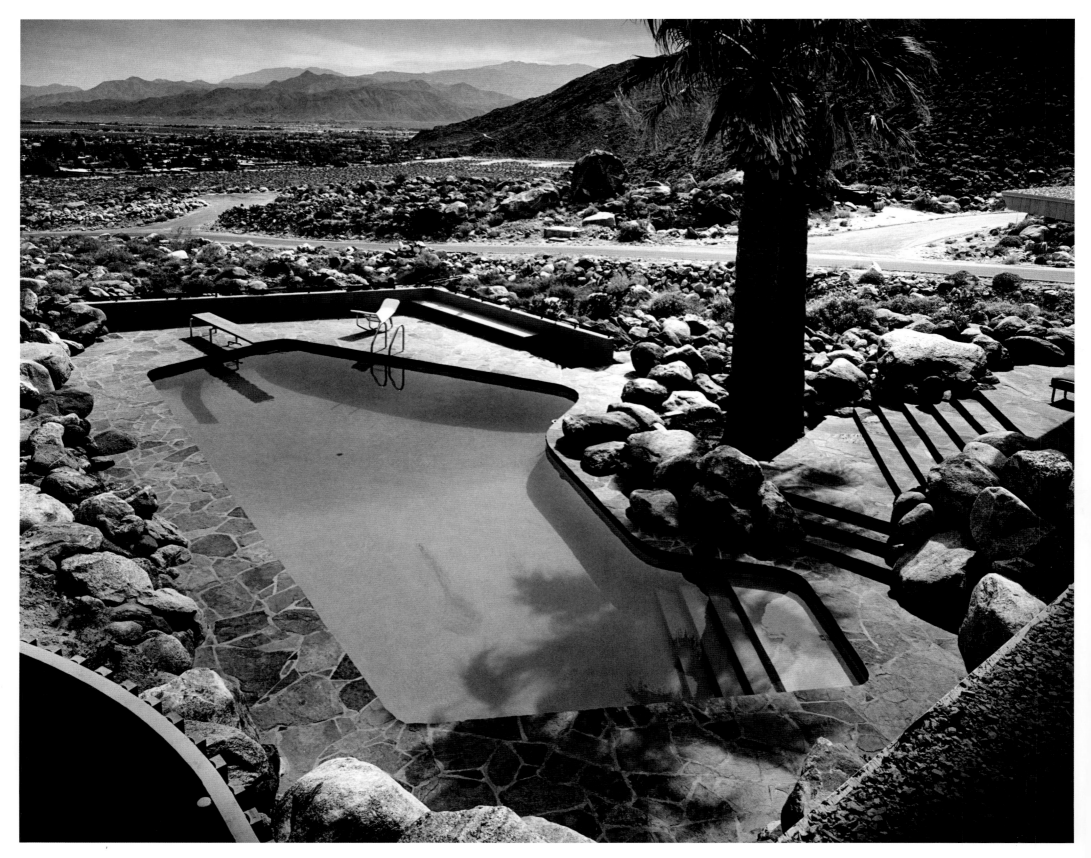

William and Marjorie Edris House,
E. Stewart Williams, 1953. Photos: 1954/55.
Right: **living room.**
Opposite: **Pool terrace off living room.**

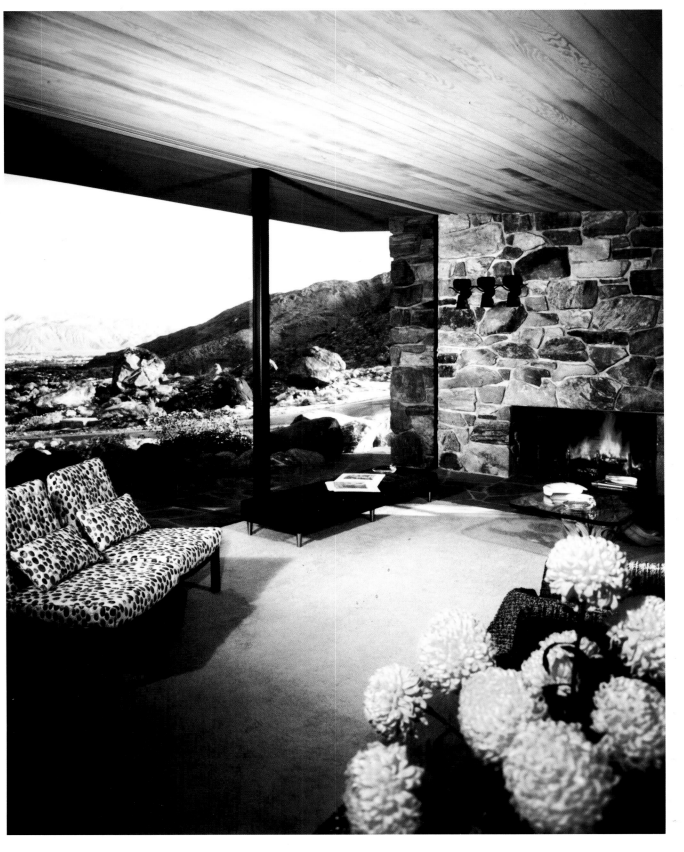

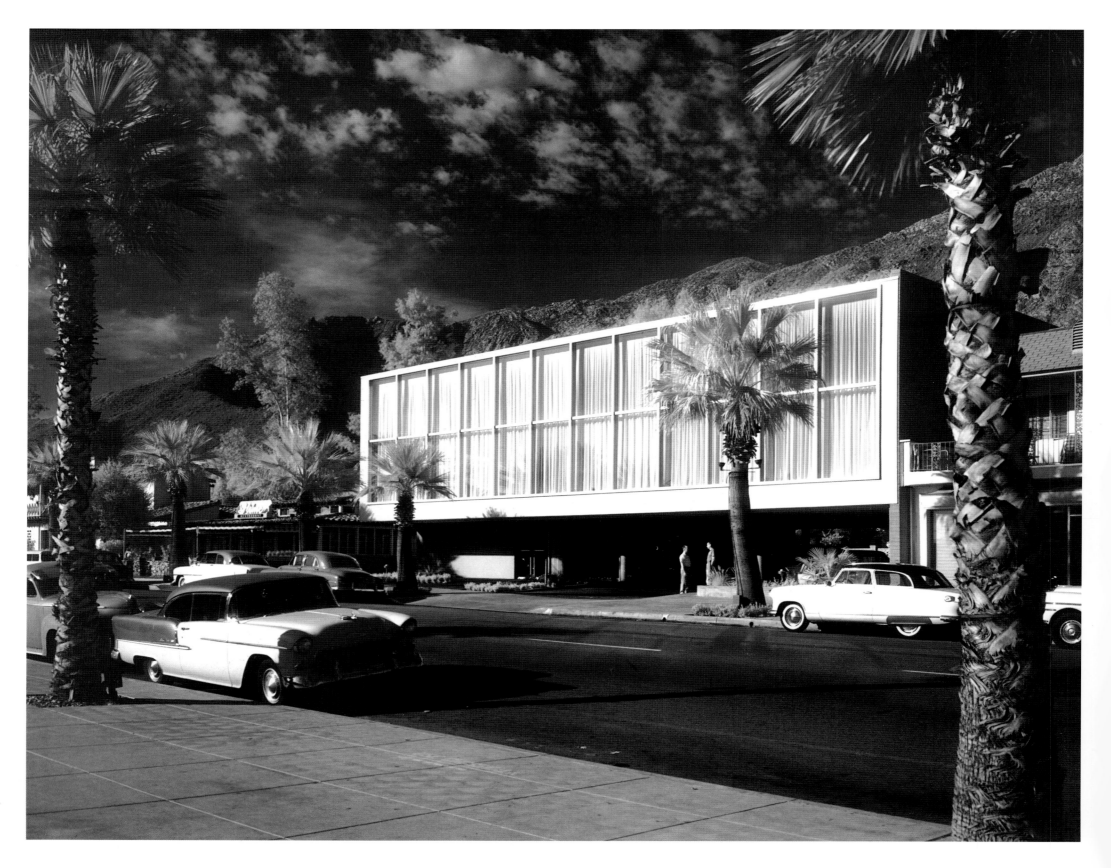

Coachella Valley Savings and Loan #1,
Williams, Williams & Williams, 1956.
Photos: 1957.
Right: Banking room.
Opposite: The two-story banking room
is lifted one story above the ground
so that cars can enter beneath it.

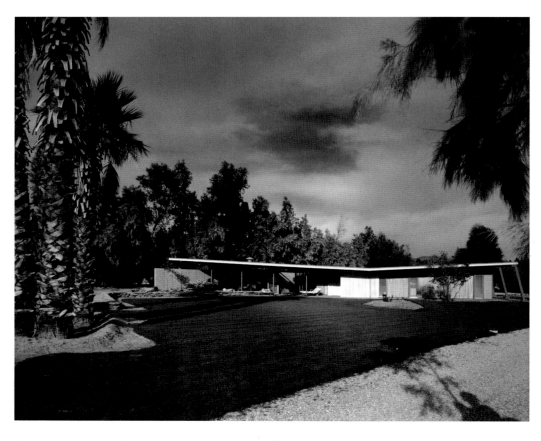

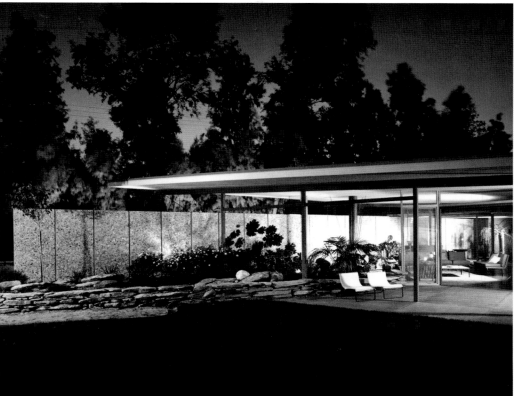

Stewart and Mari Williams House,
E. Stewart Williams, 1956. Photos: 1957.
Left, top: **Butterfly roof provides wide eaves for a year-round home in the desert.**
Left, bottom: **Glass walls and concrete panel partitions tie the living room to the garden.**
Below: **Living room.**
Opposite: **Garden spills into the living room. The divided frame marked by the vertical column showcases the flow between interior and exterior.**

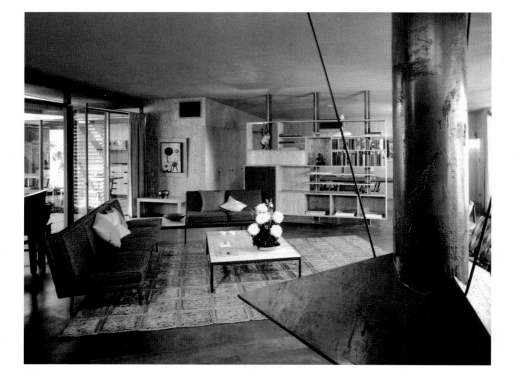

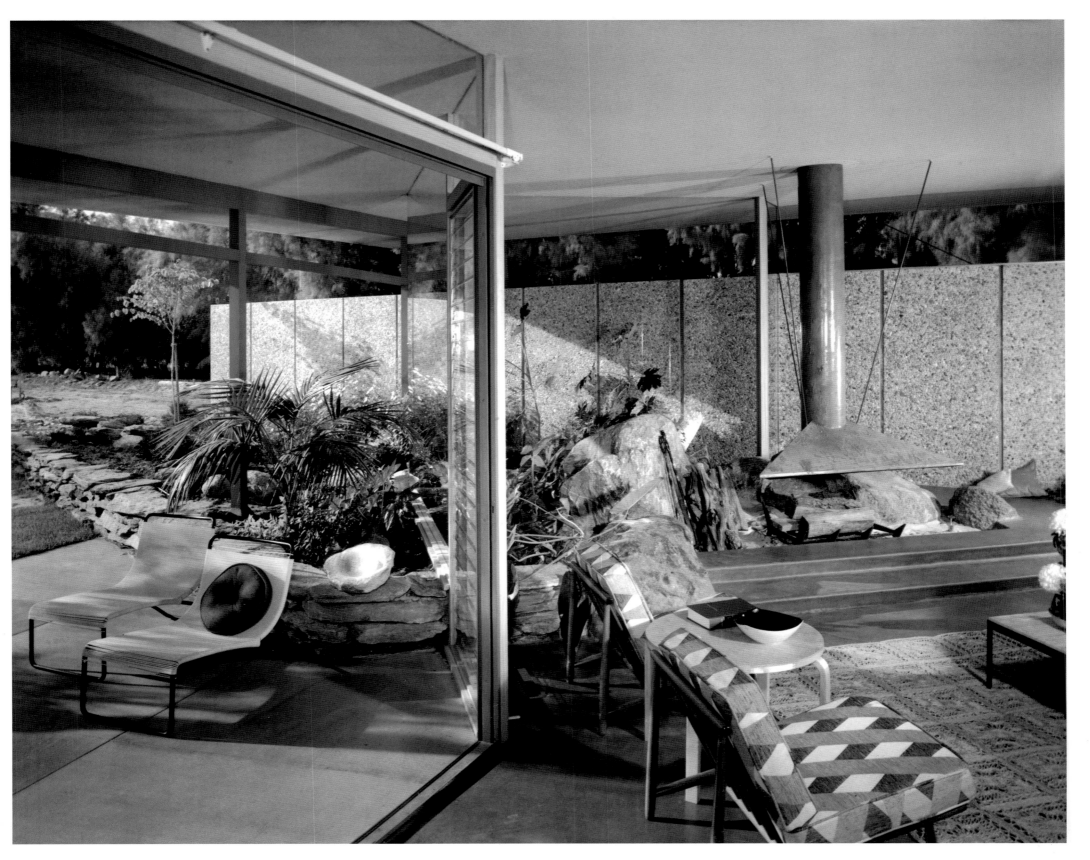

Harold Hicks Real Estate Office,
Williams, Williams & Williams, 1958.
Photos: 1958.
Right: Interior.
Opposite: Williams brought the same
modern design to commercial
projects like this as to his residential
designs.

Right: **Santa Fe Federal Savings and Loan, Williams, Williams & Williams, 1957.**
Photo: 1962.
Slender structural columns allow the glass walls to be set in far enough that the wide eave can shade them from the sun. Desert planting ties the building to the site.

Opposite: **Theodore Sutter House, E. Stewart Williams, 1960. Photo: 1961.**

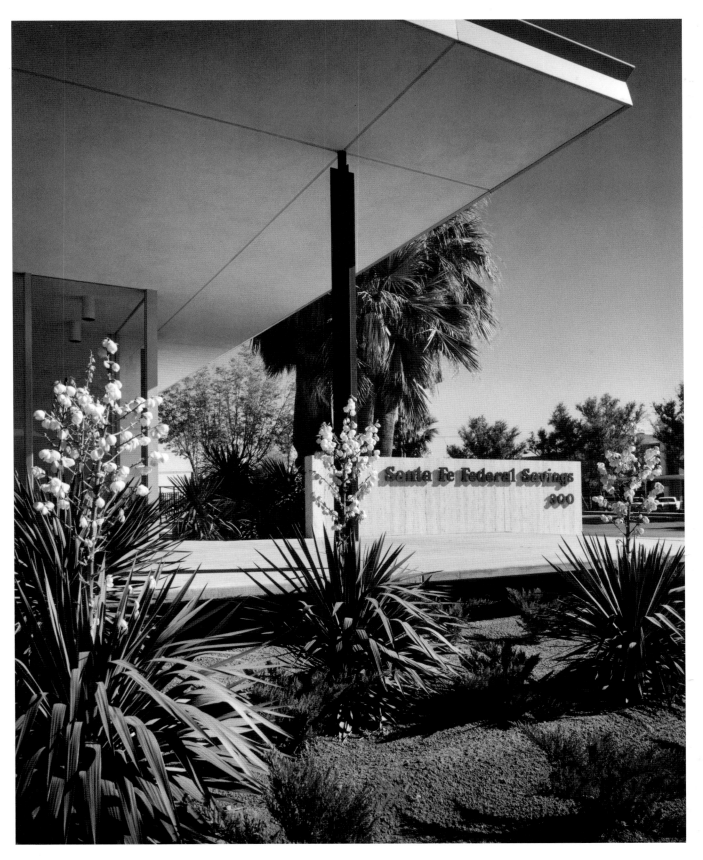

Santa Fe Federal Savings and Loan,
Williams, Williams & Williams, 1957. Photo: 1962.
Below: Interior.
Right: Sliding aluminum sunscreens shade the west side
of the building. Photographed at twilight, the interior
illumination of the building casts a vivid glow.

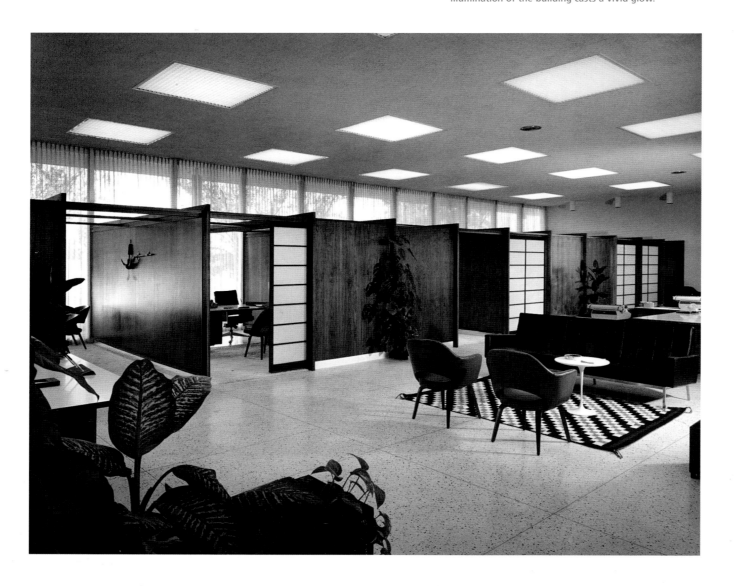

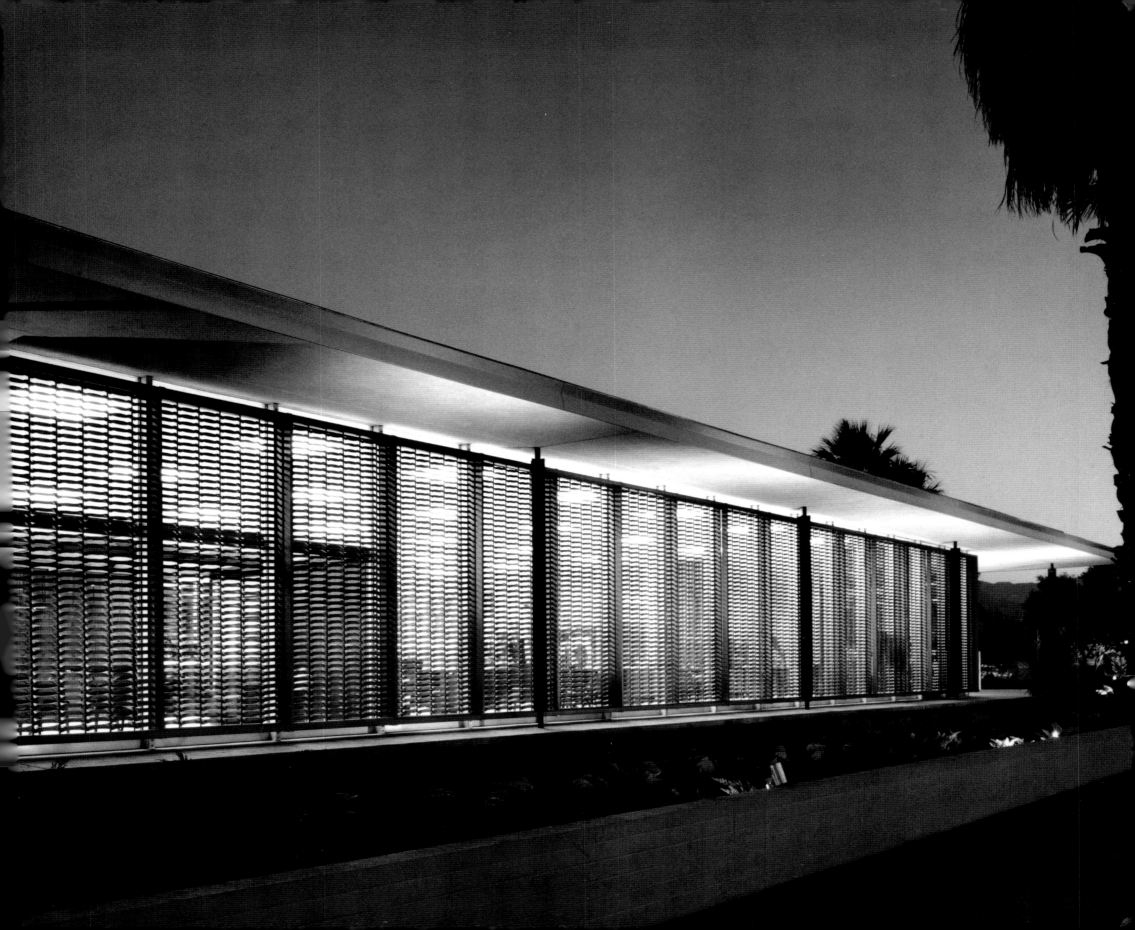

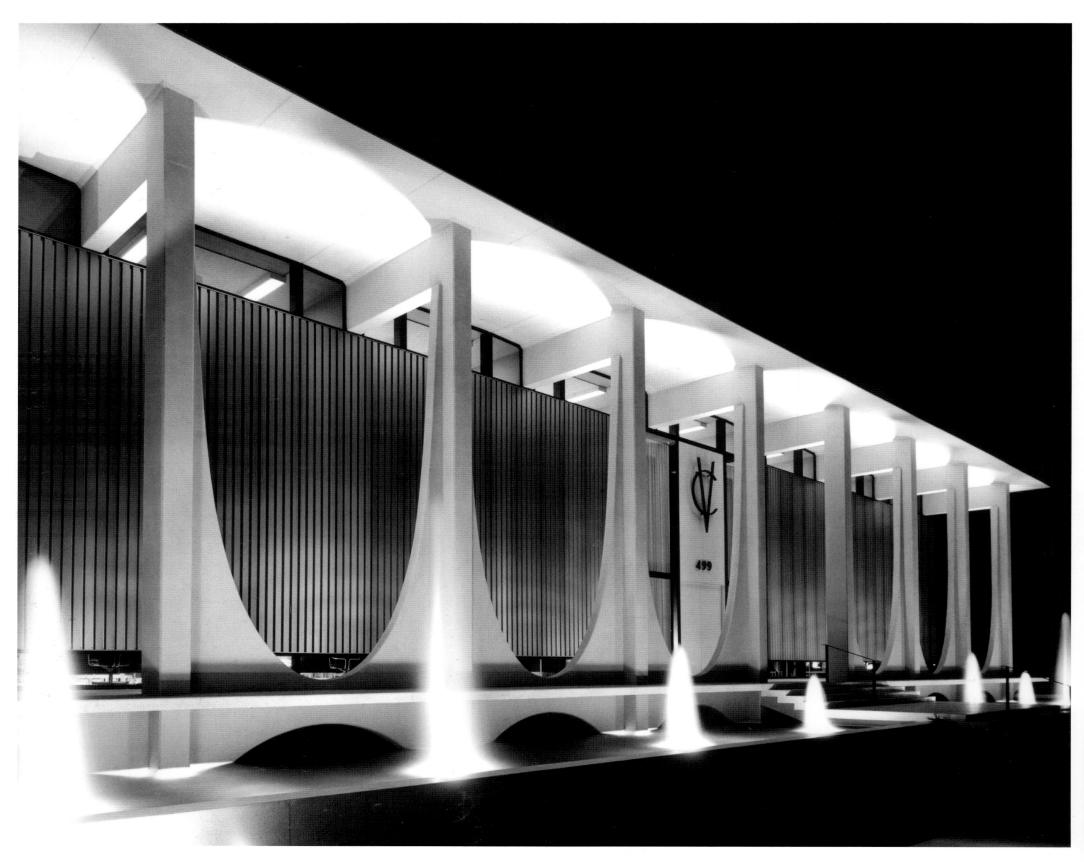

Coachella Valley Savings and Loan #2,
Williams, Williams & Williams, 1961.
Photos: 1963.
Below: **Banking room. Screen walls are
non-structural, allowing balanced light to enter
both from clerestories above and at floor level.**
Opposite: **Bold concrete structure allows the
two-story banking room to be entirely open.**

Palm Springs Tramway, Mountain Station,
Williams, Williams & Williams, 1964.
Photos: 1964.
Below and right: **Designed for winter and
summer climates, the mountain station
offered restaurants, lounges, and terraces.**

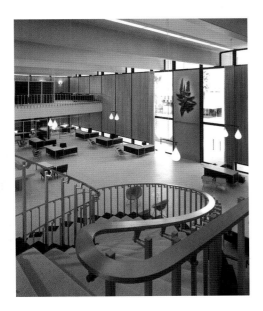

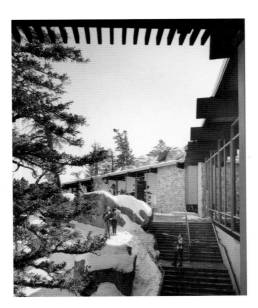

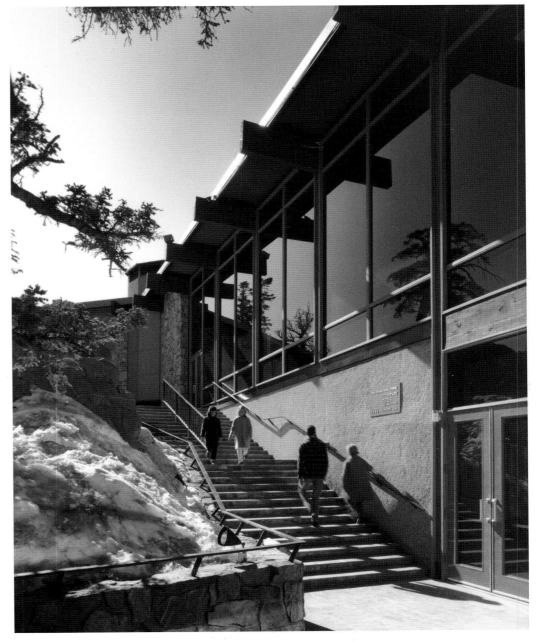

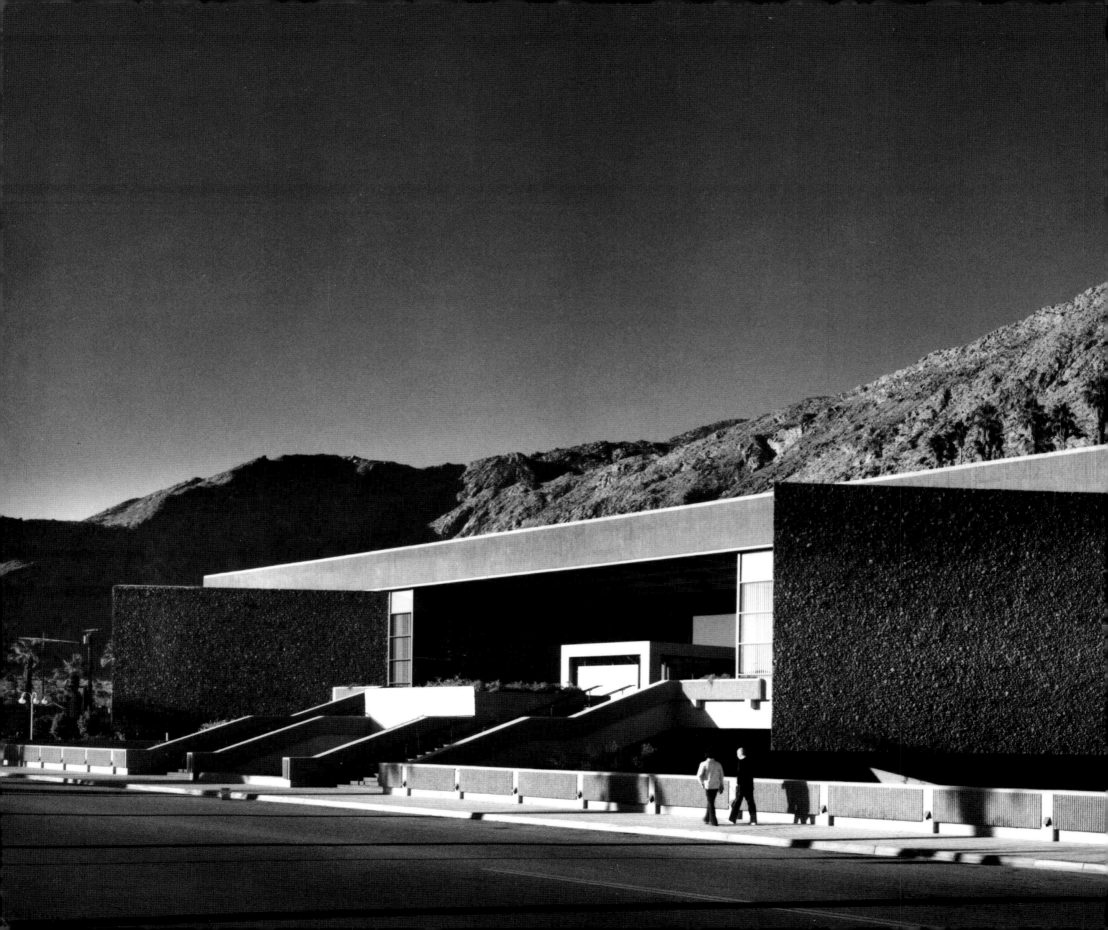

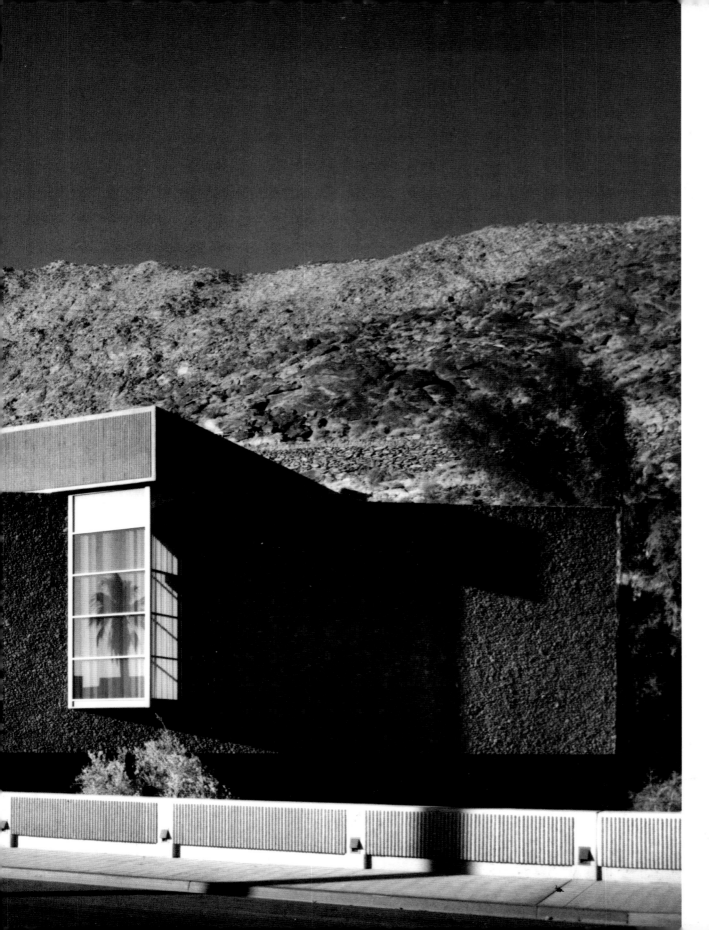

Palm Springs Desert Museum
E. Stewart Williams, 1976. Photos: 1976.
The lava rock of the exterior harmonizes
with its setting at the base of the
immediately adjacent mountains.

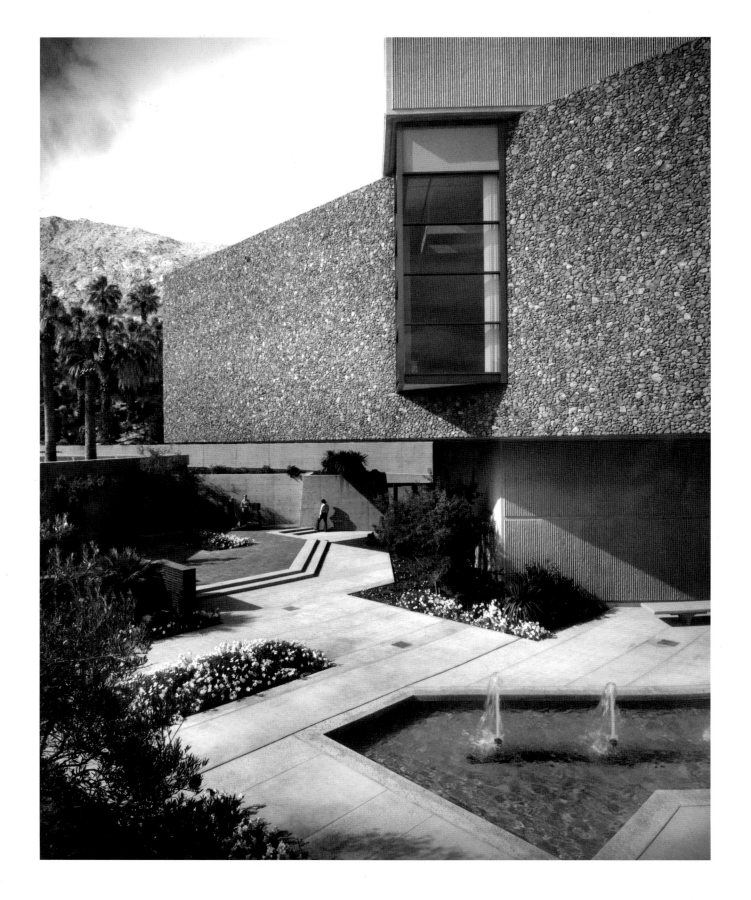

Palm Springs Desert Museum,
E. Stewart Williams, 1976.
Photos: 1976.
Left: Sunken gardens surround the
museum.
Opposite: Annenberg Theater is on
the lower level.

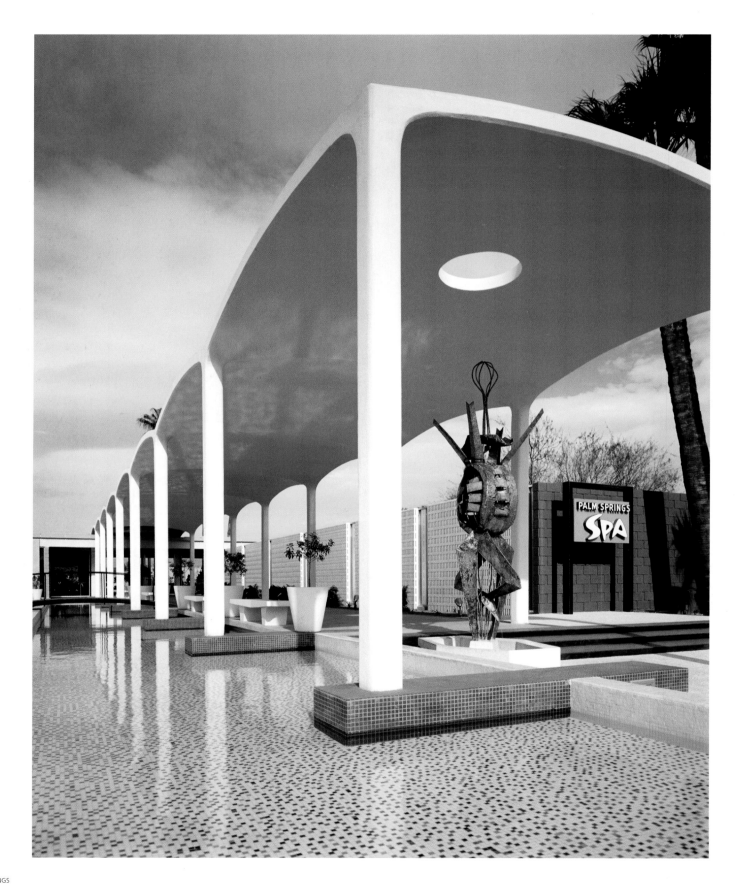

William Cody

At first William Cody resisted the wave of Modernism cresting in Los Angeles while he was in architecture school in the late 1930s. He was more in sympathy with the approach of his employer, Cliff May, whose sprawling, picturesque Ranch house designs fashioned living areas and patios with a keen eye for the comfort and pleasure of the residents.

Above: **William Cody.**
Opposite: **Spa Bathhouse, William Cody, Wexler and Harrison, and Philip Koenig, 1959. Photo: 1960.**

That changed. Cody soon became intrigued by the way Modernism could reduce a structure to an essential beauty. What sets his work apart, however, is that he never succumbed to the static simplicity of minimalist Modernism.

Cody (1916–1978) was a Midwesterner, born in Stewart Williams's hometown of Dayton, Ohio. His family had moved to Los Angeles in 1932. In 1946 he moved permanently to Palm Springs for his health (he left the Navy in 1942 because of his asthma), and by this time he was beginning to adopt Modernism's clean lines, which had already captured the attention of fellow students at the University of Southern California (USC) such as William Krisel. Though one early project was a handsome Spanish hacienda for actor Brian Aherne in Indio, Cody's unbuilt additions to Palm Springs's Desert Inn (he was then their staff architect) abstracted both the forms and the details of the Spanish style.

His first notable building in Palm Springs was a brash experiment in Organic design for the Hotel Del Marcos (1947), influenced by the desert architecture of Frank Lloyd Wright. From the street great tilting walls of desert stone rose like enormous rock buttresses anchoring the small inn to the ground. Non-rectilinear angles would reappear in some of his

greatest designs, including The Springs restaurant (1956) and L'Horizon Hotel (1952). Behind the rockwork of the del Marcos, a redwood structure formed three sides of the courtyard with the swimming pool. The careful arrangement of the stones' pattern creates a jaunty graphic pattern that would always be seen in Cody's freehand drawings.

This design's originality shows one of Cody's strengths: even when he did become a committed Modernist, he was fearless about following his own design sense. Modernists who insisted on theoretical conformity left him unimpressed; the experimental side of these new ideas inspired him.

L'Horizon is an example of his creative independence. Slender steel frames support wafer-thin flat roofs for this collection of bungalows set on a grassy carpet around a pool. Transparent glass, natural wood, and tactile slump block walls fill in the structure. But he warps each building to an 80- and 150-degree bias. This is far from the boxy, right-angle clichés of conventional Modernism; the angles create dynamic structures, making each interior space expansive and shaping courtyards between the bungalows. Their vibrant energy is in perfect tune with the Modern lifestyle. At The Springs, a roadside coffee shop in Palm Springs, Cody designed a plan of splayed angles and rhomboids—no two lines were parallel—that translated into functional but exciting three-dimensional spaces for a brilliant piece of roadside commercial architecture. His USC friend (and best man at his wedding) Eldon Davis had helped to define the Googie style of roadside building —Modern, popular, Organic—in Los Angeles, but Cody designed its greatest example. Few other Modernists—and fewer still who are well known— dared to explore such geometries.

Besides his architectural skills, Bill Cody had a talent for attracting good clients. This was a side of the job he loved; it meant mixing work and play.

Dozens of photos published in the local papers show him rubbing shoulders with bandleaders Phil Harris and Desi Arnaz, actress Alice Faye, power tool magnate Robert McCulloch, producer and hotelier Jack Wrather, and oil man George Cameron Jr., at Tamarisk, Eldorado, or Thunderbird country clubs—all of which he designed. But unlike most society architects Cody also showed a deep passion for creative, original, and superbly executed design that matched his exuberance for life.

The Spa Bathhouse (1959), designed in conjunction with Donald Wexler and Richard Harrison, and Philip Koenig, displays the elegant yet animated character of Cody's architecture. Set in the middle of Palm Springs, the Spa and the Spa Hotel that was added in 1962 were on the site of the original hot springs that drew Native Americans and then Yankees to Palm Springs. In the collaborative design process on the bathhouse, its distinctive concrete-domed arcade lead visitors diagonally to the bathhouse. Cody was responsible for the original hotel's three-story building. A flat-roofed rectangular block, it is instantly recognizable as mainstream Modern for 1962. But Cody's rhythmic, syncopated arrangement of the room units' repeated windows across the facade introduces a unique character to the design. The porte-cochere's canopy tapers ever so slightly from bay to bay, demonstrating how he honed a specific architectural element to bring out its structural nature and its graphic potential.

Cody's several country club designs combined quiet sophistication with ebullience. Eldorado Country Club (1958), designed with San Francisco architect Ernest Kump, was the poshest in the Palm Springs area, the course where Dwight Eisenhower stayed and played. It is a design of almost Miesian calm. A square concrete frame, raised and cantilevered over a pond, is surrounded by a wide porch looking out over the fairways. The building

floats lightly. Contrasting with this chaste exterior, the interiors were lively, colorful, and modern. A porte-cochere lead to a courtyard with a splashing fountain; colorful Cody-designed chandeliers hang in the lounge and dining room. Each is a different shape, creating an amusing assemblage comparable to the work of Alexander Girard or Charles and Ray Eames in the same period. The frame may be severe, but what fills it is high-spirited and animated—the ingredients of a great Cody party.

Though centered in Palm Springs, Cody also built elsewhere, including Houston, Phoenix, the San Francisco Bay Area, San Diego, and Havana; his vacationing Palm Springs clients often asked him to build in their home cities. Like other Palm Springs architects, he designed a full range of types, including churches, gas stations, condominiums, shopping centers, restaurants, libraries, as well as custom homes. He also explored a full range of styles, from the slight steel frame of his own house (1947) to the baroque concrete curves of St. Theresa's Church (1968).

If Cody could design with exuberance, he could also design some of the most clear-eyed and exquisitely controlled buildings. His custom home designs for clients tended to be quieter and more peaceful than his public designs, though never dull. He never lost the sensitivity to space, proportions, and ease that he had learned from Cliff May.

The wood frame Perlberg House (1952) is a collection of loosely-related volumes, with a slightly sloped roof settled lightly on top of them. The plan is casually arranged, turning its back on the street and opening its glass walls to the garden and views. It is not important for all the corners to be neatly tucked beneath the roof. Like Frey's houses, the thin dimensions make it appear a lightweight, almost temporary structure that sits gently on the earth.

At another country club home, the Cannon House (1961), the larger elements of the structure define the spaces: the broad sweep of the wood-plank ceiling, the solid stone fireplace wall, the Mexican-tile floor, the enclosing plane of glass. The ceiling reads as a single, uninterrupted free-hanging plane from inside to out; the supporting columns never penetrate it or blend into it, but simply sit next to its outer edge. Their mechanical connection is hidden, though expressed as an abstraction.

The J. B. Shamel House (1962) sets up a slender structural frame over its site, and then intertwines its indoor and outdoor spaces—another novel answer to the Modern goal of blending nature and human habitation. When the floor-to-ceiling sliding doors are thrown open, the entire house becomes a garden landscape. Frameless glass windows in the kitchen rise from the counters and disappear neatly into the ceiling. The cleanness of these details testifies to Cody's hard work, but the significance of this effort lies in the resulting space: when the room's outer wall virtually disappears, the edge of the space lies somewhere outside, at either the thin columns a few feet out, or at the rampart of mountains that form the distant view.

In the Shamel House as in his own house, Cody uses a fairly regular modular grid, but he treats them like a grouping of tents set one next to another; the spaces defined by each are specific and interrelated. Some are left open to the sky, some skylit, some landscaped to give a rich intermixing of spaces and pathways. Rather than creating large undifferentiated spaces, he creates a choreography of space.

Cody knew the rules of Modernism but did not feel constrained by them. The bench seating by designer Arthur Elrod in the lounge at Eldorado Country Club is not Miesian; their sides bulge out slightly, adding a note of contained power. The fireplace of the Shamel House is not a cubic volume, but a diamond shape, subtly pushing into the room's volume. He rarely misses an opportunity to inject his designs with energy. And when he chose to let loose architecturally, as at L'Horizon and The Springs, with wildly splayed angles, he does it with tremendous discipline. Each piece is humming with energy, but each is in exactly the right place to create the overall space and architecture. His was an astonishing talent. •

Opposite: **Hotel Del Marcos, William Cody, 1947. Photo: 1949.**

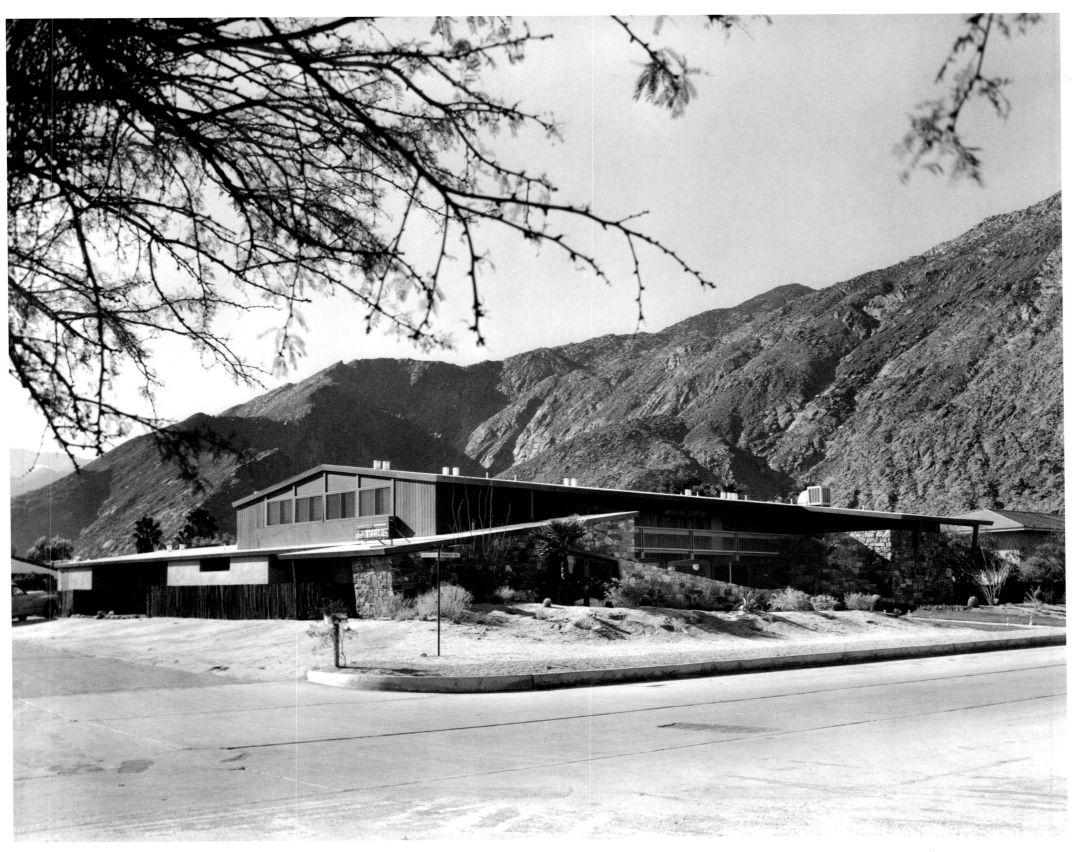

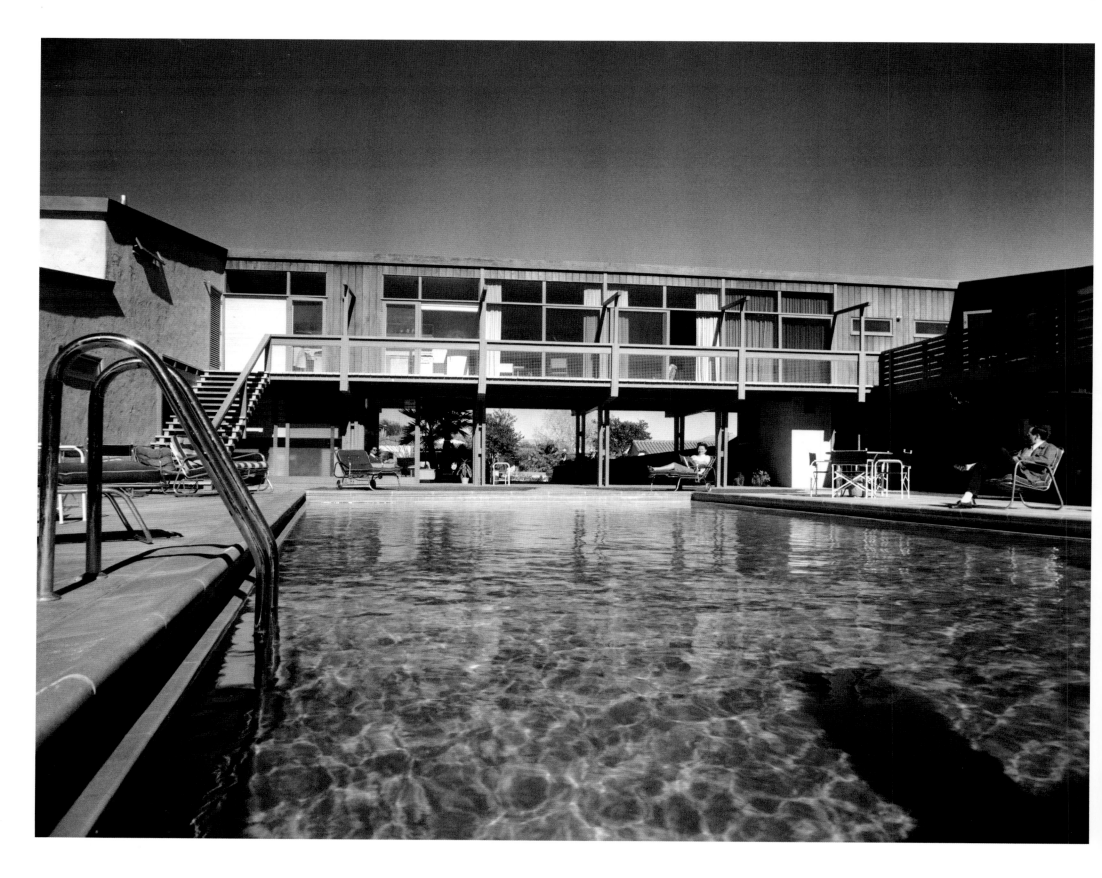

Hotel Del Marcos,
William Cody, 1947. Photos: 1949.
Below left: **Room entry.**
Below right: **Room interior. Angled desert stone walls
tie the redwood structure to the desert surroundings.**
Opposite: **Pool courtyard.**

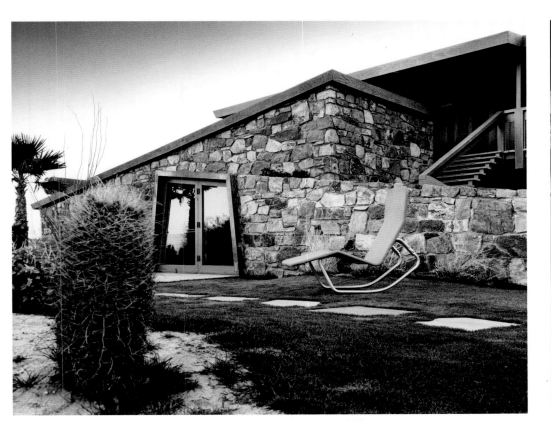

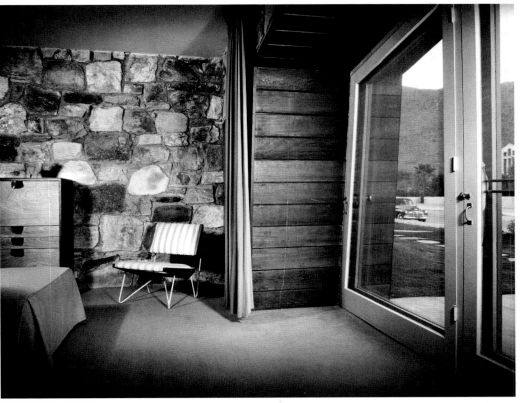

Perlberg House,
William Cody, 1952. Photos: 1952.
Right: **Pool and landscaping introduce free-form lines.**
Opposite: **Roof planes are laid at casual angles over the structure.**

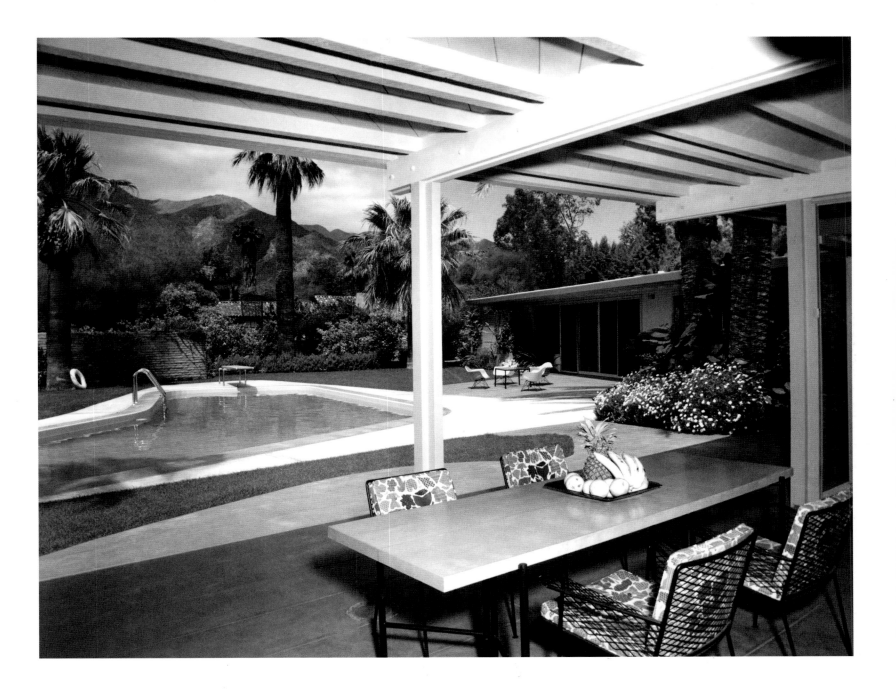

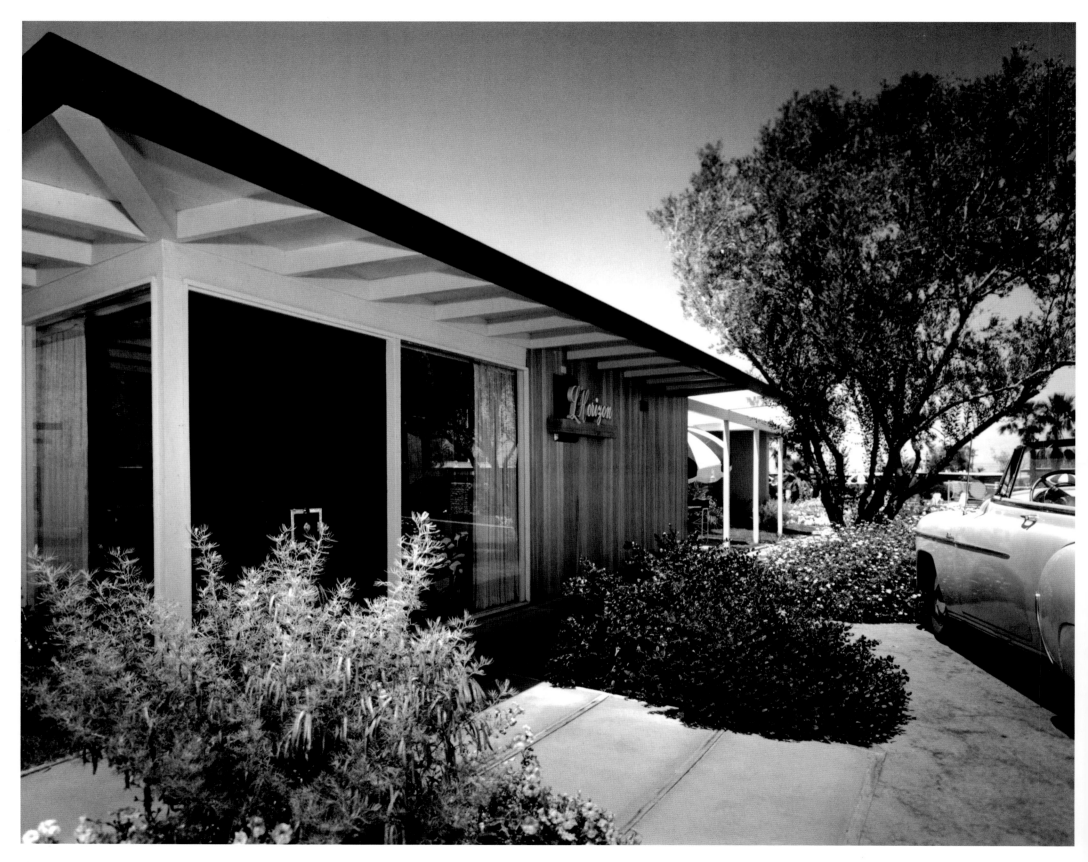

L'Horizon Hotel,
William Cody, 1952. Photos: 1954.
Right: **Rooms were situated to give**
each a semi-private patio.
Opposite: **Acute angles bring a**
dynamic energy to this design.

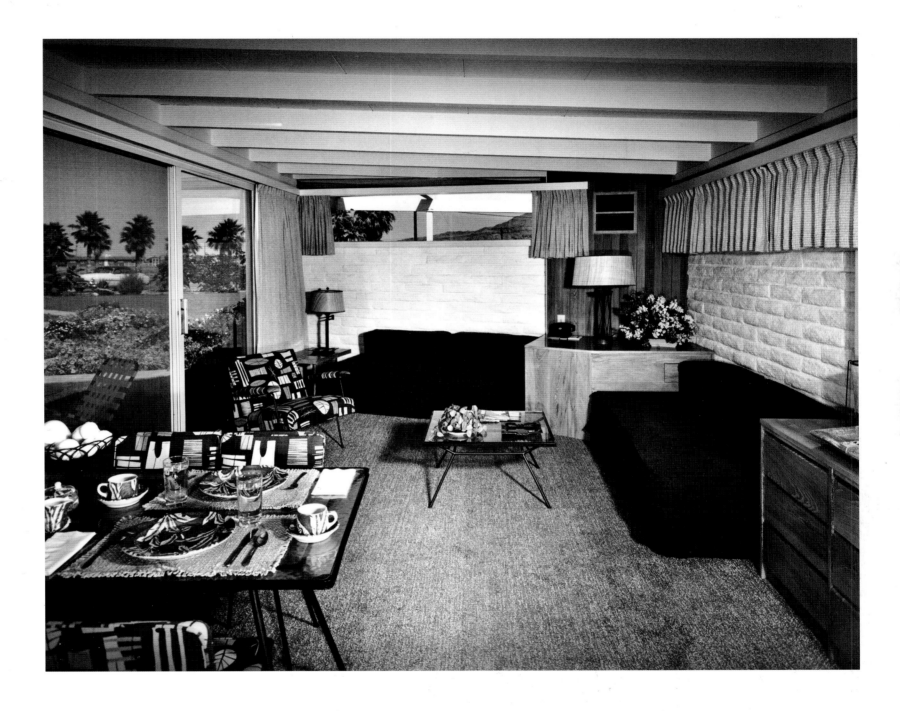

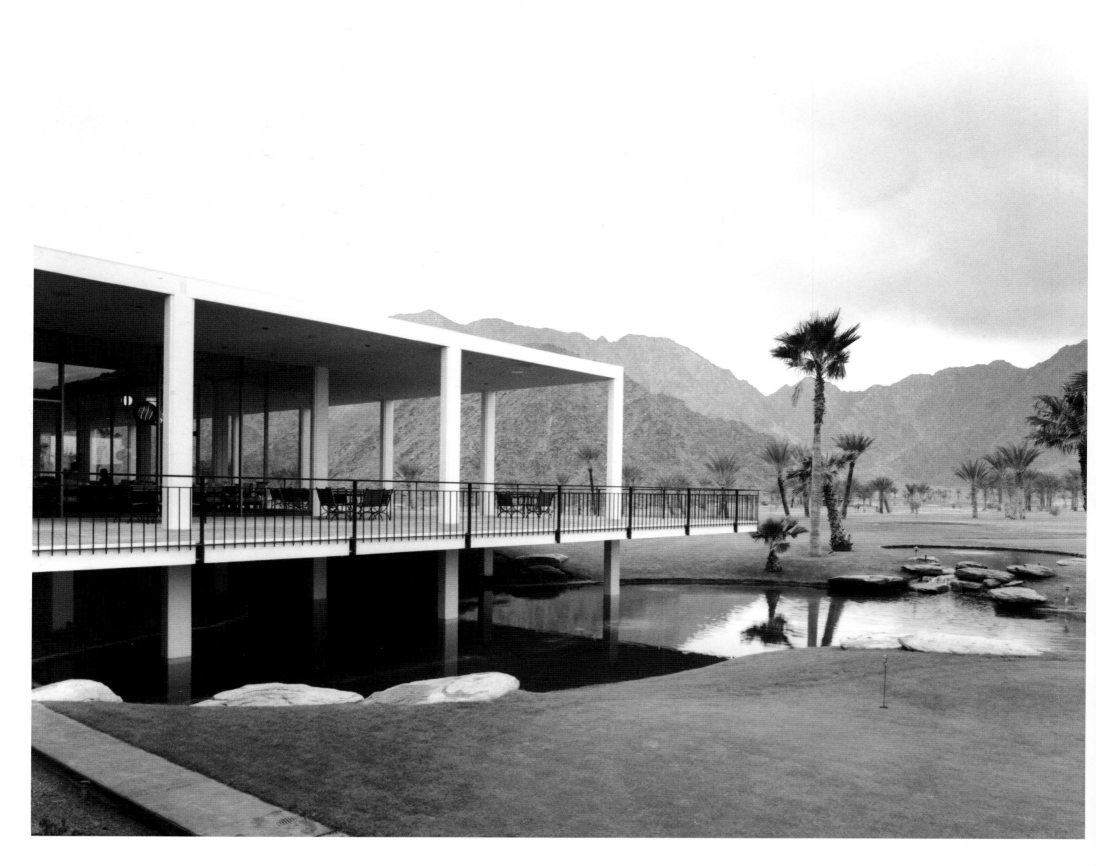

Eldorado Country Club,
**William Cody and Ernest Kump,
1958. Photos: 1960.**
Right: **A wide porch shelters the
dining room from the sun.**
Opposite: **The simple concrete
structure appears to float above
the landscape.**

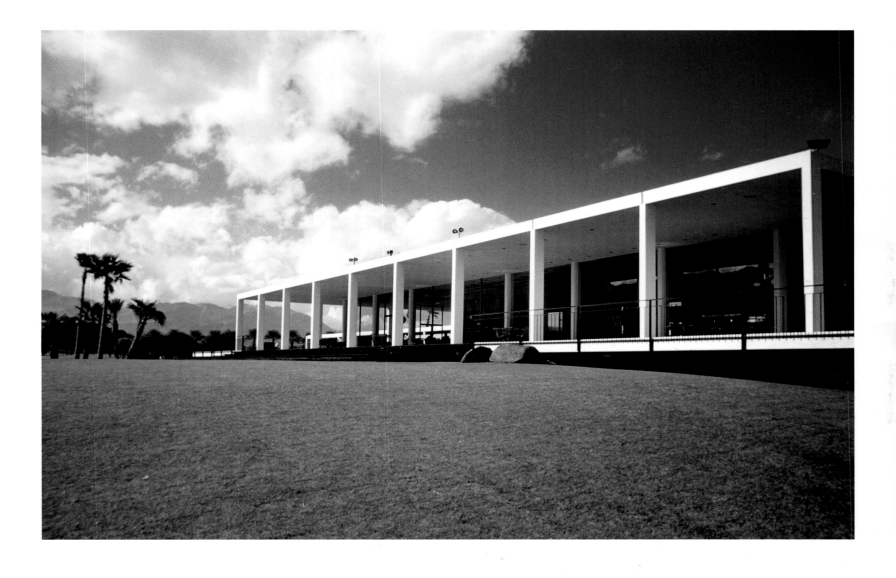

Eldorado Country Club,
William Cody and Ernest Kump, 1958. Photos: 1960.
Below left: **Bar. Colorful, even fanciful interior designs by
Cody contrasted with the structure's clean simplicity.**
Below right: **Entry.**

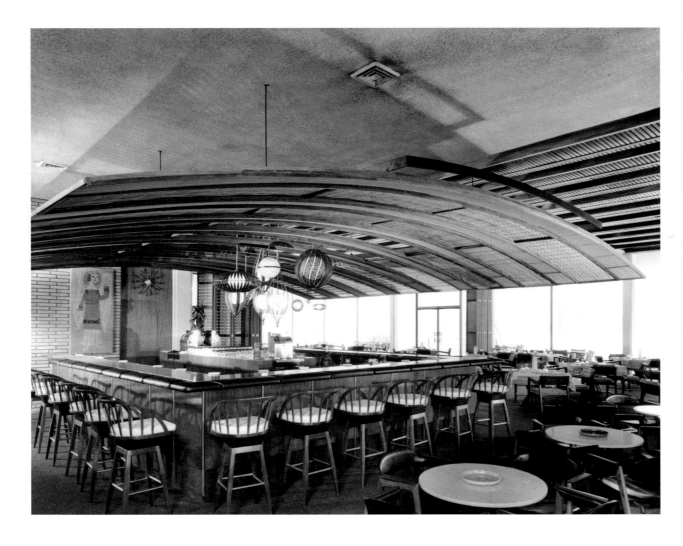

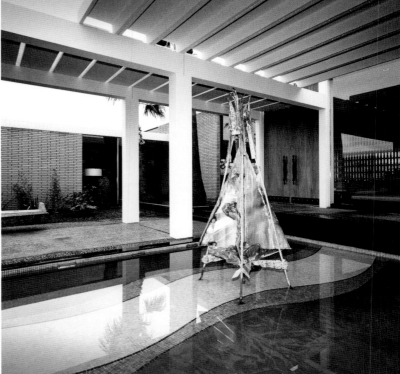

Below left: **Men's locker room.**

Below right: **Entry to men's locker room.**

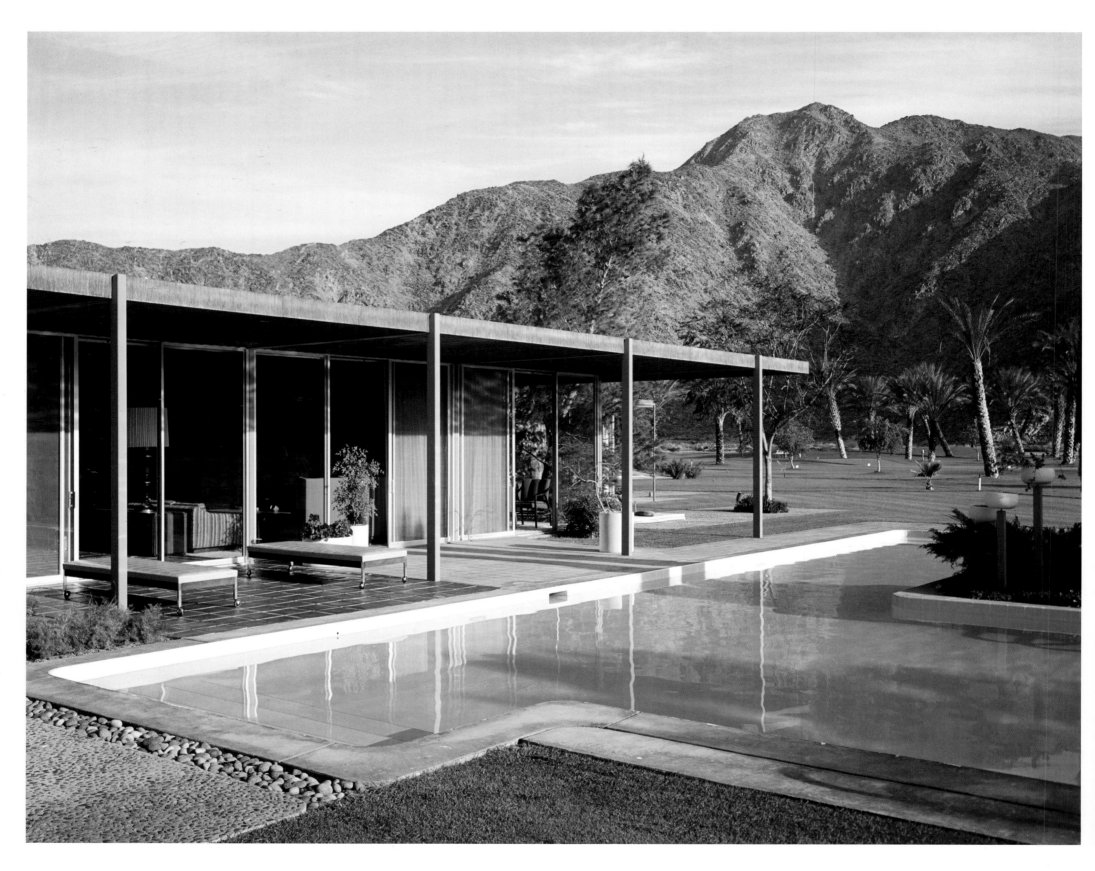

Robert Cannon House,
William Cody, 1961. Photos: 1963.
Right: Shulman's use of infrared film caused the sky to darken, haze to minimize and foliage to lighten significantly, creating a high-contrast rendering of the architectural setting.
Opposite: Manicured country club site is strikingly different than the boulder-strewn site of Neutra's Kaufmann House or Frey's Loewy House.

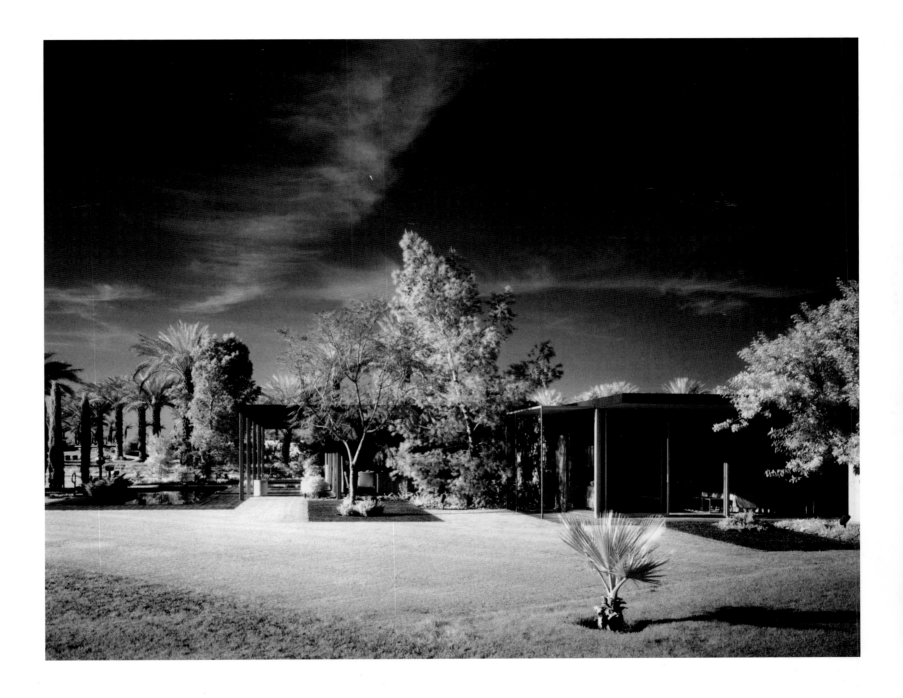

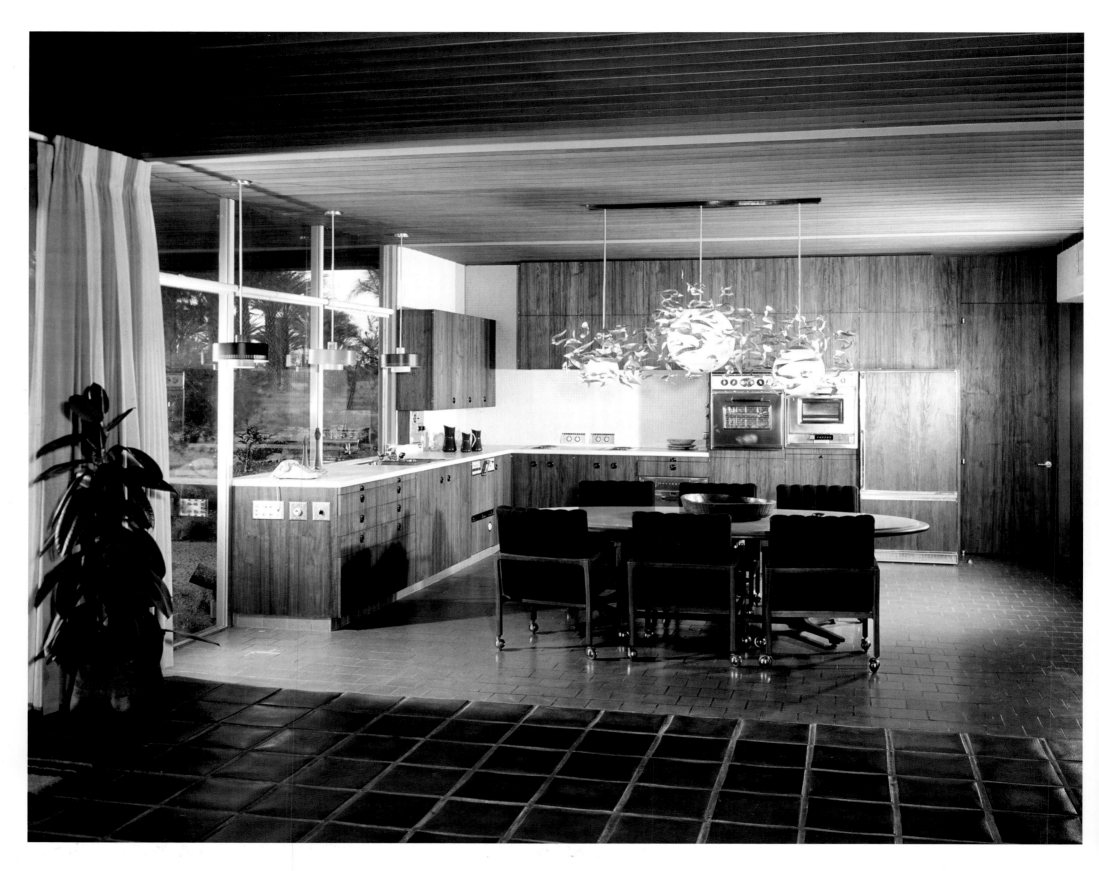

Robert Cannon House,
William Cody, 1961. Photos: 1963.
Below: **Living room.**
Right: **Pool terrace from living room.**
Cody's lithe, minimal wall almost
dissolves the barrier to the outside
pool and golf course.
Opposite: **Kitchen.**

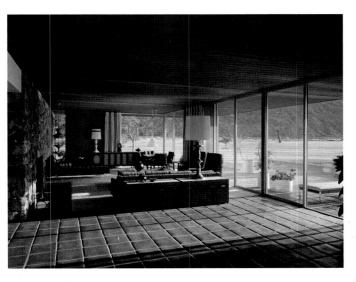

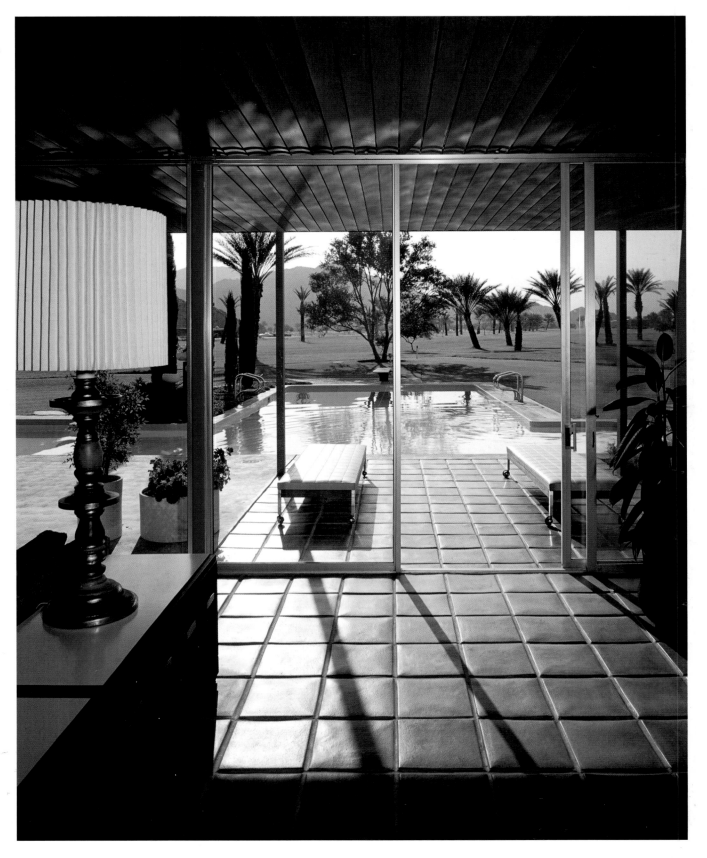

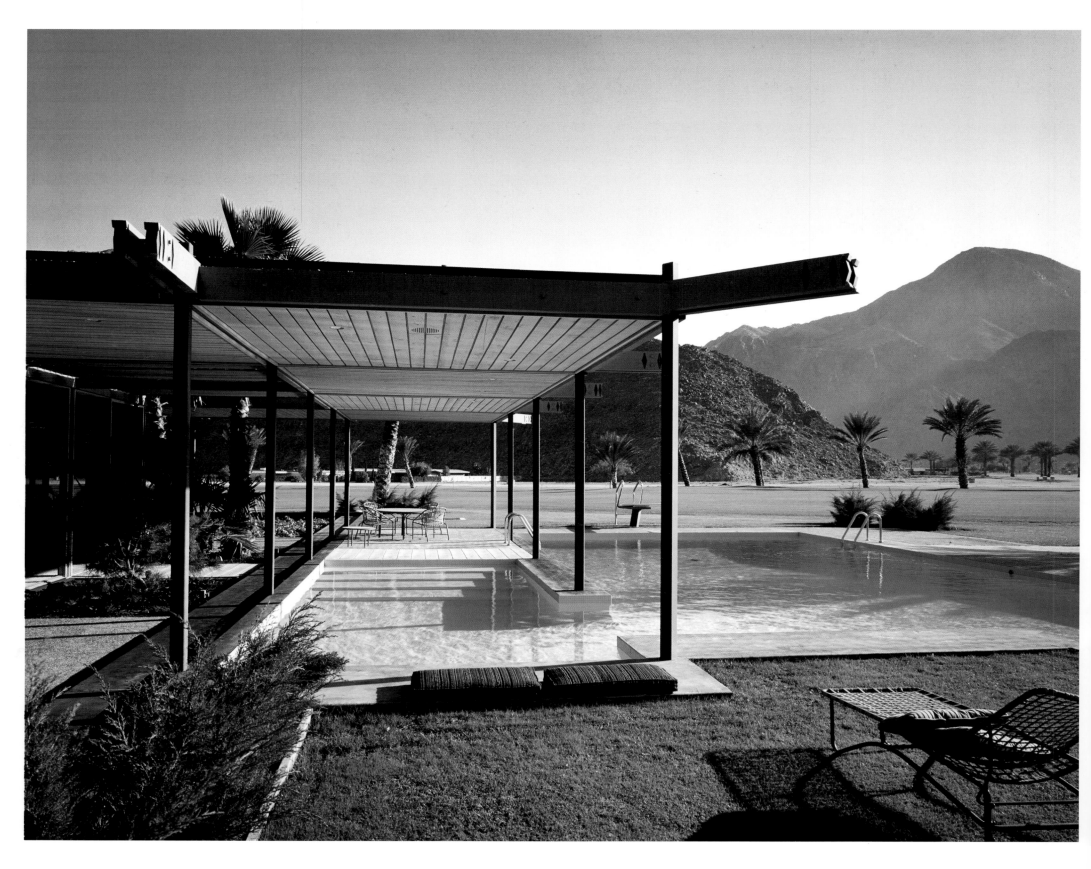

J. B. Shamel House,
William Cody, 1962. Photos: 1964.
Right: **Entry terrace. The opacity of
the entry belies the open
transparency of the other elevations.**
Opposite: **The simple structural bays
form a canopy over a complex
interwoven plan that draws pool and
garden into the home's spaces.**

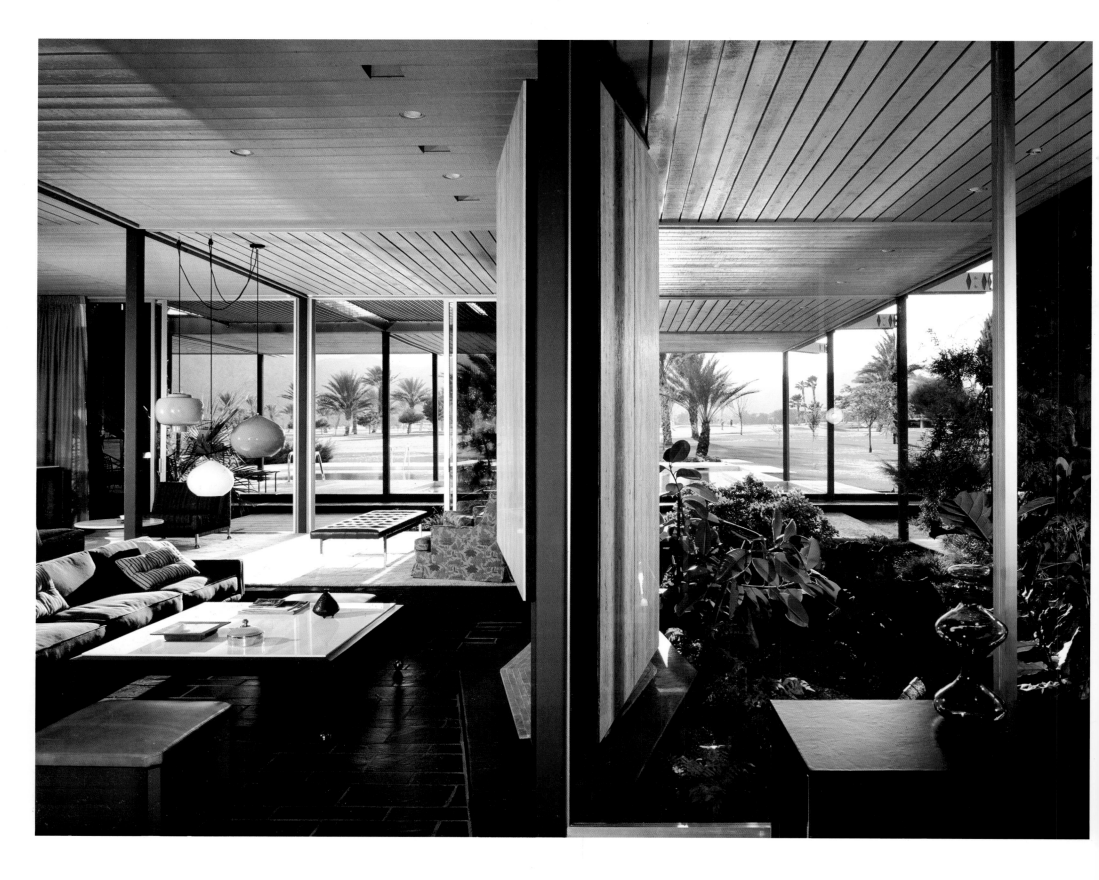

J. B. Shamel House,
William Cody, 1962. Photos: 1964.
Below left: **Kitchen and dining area.**
Below right: **View from dining area shows how varied
roof planes and the regular structural bays blur the
line between indoors and out.**
Opposite: **Living room and garden. Note the strikingly
shallow fireplace to the left of the dividing wall.**

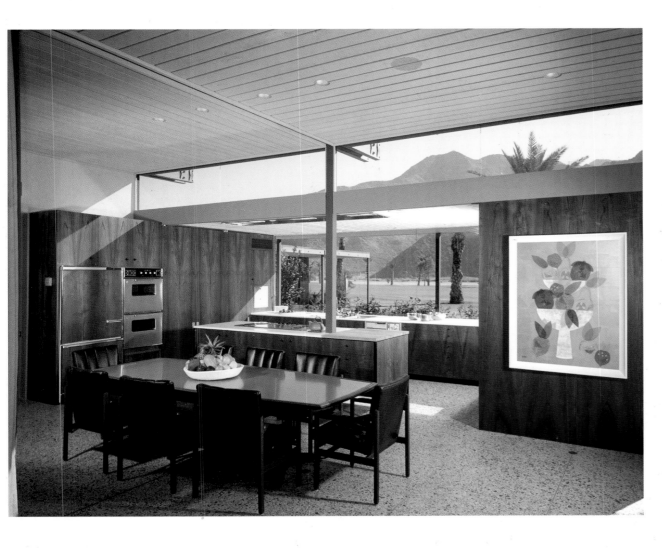

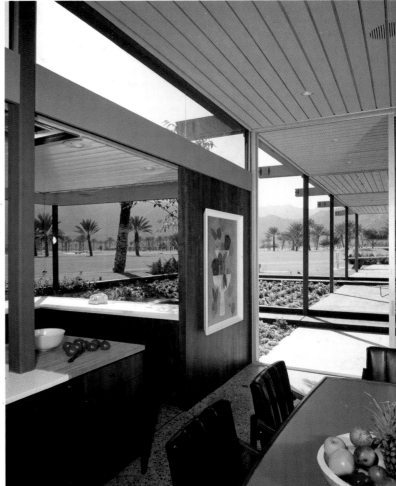

J. B. Shamel House,
William Cody, 1962. Photos: 1964.
Below left: Though the structure is trimmed to a minimum, complex relationships of spaces and patterns of materials bring richness to Cody's designs.
Below right: Terrace and living room.
Opposite: Frameless glass eliminates the line between indoors and out.

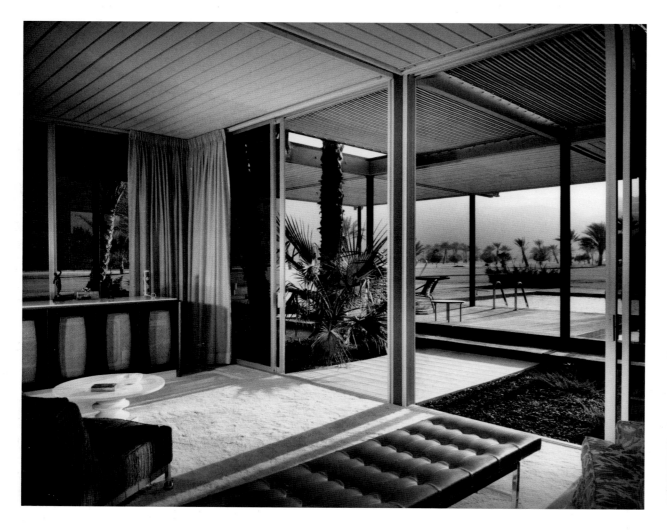

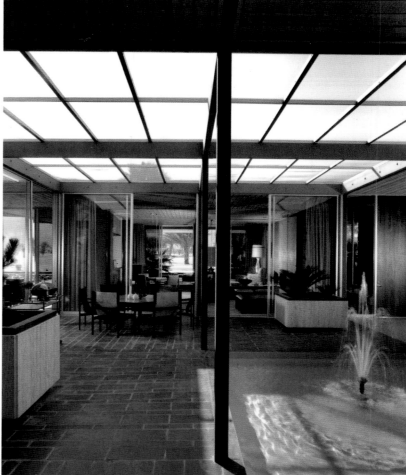

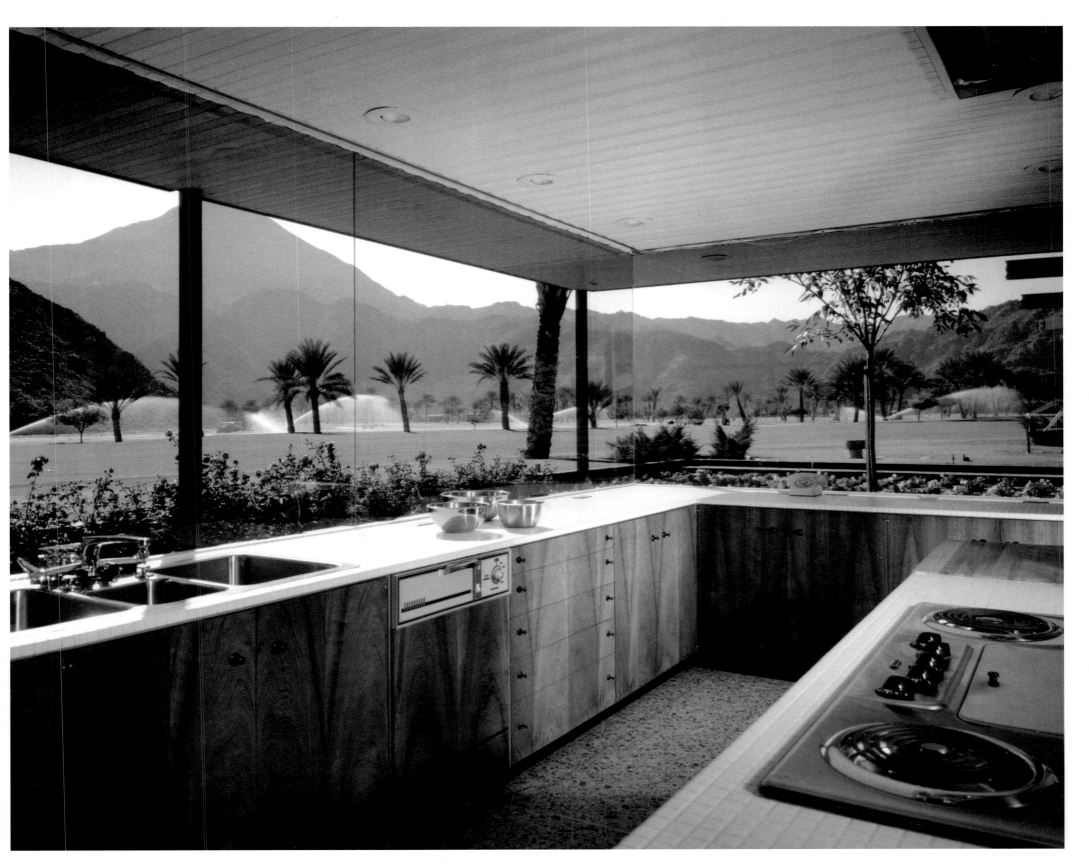

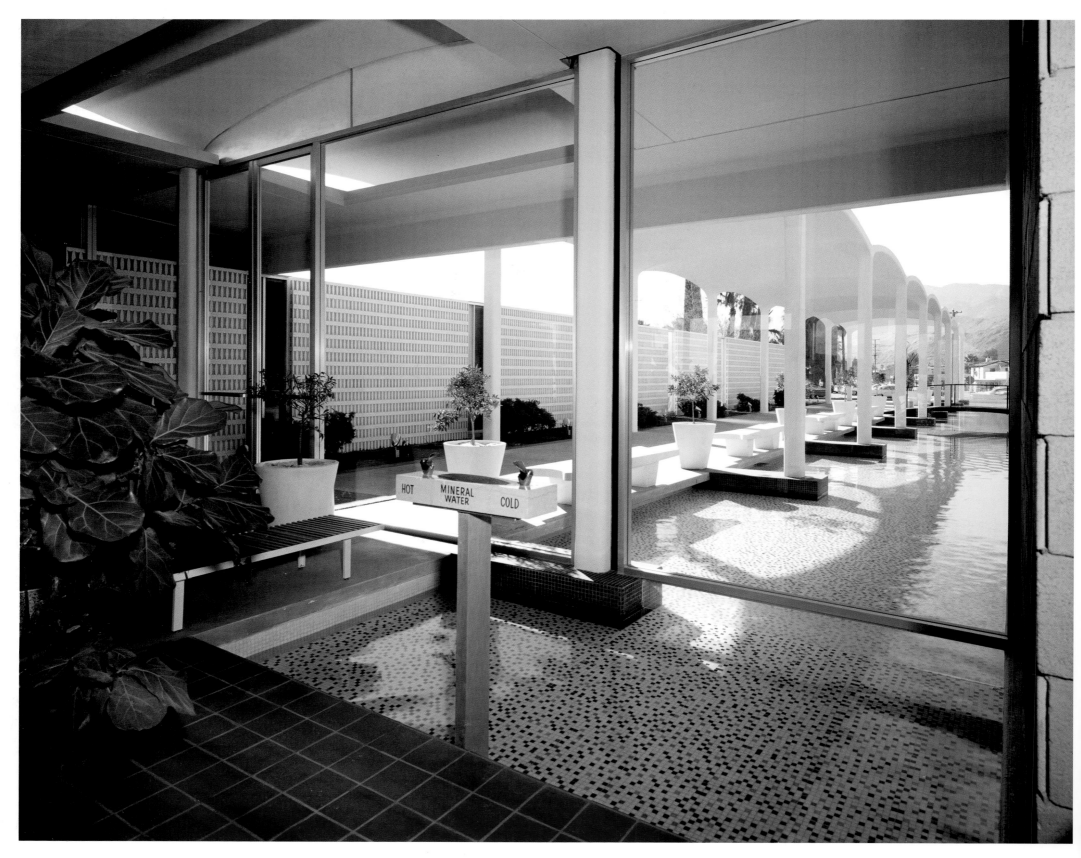

Below and right: **Spa Hotel,**
William Cody, 1962. Photo: 1963.

Opposite: **Spa Bathhouse,**
William Cody, Wexler and Harrison,
and Philip Koenig, 1959. Photo: 1960.

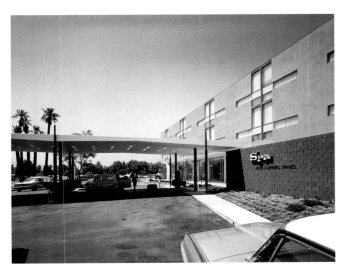

Donald Wexler

No one could have predicted Don Wexler's arrival in Palm Springs, let alone the uncommon range of opportunities the small community would offer the Minneapolis native. They included movie-star houses, an airport, mass-produced steel houses, luxury spas, and schools. The variety of projects is remarkable in itself; Wexler's equally inventive and masterful solution to each one is even more notable.

Above: Donald Wexler.
Opposite: Wexler House, Donald Wexler, 1955. Photo: 2005.

This serendipitous journey began when Wexler (b. 1926), recently graduated from the architecture school of the University of Minnesota, traveled to Los Angeles on a short trip in June 1950. He wanted to meet his architectural hero, Richard Neutra; in school Neutra's relish for new building technologies in elegant designs captivated Wexler. Looking for an excuse to meet the great architect, Wexler pretended to be seeking a job. In reality he intended to return to Minneapolis and work with his brother, a builder. Neutra derailed that plan by actually offering Wexler a job. His plans—and his entire life—changed. He accepted the job with Neutra and Robert Alexander, working on high-rise housing for the Chavez Ravine project. Two years later he moved to Palm Springs to work with William Cody on the Tamarisk Country Club project; despite expecting to stay only for the winter, he remained, and later set up his own office with Richard Harrison in 1953, a partnership that lasted ten years.

Like Frey, Stewart Williams, and Cody, Wexler designed nearly every kind of building a small community called for (houses, offices, schools, civic buildings, hotels), and then some. He is the type of architect who is an engineer at heart. He loves the technical challenges of figuring out an interesting problem in a practical and elegant manner. It could be the plan of a house, or the most efficient sequence of a prefabricated construction system, or the intricate choreography of an airport. So it was naturally intriguing to him when he learned of a prefabricated steel school building made by civil engineer Bernard Perlin for Calcor, a steel company. Wexler developed the steel structural system, and built several buildings using this system in Palm Springs. Another unexpected turn came when U.S. Steel learned of the system and asked Wexler and Perlin to investigate all-steel houses.

This was the mid-twentieth century, a time when technological solutions promised to solve all of society's problems, including decent housing. Steel homes, plastic houses, modular homes, prefabricated kit homes, A-frame homes—the solutions piled up, answering more questions than anyone had asked. For Wexler, the task of creating a workable, efficient steel prefabricated system for schools and then houses was what architecture was all about: problem solving in an elegant and practical manner.

Wexler brings another dimension to his work: an understated but assured sense of aesthetics. His buildings have a humane sense of space, a refined sense of proportion, a sureness about details that reflect the hand of an excellent architect. His buildings do not share the expressionist energy of Lautner's Elrod House, but he also has a sense of drama in a flaring, zigzagging roofline of a house, or the swept back lines of an airport roof.

This dimension is seen in both Wexler's own 1955 wood post-and-beam house for his family (a custom design) and in his steel houses for the Alexander Company (a complex modular prefabricated system for the mass market). In 1954 he had just set up his own office with partner Rick Harrison, and his wife was expecting their first child. A quickly built, air-conditioned house was a necessity.

The wood post-and-beam design shows as much expertise as any of the Case Study Houses published by *Arts + Architecture* editor John Entenza in the same period. One wing is the living room, walled in glass on two sides, looking out to the garden and pool. A carefully polished detail uses twin two-by-twelve-inch boards for the cross beams; this left a space in which to run hidden wiring. The L-shaped house allowed easy and seamless expansion as the Wexler family grew.

The same attention to the arrangement of forms and to the nature of details is seen in two much larger custom homes, one for Dinah Shore in Palm Springs, and one called the "Style in Steel" House, a version of the steel fabrication system Perlin and Wexler developed for U.S. Steel, in Buena Park, California. Spacious lots and budgets made structural efficiency less pressing, but there is still no sense of extravagance or ostentation.

For the Dinah Shore House (1963), the rectilinear wings of the house are arranged to create a spacious entry court, well landscaped with steps and planting beds leading to a long modernist colonnade. The beams jut out past the roofline, resting on freestanding steel columns. Inside, the structure is also used for aesthetic effect. The columns and beams create a regular framework among masonry walls for the finely finished stone, wood, glass, and terrazzo surfaces. These are classic representatives of Mid-Century Modern design.

But as beautiful as these houses are, even more intriguing as architecture are Wexler's designs for the prefabricated steel tract homes for the Alexander Company. They share the same sense of fine proportions, flowing spaces, and balanced light as the Shore and "Style in Steel" houses. They show off their structure to good effect. But they also had to be economically manufactured. Their integral prefabricated systems (panel walls, kitchen,

bathroom, air conditioning, plumbing) had to be honed and perfected to meet the requirements of a factory assembly line, and to be easily trucked to a distant site—and still create good spaces and homes.

This was the kind of problem Wexler enjoyed. He fashioned a house with metal panels that could fit into the regular module of the efficient steel frame. A concrete slab was poured on the site, and then the prefabricated pieces could be erected in a few days. Each step of construction had to be predetermined to avoid snags—and make well-proportioned spaces and beautiful homes.

Marketing requirements had to be figured into the design as well. To avoid a monotonous cookie-cutter appearance when each house was lined up along the street, the houses were given individual rooflines: a flat roof here, a raised roof with clerestory windows there, and a zigzag roof for added flair. The seven models built show the success of the design and the system; only a buyout by Rheem Corporation left the project in limbo when steel prices were raised.

The Alexanders found that steel was no longer competitive with wood construction.

Wexler's public buildings show the same understated panache and thoughtful design. In collaboration with William Cody and Philip Koenig, Wexler and Harrison contributed to the Spa Bathhouse (1959), a luxury facility on the site of the town's original hot springs. The striking entry arcade is a great and original piece of Modern design: as an architectural form the colonnade is ancient, but re-imagined here as a lithe construct of pre-cast concrete domes raised on steel columns encased in concrete. With a sense of drama it is placed at an angle, to draw visitors from the corner along its raised walkway, surrounded by pools, fountains, and sculpture.

At the Canyon Country Club (1963) by Wexler and Harrison, a long wall on the main public face was ornamented with a colorful stone mosaic in an angular design by the architects, echoing the stark, jagged lines of the desert. Art and architecture were united easily and naturally.

The Palm Springs International Airport similarly rises above simple function to become architecture and a singular civic space. In Palm Springs the Chamber of Commerce has always promoted the gentle winter climate, the warm sunshine, the clear air. And so Wexler created outdoor waiting rooms. Gardens and fresh air (not enclosed, air conditioned corridors) greet passengers as they disembark, and give them a last memory of Palm Springs as they depart. The mountains are on view as well; the sense of arrival in a specific and glorious place is captured by the architecture. The main lobby is angled (as is the rest of the building) with a metaphoric nod to the exciting swept wings of the jet airplane—still a new symbol of the age when the airport was built. Instead of plain columns to hold up the roof, Wexler creates sinuous, tapered columns with a distinct joint where they meet the beam; they also borrow the look of an aerodynamic airplane strut.

This is typical of Donald Wexler. He might have been happy in a career as an engineer, but he also had to take that innate knowledge of structure one step further to create pleasurable and memorable spaces. His spaces fully integrate a polished expression of the structure with purpose. His designs, pared down to a minimum, carry on in the fashion of his one-time employer Richard Neutra. But Wexler has given them his own personal stamp. •

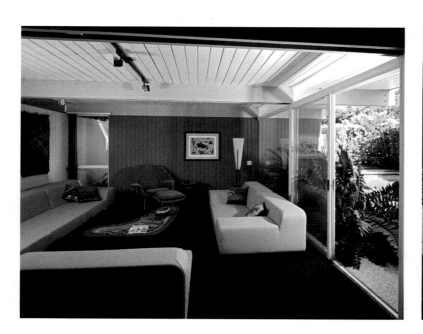 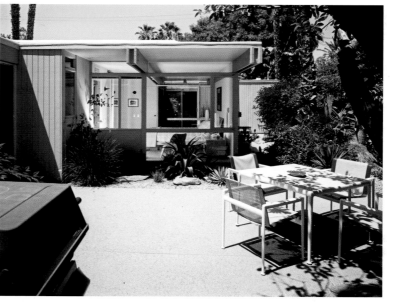

Donald Wexler House,
Donald Wexler, 1955.
Photos: 2005.
Far left: **Living room.**
Left: **Patio off kitchen and master bedroom.**

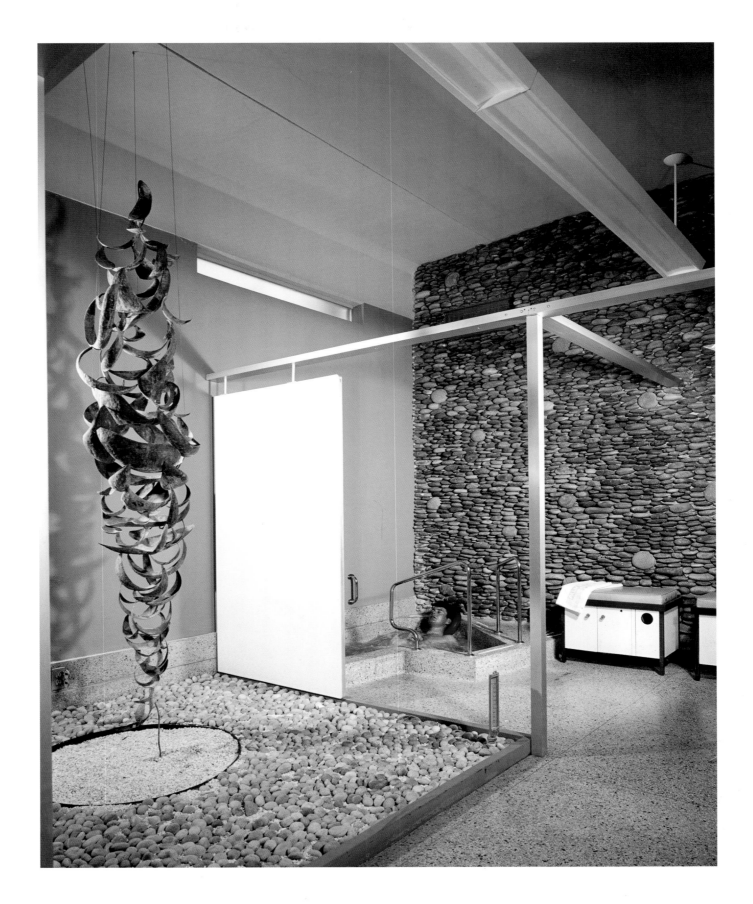

Spa Bathhouse,
William Cody, Wexler and
Harrison, and Philip Koenig,
1959. Photo: 1963.
Right: Interior of hot springs
bathhouse.

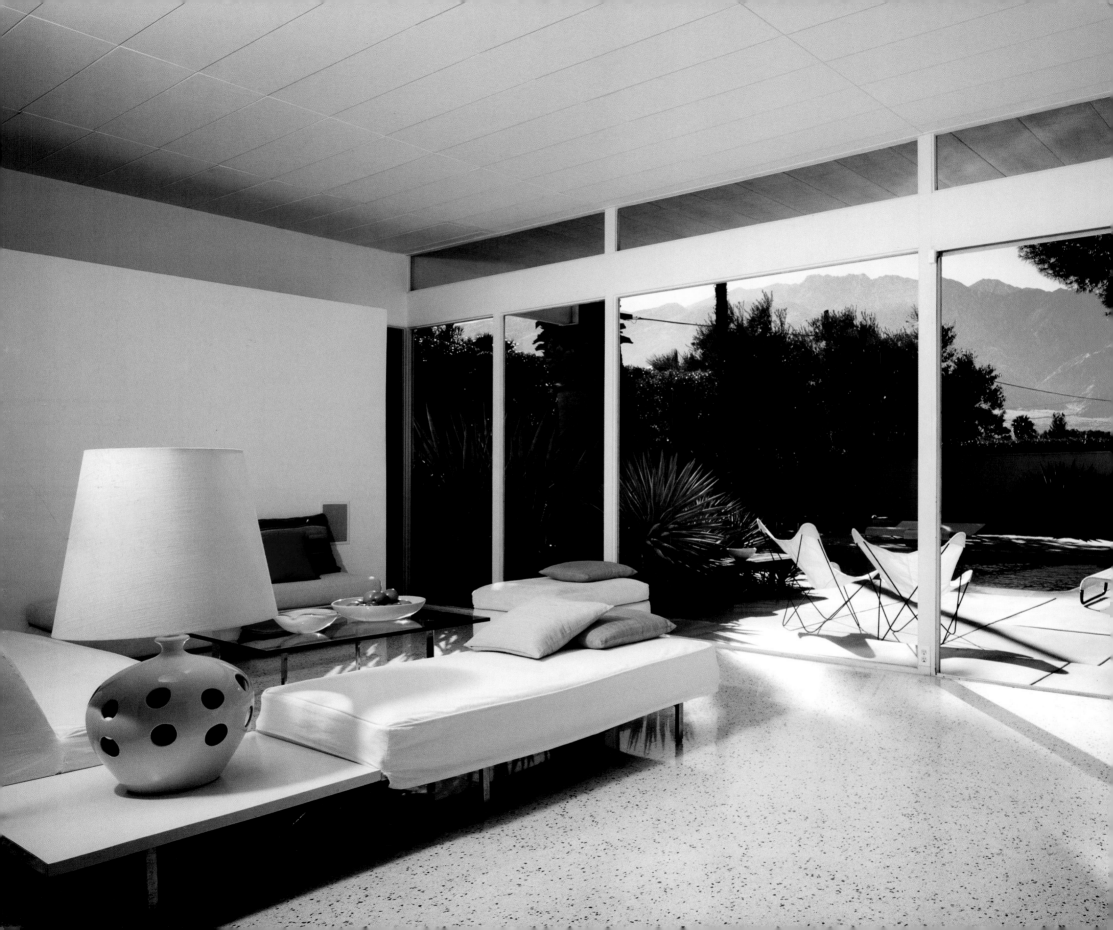

Alexander Steel Houses (flat roof model),
Donald Wexler, 1964. Photos: 2007.
Left: **Living room. The ridgeline of the
mountains is set off by the straight line of
the beam above the sliding glass doors.**
Below: **Living room from pool terrace.**

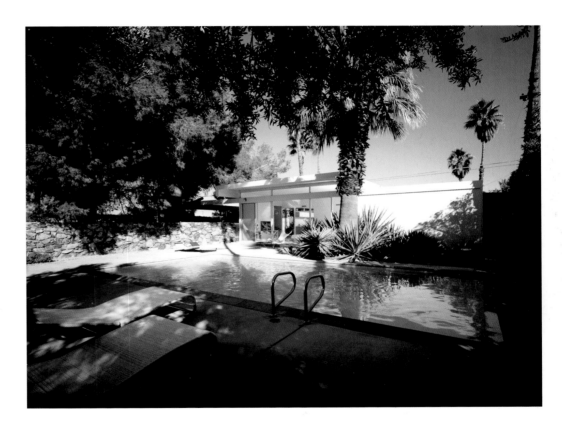

Alexander Steel Houses (folded plate roof model),
Donald Wexler, 1964. Photos: 2007.
Below left: **Front.**
Below right: **Living room.**
Opposite: **Living room from pool terrace.**

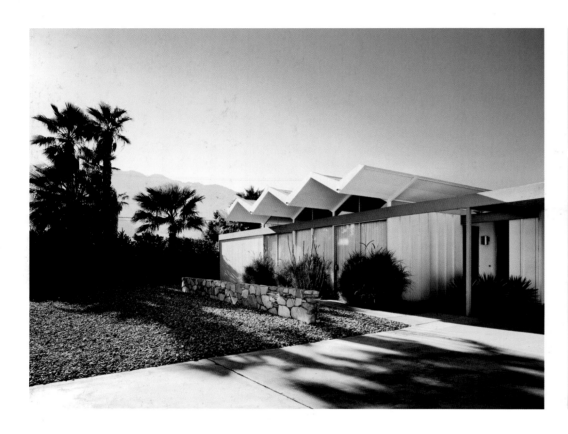

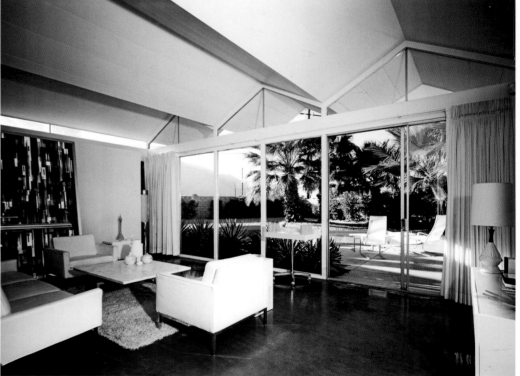

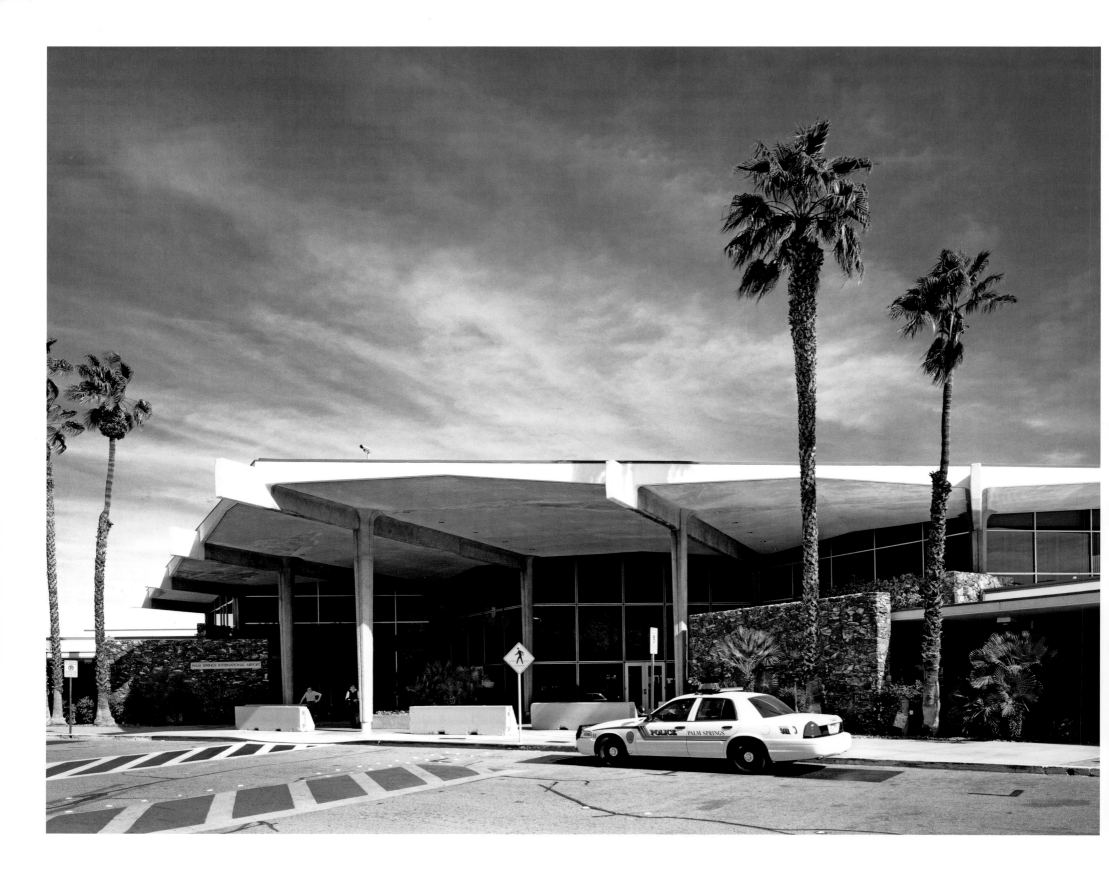

Palm Springs International Airport,
Donald Wexler, 1966. Photos: 2007.
Right and opposite: **Main entry.**

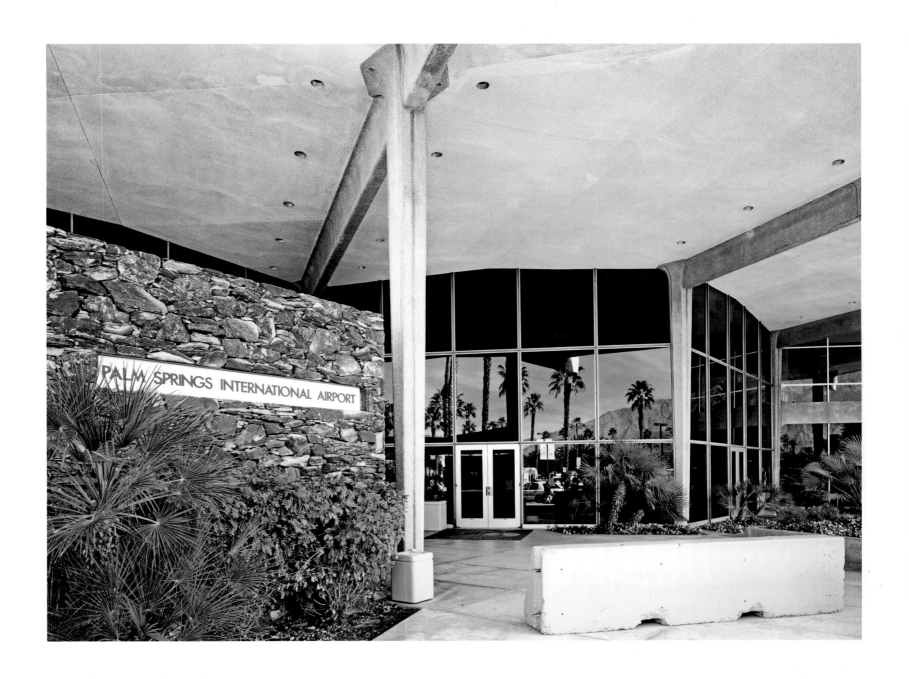

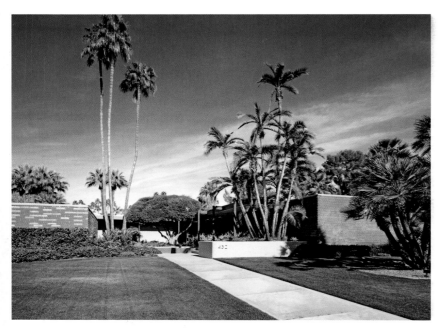

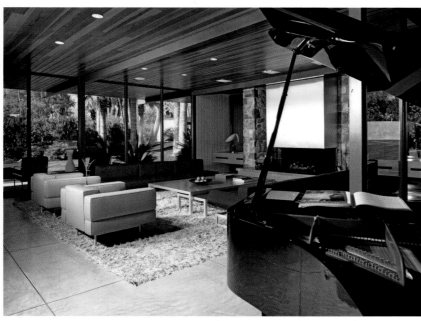

Dinah Shore House,
Donald Wexler, 1963.
Photos: 2007.
Top: **Entry.**
Bottom: **Living room.**
Right: **Pool terrace.**

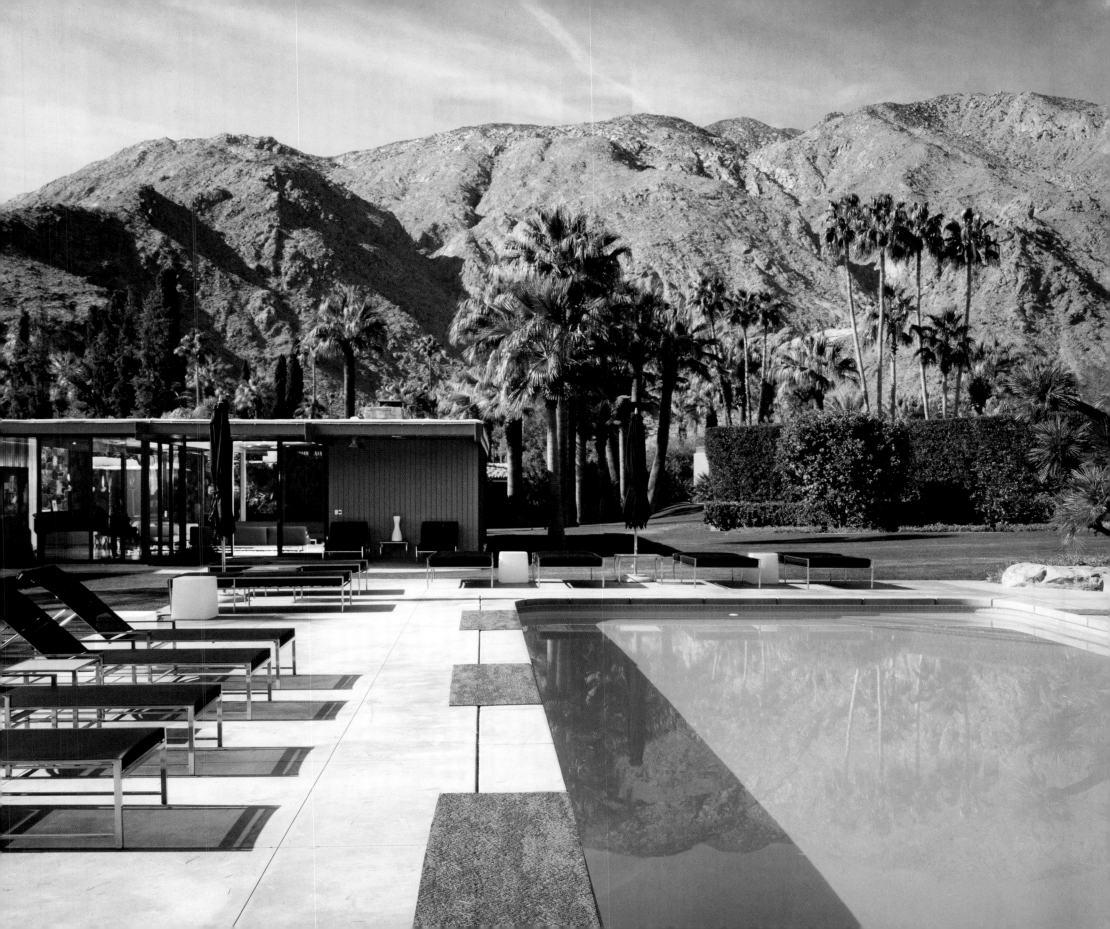

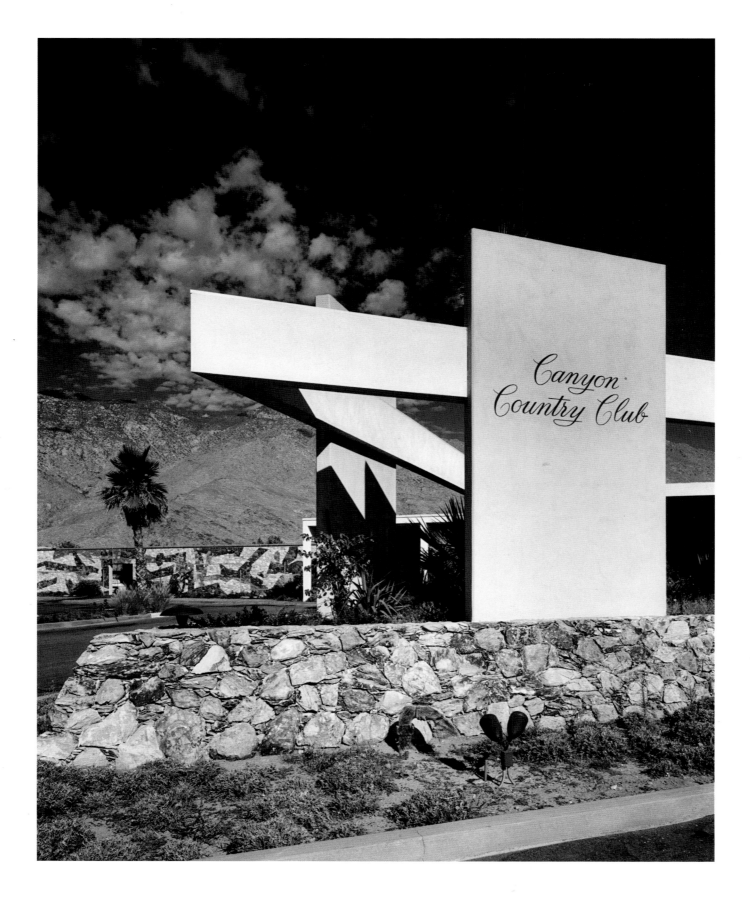

Canyon Country Club,
Wexler and Harrison, 1963.
Photos: 1963.
Left: **Entry.**
Opposite: **Stone mosaic wall was
designed by the architects.**

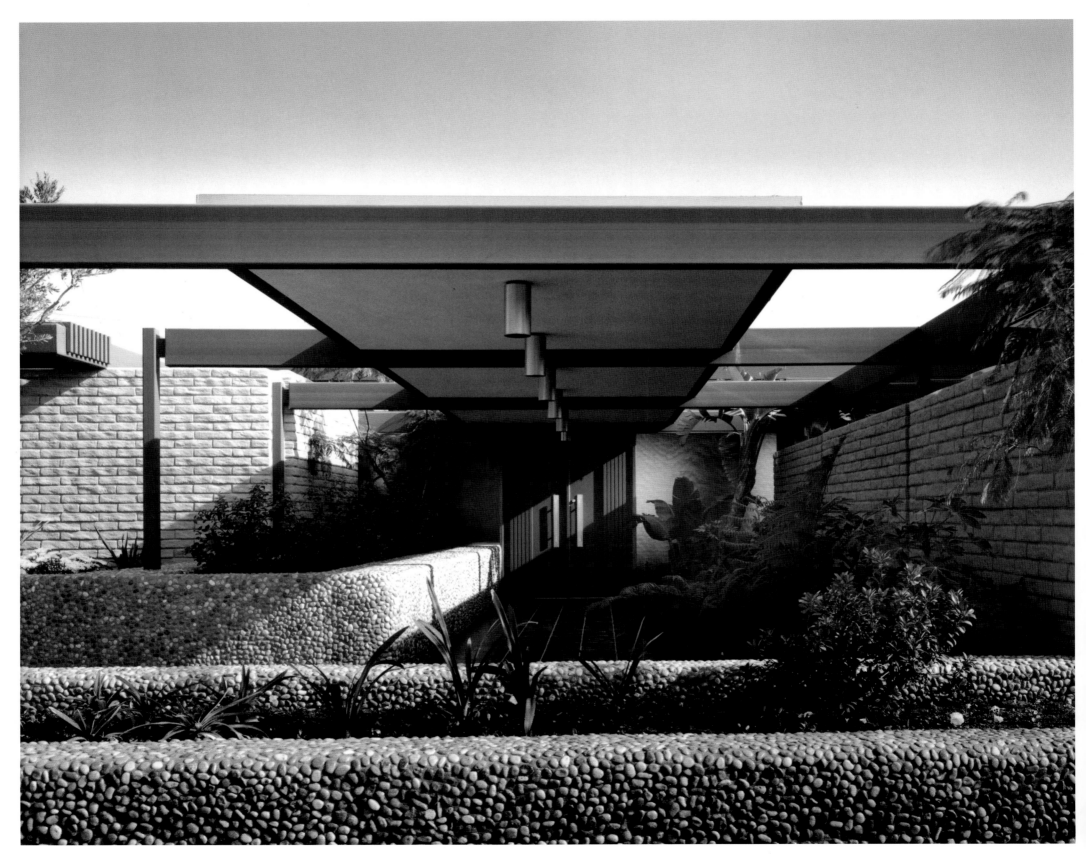

"Style in Steel" House,
Donald Wexler, 1966. Photos: 1967.
Below left: **Living room wing from pool terrace.**
Below right: **This steel structure house illustrated the flexibility of steel for a large house, as Wexler had used it for the smaller, prefabricated Alexander Houses. This house is in Buena Park, Orange County, California.**
Opposite: **Entry.**

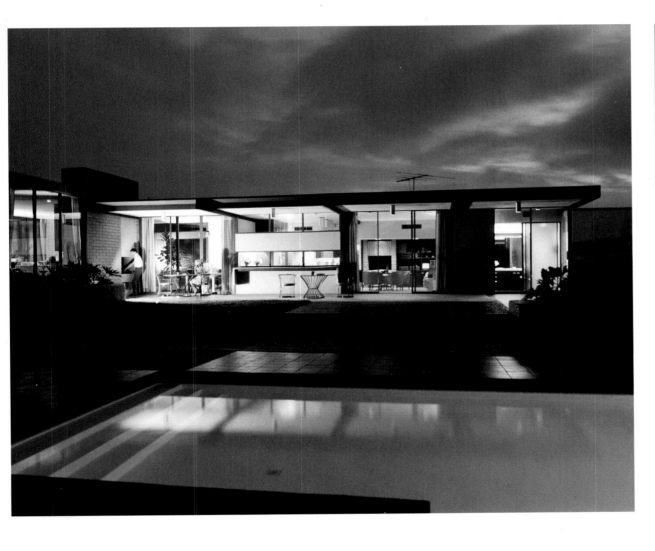

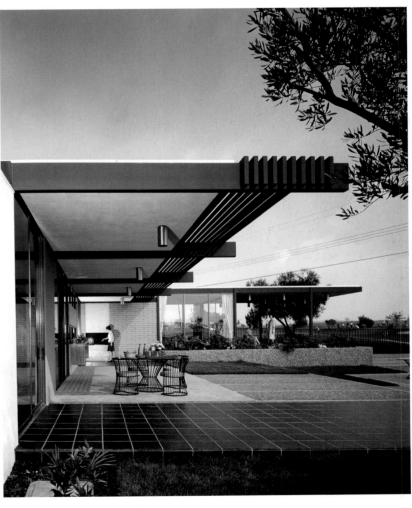

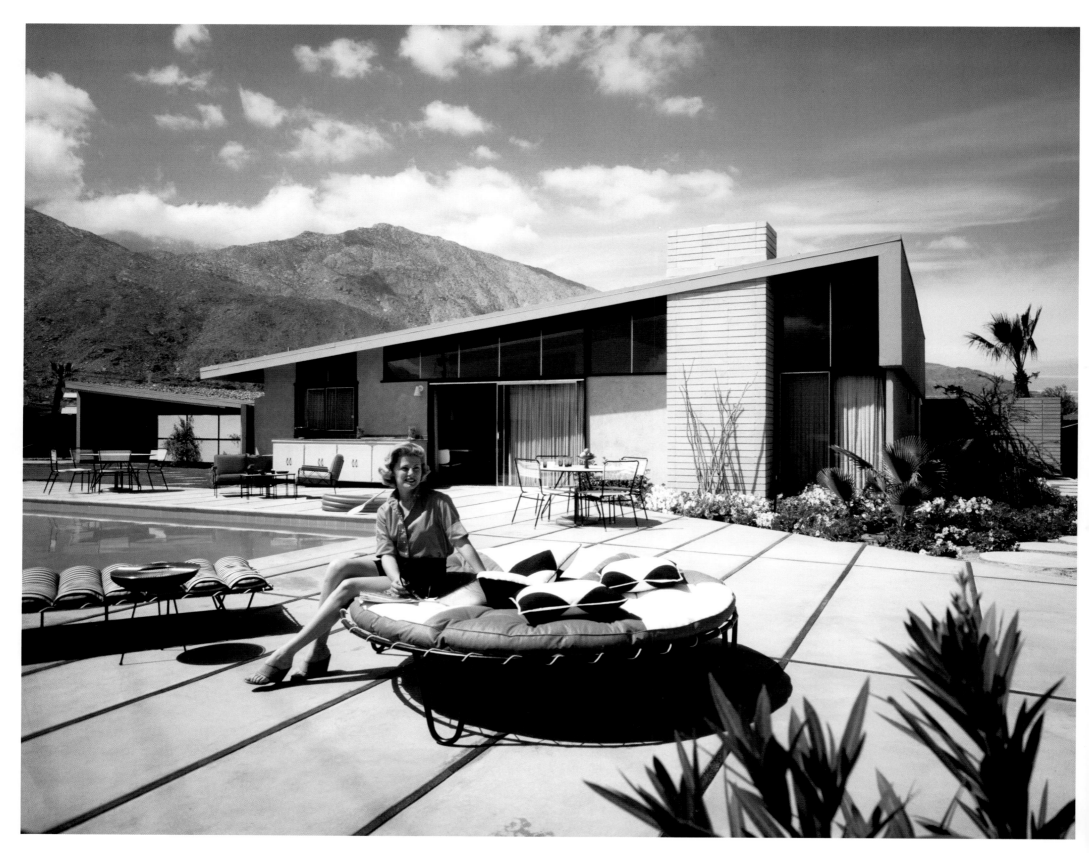

Palmer and Krisel

The best-publicized houses of the Modern era are custom designs: the glass jewel boxes that Mies van der Rohe designed for Edith Farnsworth and that Phillip Johnson designed for himself; the stony towers of Fallingwater, anchoring soaring terraces for Edgar Kaufmann's country home; and the transcendence of Neutra's steely chassis for the Kaufmann Desert House.

Above: **William Krisel.**

Opposite: **Twin Palms Houses, Palmer and Krisel, 1957.** Photos: 1957. These mass-produced homes reflected the same modern, open, outdoor design of any custom-designed home in Palm Springs. The figure on the round chaise is the wife of architect William Krisel.

Such exquisitely designed *objets des arts* engage the fundamental realities of twentieth-century life and technology on a rather ambrosian level. Certainly they exploit contemporary steel to create strong lightweight frames, and contemporary glass to create transparent walls; they could never be confused with the historical architecture of stone lintels and masonry arches. Yet these great designs use modern technology and materials more as a talisman—a symbol, a metaphor—than as a full manifestation of the implications of modernity. With designs polished to suit an individual client, responding to a specific, usually spectacular, piece of property, and draped with the costly craftsmanship and sumptuous materials that healthy budgets permit, they are special cases, slightly detached from the real impact of the age of the machine in all its vast import for people and culture.

Los Angeles architects Palmer and Krisel came much closer to expressing the truth of the machine. They were tract-house architects. They designed homes to be built by the scores, all at one time, in an efficient, assembly-line process more similar to the way Henry Ford built cars than to how Frank Lloyd Wright built houses. But Dan Palmer (1920–2006) and William Krisel (b. 1924) were not simply engineers;

they were trained and committed Modern architects. They were not only solving technical problems; they were creating flowing, usable spaces in which families could live. They used sunlight, proportions, and form as ingredients in their designs just as much as they used concrete slabs, wood studs, and prefabricated windows. They perfected modular construction, but they never forgot to consider the spaces it created for people.

Twin Palms (also known as Royal Desert Palms and Royal Palms Estates) was their first Palm Springs development. With developers George and Bob Alexander of the Alexander Company, they brought the lessons of modern mass-produced housing learned in Los Angeles's San Fernando Valley to the desert. Before World War II, Palm Springs was still a fairly exclusive resort for the wealthy and Hollywood stars. With the growth of the American economy after the war, however, the middle class was eager to partake of the same delights. The vacation economy became a major part of the growth of the West, and Bob Alexander saw a market for second homes in Palm Springs.

Krisel, the partner in charge of the desert projects, balanced two opposing requirements for tract homes: on one hand, plans had to be simple and efficiently constructed to reduce expenses; they could not be customized for any individual client. On the other hand, each house had to appear appealing and singular in order to sell. Modern architecture had often glorified the repetitive, cookie-cutter appearance of machine-made objects; now it had to learn how to make distinctive but mass-produced buildings, too.

Krisel did this by using one basic, square plan for each house at Twin Palms, but rotating that plan on each site so that a different facade faced the street. He also put a different roof on each house: a long gabled slope on one, an upswept butterfly roof on

another, a flat roof on another. For marketing appeal certain amenities were added: each house had its own pool. These were not minimal Ranch houses, but second homes for a prosperous middle class.

Krisel's designs were Modern because they brought the logic of modern technology to the task of building dozens of affordably priced houses. They were also Modern because they used clean, nontraditional lines that made the most of the environment. The houses' concrete block walls were allowed to extend past the edge of the house into the landscape, to shelter the garden and to tie the house to its surroundings. The patterns of slatted sunscreens and fences, or the geometry of molded concrete blocks, added texture, shadow, and ornament. The landscaping of the original models—also by Krisel, who had studied with Garrett Eckbo at the University of Southern California (USC) architecture school—emphasized circles and squares in stepping stones and planters. And above all, sliding doors threw open the bedrooms and family rooms to the yard, making outdoor living easy. Pleasure was as integral to these Modern designs as their structure.

Like Cody, Krisel was a graduate of the USC school of architecture, graduating in 1949 after serving in China during World War II; born in Shanghai, he spoke the language fluently. The influence of Oriental design is seen in many of the furnishings of his houses. When he went into partnership with Dan Palmer in 1950, housing was a lucrative and booming industry, as builders struggled to keep up with the demand for decent, affordable housing. Krisel and Palmer kept to their modern convictions however, bringing their practical problem-solving skills to their designs while insisting on expressing functionality with the clean lines and exposed structures of their houses. Many better-known Modern architects, from Buckminster Fuller to Walter Gropius to Frank Lloyd Wright, took

up the same challenge, but failed to develop a practical solution for the building industry. Palmer and Krisel did.

At the time, however, Palmer and Krisel's achievement received few accolades from their colleagues. Despite Modern architecture's theoretical commitment to mass housing, the profession shied away from the difficult realities of the building industry. The gentlemanly profession believed that working with rough and tumble builders and designing for a mass audience with mass tastes demanded too many compromises of pure design. Fifty years later, though, Twin Palms demonstrates the flaws in that criticism.

Krisel carried the same ideals to a different housing type, the adjoined casitas of the Sandpiper Condominiums (1958) in Palm Desert. Twin Palms had been single-family homes on individual lots, each with its own backyard. Sandpiper was a master-planned community with clusters of housing units scattered around a greenbelt and a common swimming pool. Two or three of these smaller units were in a single one-story building. One side of each unit faced a small street with carports; the opposite side faced onto the large greensward. The first units boasted an extraordinary oval-shaped kitchen with plastic cabinet doors that rolled back for access.

The concept of clustered homes on a greenbelt can be traced back to the progressive planning ideas of Clarence Stein at Radburn, New Jersey, in the 1920s, which were taught at USC; each day on his way to school Krisel passed Baldwin Hills Village (1941), an early California adaptation of the concept. At Sandpiper he updated it for the spacious contemporary resort lifestyle of the mid-century Coachella Valley.

Palmer and Krisel's work was not limited to housing, however. The Alexander Company's first project in Palm Springs was the Ocotillo Lodge, a motor inn adjacent to Twin Palms. The porte-cochere's flat roof line draped over its structure, folding down to create sunscreens. The well-appointed dining room curved in a large glass sweep around the swimming pool, putting the lifestyle of ease, sunshine, and mountain views on display for all to enjoy. Two-story wings, containing the rooms, spread out from the center public spaces, and small one-story attached casitas sprawled over the rest of the property. The buildings are simple, directly expressing their concrete block walls and wood plank-and-beam roofs, but Krisel took every opportunity to introduce a patterned block, or to divide a facade into a balanced composition of vertical windows and horizontal clerestory windows.

Palm Springs's cachet as a resort made it possible for Palmer and Krisel to bring their upscale tract homes to the desert. But they were tract homes nonetheless, embodying the processes of mass production, the advantages of standardization and repetition, and the practicality and beauty of contemporary materials. Those processes might have produced houses of much less architectural distinction; they did elsewhere, more often than not. But Palmer and Krisel's insistence on the values of Modern space and design, and Palm Springs's inclination to embrace Modernism, led to one of the great examples of Modernism's fulfillment of its promise to bring the fruits of modern life to the mass audience—not just to the Sinatras, Kaufmanns, Annenbergs, Hopes, or Desi and Lucies of the world. In the second half of the century Palm Springs lost some of its exclusivity, but its architecture gained a reputation as a model for style, leisure, and the good life. •

Twin Palms Houses,
Palmer and Krisel, 1957. Photos: 1957.
Right: Backyard walk from carport to
pool. Krisel also designed the
landscaping. The diagonal shape of
the mountains is seen in relationship
to the roofline of the house. The
diagonal of stepping stones leads the
viewer to the illuminated figure who
is outlined in a field of negative space.
Opposite: Street front. Clerestory
windows provided light while
protecting privacy.

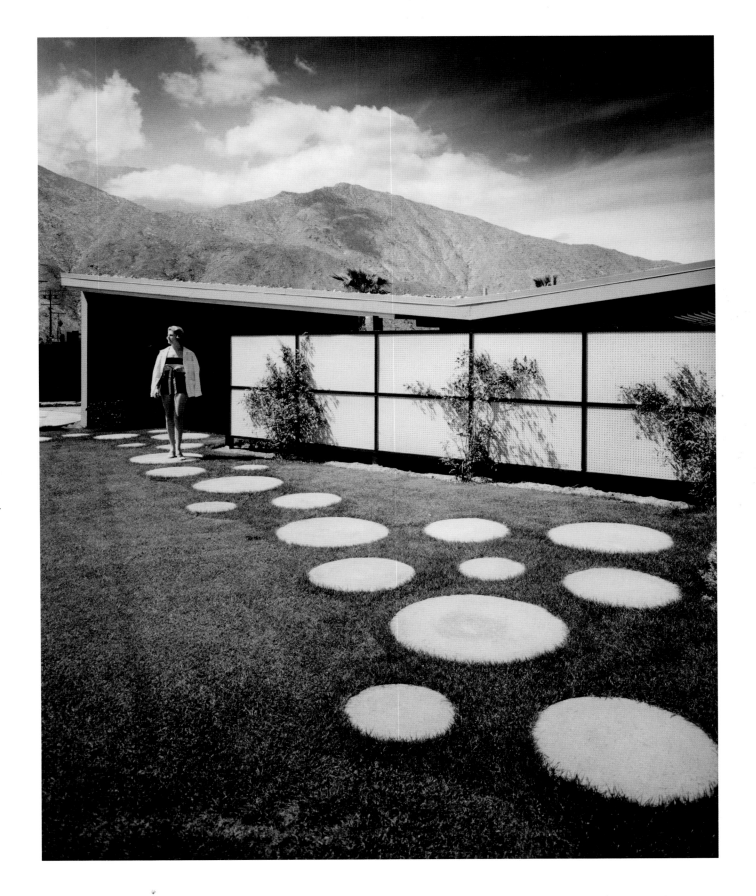

Twin Palms Houses,
Palmer and Krisel, 1957. Photos: 1957.
Below left: **Living room.**
Below right: **Though the floor plans were
similar from house to house, Krisel created a
varied streetscape by introducing different
rooflines and rotating the houses on each site.**
Opposite: **Front entry of one model with
Krisel-designed landscaping.**

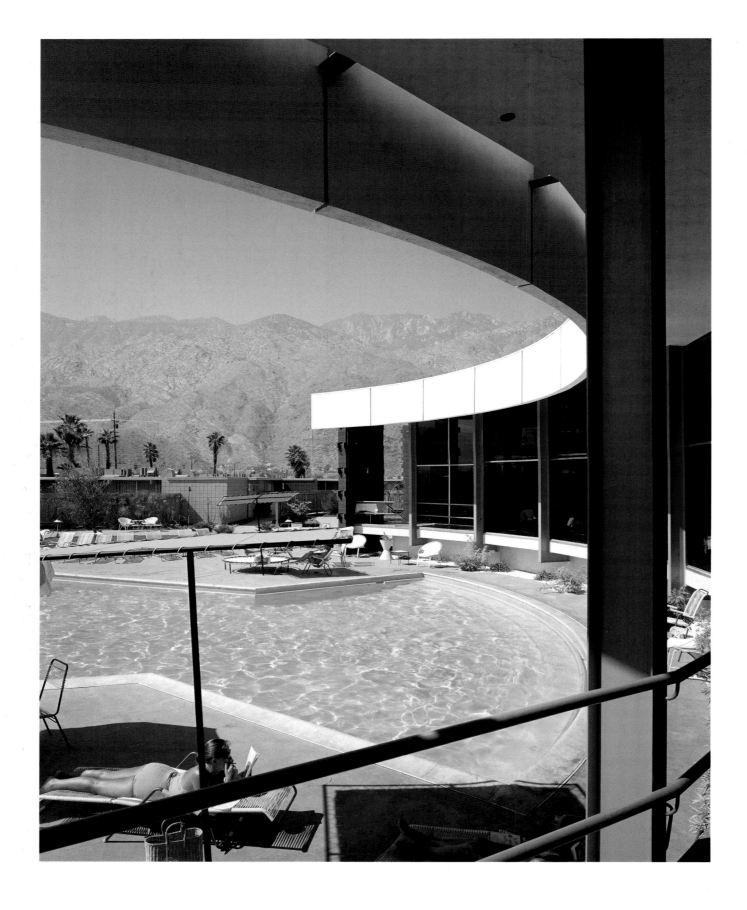

Ocotillo Lodge,
Palmer and Krisel, 1956.
Photos: 1958.
Left: Dining room overlooking
the pool terrace.
Opposite: Dining room.

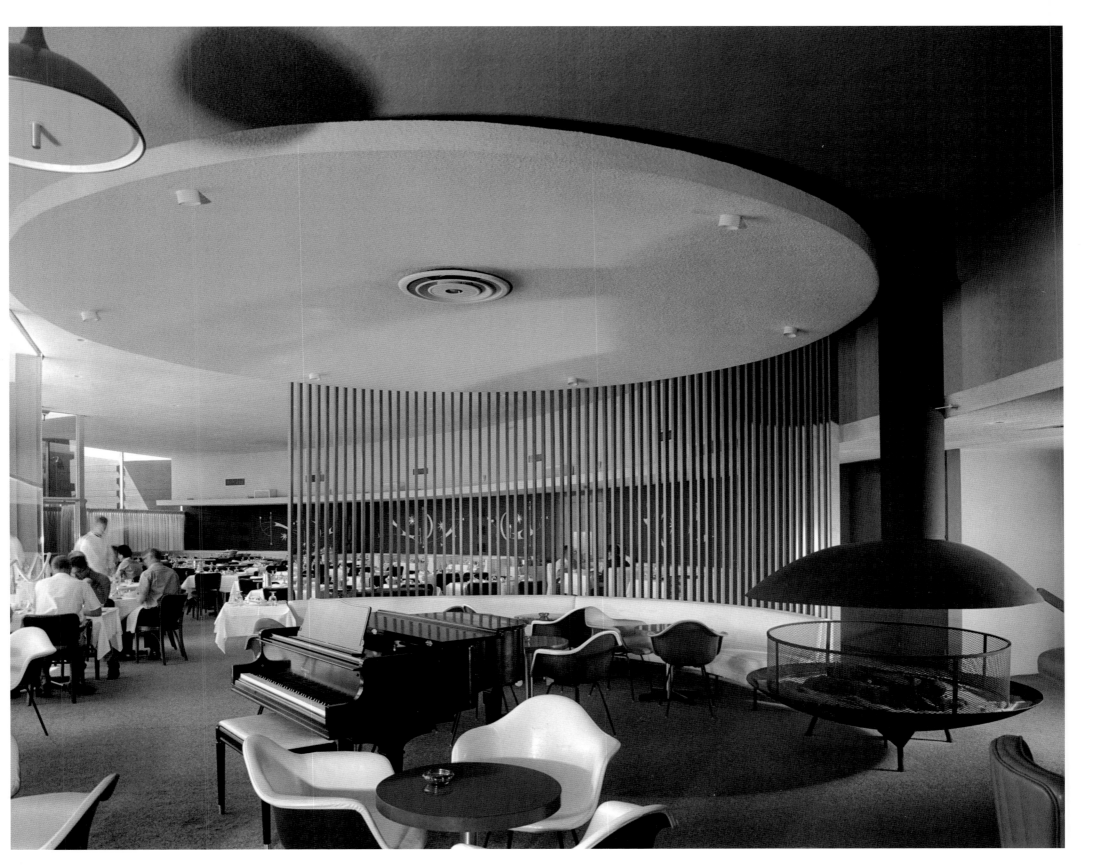

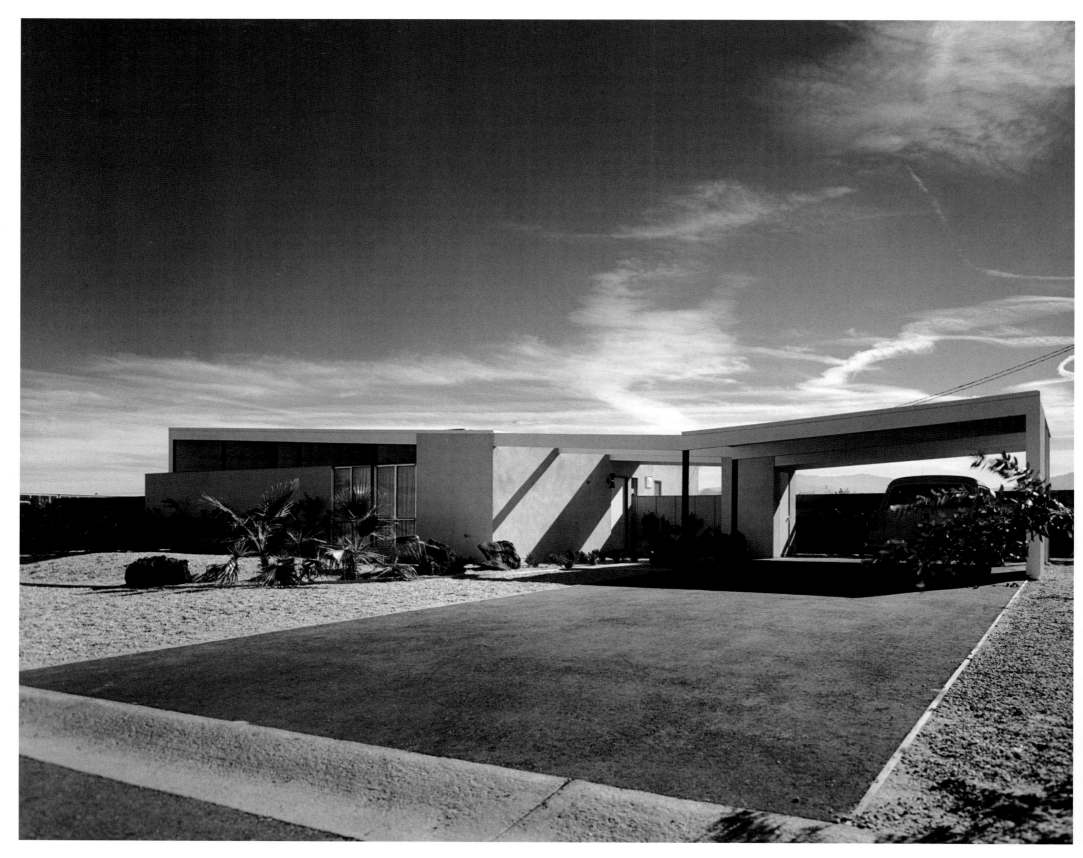

Racquet Club Estates Houses,
Palmer and Krisel, 1958–1962. Photos: 1958.
Below left: **Free-standing counter, designed
with the option to be moved, divided
kitchen from family room.**
Below right: **Kitchen and family room opened
to patio.**
Opposite: **Front door is at center, off entry
court next to carport.**

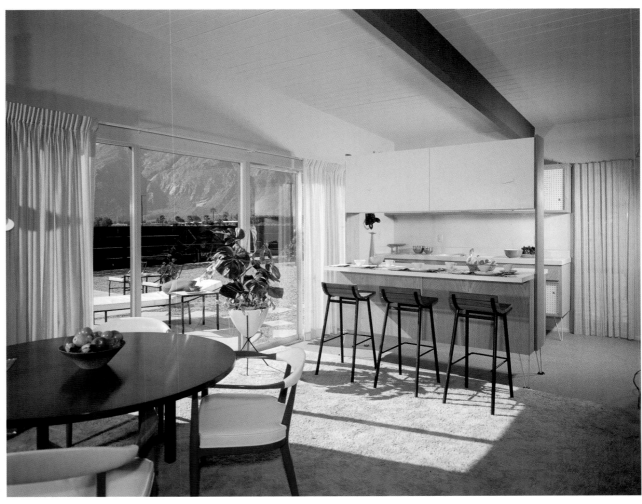

Sandpiper Condominiums,
Palmer and Krisel, 1958. Photos: 1958.
Below: **Plain facades on street contrasted
with open views to pool and common
areas at rear.**
Opposite: **Buildings with two or three
units each shared the spacious lawn and
pool terraces.**

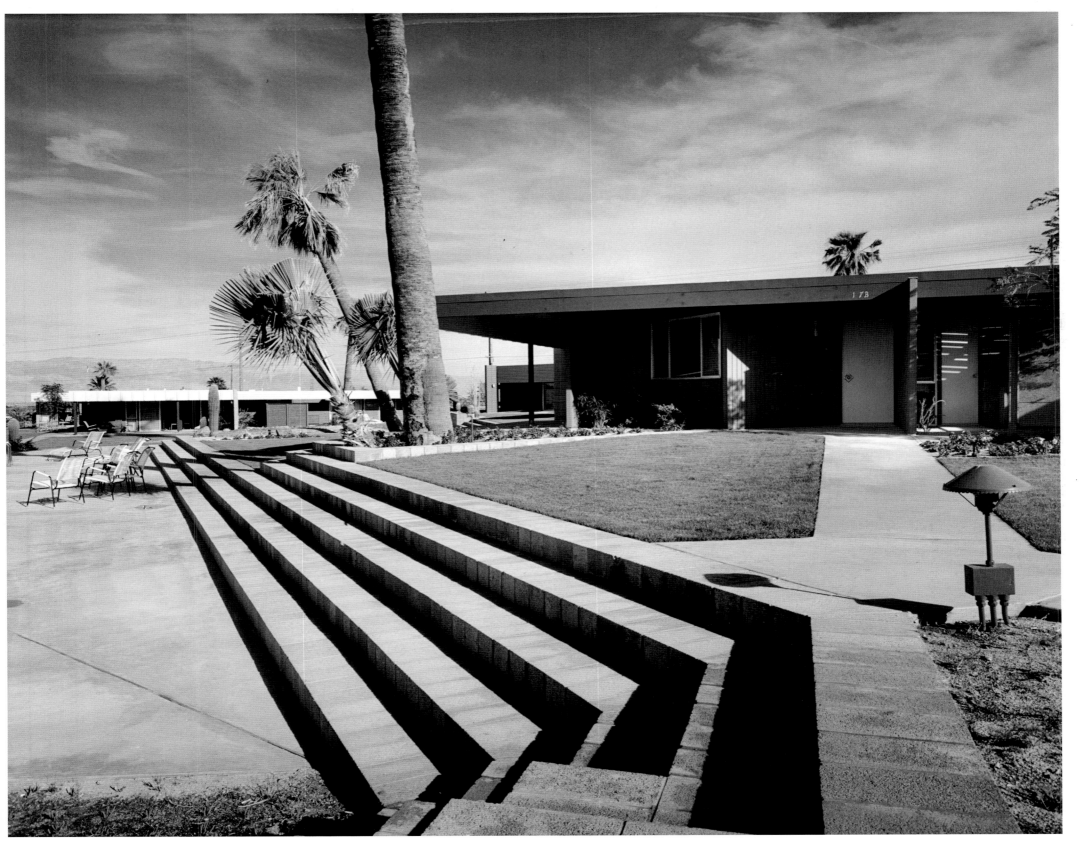

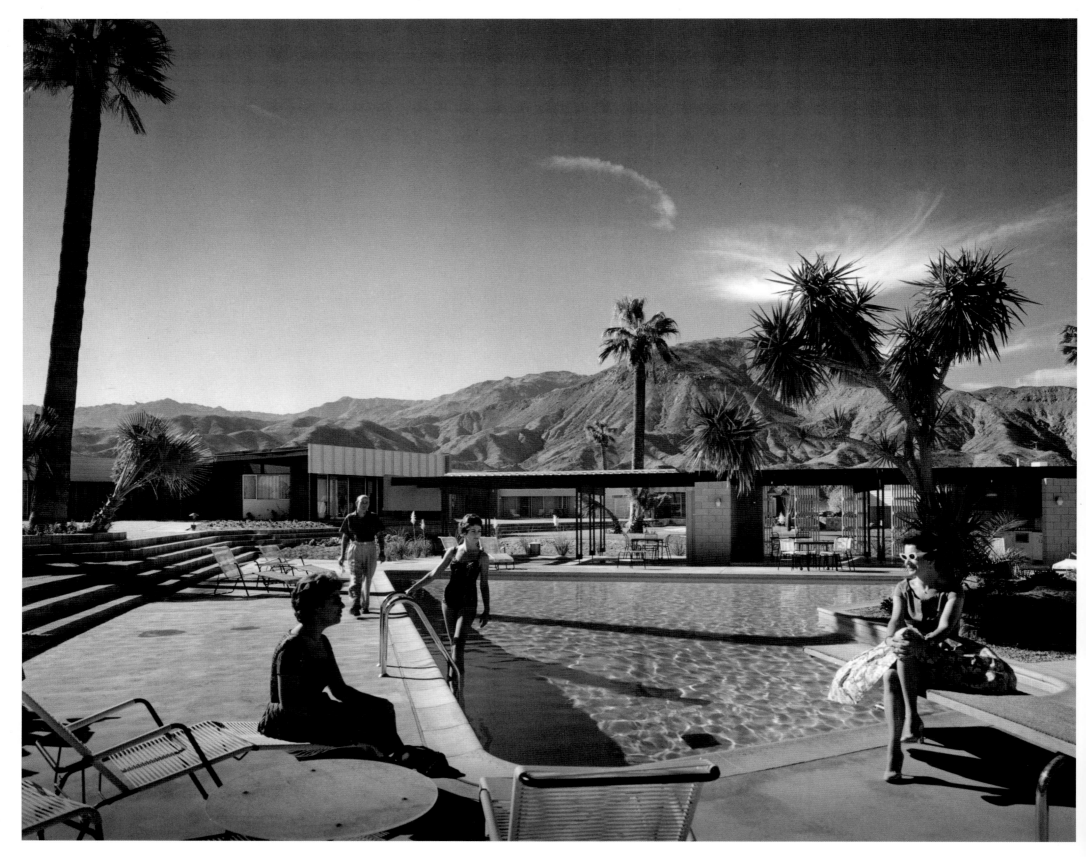

Sandpiper Condominiums,
Palmer and Krisel, 1958. Photos: 1958.
Below: **Oval kitchen with curving cabinets
were a feature of the original units.**
Right: **Each unit had a private patio.
Molded concrete blocks create a play
of light and shadow.**
Opposite: **Pool terrace.**

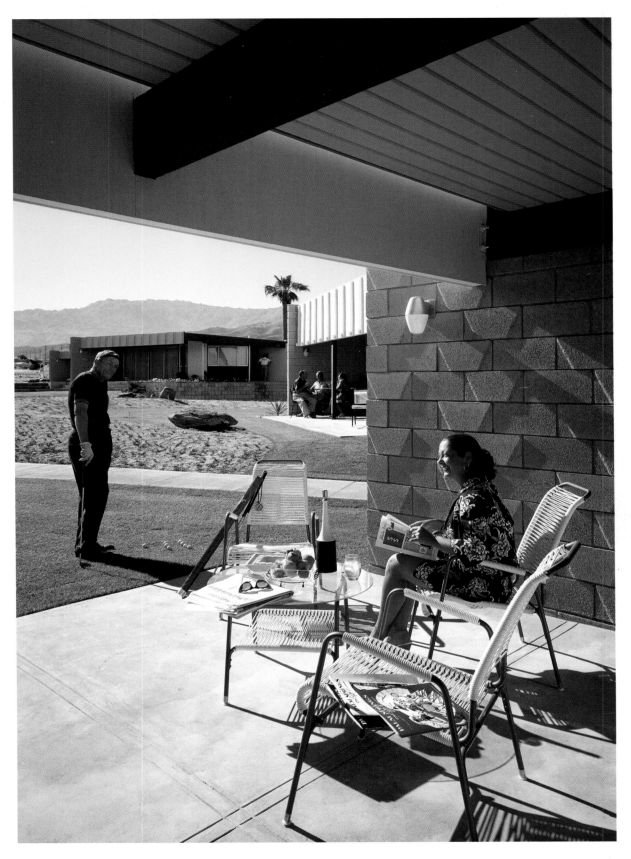

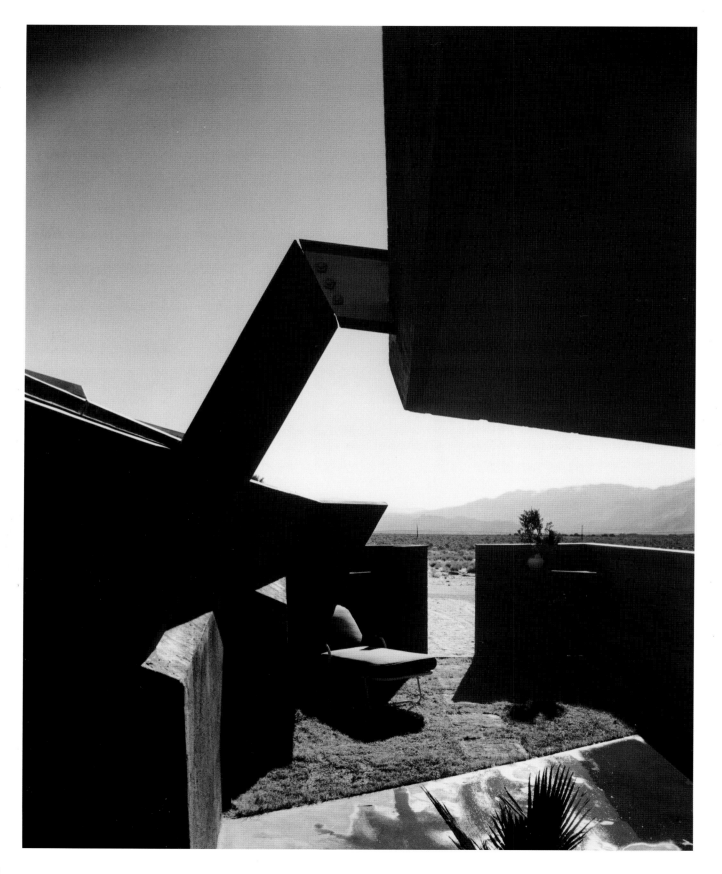

John Lautner

Of any house in Palm Springs, the Kaufmann House by Richard Neutra probably claims the widest fame in the high-art architecture world. But John Lautner's Elrod House (1968) may claim the greatest fame in the popular imagination. Like several other Lautner buildings (the Chemosphere, Silvertop, Googie's restaurant) the Elrod House strikes chords far deeper than most mainstream architecture.

Above: **John Lautner in front of 1961 Chemosphere House, Los Angeles.** Opposite: **Desert Hot Springs Motel, John Lautner, 1947. Photo: 1949. Each motel room had its own private garden.**

It plays a memorable role in the 1971 James Bond movie *Diamonds are Forever* as the exotic hide-out of a billionaire recluse. While Lautner (1911–1994) himself shunned the idea of being a mere set designer, Hollywood art directors time and again saw an unconventional, deeply expressive, fundamentally original cinematic drama in his architecture. These houses are volcanically creative. Lautner's art looks far beyond the rational perfection that gives the Kaufmann House its power. He captures an intuitive, emotional expression of human habitation that parallels the power of the movies themselves, the premier technology of the twentieth century.

So it may not be any coincidence that each of his Palm Springs designs has a strong connection to Hollywood. The Desert Hot Springs Motel (1947) was commissioned by Lucien Hubbard, a Hollywood producer and writer whose work included the 1927 Academy Award–winner *Wings*. The Elrod House became the indelible lair of the lethal Bambi and Thumper assailing James Bond. And the Bob and Dolores Hope House (1972) was designed for one of the definitive radio, movie, and television superstars of the twentieth century.

On one level, this Hollywood link may be a simple function of Palm Springs's long role as playground for the movie industry; it was a location for desert melodramas since the silent era, and a private getaway for many stars since the 1920s. Don Wexler designed a home for Dinah Shore; Bill Cody and Stewart Williams both designed homes for Frank Sinatra; Paul Williams designed Lucille Ball and Desi Arnaz's desert house.

But other facets of Lautner's designs cut deeper. They are more than a glorification and celebration of the twentieth-century machine. They connect to a more elemental visual and kinetic storytelling.

The Desert Hot Springs Motel was built in the neighboring town of Desert Hot Springs. It does not look like the Coachella Valley scenery found in Palm Springs, at the foot of craggy Mt. San Jacinto. The shallow foothills here are cut with ravines and fissures that bring the earth's thermal waters to the surface. That geological fact attracted a series of small motels to the area.

As Lautner's work became known more widely later in his career, he would be labeled by some critics as self-indulgent and undisciplined. This early Lautner design challenges that misperception. He was a disciple of Organic architecture, learned at Taliesin under Frank Lloyd Wright, and sought a deeper order to his spaces than Cartesian geometry allowed. The motel is a masterful, rigorous integration of efficient (and innovative) structure with the repetitive (but entirely agreeable) spaces required of a modern resort motel. Here Lautner demonstrated he could design a building as geometrically rigorous as any modular glass box; in the future he would use this as the jumping-off point for his freeform, experiential spatial explorations.

This highly disciplined platform also performed a small miracle of spatial legerdemain, characteristic of Lautner's talent: though each room is motel-room tiny (including kitchenette), they are spacious, filled with soft light, and enjoy their own private gardens. Lautner would never leave a design at the point of mere efficiency; it had to be a great space for people.

The structure is reminiscent of the small tents that Lautner and other Taliesin Fellows built for themselves when Wright moved the Fellowship to the Scottsdale desert for winters ten years before. The motel's gunite walls and steel roof beams are more durable than those wood-and-canvas structures, but still convey the same sense of lightness. This is a permanent tent. Three units are laid out side by side (each with its own carport), and the fourth is perpendicular to the others. The thin, gunite walls (reinforced with steel) between them incorporate origami-like folds for added strength; they rise high to deflect the stiff desert winds. A swimming pool with windscreen was built across the street.

Steel dogleg I-beams resting on these walls form the asymmetric roof on each unit; the roof slopes up to draw the eye to the sky and the private garden; the opposite, lower side of the roof incorporates a skylight that balances the light in the small space. The rooms are sunken into the desert floor, allowing the garden space to be a few steps above, at eye level to those seated in the room. The sunlight, the change in elevation, and the glass wall are basic decisions with the clear intention of shaping a remarkably pleasant space.

Back in Palm Springs, Arthur Elrod was a noted interior designer, well known in Hollywood; his friendship with Dolores Hope lead to Lautner's hiring for the Hope House nearby. Elrod designed the furniture for another daring Lautner icon, the open-air Arango House (1973) overlooking Acapulco Bay. He completely trusted Lautner's art, and set no restrictions on the design for his new house in 1968.

The house Lautner gave Elrod is an ultramodern cave. It is concrete—a material Lautner began to explore in the great curving roof of Silvertop in 1959, and which became a hallmark of his career. Solid like

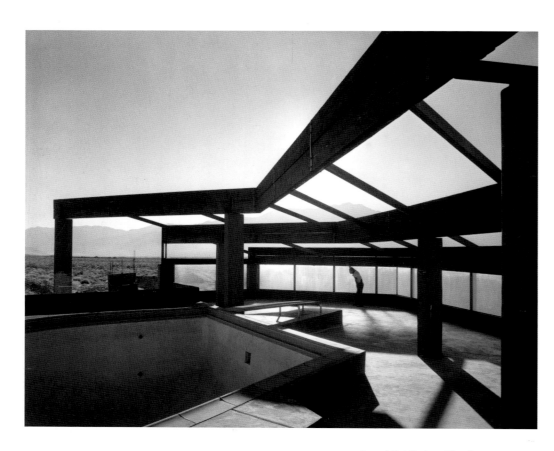

Desert Hot Springs Motel,
John Lautner, 1947. Photos: 1949.
Above: **Pool and pool house shared
by motel units.**
Opposite: **Three of the four units
can be seen with their own parking
space and walled garden.**

a rock, half buried in the living earth, the Elrod House is Lautner's forceful response to Neutra's or Frey's assertion that modern technology should be expressed as lightweight, steely, and sharply honed. Despite their differing aesthetics, Frey nonetheless found it an "exciting house."[1]

The Elrod House sits on an elevated site, on Southridge. It has an impressive outlook to the mass of Mt. San Jacinto; where most other Palm Springs houses look up at the scaleless mountain, this house looks out almost eye to eye with its massive presence, rising from the broad valley floor. Panoramic windows circle the living room and slide out of the way at the touch of a button, leaving the house at one with the magnificent view. Lautner began the design by excavating the lot, digging down several feet to reveal the boulders that shape the living room and the adjoining master bedroom; the site's topography literally shapes the plan. The great petal-like spokes of the concrete roof rest above this natural space like a tent; their construction shapes the structure, as the great tension ring that circles the living room holds them in place. The design is full of knowing contradictions; the roof is weighty concrete, but its skylight slits modulate its heaviness. The living room is on two levels, overlooking an indoor-outdoor pool and terrace; the drop of the steep natural ridge is thus made part of the house.

The Hope House began as one of Lautner's most daring visions, and it had the location and (it seemed) the budget to become magnificent. It was a further exploration of the territory Lautner pioneered in the Arango House in Acapulco: an open-air house that draws the breathtaking natural scene into the life of the residents and the architecture of the building. The project was, however, ill-fated. The enormous sheltering roof was to have been concrete (an inversion of the upsweeping Arango roof), and Lautner consulted with the great Mexican engineer Felix Candela on its design. Budget concerns, however, forced him to create the great complex curve with a steel frame, clad with a wood skin and surfaced in cement plaster (later replaced with copper). While it was under construction in the middle of the scorching summer, however, an accidental fire destroyed the structure and delayed the building schedule. In the meantime, Arthur Elrod, whom Dolores Hope had hired to design the interiors, died in an auto accident. These two events dealt a blow to the project.

Though the house was ultimately completed, Lautner was dissatisfied with the results. The spatial concept and execution are impressive nonetheless. The great roof with its circular oculus hovers over the site. The enclosed rooms and spaces are tucked beneath its edge, allowing the landscape to flow in and around the open terrace and patios.

John Lautner's work in Palm Springs and environs adds breadth to the town's role as a catalog of twentieth-century California architecture. With his usual self-assurance he represents the Organic tradition in American Modernism, stretching back to his teacher Wright and Louis Sullivan. His buildings are from a realm of architecture far beyond the intellectual exploration of steel construction and glass technology, far beyond the idolization of the box, somewhere in the realm of mankind's ancient habitation in forest, meadows, and caves. Lautner enthusiastically embraced the tools of modern technology, but unlike Le Corbusier and Neutra, he did not stop at the point where his houses became elegant machines for living. He pushed further. •

1 Jennifer Golub, *Albert Frey/House 1 + 2* (New York: Princeton Architectural Press, 1999), 81.

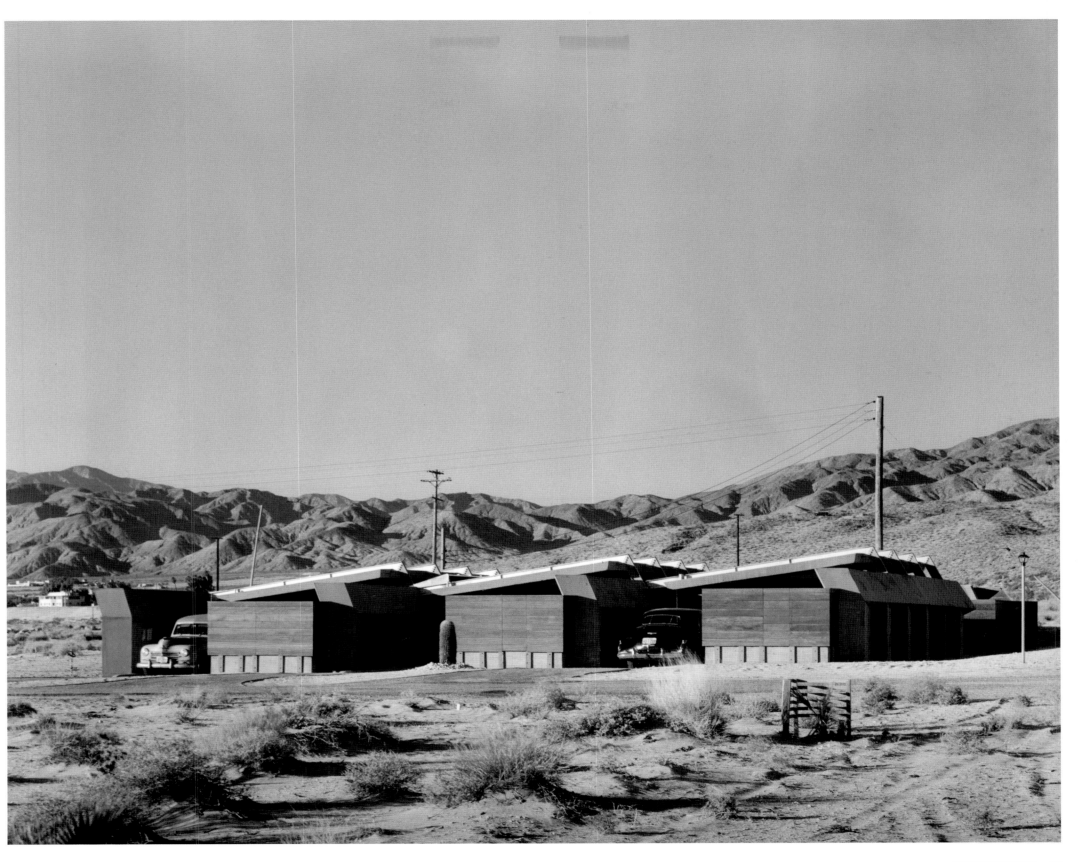

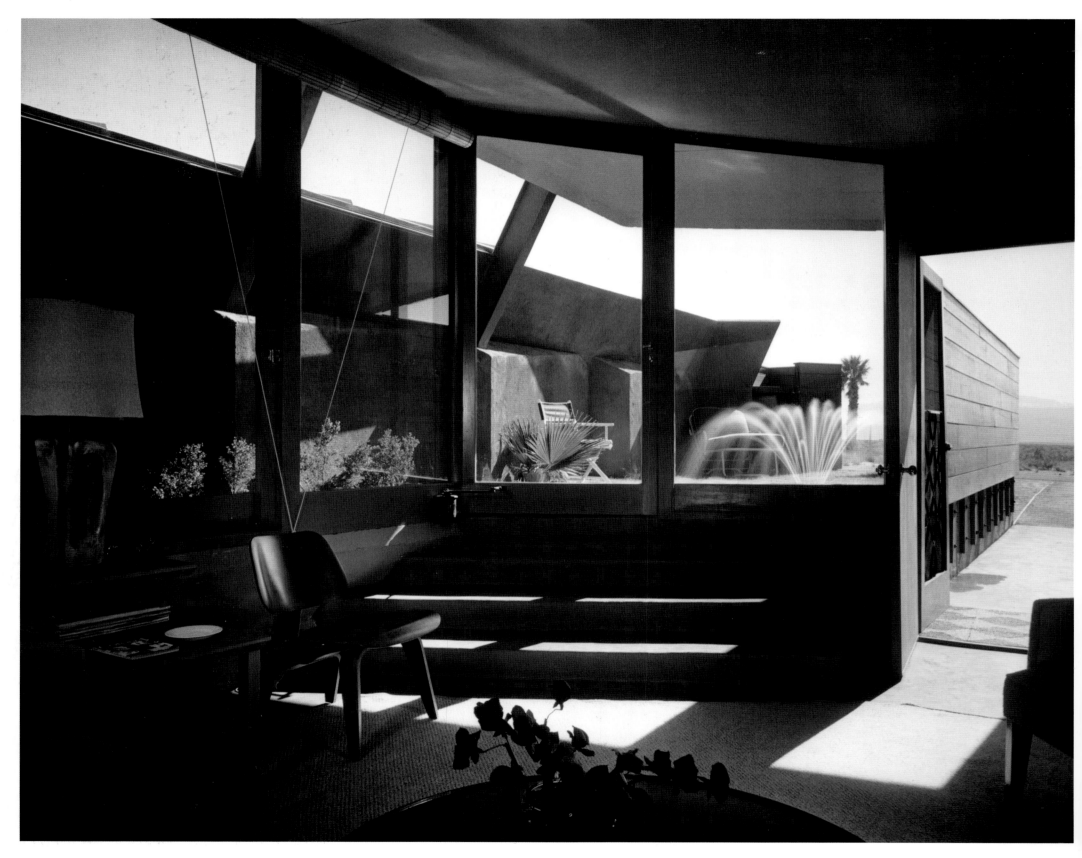

Desert Hot Springs Motel,
John Lautner, 1947. Photos: 1949.
Below: **Efficiency kitchen is behind the wood wall at center. Glass wrapped around two sides of the room.**
Right: **View of room from garden.**
Opposite: **Room stepped up to private garden.**

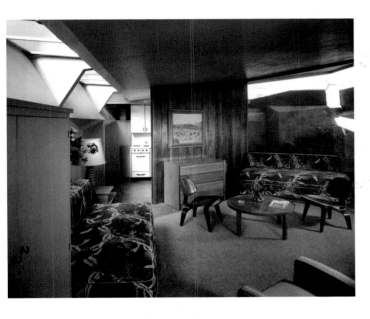

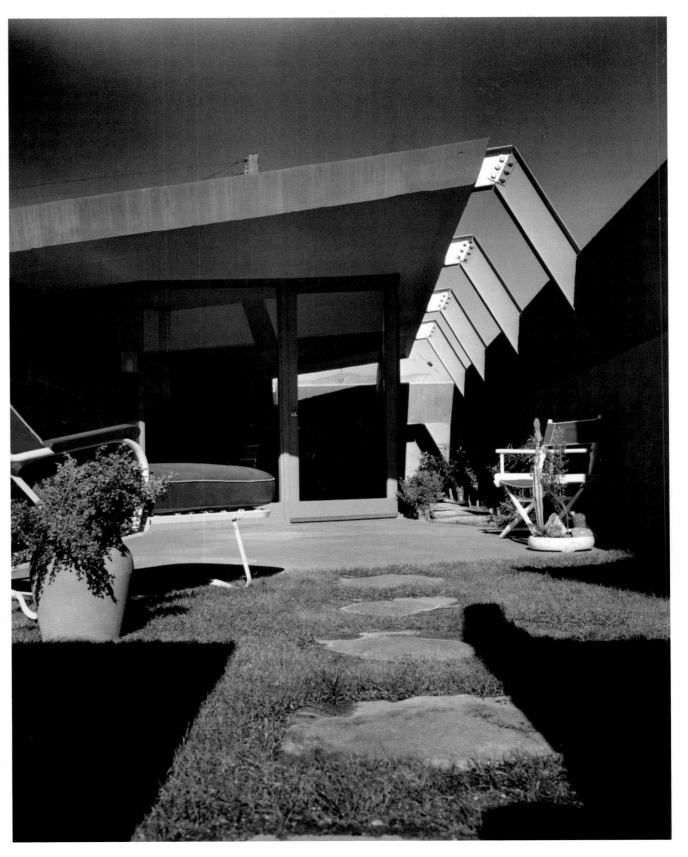

Arthur Elrod House,
John Lautner, 1968. Photo: 2007.
Below left: **Curving glass wall slides completely off the face of the house to unite the two-level living room with the pool terrace.**
Below right: **Skylight slits divide the circular concrete roof into sections.**
Opposite: **Pool stretches into the house.**

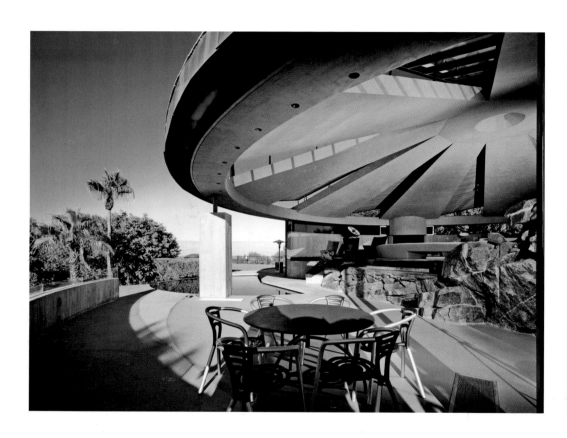

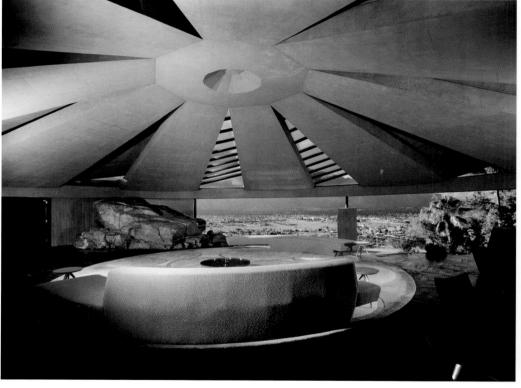

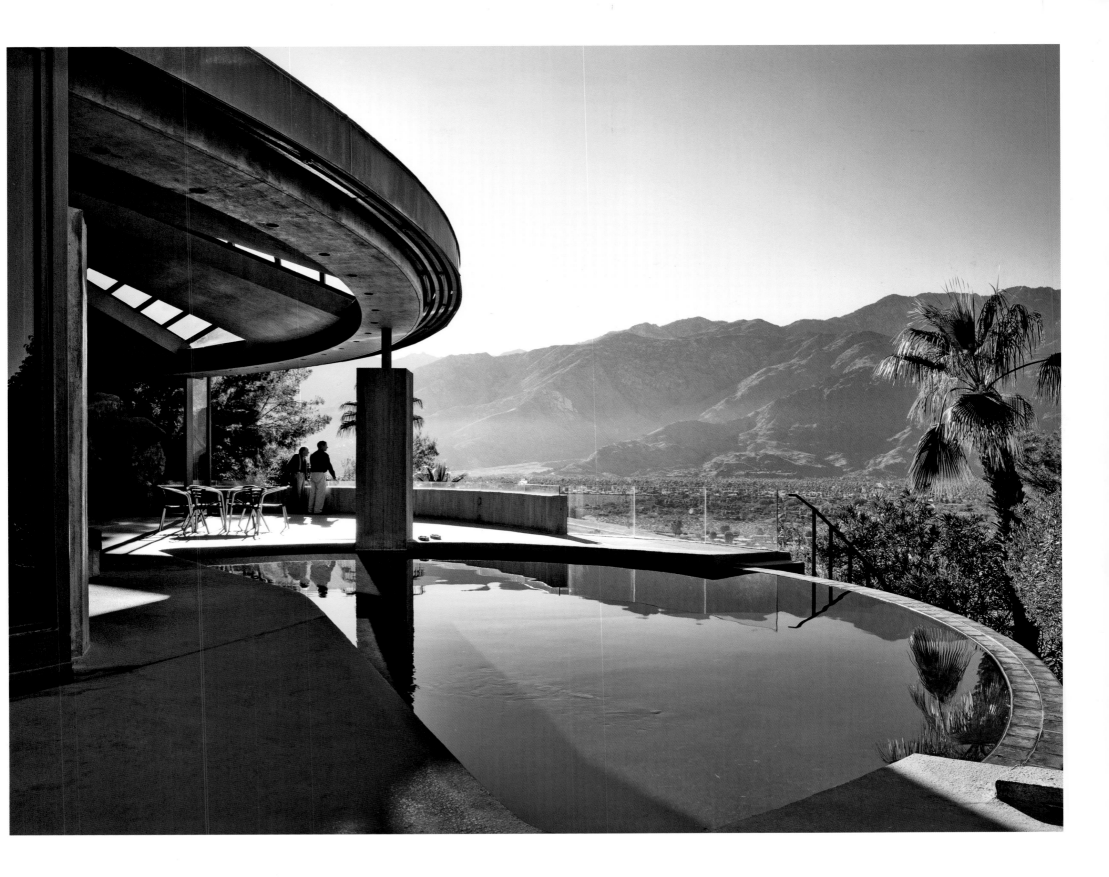

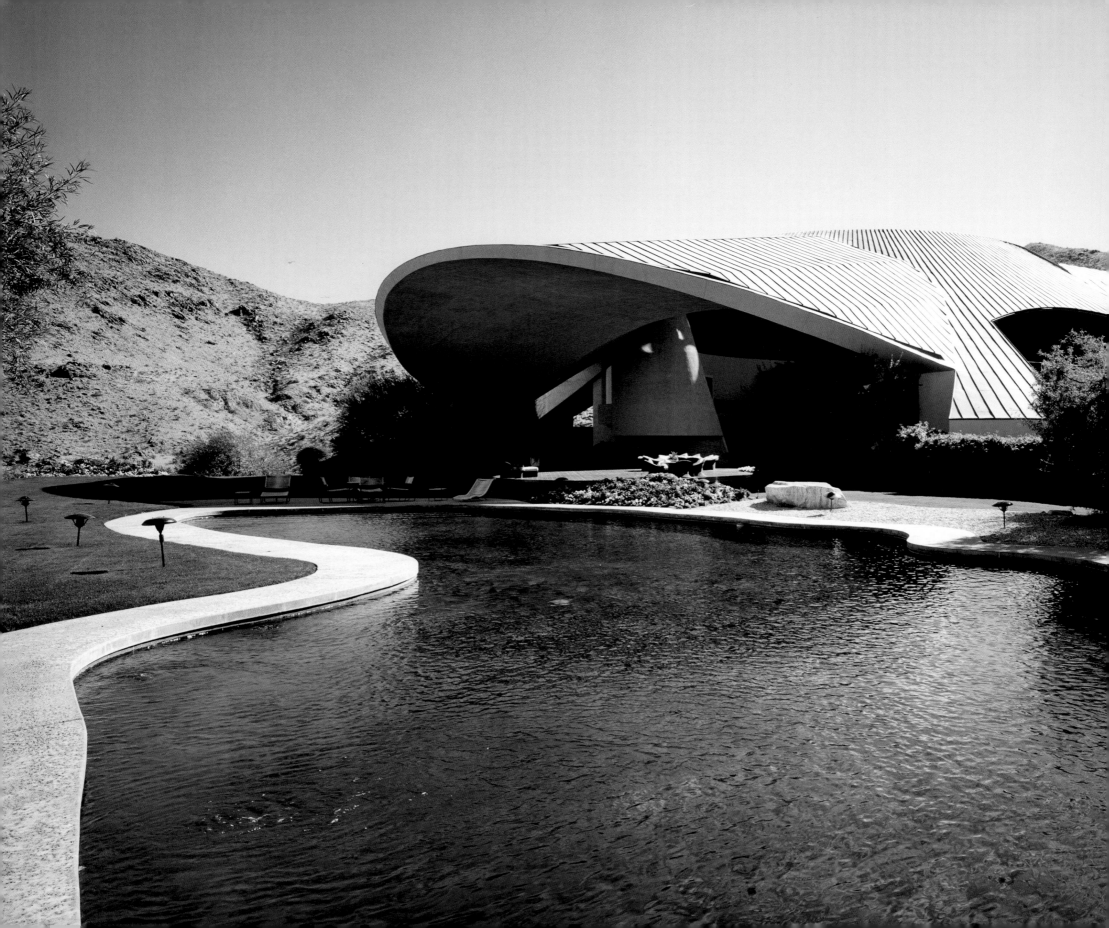

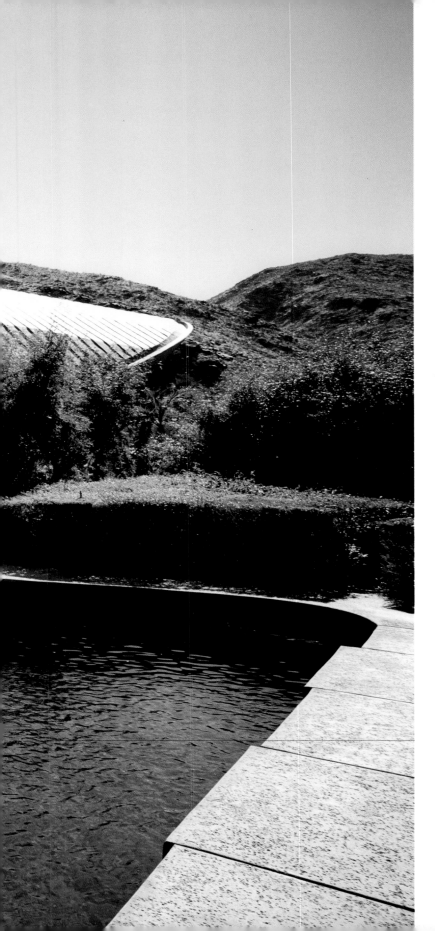

Bob Hope House,
John Lautner, 1979. Photos: 2007.
Left: A large metal-clad roof (originally intended as concrete) stretches over both indoor and outdoor rooms.
Below: Oculus allows light while the roof provides shade.

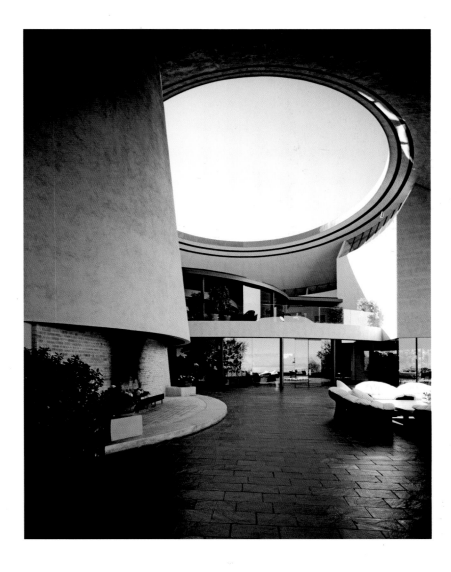

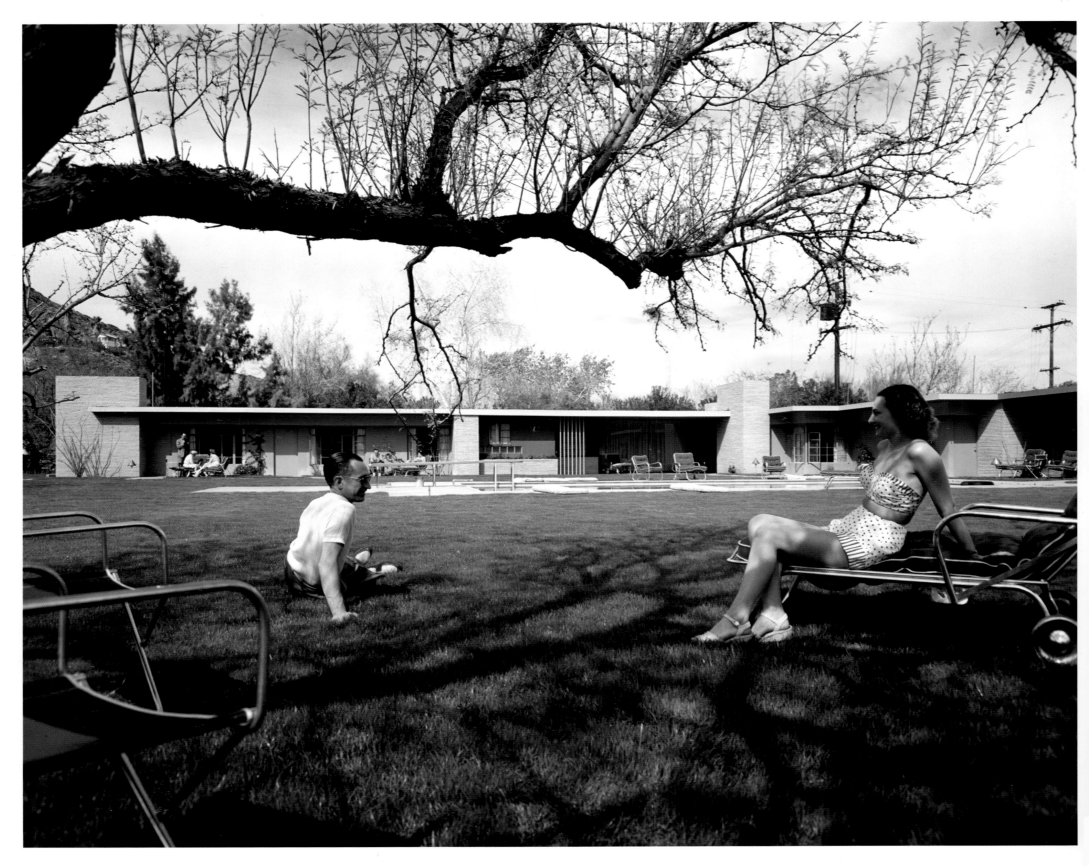

Significant Others

Neutra, Lautner, Jones, and Paul Williams were not Los Angeles's only well-known architects to build in Palm Springs. Some of the largest commercial firms in the great city were drawn out to the desert, which provoked some of their best design work. Though adobe-style Spanish and Ranch architecture were still popular in Palm Springs, Modernism had its constituency.

Opposite: **Town and Desert Inn, Herbert Burns, 1947. Photo: 1947. Modern design characterized a wide range of buildings in Palm Springs in the mid-twentieth century.**

Often the architects' established clients (such as Robinson's, Bullock's, and City National Bank) asked for branches near their wealthy vacationing clientele; there was a clear expectation that these would express the same high-quality of architecture on vacation as their architecture in town.

None were disappointed. Shortly after the end of World War II, the rising young firm of Walter Wurdeman and Welton Becket was given an extraordinary commission by Bullock's, the well-established department store to the carriage trade. Bullock's had already broken the rule that department stores had to be downtown; Bullock's Wilshire in 1928 (by John and Donald Parkinson) and Bullock's Pasadena in 1947 (by Wurdeman and Becket) followed their automobile-oriented customers to the suburbs. Now, they followed their customers to the vacationland of Palm Springs. It would be a smaller store, but with all the class and amenities their customers demanded.

Two short wings embraced a courtyard that extended the public pedestrian space of La Plaza shopping center (1936) by Harry Williams across Palm Canyon Drive. Like Bullock's Wilshire, the parking lot was on the back, leaving the front to greet pedestrians along the town's main street. The building was a classic piece of Late Moderne design,

related to the 1948 Town and Country Center by Jones and Williams nearby. The two-story building's mint-toned stucco skin emphasized its volumes; the forecourt was lined with zigzagging display windows between Roman brick pylons—a sure draw for customers. A large egg-crate grill and louvers (Late Moderne motifs seen at Town and Country and the Loewy House) added decorative appeal and sun shading. As at Bullock's Pasadena, each department was exquisitely furnished with custom cabinetry and showcases complementing the brick walls.

Not to be outdone, Bullock's competitor, Robinson's Department Store, hired another noted young firm, Pereira and Luckman, to build its Palm Springs branch. Modernism had advanced quickly since the early postwar years, and Pereira and Luckman stayed at the forefront. In such high-profile buildings as the Union Oil headquarters, the Flamingo Hotel's major remodeling on the Las Vegas Strip, and Marineland of the Pacific, they captured the dynamism of the new Western economy. The Palm Springs Robinson's (1958) reflected Los Angeles Modernism's trend to an artful revelation of structure. A glassy pavilion is raised on a plinth of three steps; a row of lithe freestanding columns lifts a high accordion-fold roof with a zigzag fascia reflecting the shape of a modern steel truss. The slender columns are strengthened by tapering fins that also add a decorative flair. Tucked beneath this transparent pavilion on the south side is a wall of duotone concrete block, each molded into a lozenge-shape that echoes the roof fascia. At the right time of day the blocks' bas-relief captures the grazing sunlight.

This was Modern design at its most self-confident: Robinson's is a Greek temple in twentieth-century materials. With E. Stewart Williams's Santa Fe Federal Savings across the street, Robinson's forms a fine pairing of two excellent interpretations of the Modern glass-walled pavilion.

An equally arresting design nearby is the City National Bank (1959), designed by Victor Gruen Associates. This large Los Angeles firm made its international reputation in the 1950s by redefining the shopping center in landmark mall designs for Northland Center in Detroit and Southdale Center in Edina, Minnesota. Lead by Gruen associate Rudi Baumfeld (an Austrian refugee from Nazi occupation, like Gruen), this bank design started with a new sculptural, expressive direction of design recently sanctioned by Le Corbusier in his 1955 chapel of Notre Dame in Ronchamps, France. The bank's confidently irregular upswept roof and curvilinear walls echo the chapel, but it is not a copy or even an homage; it is a design re-imagined for its desert site, commercial function, and Palm Springs culture. Whereas Corbusier created a mysterious, sacred interior by carefully controlling interior light with colored glass, Baumfeld threw two sides of the building open to the view through glass walls, shaded with appropriate aluminum sunscreens hung from the eaves. Instead of Ronchamps's stubbled concrete plaster, the exterior walls are clad in brilliant blue tiling. All appointments of chandeliers, doors, paneling, and an outdoor fountain are custom, integral designs. Like Robinson's and Bullock's, this design is a palatial expression of Palm Springs wealth.

Palm Springs's embrace of Modernism in the 1950s is also seen in a less opulent building for the police department. Designed by John Porter Clark (1905–1991)—Albert Frey's partner from 1935 to 1957 (excepting two years in the late 1930s when Frey returned to New York to work on the design of the Museum of Modern Art)—it shows the spare but elegant simplicity of his work. The surefooted design reflects Clark's experience designing many schools with steel. Trusses form the flat roof and wide overhangs for shade. The metal panel walls are set in,

and the entry is marked by a simple curved concrete block wall and landscaping. The regular steel system is treated almost like wallpaper, sliced off at the point it is no longer needed; it continues into the landscape as a frame past the enclosing walls. The concept is modest but strong. Where lesser architects used Modernism's simplicity to cut corners, Clark makes the most of a limited palette of materials and shapes.

Clark was the first of the Modernists to open an office in Palm Springs. Born in Iowa and raised in California, he attended Cornell University architecture school, as did E. Stewart Williams. While working in Los Angeles during the hard years of the early Depression, he was invited in 1932 by Sally and Culver Nichols to move to Palm Springs. As landowners and developers, they had faith in the town's future. After his partnership with Frey ended in 1957, Clark joined Stewart and Roger Williams. Stewart Williams praised him "not just as a designer, but as a salesman, engineer. . . . John Clark was the most trusted man in the Valley . . . he made people recognize architects were an important part of the community."[1]

According to his colleagues, Clark was a capable architect who worked well with the pragmatic requirements and constraints of a school board client. He was an equally capable designer, as demonstrated in his own house, built before Frey's first house. He had worked with Marston, Van Pelt and Maybury, a noted firm known for its elegant traditional designs in the early 1930s; but when Frey arrived in Palm Springs in 1934 he found in Clark a kindred spirit with an interest in simple, steel structures, especially in designing schools. While most clients did not want a steel house, a school board was impressed by the efficiencies, cost savings, and low maintenance of steel construction. Modernism thus gained a foothold in the community.

Clark's house (1939) is as direct and imaginative in its manipulation of a few forms and materials as Frey's two houses. It is also a rectilinear box clad in corrugated metal. But here Clark raises the box above the ground on angled supports, instantly and inexpensively doubling the usable living space of the house by creating a shady open patio. As Clark's family grew, a one-story wing with more bedrooms was added to enclose the yard.

The work of Herbert Burns showed a less austere and frankly less daring approach to Modernism than Frey or Lautner, and yet his design's clean lines, strong composition, warm materials, open plans, and response to the climate reflect a clear and moderate Modernism. Burns was a developer who built houses, inns, and offices; he owned and ran the small vacation inns he built. Though not trained in design, he had both a strong respect for and a good grasp of Modern architecture.

The Crockett House (1956) establishes the motifs to which Burns was drawn: flat roofs for the rainless climate, wide eaves for the harsh sun, and an informal plan inside that blends almost seamlessly with the private backyard. He uses rough ashlar stone plentifully in extended pylons or fireplace walls; they contrast the unpainted wood partitions. Low soffits hide indirect lighting, reflecting against a raised ceiling. His designs echo the aesthetic of the California Modern style that evolved in the late 1930s in the work of Los Angeles architects Douglas Honnold, George Vernon Russell, and A. Quincy Jones; the Crockett House was built in the same spirit as Town and Country Center, with certain similarities of materials and composition.

Vacationers spending a month or a season in the desert would rent small efficiency apartments such as Burns's Town and Desert (or Stewart Williams's Cordrey's Colony.) A pool, sunbathing terrace, and lawns were an essential part of the design. The Town and Desert (1947) used many of the same materials and forms as in the Crockett House. Each visitor had their own comfortable private realm, but it was always connected through large window walls to the semipublic pool area and its social activity, and to the mountain views beyond. Screens of pipe columns or louvers were used to distinguish entries and terraces, or simply as design accents. The openness of the plan allows people to fully enjoy the sunshine and fresh air—the main reasons that Canadians, Midwesterners, or Easterners visited Palm Springs.

Further examples of the range of Modern design in the microcosm of Palm Springs are the 1950 Allen Cabin in 29 Palms (architect unidentified), the 1958 Burgess House by Hugh Kaptur and William Burgess with a later guesthouse addition by Albert Frey, and the 1962 Lew Wasserman House by Harold Levitt. Nature dominates each design, from the open rocky desert of the Allen Cabin, to the panoramic views of the Burgess House perched on a rocky ledge above downtown Palm Springs, or the lavish naturalistic landscaping of the Wasserman House. In each example, the setting defines the architecture. The simple open framework of the Allen Cabin creates the simplest shelter that blends with the austere severity of the desert. The sculpted posts and beams of the Burgess House create a flexible framework for open air terraces and enclosed spaces as needed. Kaptur (b. 1931) arrived in Palm Springs in 1956 after studying at Detroit's Lawrence Institute of Technology, and working in the General Motors Styling department (where his father was a key designer) under the legendary Harley Earl; while there Kaptur worked on interiors for the new GM Technical Center by Eero Saarinen. He worked with Wexler and Harrison before starting his own office in 1957. The Wasserman House's (see page 10) dramatic diagonal structure suggests the adventurous and exotic

freedom of ultramodern design, well funded by a good budget. Levitt also designed Wasserman's Beverly Hills home. The legendary head of Universal Studios for many years, Wasserman was one more in the long list of Hollywood magnates from Joe Schenck to Jack Warner to Darryl Zanuck who owned lavish homes in Palm Springs. Levitt was a Los Angeles architect who had worked (as did A. Quincy Jones) with architect Burton Schutt in the 1940s and 1950s. Levitt's practice was varied, ranging from private homes in San Diego, Palm Springs, and Los Angeles to additions to the Riviera Hotel tower and convention hall in Las Vegas in the mid-1960s.[2]

The wide scope of Modernism is also seen in the public and semipublic buildings that formed the heart of Palm Springs's social life. As centers for recreation, dining, and socializing during the winter season, country clubs and hotels were luxurious multiservice complexes for the privileged set. Often bungalows and tennis courts were included; the land bordering the golf-course fairways was sold for private homes, creating small enclaves. In 1950s Palm Springs, this privileged set enjoyed the forward-looking stylings of Modernism. Though the Thunderbird Country Club by William Cody reflected a rustic character (he remodeled Gordon Kaufmann's earlier ranch-style riding club), the Tamarisk, Eldorado, Indian Wells and Canyon country clubs all embraced Modernism.

For the Indian Wells Country Club (1959), Val Powelson announced its entry with a tall framed box with a glass wall. Along its long adjacent wing, a walkway ran beneath the steel beams and columns that projected from the main building—an architecture expressing the structure. Developer Bob Alexander had proved that middle-class vacationers seeking second homes in the desert were willing to live modern. Powelson learned the same applied to custom-home designs; several celebrities sought him out for highly distinctive ultramodern homes set on

golf courses. Powelson's 1957 house for Gummo Marx at Tamarisk Country Club boasted a bold prowlike roof with a large glass facade. Even more eye-catching was his 1961 Leo Maranz house; its dramatic butterfly roof soared upward.

The Biltmore Hotel (1948) updated the glamour that El Mirador had brought to town twenty years before. For the postwar era, architect Frederick Monhoff adopted the modern lines that other Los Angeles architects, such as George Vernon Russell and Wayne McAllister, were introducing at the same time in the hotels and casinos of another desert resort town, Las Vegas. The curving wall of the Biltmore's main entry followed the smooth curve of a car arriving at the front door to drop off vacationing passengers; dignified sans-serif letter blocks add an elegant ornament. The rest of the building with its restaurants, lounges, bars, and kitchens curved in the opposite direction, wrapping around the pool and sunbathing terrace. A large window wall slanting outward accents the sweep of this bold formal gesture. The rooms were in separate one-story bungalows spread throughout the lawn.

Historian Beth Harris coined the term "Martini Modern" to describe the swank minimalist architecture of Palm Springs that has grabbed the attention of the world in the past decade.[3] In the flat-roofed neo-Modern houses that are being built today, and in the international style magazine spreads of white-walled and glass-walled rooms with Eames furnishings, we see the revival of Martini Modernism. Its appeal is unquestionable; at its best it depends on exquisite proportions and the well-placed accent, unlike the purposefully excessive ornament of today's neo-Tuscan, neo-Mediterranean architectural fashions in many Palm Springs homes.

But Julius Shulman's seventy years of photographs of Palm Springs reveal a much wider landscape of architecture beyond Martini Modernism. The distinguished, flat-roofed Kaufmann House is a part of that landscape. But so is the sumptuous, curvilinear shapes of Lautner's Elrod House. Burns captured a widely popular sense of Modern lines, while Jones and Paul Williams played and danced with the same forms to make an even more exciting architecture. Palm Springs's wealth created deluxe designs for fashionable country clubs, banks, stores, and inns, but there was also room for the spare reductions of Frey's designs, distilling the desert color and silence into architecture. There was room in Palm Springs for Stewart Williams' solid, settled forms, and also Cody's energetic compositions. Wexler, Jones, and Neutra could build grand custom homes tailored to the taste of individual clients, and Palmer and Krisel could create equally elegant and successful homes for mass-market customers. Palm Springs architects could work a lifetime in the modest geographical confines of the Coachella Valley, or they could come from elsewhere and discover inspiration for remarkable work; Palm Springs was a muse to all. Equally great architecture was certainly built elsewhere in the twentieth century's grand revolution of Modernism. Still it must be said that the breadth, depth, variety, and quality of Palm Springs architecture captured in Shulman's photographs reveals an extraordinary collective accomplishment in architecture. •

1 E. Stewart Williams, interview by Alan Hess, Aug, 1, 1999.

2 Martin Stern Archives, Special Collections, University of Nevada, Las Vegas.

3 Adele Cygelman, *Palm Springs Modern* (New York: Rizzoli, 1999), 56.

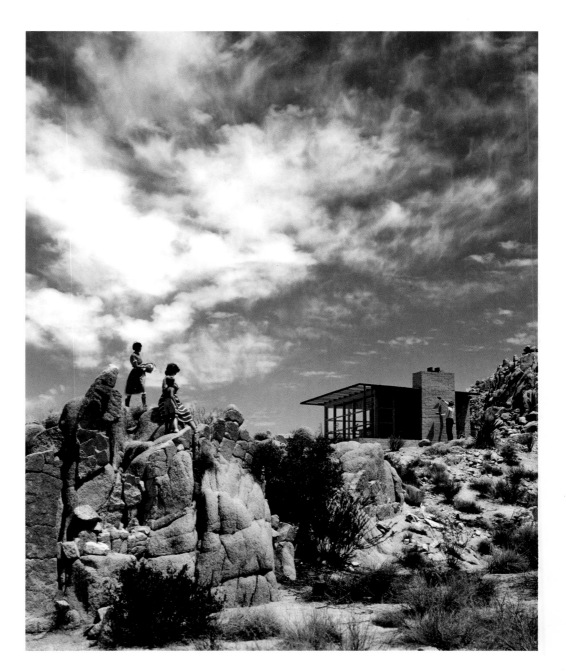

Allen Cabin, architect unidentified, 1950. Photo: 1950.

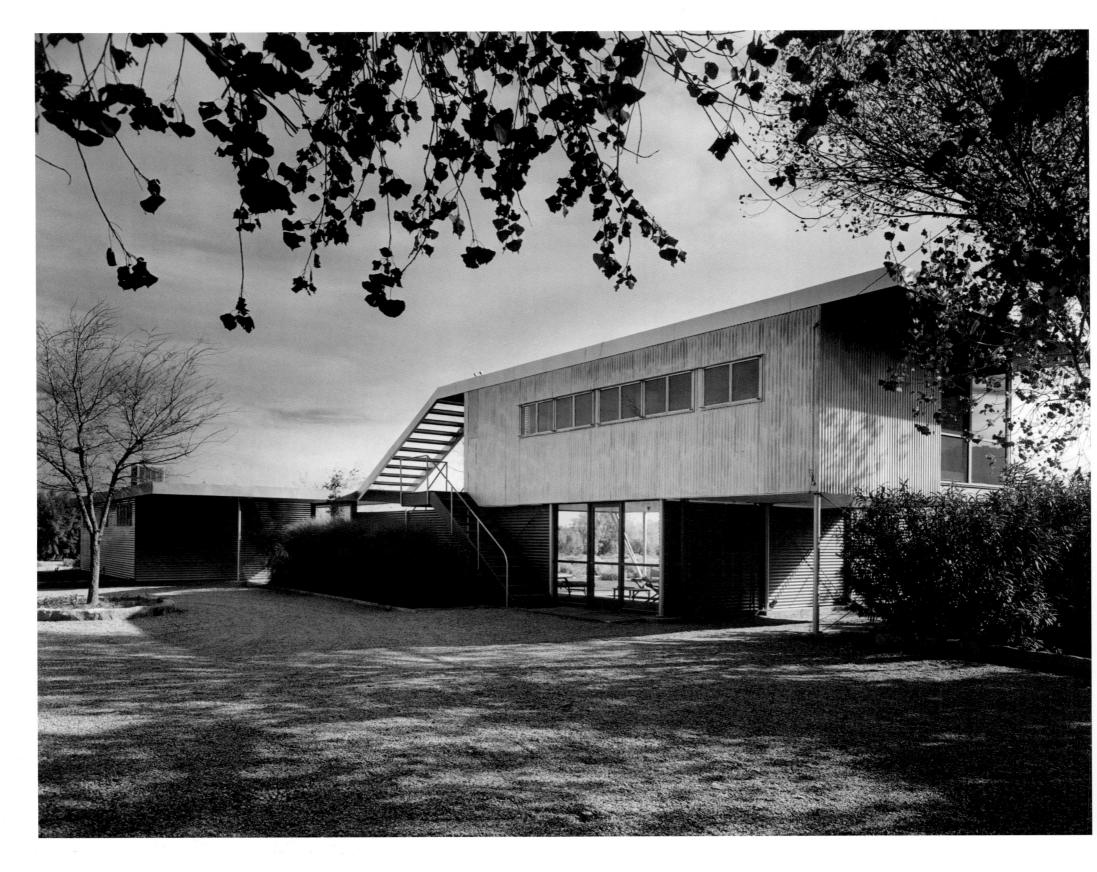

John Porter Clark House,
John Porter Clark, 1939. Photo: 1947.
Below: **Open landscape typified Palm Springs into the 1950s building boom.**
Right, top: **Bedroom wing looking toward living room and kitchen in two-story wing.**
Right, bottom: **Bedroom wing.**
Opposite: **Original house at right, lifted above the ground, was extended later in the one story wing at left.**

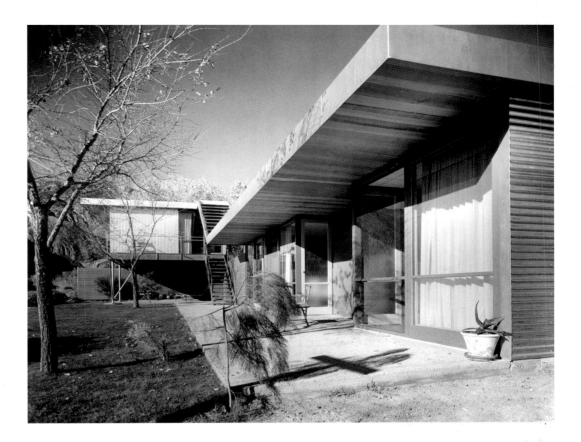

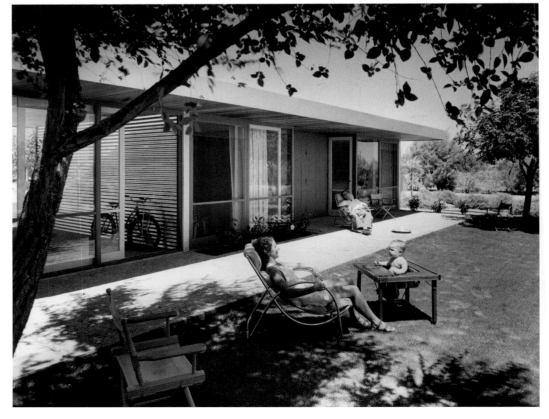

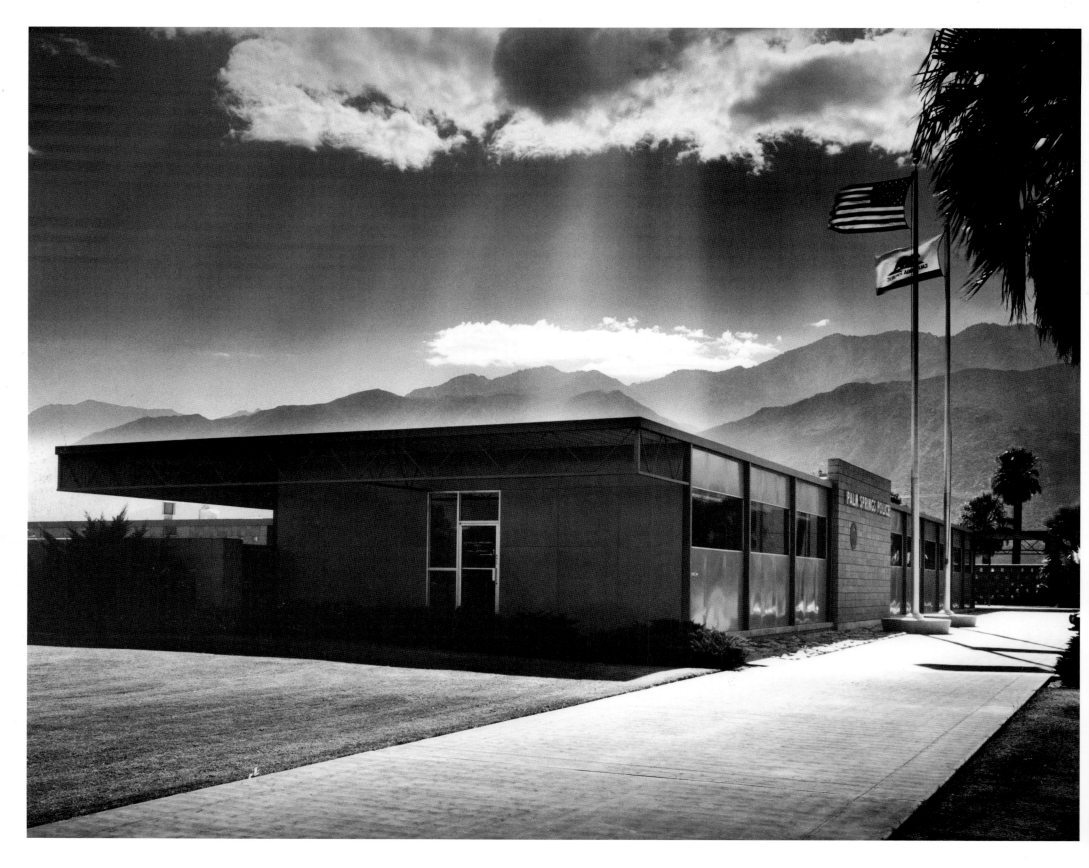

Palm Springs Police Building,
John Porter Clark, 1962. Photo: 1963.
Right: Shaded entry and garden.
Opposite: Simple steel frame and
well-studied proportions create a
small civic building for the city of Palm
Springs. Clark was a partner with
Albert Frey from 1935–1957, and with
E. Stewart Williams from 1972–1990.

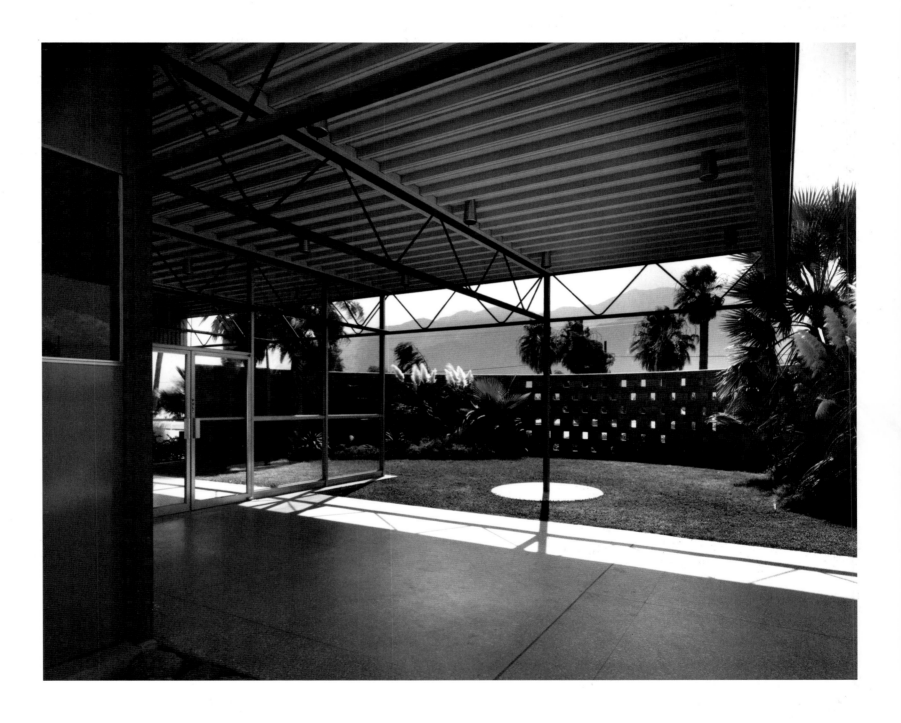

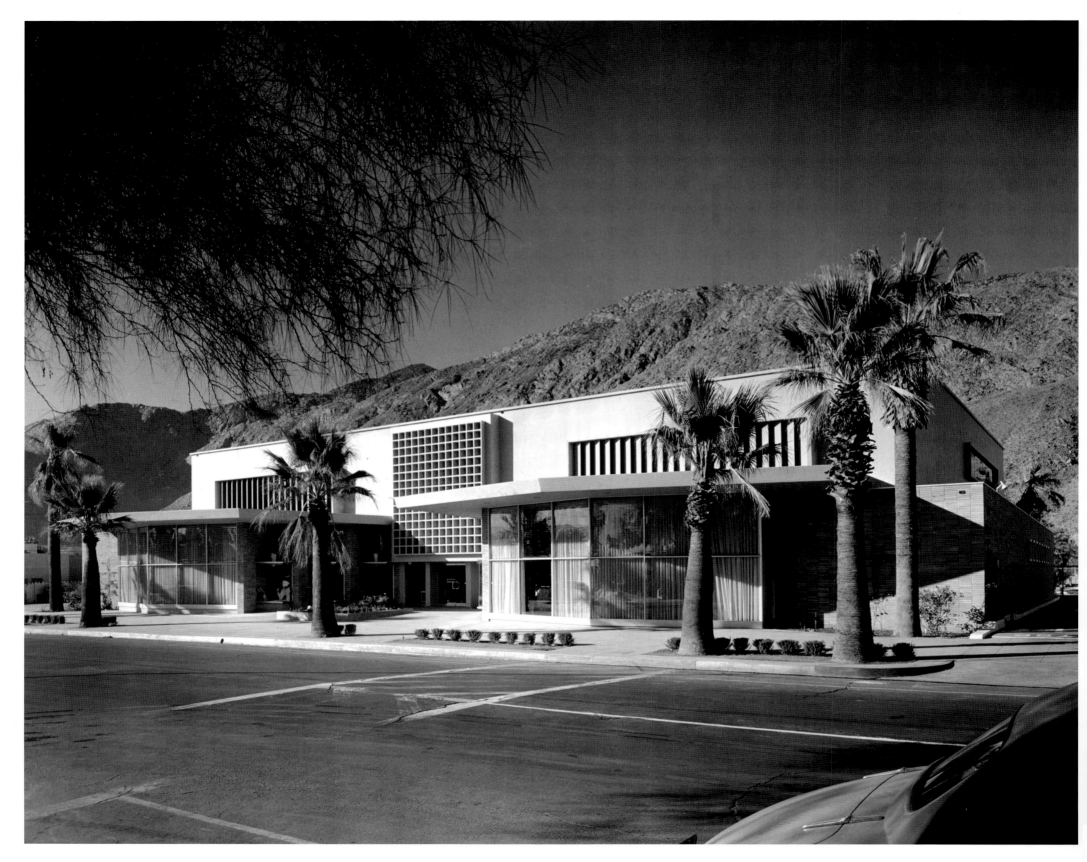

Bullock's Department Store,
Wurdeman and Becket, 1947.
Photos: 1947.
Right: Dynamic angles and sharply
chiseled lines mark the Late
Moderne style.
Opposite: One entry facing Palm
Canyon Drive drew in customers
with display windows and a
courtyard.

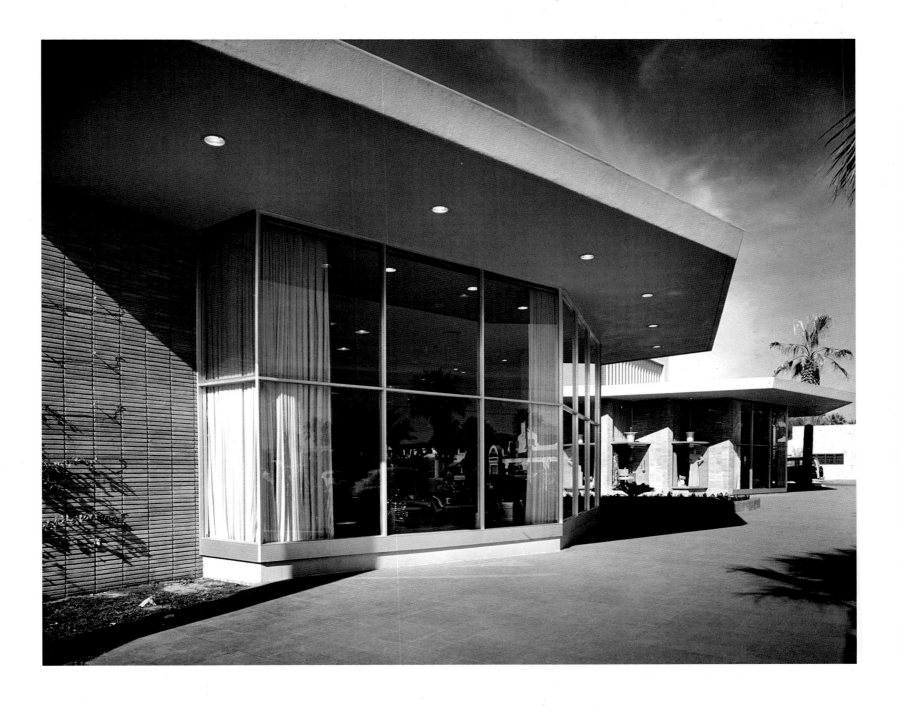

Bullock's Department Store,
Wurdeman and Becket, 1947.
Photos: 1947.
Right: **Display windows opened the
store to the heart of downtown
Palm Springs.**
Opposite: **Custom-designed display
cases in men's department.**

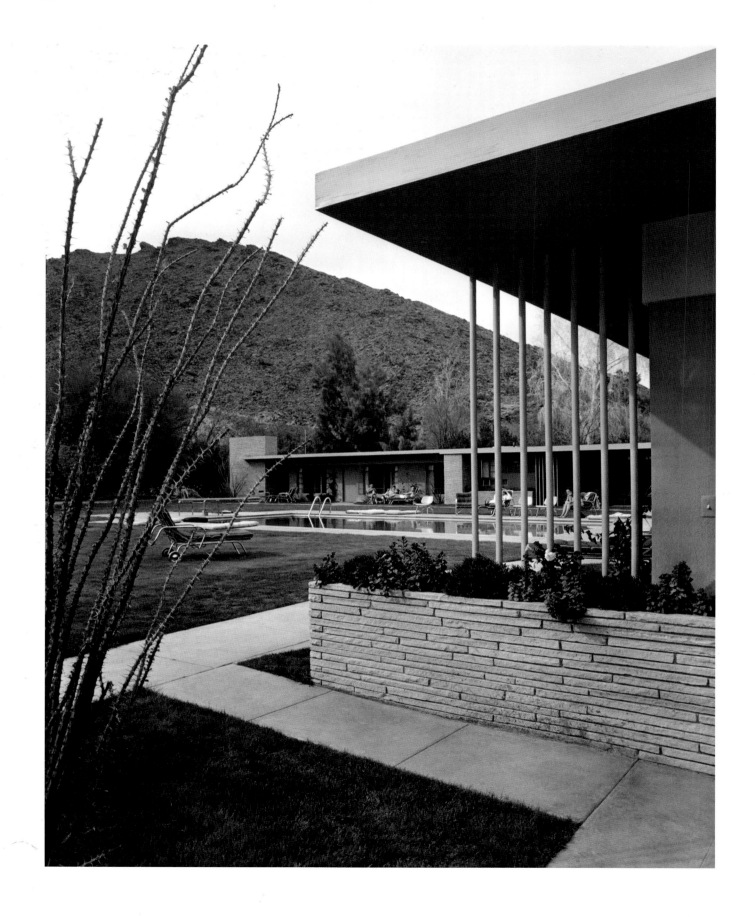

Town and Desert Inn,
Herbert Burns, 1947. Photos: 1947.
Left: Planters integrated into the
architecture, screen of pipes, and tall
brick pylons created a vivid modern
vocabulary. Shulman positioned his
camera to create a parallel
relationship between the roofline
and the mountain.
Opposite: Picture windows united
indoors and outdoors.

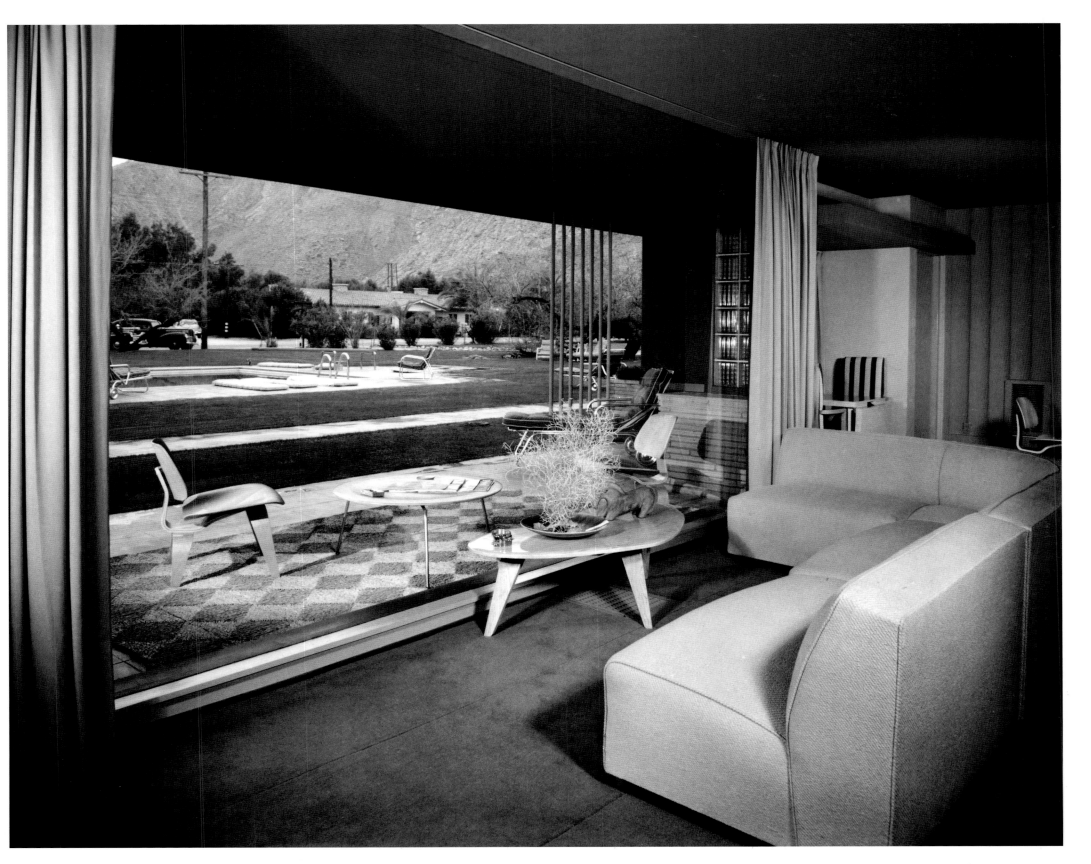

Town and Desert Inn,
Herbert Burns, 1947. Photos: 1947.
Left: Living room of residential unit.

Crockett House,
Herbert Burns, 1956. Photos: 1956.
Below: **Flat roof, dominant horizontal lines, and natural materials tie this design to the desert and the modern era.**
Right: **Living room.**

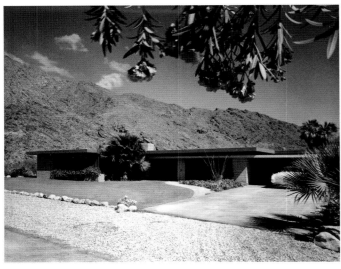

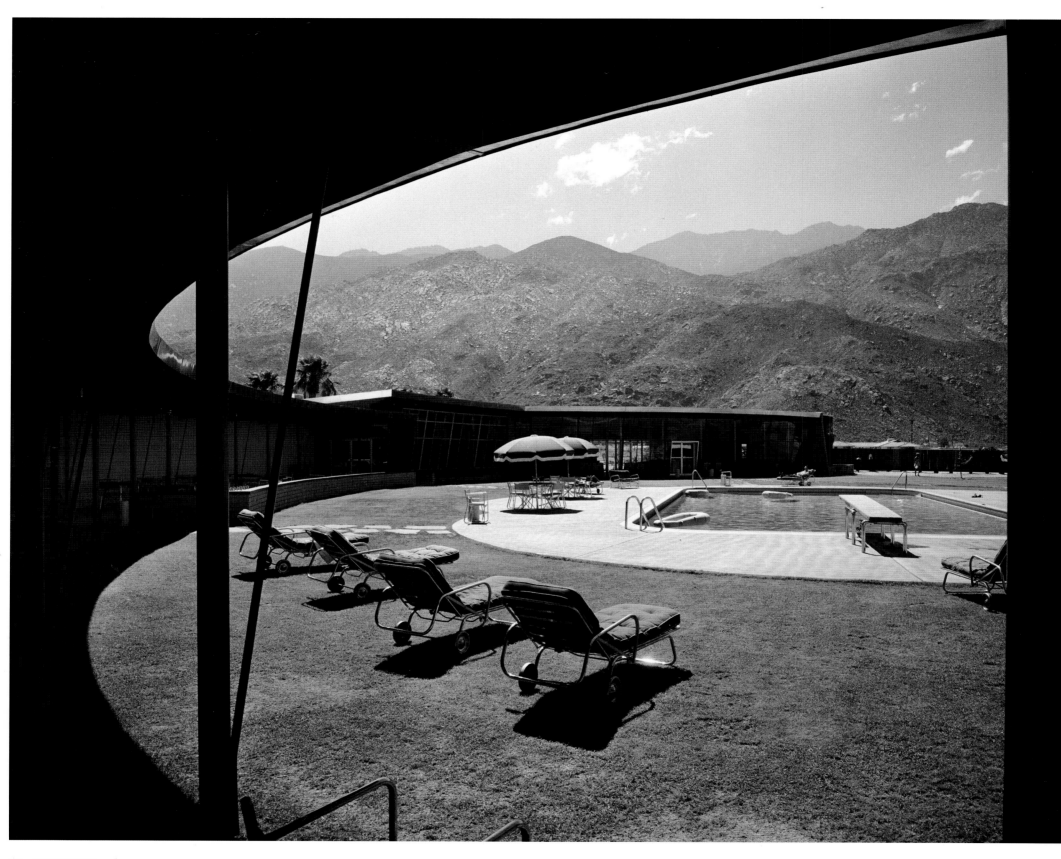

Biltmore Hotel,
Frederick Monhoff, 1948. Photos: 1948.
Right: **Lobby. Angled glass provides view of pool.**
Opposite: **A single large curve created an embracing, vivid, modern form for the hotel's pool terrace.**

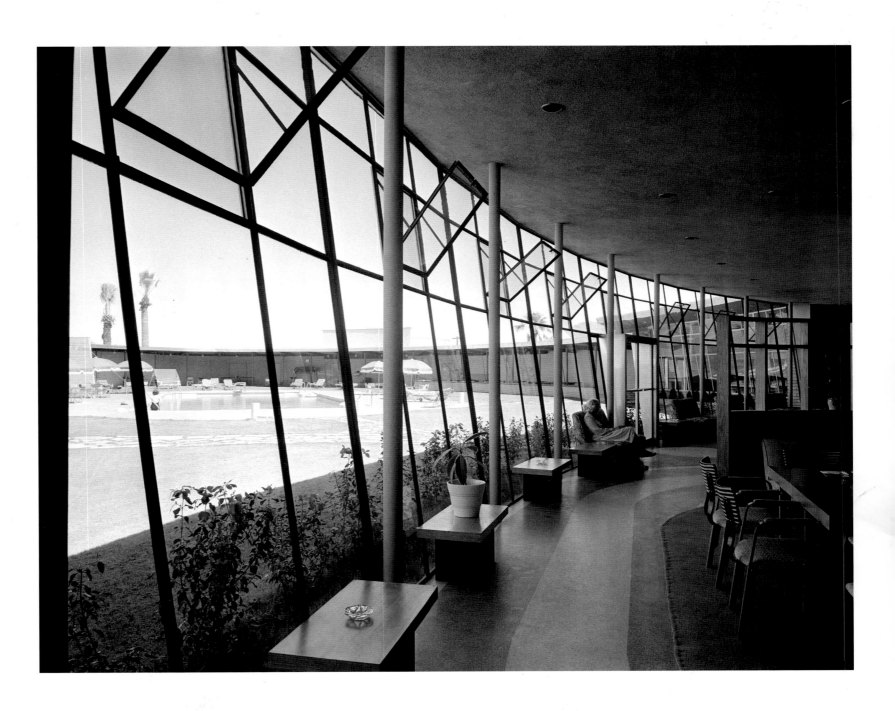

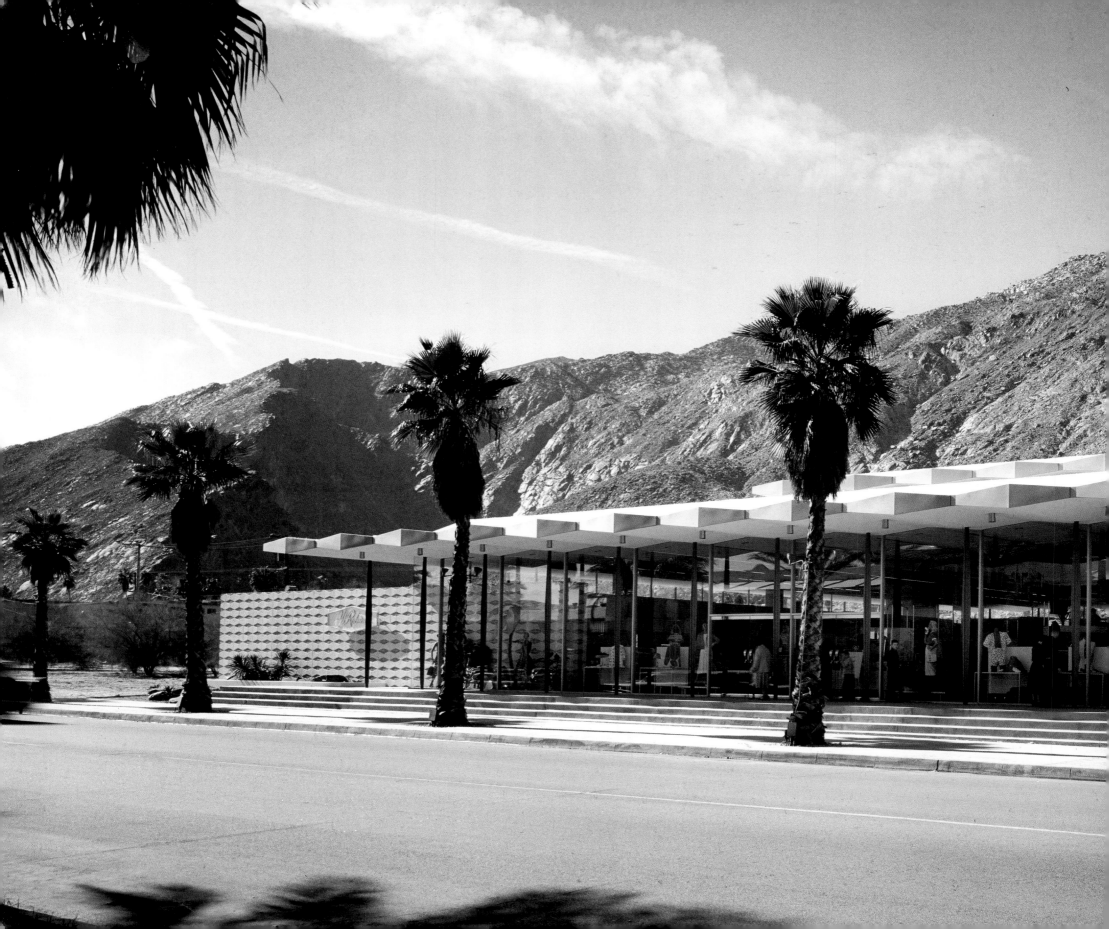

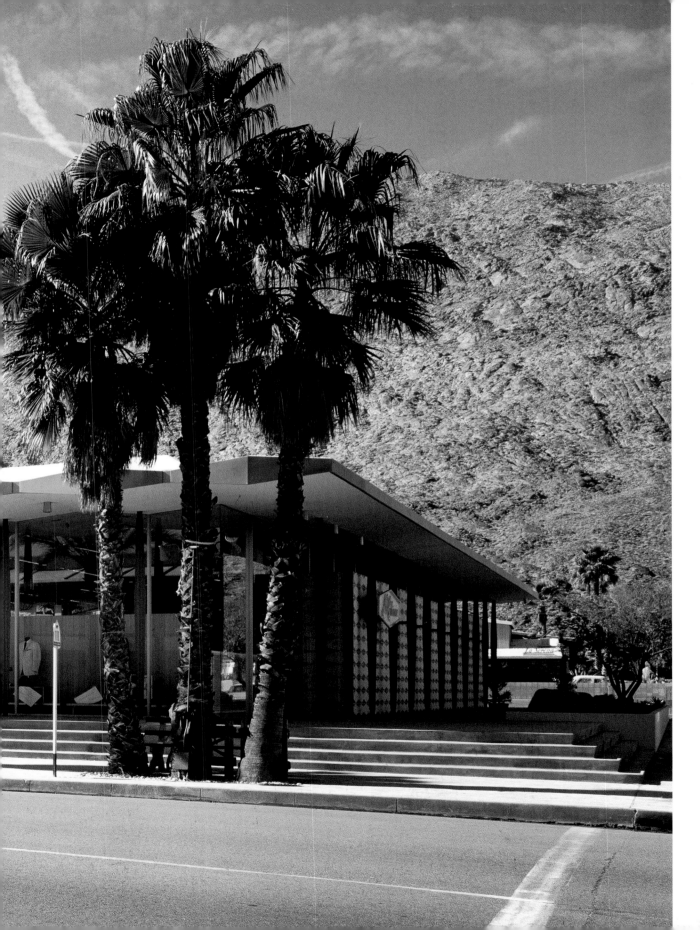

Robinson's Department Store,
Pereira and Luckman, 1958.
Photo: 1958.
This glassy, weightless pavilion
introduced yet another aspect
of Modernism to Palm Springs.

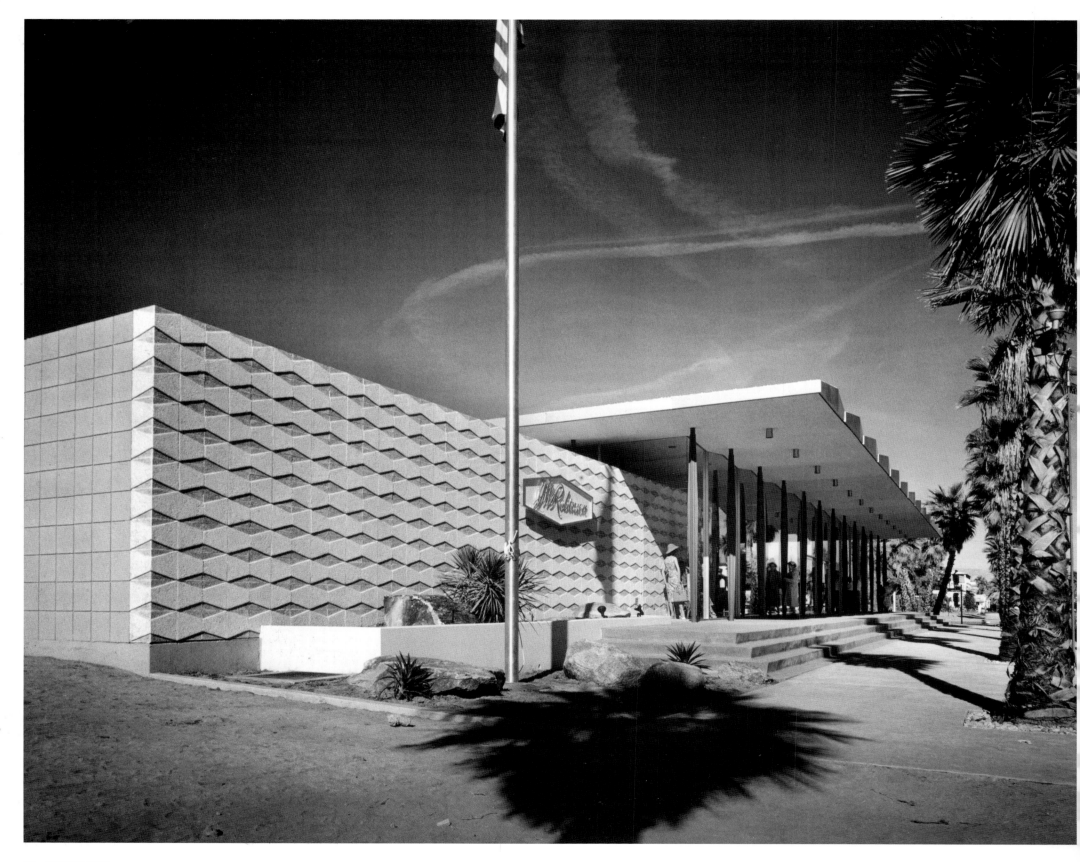

Robinson's Department Store,
Pereira and Luckman, 1953. Photo: 1958.
Below: **Glass front opens store to street.**
Right: **Tapered columns hold the steel truss
roof aloft, leaving the interior of the
department store free of columns.**
Opposite: **Low wing of molded concrete
block tucks beneath the high roof of the
main store.**

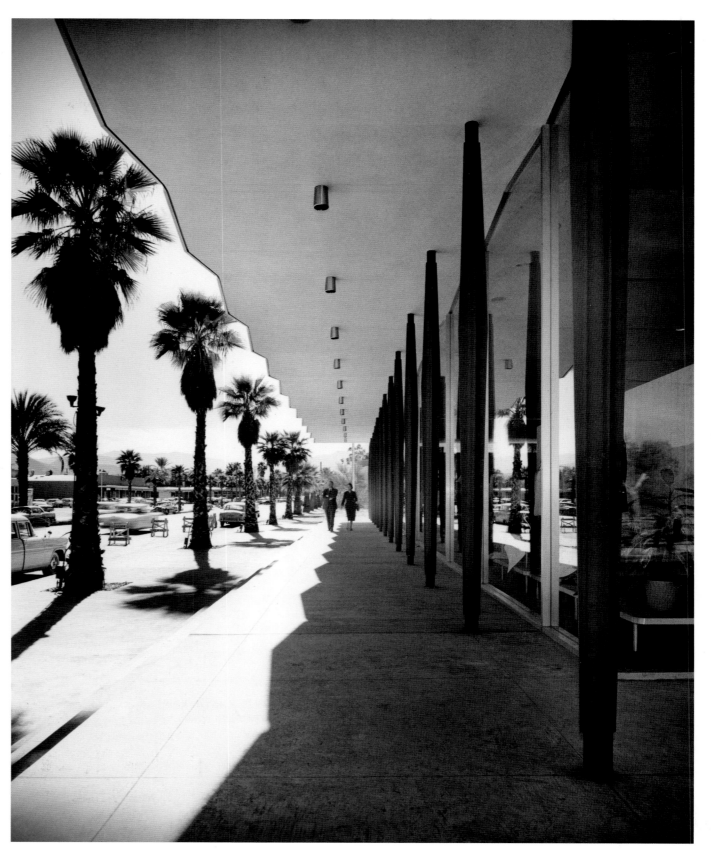

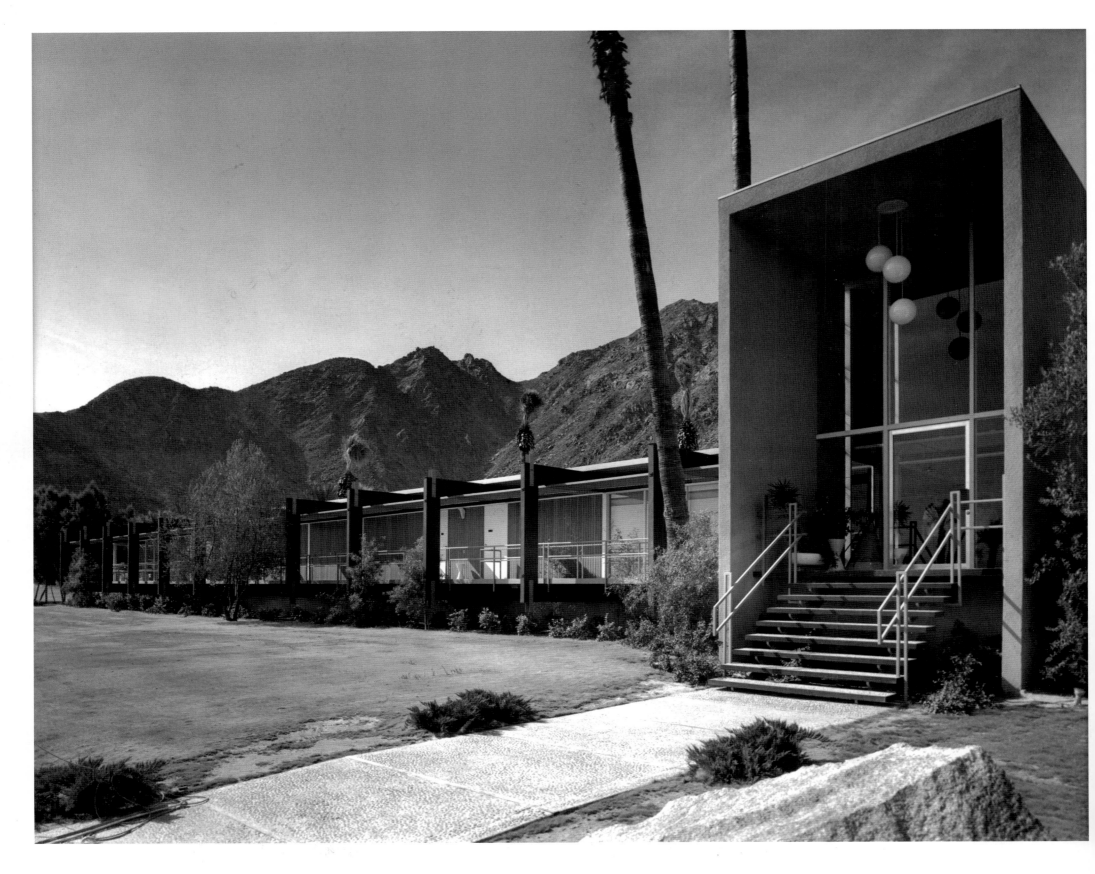

Indian Wells Country Club,
Val Powelson, 1959. Photos: 1959.
Right: **Walk shaded by expanded
metal screen extends length of
building. Shulman, photographing
through a glass door, is subtly
reflected just left of center.**
Opposite: **Entry.**

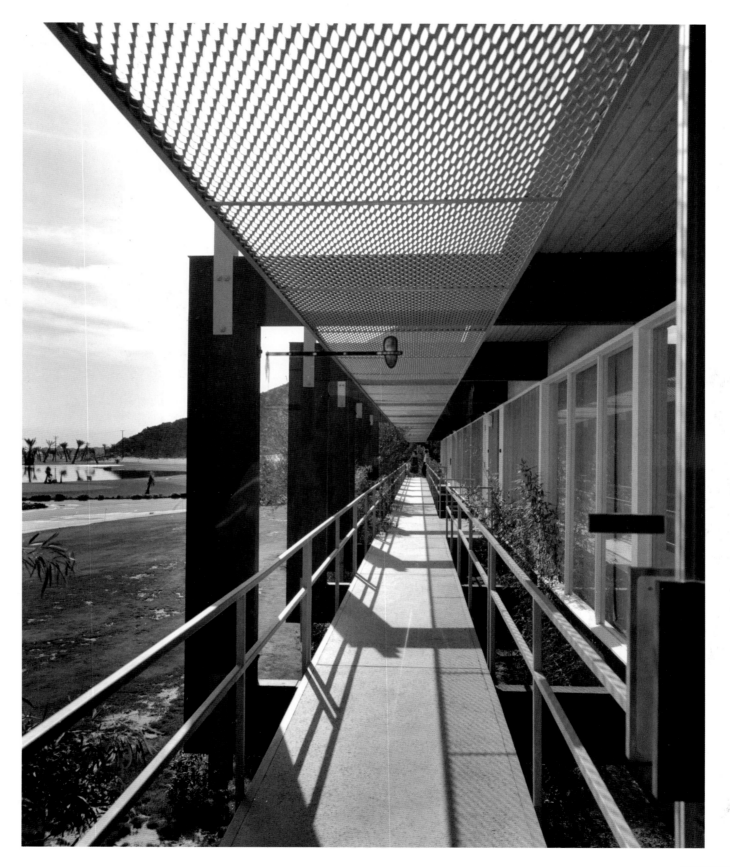

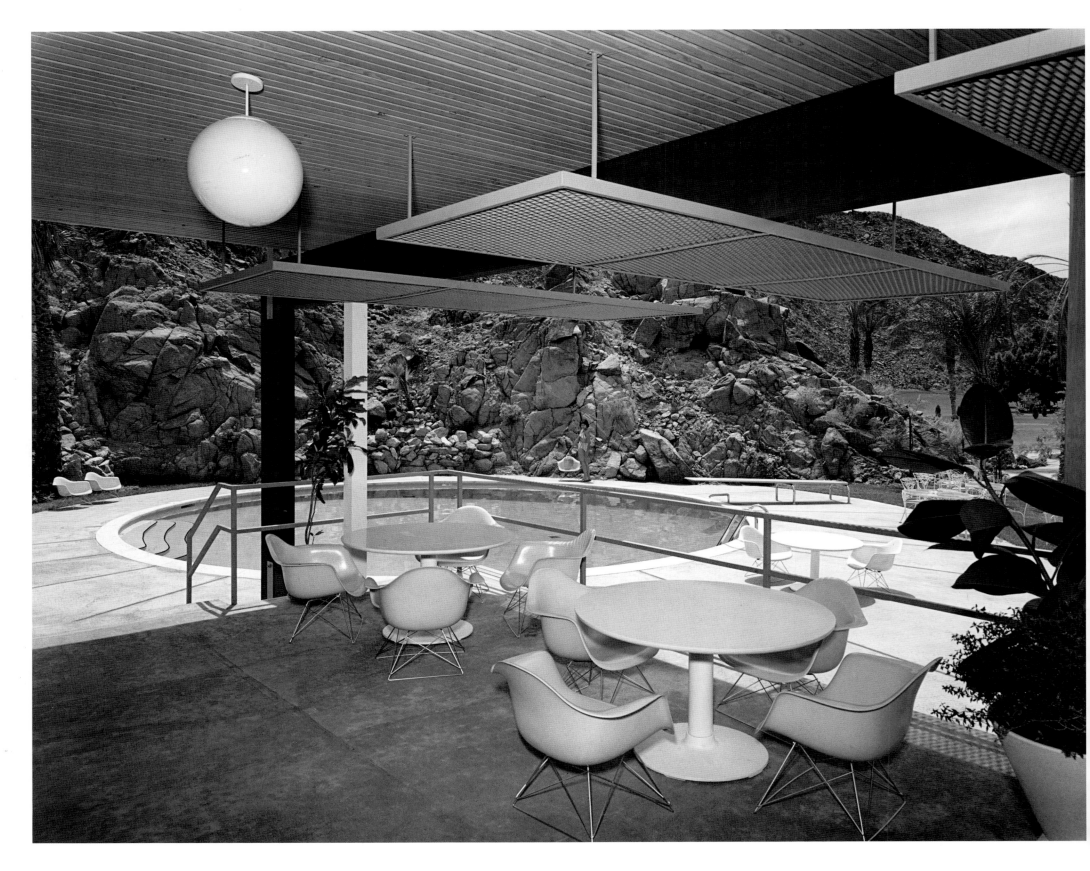

Right: **City National Bank,**
Victor Gruen Associates, 1959.
Photo: 2007.
A prominent downtown corner is
marked by a boldly sculpted roof
and a brilliant blue mosaic tile wall.

Opposite: **Indian Wells Country Club,**
Val Powelson, 1959. Photo: 1959.
Pool terrace.

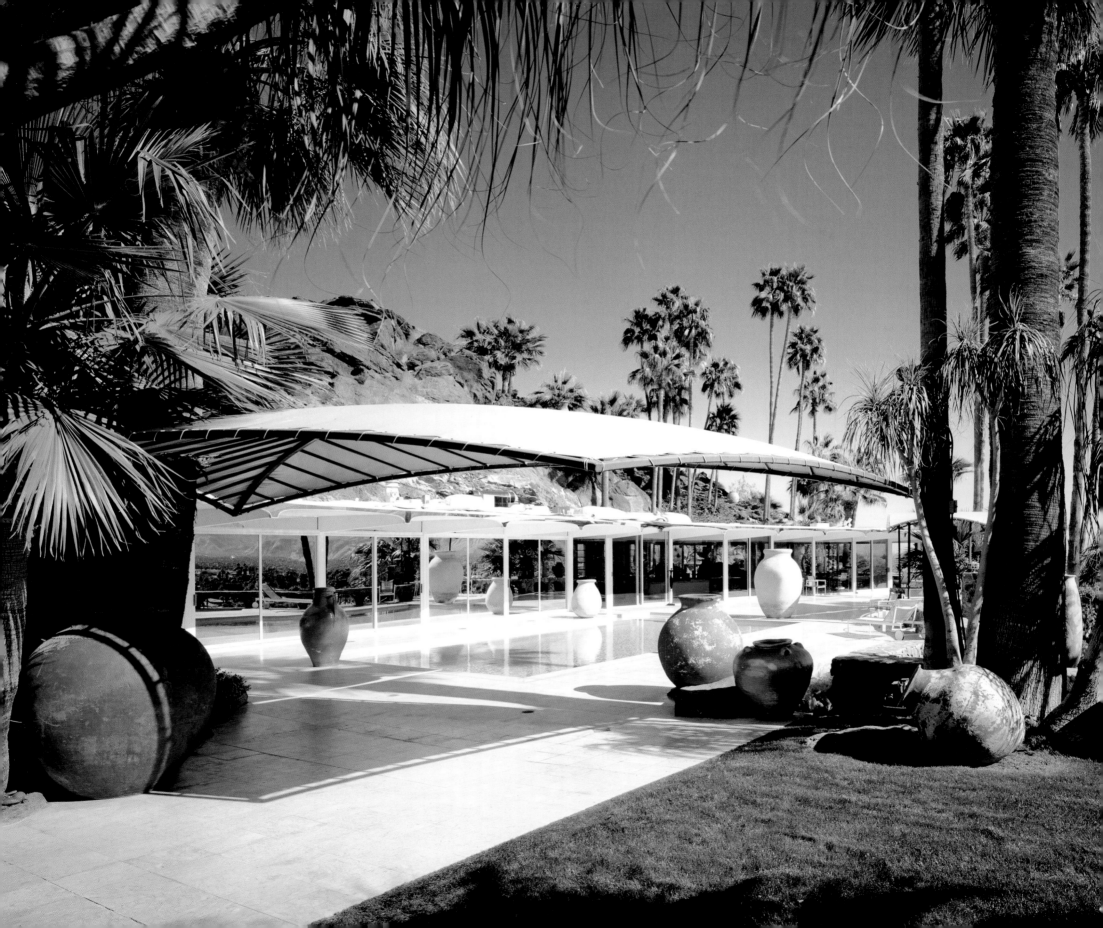

William Burgess House,
Hugh Kaptur and William Burgess
(with additions by Albert Frey), 1958.
Photos: 2007.
Left: **Pool terrace.**
Below: **Bedroom.**

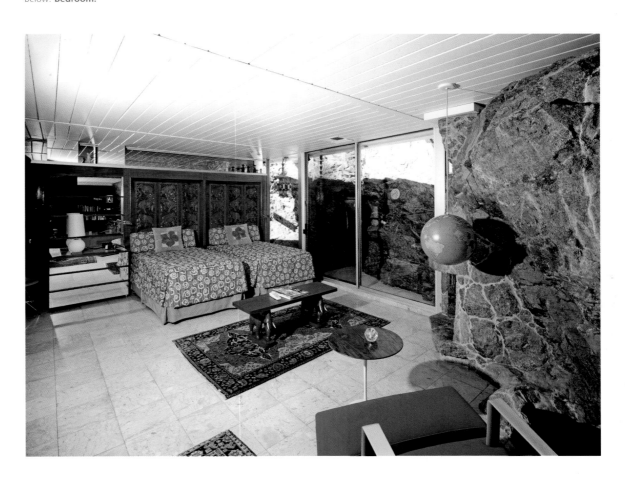

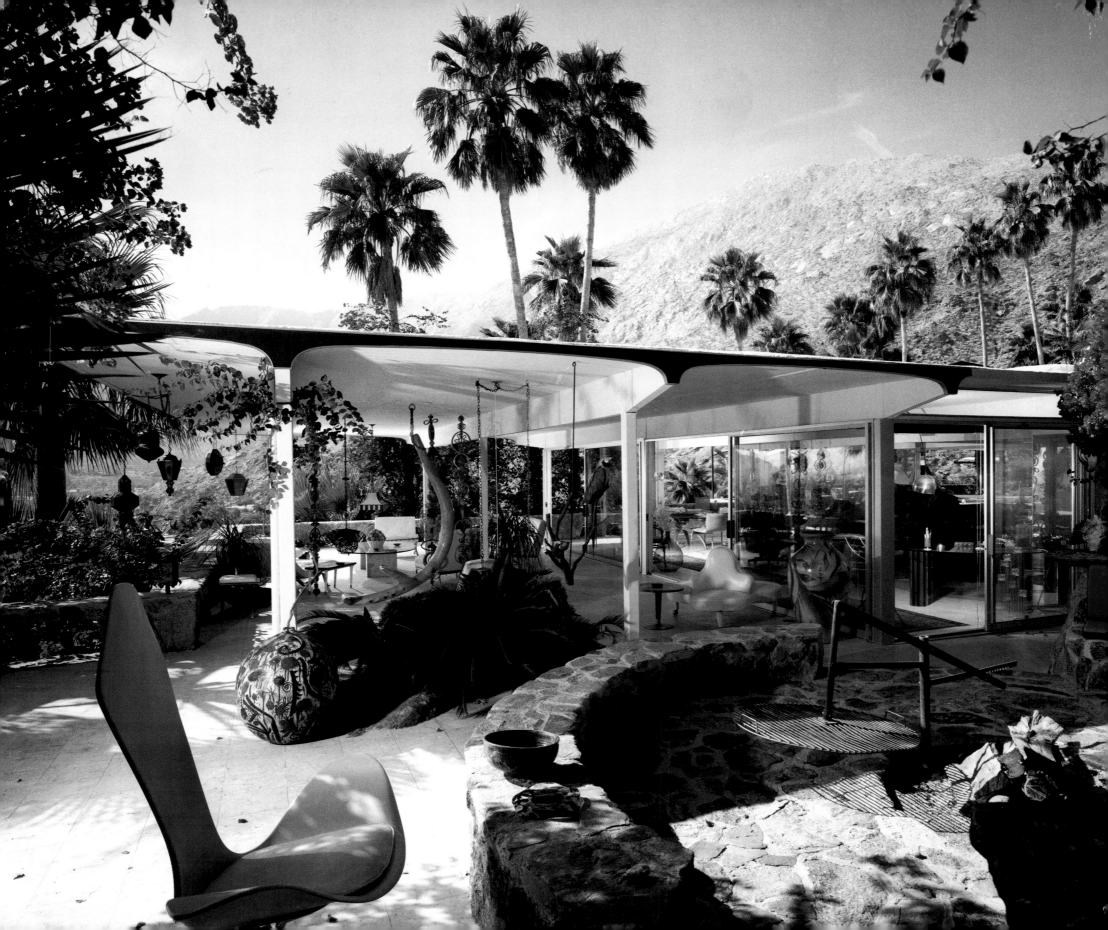

William Burgess House,
Hugh Kaptur and William Burgess
(with additions by Albert Frey), 1958.
Photos: 1984.
Left: Terrace.
Right: Outdoor dining pavilion.

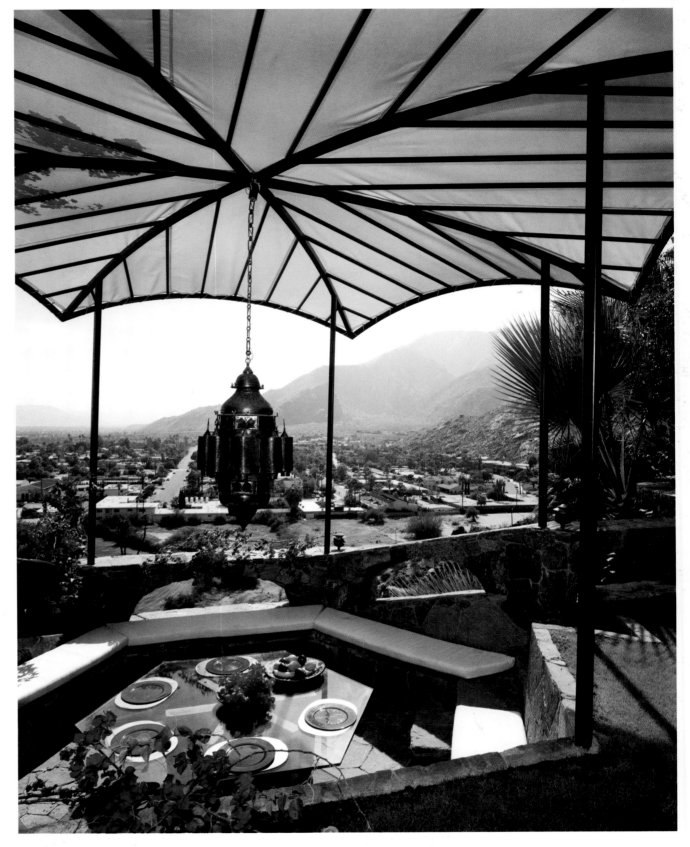

Credits

First published in the United States of America in 2008 by
RIZZOLI INTERNATIONAL PUBLICATIONS, INC.
300 Park Avenue South, New York, NY 10010
www.rizzoliusa.com

ISBN: 0-8478-3113-2
ISBN-13: 978-0-8478-3113-5
Library of Congress Control Number: 2007933610

Cover: Elrod House, John Lautner, 1968. Photo: 2007.
Back cover: Frey House #1, Albert Frey, remodeled 1953.
　　　Photo: 1954/56.
p. 1: Premiere Apartments, Clark, Frey and Chambers, 1957.
　　　Photo: 1958.
p. 2: Edris House, E. Stewart Williams, 1953. Photo: 1954/55.
p. 6: Left: Canyon Country Club, Wexler and Harrison, 1963.
　　　Photo: 1963. Right: Sandpiper Condominiums, Palmer and
　　　Krisel, 1958. Photo: 1963.
p. 14: Oasis Hotel, Williams, Williams & Williams, 1953.
　　　Photos: 1953.

Distributed to the U.S. trade by Random House, New York

Designed by Zand Gee

Printed and bound in China

2008 2009 2010 2011 2012/ 10 9 8 7 6 5 4 3 2 1

The following buildings are either no longer standing, or significantly altered:

Alpha-Beta Shopping Center

Biltmore Hotel

H. J. Bligh House

Bullock's Department Store

Desert Hospital

El Mirador Hotel

Albert Frey House #1

Samuel and Luella Maslon House

Oasis Hotel

San Gorgonio Pass Memorial Hospital

Premiere Apartments

J. B. Shamel House

Currently threatened:

Santa Fe Federal Savings and Loan

Spa Hotel and Bathhouse

Town and Country Center

Bibliography

Buckner, Cory. *A. Quincy Jones*. London: Phaidon, 2002.

Cygelman, Adele. *Palm Springs Modern*. New York: Rizzoli International Publications, 1999.

Escher, Frank, ed. *John Lautner, Architect*. London: Artemis, 1994.

Golub, Jennifer. *Albert Frey / Houses 1 + 2*. New York: Princeton Architectural Press, 1999.

Gossel, Peter, ed. *Julius Shulman: Architecture and Its Photography*. Koln: Taschen, 1998.

Hess, Alan. *Googie Redux: Ultramodern Roadside Architecture*. San Francisco: Chronicle Books, 2004.

_____. *The Ranch House*. New York: Harry Abrams, Inc. 2004.

Hess, Alan and Andrew Danish. *Palm Springs Weekend: The Architecture and Design of a Midcentury Oasis*. San Francisco: Chronicle Books, 2001.

Hess, Alan and Alan Weintraub. *Forgotten Modern: California Houses 1940–1970*. Salt Lake City: Gibbs Smith, Publisher, 2007.

_____. *The Architecture of John Lautner*. New York: Rizzoli International Publications, 1999.

Hines, Thomas S. *Richard Neutra and the Search for Modern Architecture: A Biography and History*. New York: Oxford University Press, 1982.

Hudson, Karen E. *Paul R. Williams, Architect: A Legacy of Style*. New York: Rizzoli International Publications, 1993.

Hunt, William Dudley, Jr. *Total Design: Architecture of Welton Becket and Associates*. New York; McGraw-Hill Book Co., 1972.

Leet, Stephen. *Richard Neutra's Miller House*. New York: Princeton Architectural Press, 2004.

McCoy, Esther. *Richard Neutra*. New York: George Braziller, Inc., 1960.

Merchell, Anthony A. *Modern Architecture in Palm Springs, California*. Los Angles: privately published, 1996.

Nichols, Chris, ed. *Built by Becket*. Los Angeles: The Los Angeles Conservancy, 2003.

Rosa, Joseph. *Albert Frey, Architect*. New York: Princeton Architectural Press, 1999.

Rosa, Joseph and Esther McCoy. *A Constructed View: The Architectural Photography of Julius Shulman*. New York: Rizzoli International Publications, 1999.

Serraino, Pierluigi and Julius Shulman. *Modernism Rediscovered*. Koln: Taschen, 2000.

Sewell, Elaine K., Ken Tanaka and Katherine W. Rinne. *A Quincy Jones: The Oneness of Architecture*. Tokyo: Process Architecture Publishing Co., 1983.

Shulman, Julius. *Photographing Architecture and Interiors*. New York: Whitney Library of Design, 1962.

Sotta, Andy. *The Architecture of William F. Cody: A Desert Retrospective*. Palm Springs: Palm Springs Preservation Foundation, 2004.

Sotta, Andy, Tony Merchell, and Jade Nelson. *E. Stewart Williams: A Tribute to his Life and Work*. Palm Springs: Palm Springs Preservation Foundation, 2005.

Steele, James. *William Pereira*. Los Angeles: Architectural Guild Press, 2002.

Wall, Alex. *Victor Gruen: From Urban Shop to New City*. Barcelona: Actar, 2005.

When Mod went Mass: A Celebration of Alexander Homes. Palm Springs: Palm Springs Historic Site Foundation, 2001.

Index